Vincent van Gogh

and the
Painters
of the
Petit
Boulevard

Saint Louis Art Museum
February 17 – May 13, 2001

Städelsches Kunstinstitut, Frankfurt
June 8 – September 2, 2001

Charles Angrand

Louis Anquetin

Emile Bernard

Paul Gauguin

Vincent van Gogh

Camille Pissarro

Lucien Pissarro

Paul Signac

Georges Seurat

Henri de Toulouse-Lautrec

Cornelia Homburg

Vincent van Gogh

and the Painters of the Petit Boulevard

with essays by
Elizabeth C. Childs
John House
Richard Thomson
and a chronology by
Lynn DuBard

Saint Louis Art Museum
in association with Rizzoli International Publications, Inc.

Published on the occasion of the exhibition
Vincent van Gogh and the Painters of the Petit Boulevard
Saint Louis Art Museum, February 17–May 13, 2001
Städelsches Kunstinstitut und Städtisches Galerie, Frankfurt, June 8–September 2, 2001

This exhibition and its promotion are made possible by the William T. Kemper Foundation,
Commerce Bank Trustee; Commerce Bank; and the Arthur and Helen Baer Foundation.

Library of Congress Cataloguing-in-Publication Data

Vincent van Gogh and the Painters of the Petit Boulevard/edited by Cornelia Homburg
Essays by Elizabeth C. Childs, Cornelia Homburg, John House, Richard Thomson
p. cm.

ISBN (hardcover edition) 0-8478-2332-6
ISBN (paperback edition) 0-89178-083-1

1. Gogh, Vincent van, 1853–1890 —catalogs
2. Gogh, Vincent van, 1853–1890 —criticism and interpretation
3. Petit Boulevard, painters
I. Homburg, Cornelia II. Childs, Elizabeth C. III. House, John IV. Thomson, Richard

Library of Congress Number 00-103001

Front cover: Vincent van Gogh, *Stairway at Auvers*, 1890, oil on canvas, 51 x 71 cm, Saint Louis Art Museum
Back cover: Paul Signac, *Snow, Boulevard de Clichy, Paris*, 1886, oil on canvas, 45.7 x 65.4 cm,
The Minneapolis Institute of Arts, Bequest of Putnam Dana McMillan

Edited by Mary Ann Steiner, St. Louis, and Christopher Lyon, New York
Design by Hans-Werner Holzwarth, Berlin

Printed in Italy

Contents

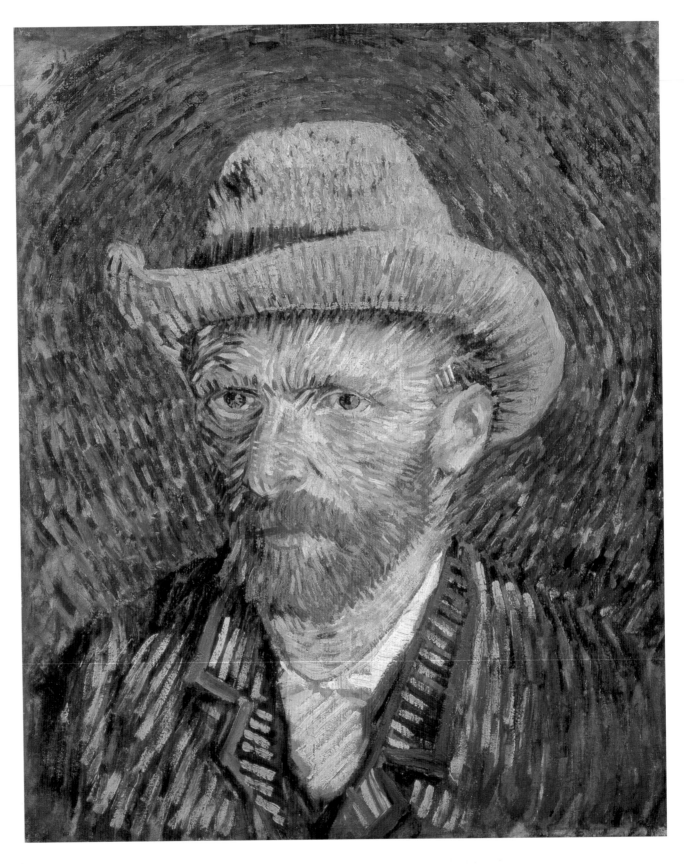

SELF-PORTRAIT WITH GRAY FELT HAT, 1887–88 Oil on canvas, 44 x 37.5 cm

Foreword

Vincent van Gogh and the Painters of the Petit Boulevard takes a pioneering look at perhaps the best-known artist in the world. With new scholarship, the exhibition examines van Gogh not only as a brilliant painter and draftsman, but also as a strategist and theorist whose major role in the definition of a new avant-garde has not been truly recognized. After his arrival in Paris in 1886, the artist sought the company of a disparate group of innovative younger artists: Paul Gauguin, Emile Bernard, Henri de Toulouse-Lautrec, Charles Angrand, Georges Seurat, Paul Signac, Louis Anquetin, and Camille and Lucien Pissarro; van Gogh himself called them the painters of the *petit boulevard*. This exhibition presents van Gogh in the context of other artists who all were determined to move beyond impressionism in search of a new style of modern painting.

A presentation as intellectually intriguing and visually stunning as this happens only with the gracious participation of many lenders. On behalf of the many people who will visit the exhibition, we extend our thanks to each of the individuals and institutions whose beautiful works of art have given the exhibition its remarkable scope.

We are deeply grateful to the William T. Kemper Foundation, Commerce Bank Trustee; Commerce Bank; and the Arthur and Helen Baer Foundation. Their extraordinarily generous financial support has provided the underpinning of this beautiful and important exhibition.

It is a great pleasure to recognize our colleagues, Professor Dr. Herbert Beck, director, and Dr. Sabine Schulze, curator of nineteenth- and twentieth-century painting, at the Städelsches Kunstinstitut und Städtische Galerie in Frankfurt, which serves as the second venue for the exhibition. We appreciate their keen interest in bringing the exhibition to a European audience and in working with us to produce a German edition of the catalogue.

We thank Cornelia Homburg, assistant director for curatorial affairs and curator of modern art, for her vision and success in making this exhibition a reality. Her formidable knowledge of the subject matter and commitment to collaboration have brought us an exceptional presentation. With her, I extend our appreciation to the contributors to the catalogue, all distinguished scholars of the nineteenth century: Elizabeth C. Childs, professor of art history at Washington University in St. Louis; John House, professor of art history at the Courtauld Institute, London; and Richard Thomson, professor of art history at the University of Edinburgh, Scotland. Together they have brought to life a critical moment in the rise of modern art.

Brent R. Benjamin
Director
Saint Louis Art Museum

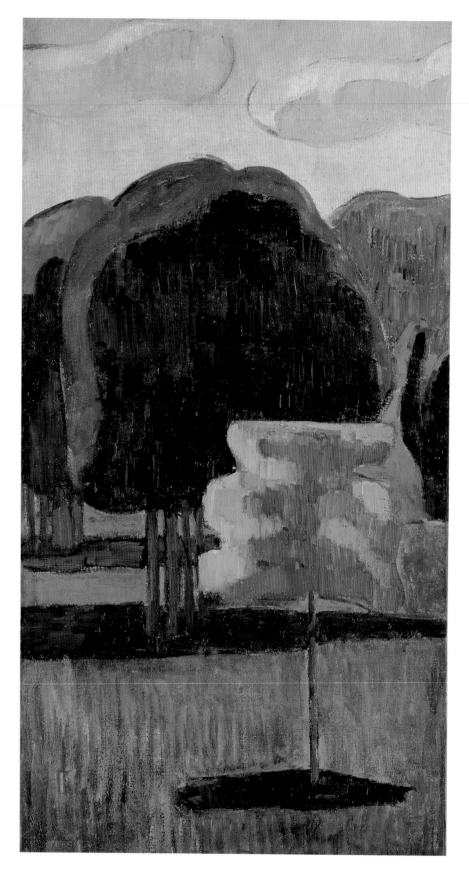

THE YELLOW TREE, C. 1892 Oil on canvas, 65.8 x 36.2 cm

Lenders to the Exhibition

Albright-Knox Art Gallery, Buffalo

Arthur G. Altschul Collection, New York

The Art Institute of Chicago

Ashmolean Museum, Oxford

The Baltimore Museum of Art

Boston Public Library

The British Museum, London

Brooklyn Museum of Art, New York

Sterling and Francine Clark Art Institute,
 Williamstown

Courtauld Gallery, Courtauld Institute of Art,
 London

Dallas Museum of Art

Fogg Art Museum, Cambridge

Indianapolis Museum of Art

Kimbell Art Museum, Fort Worth

Kröller-Müller Museum, Otterlo

Leeds Museums and Galleries (City Art Gallery)

Daniel Malingue Collection, Paris

The Marion Koogler McNay Art Museum,
 San Antonio

The Menil Collection, Houston

The Metropolitan Museum of Art, New York

The Minneapolis Institute of Arts

Musée des Arts Décoratifs, Paris

Musée des Beaux-Arts, Rennes

Musée des Beaux-Arts de Nantes

Musée de Brest

Musée Départemental Maurice Denis "Le Prieuré,"
 Saint-Germain-en-Laye

Musée de Grenoble

Musée d'Orsay, Paris

Museum of Fine Arts, Boston

The Museum of Modern Art, New York

The National Gallery, London

National Gallery of Art, Washington, D.C.

The Nelson-Atkins Museum of Art,
 Kansas City

Öffentliche Kunstsammlung Basel,
 Kunstmuseum

Ordrupgaard, Copenhagen

Petit Palais, Musée d'Art Moderne, Geneva

Saint Louis Art Museum

Stedelijk Museum, Amsterdam

The Tate Gallery, London

Van Gogh Museum, Amsterdam

Wadsworth Atheneum, Hartford

Jane Voorhees Zimmerli Art Museum,
 New Brunswick

Anonymous lenders

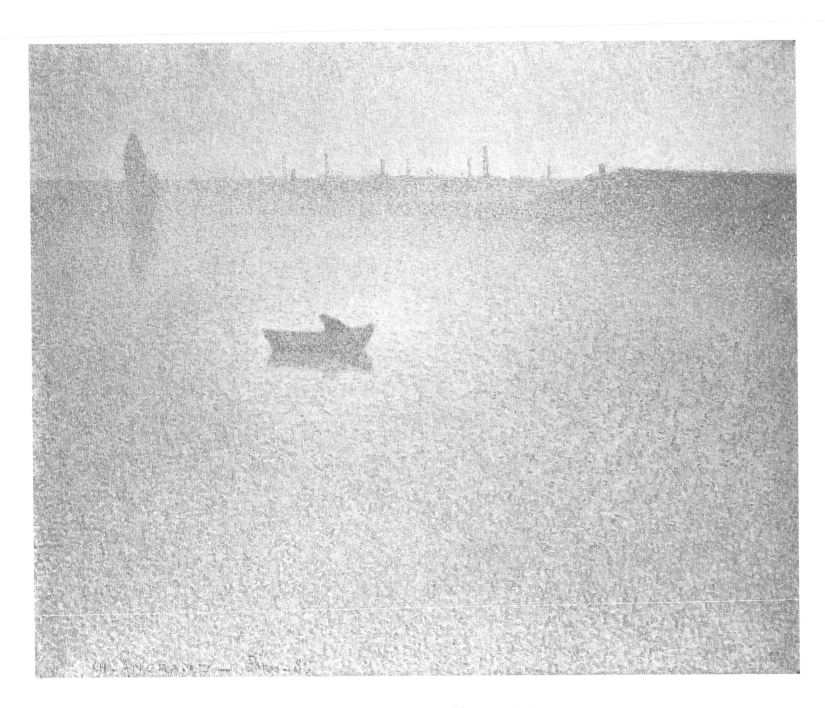

THE SEINE AT DAWN, 1889 Oil on canvas, 65 x 81 cm

Acknowledgments

This project has become reality because many people were willing to give it their generous support, and I am grateful to each and every one of them. The lenders have played a particularly important role, as they have allowed us to borrow their fabulous artworks for the duration of the exhibition. Their willingness to part with their treasures gave us the opportunity to develop our argument visually and present a fascinating view of artistic achievements in the late 1880s. We deeply appreciate this generosity.

While the topic of van Gogh's professional ambitions along with his relationships with other artists has been on my mind for a long time, it has received valuable insights and important direction through stimulating discussions with the other essayists in this book: Elizabeth C. Childs, John House, and Richard Thomson. I thank them for their engaging and penetrating written contributions as well as for their enthusiastic support of this project.

The exhibition received early encouragement from James D. Burke, director emeritus, and from Brent R. Benjamin, director, who has given his active support since the moment of his arrival in 1999.

Without my colleagues at the Saint Louis Art Museum this exhibition would not have come about. Virtually every department has contributed in major ways. It is impossible to mention everyone individually, but I would like to extend my heartfelt thanks to all of them. My research assistants Lynn DuBard, who is also the author of the chronology in this book, Nicole Myers, Anabelle Kienle, and Michelle Komie have been a great help through the years, and Susan Shillito has provided constant support for many of my activities related to the project. I thank Jeanette Fausz, registrar, and Diane Mallow, associate registrar, for the handling of the loans, and Linda Thomas, assistant director for collections and exhibitions, for her supervision of many aspects of the exhibition. I am grateful to Paul Haner for his conservational care and to Jon Cournoyer, Dan Esarey, Larry Herberholt, Jeff Wamhoff, and their teams for their expertise in realizing the exhibition.

The beautiful catalogue would not exist without the great care and dedication of Mary Ann Steiner, director of publications at our museum, and her staff. To them and to Christopher Lyon at Rizzoli International Publications, I extend my deep gratitude. I am also grateful to Marijke de Groot for reading my manuscript.

I thank my colleagues at the Städelsches Kunstinstitut und Städtische Galerie in Frankfurt, Germany, particularly Sabine Schulze and Mirjam Neumeister. I am very pleased that this exhibition will be seen in Europe.

For their generous support in a variety of ways, I would like to express my gratitude to Tobia Bezzola, Marc Blondeau, Sylvie and Philippe Brame, John Buchanan, Rupert Burgess, Marie El Caïdi, Galerie Cazeau Beraudiere, Claire Conway, Danièle Devynck, Barney Ebsworth, Richard Francis, Caroline Durand-Ruel Godfroy, Monique Hageman, Margrit Hahnloser, Colin Harrison, Robert Herbert, Sona Johnston, Marc Larock, Fred Leeman, François Lespinasse, Dominique Lobstein, Charles Moffett, John Morton Morris, Helly Nahmad, Monique Nonne, David Norman, Lucrezia Recchi, Joseph J. Rischel, Herbert D. Schimmel, Roger Ward, Bogomila Welsh-Ovcharov, and Mary Woolever.

Cornelia Homburg
Saint Louis Art Museum

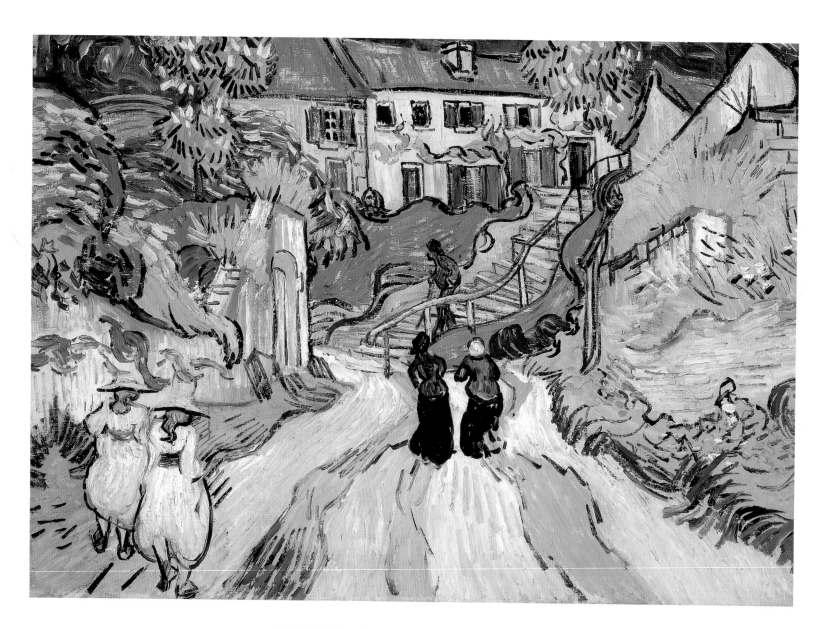

STAIRWAY AT AUVERS, 1890 Oil on canvas, 51 x 71 cm

Introduction

Cornelia Homburg

I find myself in the not very easy position of having to convince *Tersteeg that I am actually a genuine impressionist of the Petit Boulevard, and that I intend to remain so.*

Vincent van Gogh, *Complete Letters*, 473

As difficult as Vincent van Gogh thought it was to be recognized as a member of the avant-garde in the late 1880s, it is with equal difficulty that the public and art historians have considered him as actively participating in the efforts of the avant-garde to establish itself. More often van Gogh has been seen as a loner, isolated in the South of France after a short stint in Paris, creating extraordinary works of art. Presentations of van Gogh's work have most often been retrospectives, focusing on selections from his oeuvre or defining some aspect of it in isolation.[1]

The present exhibition and book take a fresh look at van Gogh's contacts and exchanges with other artists in Paris and the context in which they took place. They aim to present his work from 1886 until 1890 in light of his ambitions to be part of the avant-garde groups that were forming at that time. A variety of artists were deeply engaged in distinguishing themselves as modern and at the forefront of artistic matters. Diverse in their ideas, often only loosely connected, they frequently criticized each others' styles and concepts. Yet they shared a range of issues that characterize their avant-garde ambitions: while they were clearly building on the achievements of impressionism, they wanted to distinguish themselves from this and

other movements by introducing new styles of painting and giving more personal interpretations of subject matter. They proposed theories to support their painting, and their aspirations were recognized and hailed by critics. While they often worked together to create a modern identity and to develop a market for the new styles of painting, they each also sought individual recognition and success.

The activities and ambitions of these artists were beginning to unfold at the time van Gogh arrived in Paris in 1886. Initially he was unprepared for the already established presence of impressionism and was unaware of the developments of even newer ideas. However, it did not take him long to join in the discussions and enterprises of the emerging groups. He played down the differences and competition among the various camps, such as Signac and Seurat on the one side and Gauguin and Bernard on another, eager to learn from all and convinced that identity and strength could be found in numbers. He identified these painters as members of the *petit boulevard*, thus contrasting them with the impressionists, whom he called the painters of the *grand boulevard*. With that nomenclature, he emphasized the difference between the recognized and relatively established impressionists, such as Monet and Renoir, and the younger, lesser-known artists still striving for new forms of expression. When van Gogh left Paris for the South of France in 1888, he did not abandon what he had learned in the city but continued to practice the strategies and stylistic ideas he had developed there, always determined

to create an audience and distinguish himself as a modern artist.

With this book and exhibition, we intend to place van Gogh in the context of artistic activities and thinking in the late 1880s. His work is shown with that of Charles Angrand, Louis Anquetin, Emile Bernard, Paul Gauguin, Camille and Lucien Pissarro, Paul Signac, Georges Seurat, and Henri de Toulouse-Lautrec. We know that these artists were in contact with van Gogh during his sojourn in Paris and that he associated himself with their ideas and activities in his quest to become a modern artist. The themes addressed in the exhibition and discussed in the catalogue essays exemplify the subject matter central to them: urban, modern life in and around Paris; nightlife in the cafés and cabarets around Montmartre, where most of the artists lived and worked; and a new interpretation of landscape and portraiture. The first essay discusses van Gogh's relationships with his contemporaries and his strategies to position himself as a modern artist. In the second essay, Richard Thomson takes up van Gogh's notion of the *petit boulevard* and locates it within the Paris of his time. He shows that there was indeed a geographical area as well as a context among artists and writers in the late 1880s that correspond to van Gogh's concept. Elizabeth C. Childs discusses Gauguin's sojourns in Brittany and van Gogh's dream of a Studio of the South in Arles as examples of the concept of an ideal community that was developed by several of the painters. John House looks at how painters of the late 1880s addressed the subject of landscape, how their work differs from that of their impressionist predecessors, and how landscape came to be defined. Finally, a chronology traces the activities of the ten artists in the crucial years from 1886 to 1892.

We hope that this project will contribute to a discussion and reevaluation of artistic ideas and avant-garde strategies in the late 1880s among the artists in Paris. Van Gogh was no less ambitious than his contemporaries to orchestrate his recognition, and he participated in a variety of projects that were evolving at the time. His commitment was sometimes obscured and slowed down by bouts of illness that he suffered from December 1888 onwards, but his intentions and plans were nevertheless continuous and can be followed throughout his letters and in his actions. The myth of the mad genius has frequently guided the public perception of the artist, and his behavior has too often been regarded as emotionally motivated, led mostly by chance and illness. There is no question that van Gogh was intense: his letters reflect an absolute and almost fanatic concentration on his work and a dramatic loss of self-confidence after every recurrence of his illness. However, neither his illness nor his absorption in his work diminished the artist's awareness of modern trends. Nor did they prevent his participation in the plans and projects of the avant-garde in Paris. Van Gogh's concept of the *petit boulevard* crystallized his awareness of those strategies and intensified his ambition to gain recognition as a modern artist himself. And his interactions with his contemporaries show the ways he learned of, participated in, and contributed to the activities of the avant-garde of the second half of the 1880s.

Note

1 A notable exception is the research and exhibitions of Bogomila Welsh-Ovcharov, who more than twenty-five years ago began to investigate van Gogh's activities in Paris and also attempted to establish van Gogh's place within the development of cloisonnism. See Bogomila Welsh-Ovcharov, *Vincent van Gogh: His Paris Period 1886–1888* (Utrecht: Editions Victorine, 1976); Bogomila Welsh-Ovcharov, *Vincent van Gogh and the Birth of Cloisonism*, exh. cat. (Toronto: Art Gallery of Ontario, 1981); and Musée d'Orsay, *Van Gogh à Paris*, exh. cat. (Paris: Réunion des Musées Nationaux, 1988).

SEASCAPE AT PORT-EN-BESSIN, NORMANDY, 1888 Oil on canvas, 65.1 x 80.9 cm

BOULEVARD DES BATIGNOLLES, THE KIOSK: BOULEVARD DE CLICHY, 1886 Oil on canvas, 44.2 x 36.5 cm

PORTRAIT OF HENRI DE TOULOUSE-LAUTREC, C.1886 Oil on canvas, 40.3 x 32.5 cm

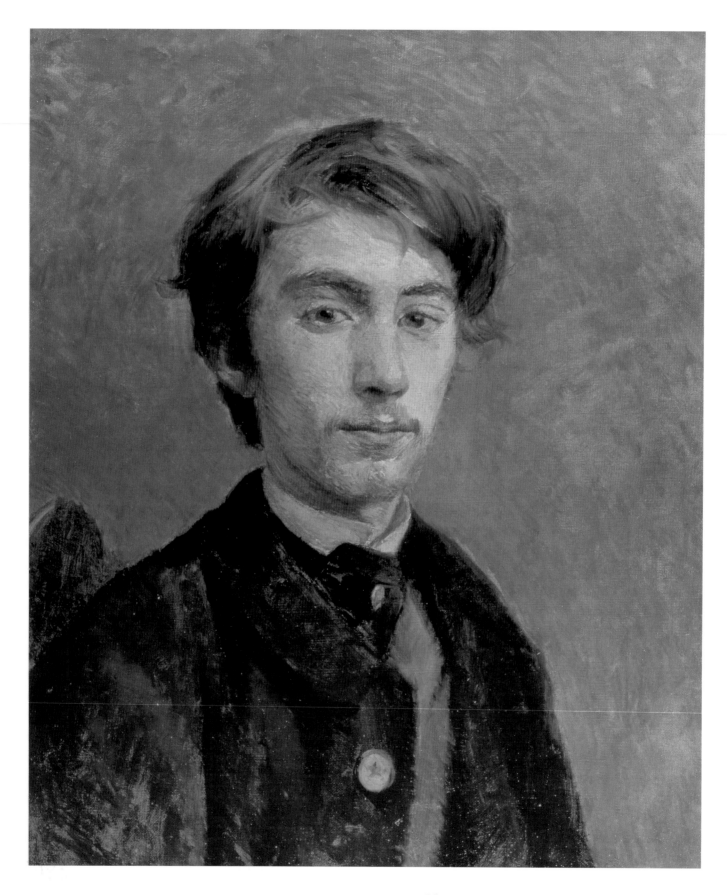

PORTRAIT OF EMILE BERNARD, 1885 Oil on canvas, 54 x 44.5 cm

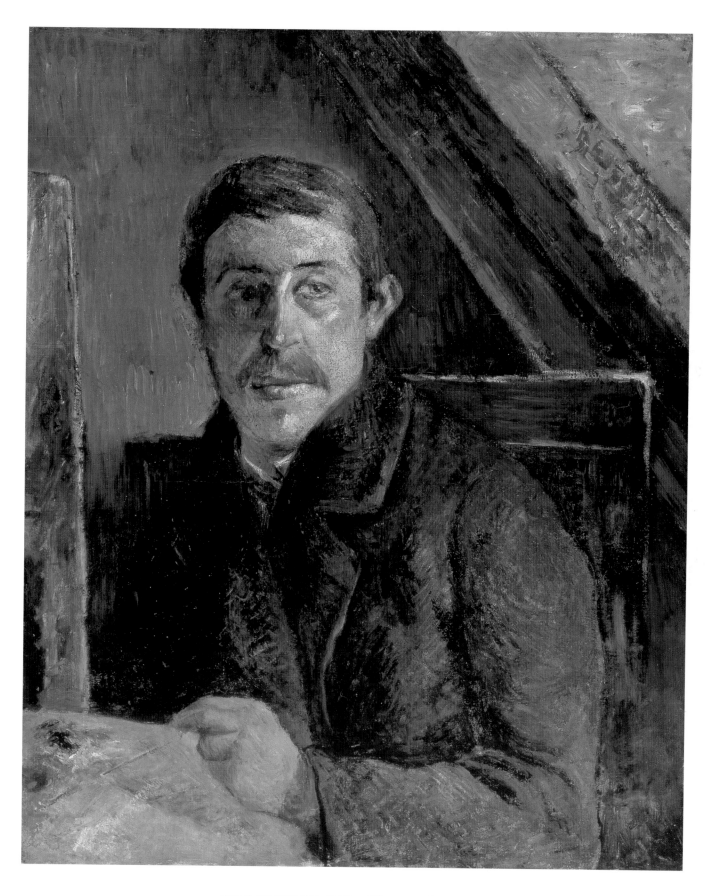

SELF-PORTRAIT, 1885 Oil on canvas, 65.2 x 54.3 cm

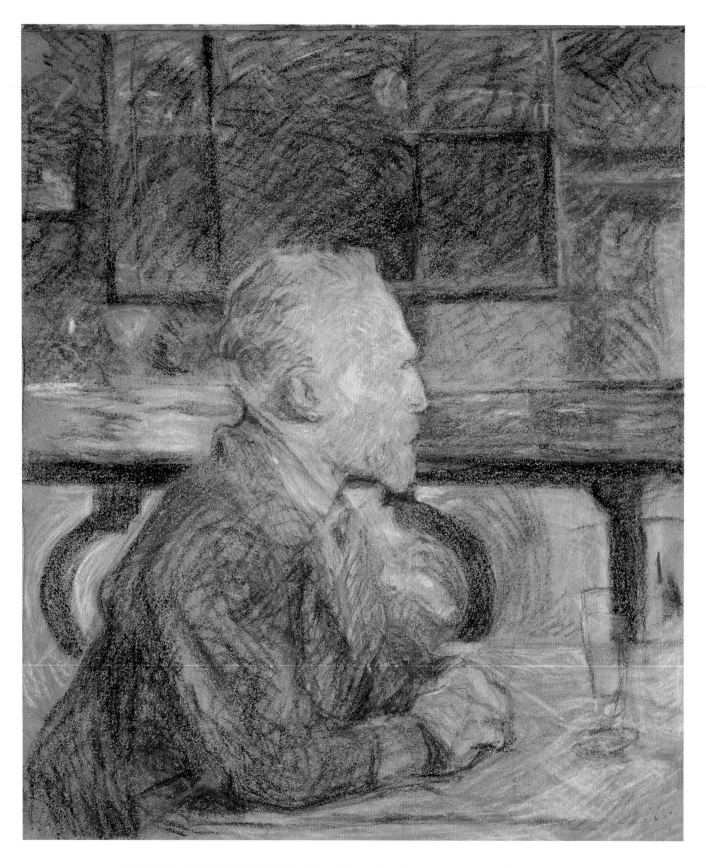

PORTRAIT OF VINCENT VAN GOGH, 1887 Colored crayon on paper, on pasteboard, 57 x 46.5 cm

Vincent van Gogh's Avant-Garde Strategies

Cornelia Homburg

Sometime between 1886 and 1888, when he was living in Paris, Vincent van Gogh began to refer to the "painters of the *petit boulevard*."[1] With that term he identified those members of his artistic generation who were attempting to formulate new artistic concepts. His idea was to distinguish them from the impressionists,[2] whom he referred to as the painters of the *grand boulevard*, indicating not only that they had achieved a relatively secure status as modern painters, but also that they were receiving increasing attention in the art market. Van Gogh's terminology corresponded to developments that he encountered and participated in during his stay in Paris. Although he was unaware of his extraordinary timing, van Gogh had arrived in the French capital just when many young artists were eager to move beyond impressionism. Rejecting an approach to painting that aimed to capture nature and contemporary life in their fleeting, ever-changing appearances, this new generation of artists wanted instead to create highly personalized interpretations of reality and sought to redefine their art stylistically as well as in terms of subject matter.

Neo-impressionism, introduced by Georges Seurat and Paul Signac at the eighth and last impressionist exhibition in 1886, offered a new vocabulary of representation and received prompt critical praise as a new art form.[3] In the years following, many artists adopted this style of painting, or experimented with it briefly, only to discard it for other possibilities, such as cloisonnism, or symbolism, which Louis Anquetin, Emile Bernard, and Paul Gauguin each claimed to have formulated. Ideas and stylistic solutions differed widely and were often highly contested.

When van Gogh arrived in Paris in early 1886, he was ignorant of the new developments in art and initially had a hard time even coming to terms with impressionism. However, within his first year there he took pains to lighten his palette, and he soon began to explore new ideas. By 1887 he was familiar with contemporary trends in painting and had become acquainted with many artists of the new generation. He realized that Paris and its artistic community offered him the chance to establish himself as a modern artist, and he entered into any endeavor that could help achieve his goal. His own ideas and ambitions were influenced by those of his peers and developed in similar patterns. He experimented with the impressionist brushstroke and new techniques of painting such as pointillism, and he updated his knowledge of color theory. He established allegiances with his contemporaries and participated in exchanges of ideas and discussions of the latest trends. In a relatively short time, he began to develop the concept of the *petit boulevard*, within which he would define his own artistic identity.

Together with the other artists of the *petit boulevard*, van Gogh investigated possible venues for exhibitions and sales. Few galleries were willing to display their work. To create a market for themselves, they hung their paintings in shop windows such as that of Père Tanguy, who sold art supplies, and in restaurants, cabarets, and any other location that offered them an opportunity to exhibit. Van Gogh saw the advantage

of cooperating with other contemporary artists, pooling resources, and exploring possibilities together. The recognition that neo-impressionists were receiving from critics such as Félix Fénéon must have seemed a good example of what a cohesive approach could accomplish, and van Gogh may have seen it as a model for the larger, more diverse group of artists that he had in mind. His concept of the *petit boulevard* resulted from his wish to work within a group whose ambitions and successes he could share and make his own. He was convinced that recognition could be gained through group representation, and he was keen to support the idea of a community.

Van Gogh's notion of the painters of the *petit boulevard* as a consolidated avant-garde was a construct that did not exist in reality. By 1887 there were already several competing camps, most prominently the neo-impressionists under the leadership of Seurat and Signac, and another group gathering around Gauguin. The scramble for leadership and individuality became even more pronounced in 1888. Seurat was worried that there were so many followers of neo-impressionism that it might lose its uniqueness, and he took pains to declare his leadership of the movement.[4] Gauguin's claim that he was the founder of symbolism and his attempt to ignore Bernard's contribution to that movement reflected a similar ambition.[5] Van Gogh surely was aware of the competition among the members of the *petit boulevard*, yet he proposed his concept, convinced that a collective identity could be a useful vehicle in an environment swarming with talent.[6] In fact, it must have been an intense thrill for this man who had lived in isolation throughout most of his artistic career to construct an identity that not only made him part of a group, but even depended on such a concept.

Along with imagining a cohesive group of modern artists, van Gogh also sought, like most of his contemporaries, to create a kind of art that was uniquely his own. If his artistic identity had been shaped by current developments, it still needed not only to differentiate him from other artists but also to enable him to rise above them. Paris had provided him with the necessary foundation, and from 1888 on, van Gogh's work and letters reveal how he strove to define himself through a new and modern technique of painting that centered on an intense, often exaggerated, use of color and a distinctive, highly stylized brushstroke. For subject matter he focused on his favorite genres: landscape and portraiture. He claimed as his own the characteristic imagery of Provence, such as its cypresses and olive trees, thus distinguishing his subject matter from that of his contemporaries. And he committed himself to creating a modern style of portraiture, whose aim of representing a type rather than an individual would have a lasting impact.

It is important to realize that van Gogh's pursuit of uniqueness as well as his strategies to attract attention for his work were very much in line with the interests and activities of his peers. All members of the new avant-garde, from Gauguin to the Pissarros to Seurat, realized that efforts to build a reputation and secure sales had to be focused on Paris, the center of the art world, regardless of where an artist decided to work or live. During his relatively short stay in the city, van Gogh quickly recognized the importance of Paris for his success; this knowledge and an understanding of what was needed for him to become a member of the avant-garde guided his ambitions and activities for the rest of his career. Even when illness disrupted his work during 1889 and 1890, van Gogh continued to formulate his artistic identity within these parameters. Towards the end of his short career, van Gogh was actually able to attract the attention and admiration of his peers, as well as avant-garde critics, and he was taking some small first steps in building a market for his work. His dramatic early death sped his rise to fame, which was soon supported by the myth of the mad and isolated genius that continues to surround his image.[7]

Colleagues and Contacts

Van Gogh's contacts in Paris have frequently been considered marginal. However, it is clear that the people he knew there and the experiences he shared with them significantly shaped his identity as a modern artist. This

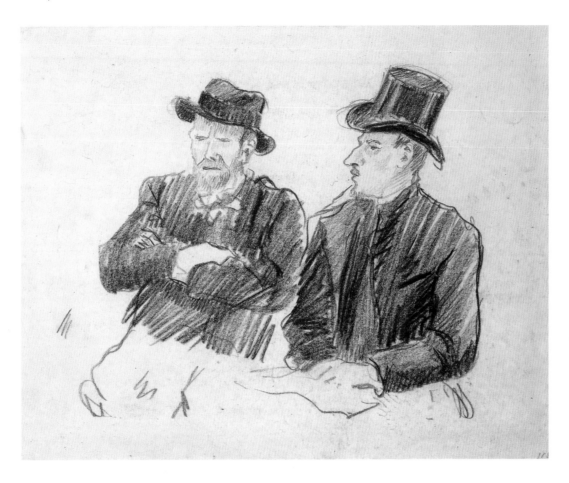

VINCENT IN CONVERSATION, 1887 Black crayon on paper, 19.6 x 29.2 cm

does not imply that van Gogh discarded what he had learned before coming to Paris, but that while there he adjusted his image of what constituted a modern artist and the role he might play in the developments taking place in the art world. In fact, he was enthusiastically involved in the activities of the emerging generation of artists, learning with them new techniques and approaches to painting, and proposing plans and actions of his own.

Throughout his life van Gogh had few close friendships. This may have been primarily due to living in isolation much of the time; however his difficult personality and intense mode of interacting with people were also significant factors. His only close relationship was with his brother, Theo, and that, too, was tense and often uncomfortable. Numerous letters by both brothers testify to strained moments, and frequently it seems to have been the patience of Theo that overcame the tensions:

There was a time when I loved Vincent a lot and he was my best friend but that is over now. It seems he never loses an opportunity to show me that he despises me and that I revolt him. That makes the situation at home almost unbearable.... It appears as if there are two different beings in him, the one marvelously gifted, fine and delicate, and the other selfish and heartless.... I have firmly decided to continue as I have done up to now....[8]

In Paris most of the artist's contacts were work driven. His interaction with his peers seems to have been based on the exchange of ideas and on discussions of artistic

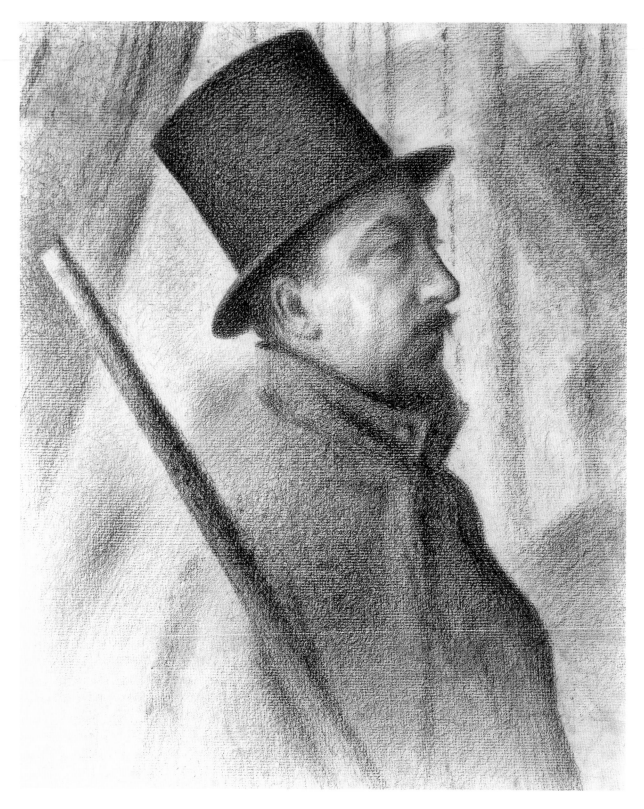

PORTRAIT OF PAUL SIGNAC, 1889–90 Conté crayon on paper, 36.5 x 31.6 cm

recognition. He would paint with Signac or Bernard, enjoying their company but always focused on gathering new insights into art-making from them. This attitude continued beyond Paris: Gauguin's famous visit to Arles in the fall of 1888 was not an expression of his friendship with Vincent, but rather a temporary solution to Gauguin's difficult financial situation. Vincent, desperate for company, convinced Theo to take on the financial burden of luring Gauguin to Arles.

A look at some of van Gogh's contacts with other artists in Paris serves to illustrate his wide-ranging interests and the influences that helped shape his activities and ambitions. In 1886 the artist fulfilled a long-standing wish when he began to study drawing at the studio of the academy professor Fernand Cormon. The largely self-taught van Gogh felt the need for more formal training, especially in drawing. Earlier that year he had attended the academy in Antwerp for two months, but he hoped for more useful instruction in Paris. At Cormon's he soon became acquainted with a number of artists who were keen to explore new ways of painting. He met the young and enterprising Emile Bernard, Henri de Toulouse-Lautrec, and Louis Anquetin, as well as foreign painters such as Frank Boggs, John P. Russell, and A. S. Hartrick—a varied and active group with a wide range of interests. Like van Gogh, many of them felt the need to practice drawing but were also intrigued by the possibility of new avenues of painting outside traditional guidelines.

The young Emile Bernard showed great ease in experimenting with new ideas and bold stylistic solutions. His explorations of impressionism and neo-impressionism in late 1886 and 1887 and his willingness to set aside tradition must have inspired the older artist to experiment more himself. The two visited each other regularly and embarked on a series of projects. After van Gogh left Paris, they replaced their meetings with a vivid exchange of letters and drawings in which they discussed artistic concepts in great detail. In Paris Bernard had been Vincent's guide to new trends, but from Arles Vincent often assumed the mentor role, a shift reflecting his increasing self-confidence.[9]

Bernard claimed to have introduced van Gogh to Toulouse-Lautrec and Anquetin at Cormon's studio. The sparse original sources known to us confirm that van Gogh kept in contact with these two artists, who were already close friends.[10] Toulouse-Lautrec's surviving letters are primarily directed to his family and do not address many of his contacts and daily activities. Like van Gogh, he was training at Cormon's to acquire the basic skills of drawing and painting.[11] Despite the great differences in their personal backgrounds and lifestyles—van Gogh older, a failed evangelist, a painter of peasants who had lived in isolation in the countryside for many years; Toulouse-Lautrec younger, a worldly, polished aristocrat, full of ironic wit—the two artists' interests show striking parallels. Exposed to new ideas while they were at Cormon's studio, both began to address impressionism and other artistic concepts in 1886–87. In fact, it was only from 1886 onwards that Toulouse-Lautrec was ready to confront more radical ideas, in part because he felt more secure in his ability to draw.[12] Van Gogh too had the need for such exercise.[13]

Illustration and caricature were common interests for both artists. For Toulouse-Lautrec they were ways to explore the expressive potential of the print medium and provided him with a vehicle to get his work before the public. Throughout his career he provided drawings and prints for numerous publications, including Aristide Bruant's *Le Mirliton* in the mid-1880s and the journal *L'Escarmouche* in the early 1890s.[14] Van Gogh's interest in illustration can be traced to his early interest in English illustrators. He also deeply admired the work of Honoré Daumier and was very enthusiastic about Arsène Alexandre's monograph on the artist when it appeared in 1888.[15] Van Gogh was fascinated by Daumier's mastery in capturing human emotions and relationships; several of Toulouse-Lautrec's compositions reveal a similarly close study of Daumier's oeuvre. Daumier not only provided brilliant examples of caricature, but he focused on the representation of social conditions and human weaknesses. Both van Gogh and Toulouse-Lautrec were interested in this

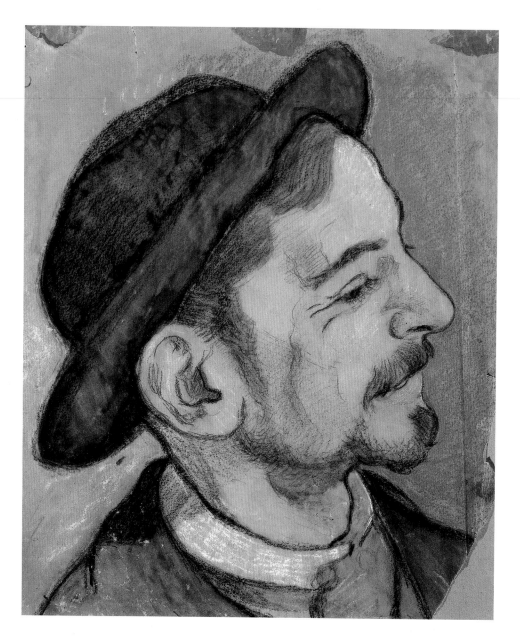

PORTRAIT OF EMILE BERNARD (STUDY), 1887 Pastel and ink on paper, 29 x 24 cm

subject matter, the former often with a commitment to reforming society, while the latter favored satirical commentary. For van Gogh, Daumier's work represented life in the city rather than the country; as such, it corresponded to a subject that would fascinate Toulouse-Lautrec for most of his career.

It seems that van Gogh's passion for Japanese woodblock prints stimulated the interest of Toulouse-Lautrec, Bernard, and Anquetin. In 1887 van Gogh took the three to the Café du Tambourin, where he had installed an exhibition of Japanese prints. He also introduced Bernard and Anquetin to Samuel Bing, the dealer from whom Vincent and his brother acquired many of their prints.

Toulouse-Lautrec, for his part, seems to have introduced Bernard and van Gogh to the world of cabarets and nightlife.[16] All of them lived or worked in Montmartre, the section of the city where most of

these entertainments were located. While numerous compositions by Toulouse-Lautrec and Bernard (e.g., pp. 97 and 62) testify to their interest in representing this environment, van Gogh chose it as subject matter only in his paintings of the Café du Tambourin and a few restaurant scenes (e.g., p. 105). Apart from portraiture and still life, he continued to paint landscapes, mostly in the suburbs of Paris (e.g., p. 58).

Toulouse-Lautrec invited his companions to weekly soirées in his Paris studio, but van Gogh's awkwardness and lack of social skills prevented him from playing a significant role. Unable to participate in the conversation, he hoped to attract attention by displaying his latest work.[17] Many of the artists who spent time together painted or drew each others' portraits (pp. 17, 18, and 23). Toulouse-Lautrec's portrait of van Gogh seated at a café table, probably in one of the places they frequented, captures some of the intensity that characterized van Gogh's behavior (p. 20). We know from references in van Gogh's correspondence from Arles that the two artists wrote to each other, although no letters survive. Theo kept Vincent informed of Toulouse-Lautrec's achievements as well.[18] Theo's own interest in Toulouse-Lautrec led him not only to buy works for his own collection but also to encourage sales to others. Initially, the connection with Toulouse-Lautrec seems to have been established by Vincent, but it came to be nurtured just as much by the prospect that Theo, manager of the Montmartre branch of the art dealer Boussod and Valadon, might sell Toulouse-Lautrec's work.[19]

By the winter of 1886–87 van Gogh was becoming more familiar with impressionism and was learning and experimenting together with Bernard, Anquetin, Toulouse-Lautrec, and other friends. The impact of neo-impressionism cannot be underestimated for these artists. Its presence invited discussions not only about painting techniques, but also about color theory, which already had fascinated van Gogh in the Netherlands. An important contact for Vincent was Paul Signac. This promoter of neo-impressionism must have considered van Gogh a potential candidate to be won over

to the new style. Painting together in Asnières and Clichy, the two artists took as their subject matter the countryside in and around those recently developed suburbs and the newly constructed bridges and quays. Signac's concern for the working class resonated with van Gogh, whose social commitment had been important to the artist from his Dutch years; that the topic recurred in their conversations is confirmed by Signac's reminiscences of his visit with van Gogh in Arles in early 1889.[20] Signac's *Quai de Clichy* and van Gogh's *Factories at Asnières, Seen from the Quai de Clichy* (both 1887, pp. 28 and 29) represent this shared subject matter. Signac chose to depict the quay with its recently planted trees in a sunny, light-flooded picture. The buildings and smokestack illustrate the area's industrial focus, while the iron bridge in the left background suggests modern construction and materials. Van Gogh, too, presented a modern industrial subject with a cluster of houses and smokestacks. Instead of using Signac's thorough execution of pointillist technique, however, van Gogh applied a variety of stylistic solutions, from the dense strokes of the foreground to the feathery brushwork of the sky. In this painting he came closest to a neo-impressionist treatment in his depiction of the buildings in the middle ground, where he made effective use of the color contrast red and green.

Van Gogh's interest in neo-impressionism was at least one reason for him to establish contact with Camille Pissarro and his son Lucien, both fervent followers of the new style. Not only was the older Pissarro always attracted to new ideas, but throughout his life he willingly served as a mentor for young or aspiring artists. He must have welcomed van Gogh into their circle and encouraged his exploration of contemporary ideas and styles. With Lucien, Vincent found a common interest in graphic arts and illustration. In addition to his painting, Lucien made numerous prints and published them, first in French and later in English journals. Vincent had long been a collector of British graphics, and he shared Lucien's passion for social issues. An exchange of works between the artists while

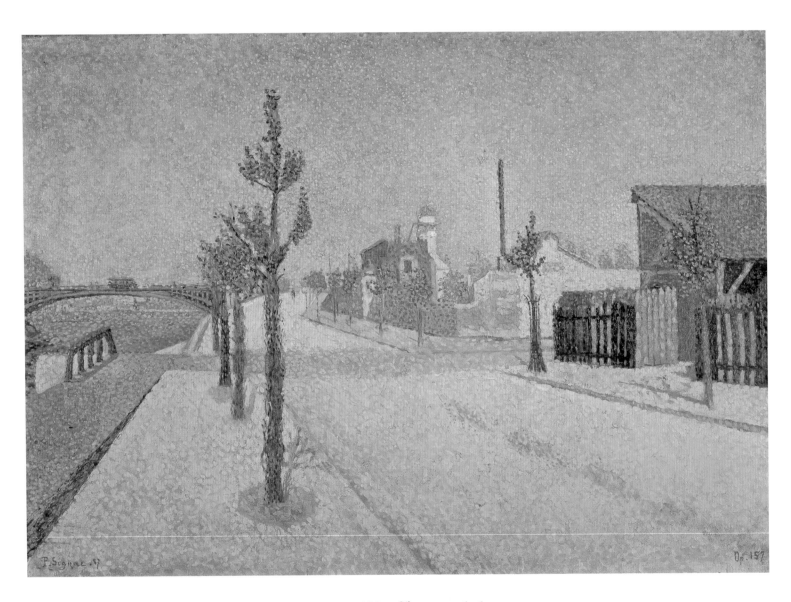

QUAI DE CLICHY, 1887 Oil on canvas, 46 x 65 cm

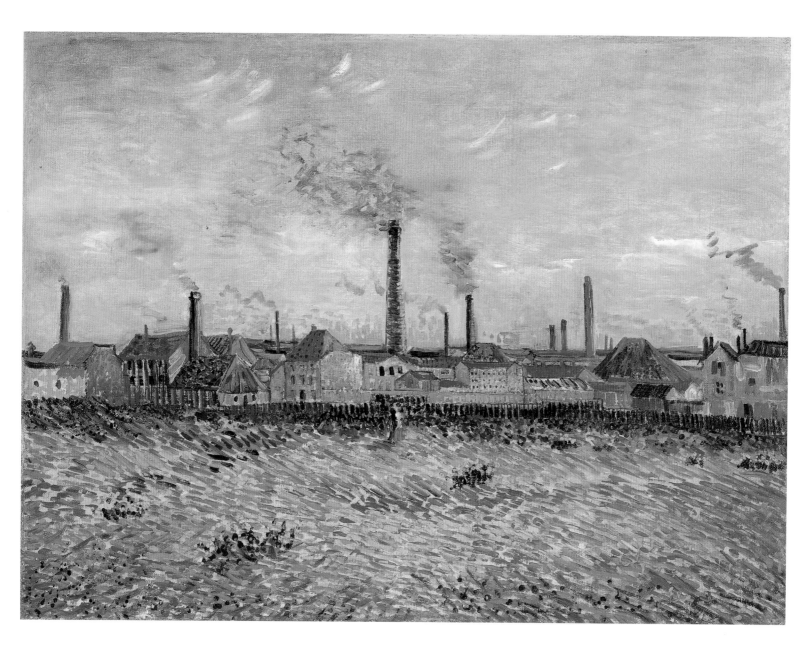

FACTORIES AT ASNIERES, SEEN FROM THE QUAI DE CLICHY, 1887 Oil on canvas, 54 x 72 cm

SELF-PORTRAIT, C.1890 Etching and drypoint on zinc, printed on laid paper, state 2 of 2, 18.6 x 17.7 cm

both were in Paris reveals their camaraderie: Vincent presented Lucien with *Still Life with Basket of Apples* (1887; Otterlo, Kröller-Müller Museum, F378) inscribed "à l'ami Lucien Pissarro" and in turn received wood engravings from Lucien.

In the early months of 1888 van Gogh left Paris and moved to Arles in the South of France. He had a number of reasons for this change of scene. Paris and its demanding activities had exhausted him, and he looked forward to a calmer environment in the countryside. Arles offered the bright sunlight and colors of the South, which his great models Delacroix and Adolphe Monticelli had sought before him and which van Gogh was keen to see for himself. Going to Arles offered an escape from the city similar to Gauguin's and Bernard's sojourns in Brittany or Signac's

and Seurat's long summer trips to the French coast. Van Gogh also hoped to establish a studio that would allow his peers to work with him in Arles; he even thought of possibly founding a school of modern artists in the South.[21] His letters reveal his loneliness at times, especially when his work was not going smoothly, though he took pains to establish contact with artists in the vicinity of Arles, including Dodge MacKnight, Christian W. Mourier-Petersen, and Eugène Boch.

Despite his removal from the city, van Gogh stayed in touch with his contacts in Paris. He kept himself informed of what was going on and continued to share ideas through letters to and from his brother and friends, publications, and visits from other artists. Although he was aware that he was missing

SELF-PORTRAIT, 1882 Charcoal on paper, 59 x 42 cm

exhibitions — for example, he noted with disappointment that he was unable to see the Monet show that his brother mounted in 1888[22] — he continued to plan and participate as if the distance were of little importance. He knew when his friends sold works of art and asked them to send him sketches or photographs so that he could keep abreast of what they were doing.[23]

Striving for Recognition

Paris not only offered a community of artists and an opportunity to experiment with new art forms, it was also the most prominent marketplace for modern art in Europe. The city accommodated established venues for exhibitions and a burgeoning number of galleries and small shops where art could be displayed to prospective customers.[24] Van Gogh was dedicated to fostering recognition for himself and his peers, and with them he took advantage of all the marketing mechanisms that were available. Like the impressionists before them, the younger generation of artists had to identify new venues where they could show their art, since it was not yet accepted by the more established galleries. They chose shop windows, theater foyers, cafés, and restaurants; they rented spaces for

exhibitions; they showed at already existing venues like the Salon des Indépendants; and they hoped for invitations from organizations like Les XX in Brussels.

From 1886 on, van Gogh frequented Julien Tanguy's shop, a meeting place for the avant-garde. With Signac and Seurat, van Gogh exhibited paintings in the foyer of the Théâtre Libre, run by André Antoine; among them was *Voyer — d'Argenson Park at Asnières* (p. 78), one of the most ambitious canvases of his Paris period.[25] A year later he was invited to show in the offices of the *Revue indépendante*, but he did not like the terms of the arrangement and refused. From 1888 he displayed work regularly at the Salon des Indépendants, and eagerly accepted an invitation to show with Les XX in 1890. Gauguin invited him in 1889 to participate in the exhibition at the Café Volpini on the grounds of the Exposition Universelle, but Theo advised his brother against it.[26]

Vincent organized a number of events himself. The Japanese prints that he exhibited at the Café du Tambourin were followed by displays of his own work at the restaurant. His exhibition of the painters of the *petit boulevard* at the Grand Bouillon, Restaurant du Chalet was an ambitious undertaking, as the manager had offered him a large dining room that needed to be filled with paintings. The restaurant was located on the avenue de Clichy in the Montmartre area where most of the artists of the *petit boulevard* were living and working. The exhibition has received little attention because it did not attract reviews and there was no catalogue. Nevertheless, it is worth pointing out that the works shown by van Gogh, Bernard, Anquetin, Toulouse-Lautrec, and Arnold H. Koning warranted visits from other members of the avant-garde including Seurat, Signac, Gauguin, and Armand Guillaumin. It must have been a topic for discussion in their circles and it even saw some limited financial success: both Anquetin and Bernard made their first sales.[27]

Vincent continued his efforts to build a market for his *petit boulevard* group while he was in Arles. Theo, of course, was considered an ally for any undertaking. In the spring of 1888 van Gogh outlined for his brother

how knowledge about the *petit boulevard* should be disseminated in Holland and England — uncharted territory where Vincent decided that his brother could be the leading force.[28] (He did not mention Belgium, where the avant-garde group Les XX was already very active.) Theo had contacts in the two countries who Vincent felt would be useful: representing Boussod and Valadon in The Hague was H. G. Tersteeg, a seasoned art dealer and an old friend who was often resistant to new art; and the company also had a subsidiary in London. While Vincent himself was very ambivalent about his brother's employer, he nevertheless imagined that Theo could use the firm to develop a market for the *petit boulevard* painters. Vincent envisioned not only success for the avant-garde but pioneering acclaim for himself and Theo for introducing this new art. Other areas of France also offered possibilities: van Gogh imagined a market for their art in Marseille and wrote about plans to rent a shop window there in the Parisian tradition.[29] He considered asking his friends to send him pictures for exhibitions, and in July 1888 van Gogh asked Bernard to send him material in time for Gauguin's arrival so that the three of them could organize an exhibition there.[30]

If van Gogh worked hard for the success of the members of the *petit boulevard* in general, he was no less eager to create opportunities specifically for himself. From the summer of 1887 onwards, van Gogh began to display his work at Tanguy's shop. He was also always keen to exchange pictures with other artists; it allowed him to make his own work known as much as it offered him the opportunity to build a collection of new art for himself and his brother. His appearances at Toulouse-Lautrec's weekly gatherings, during which he would prop one of his paintings against the wall, must be considered in this context and seen as an attempt to gain attention for his work. Whether he was participating in projects organized by his contemporaries or engaged in his own undertakings, van Gogh's motive was always to showcase his own works and gain acceptance as a member of the avant-garde.

THE CHURCH OF ERAGNY, 1886 Oil on canvas, 51 x 70 cm

In addition to van Gogh's own efforts, Theo's role in this context cannot be underestimated. Indeed, Vincent's fellow artists must have found it extremely attractive that he had a brother who was an art dealer in a well-established firm. They gained access to Theo as Vincent often encouraged his younger brother to look at their work and to sell it. Toulouse-Lautrec's contact with Theo has already been mentioned. In March 1888 Theo bought a drawing by Seurat,[31] whom Vincent considered the leader of the new avant-garde.[32] In his letters from Arles, Vincent also urged Theo to famil-iarize himself with Signac's work and to visit him.[33] Nor was Vincent naive about this advantage: when he was trying to interest Charles Angrand in an exchange of pictures, he invited Angrand to visit Theo in his gallery. Not only was he underscoring Theo's position, but he also was declaring his own allegiance to modern art by mentioning Degas and Pissarro, whose work was on view in Theo's gallery.[34]

Not only for the painters of the *petit boulevard* in general, but also specifically for his personal benefit, van Gogh tried to expand his audience beyond France.

Tersteeg in The Hague was needed to play a major role, and Vincent tried in a variety of ways to draw his attention. Theo's assignment was to cajole the dealer into taking some modern pictures into his shop.[35] When the artist decided to send his painting of a peach tree in bloom (1888; Otterlo, Kröller-Müller Museum, F394) to the widow of Anton Mauve in memory of her spouse, his old teacher, van Gogh did so partly out of sentiment, but he also saw it as an opportunity to get one of his works to a place in Holland where Tersteeg would then certainly see it in her home.[36] Vincent also suggested that Theo donate some of his paintings to the modern art museum in The Hague, so that he would be represented in the Netherlands.[37] And when he heard that Gauguin was having an exhibition in Denmark, van Gogh considered exchanging a work with him so that one of his paintings could find its way to Scandinavia.[38]

A similar motivation surfaced when Theo provided his brother with some background information on the painter Eugène Boch, who was staying in the vicinity of Arles. Van Gogh immediately tried to cultivate the acquaintance.[39] Theo probably had advised Vincent that Eugène was the brother of Anna Boch, one of the founders of Les XX in Brussels. Vincent knew about this avant-garde organization through his friends in Paris, as both Toulouse-Lautrec and Signac had already exhibited in the annual exhibitions of Les XX. Friendship with the brother of one of the founders might lead to his own invitation to show in Brussels. Van Gogh's decision to paint Boch's portrait (p. 35) thus takes on added significance, and his detailed explanations about the portrait, which outline his views on the modern portrait painter, have to be considered in light of his ambition to establish himself as an avant-garde artist in the eyes of his peers.

It is amazing that van Gogh so often pursued such schemes without any real understanding of his own situation. His expectations of sales were always overblown, and his acknowledgment of his brother's limited resources lasted only until the next time he urgently needed money to execute a new plan. Van Gogh's schemes were often impractical and unworldly, doomed to fail in most cases. On the other hand, his constant maneuvering bespeaks a deep commitment to the new art that he and the other painters of the *petit boulevard* were producing and faith in its eventual success.

A Modern Painter

Van Gogh's ambition to position himself as a modern painter extended beyond his efforts to make his work known; it also affected the directions he followed in his art-making. Paris had been the place to learn new art forms and to initiate the mechanisms that would define his avant-garde identity. Van Gogh's participation in exhibitions and his exploration of new styles of painting indicate his awareness of this system. In Arles he not only continued to foster these opportunities, but he also began to develop the parameters by which he would establish his identity as a modern painter. Inspired by the bright light of Provence, the return to a rural environment (which he had cherished in the Netherlands), and the new directions that had so influenced him in Paris, van Gogh began to explore in earnest a range of issues that were linked directly to his artistic formation. His intentions, which can be traced throughout the rest of his career, are documented for the first time in his letters from Arles. He proclaimed his modernity through his painting technique, in particular his use of color and brushstroke, and through his adoption of specific types of subject matter. Landscape and portraiture had been his two favorite genres from the beginning of his career, but he now firmly anchored them in the context of modernity. He claimed the characteristics of the Provençal landscape as his own original subject matter, which he could present in a new and personal way. He declared portraiture to be an essentially modern art form in which he could make a mark that would remain for posterity.

In his paintings of 1885, van Gogh had attempted to apply complementary color contrasts in the manner of Delacroix. However, having no actual examples of Delacroix's paintings to study, he was unable to think in terms of pure color and his palette remained rather

PORTRAIT OF EUGENE BOCH, 1888 Oil on canvas, 60 x 45 cm

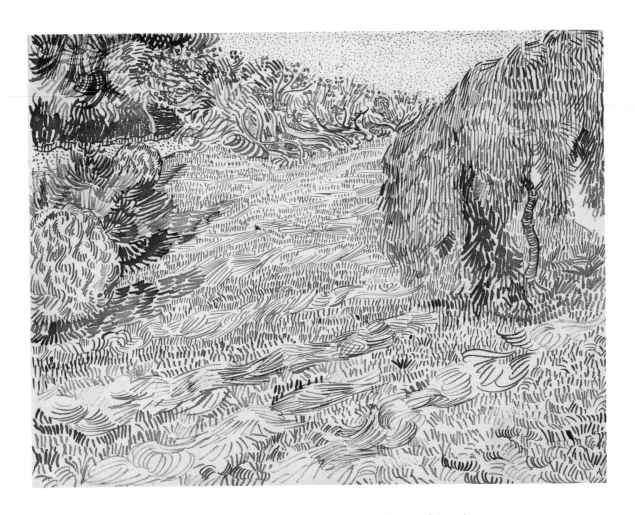

GARDEN WITH WEEPING TREE, ARLES, 1888 Ink with traces of charcoal on paper, 24 x 31.5 cm

muted.[40] In Paris he experimented with intense color and became increasingly concerned with how it affected the representation of nature. In the years following, color became a sign of his modernity, and he declared that "the painter of the future will be *a colorist such as has never yet existed.*"[41] Even though doubts about his ability to make a mark of such significance continued to plague him, van Gogh was clearly striving towards that goal. The intense light of the South would allow him to make a real contribution to the exploration of color, and his studio would be available for others wishing to explore similar terrain. "I believe that a new school of *colorists* will take root in the South, as I see more and more that those in the North rely on their ability with the brush, and the so-called 'picturesque,'

rather than on the desire to express something by color itself."[42] His aim was not to make a painting that would describe a scene in strong hues, but to give color an almost autonomous force in the picture. Color offered the opportunity for interpretation and expression of emotion. It was not supposed to be used as it appeared in nature, but exaggerated to reflect emotional intensity. When he painted his *Night Café* (1888; New Haven, Yale University Art Gallery, F463), he explained that he had tried "to express the terrible passions of humanity by means of red and green."[43] He frequently referred to the example of Delacroix, who had been able to convey intense emotional tension by means of color.[44] Among his contemporaries, van Gogh admired Seurat as an "original colorist," and though he did not

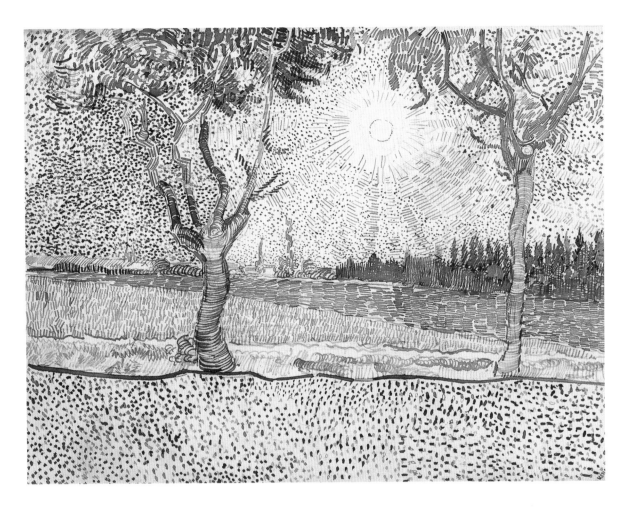

THE ROAD TO TARASCON, 1888 Pencil and ink on wove paper, 24.5 x 32 cm

believe that the neo-impressionists' systematic application of paint was suitable for him, their use of pure color and complementary color contrasts was an important guideline that he had only to adjust for his own purposes. The extent to which these influences were on his mind, and how much he was comparing his own achievements with those of his peers, becomes apparent in a letter of September 1888, when he felt confident enough about his most recent pictures that he wanted his friends to see them.[45] The importance of color remained a guiding principle for all his paintings and determined his modernity. When he painted a traditional subject such as the sower, a figure that one of his heroes, the painter Jean-François Millet, had made famous, he used color to turn it into a modern

composition.[46] With regard to his copies after works by Delacroix, Rembrandt, and Millet, van Gogh claimed that his personal interpretations in color not only resulted in modern works of art but, even more importantly, they allowed him to declare them as his own work.[47]

It was in his portraits that van Gogh especially capitalized on the interpretative impact of color. Of the portrait of Eugène Boch he wrote, "Instead of trying to reproduce exactly what I have before my eyes, I use color more arbitrarily, in order to express myself forcibly."[48] He explained that he exaggerated the actual color to evoke the dreamlike, mysterious impression that he wanted to achieve in the picture. He so believed that the emotive content of a portrait

had to be expressed through intensification of color that he sometimes went to extremes: even when he felt a picture was not only exaggerated but downright ugly, he was willing to accept such a result if he had succeeded in conveying his interpretation. When he painted a portrait of a Zouave, he wrote to Bernard, "It is hard and utterly ugly and badly done."[49] He further referred to a certain roughness in execution and his use of almost harsh color. Describing the sitter as having "a bull neck, and the eye of a tiger," van Gogh explained that he wanted to capture the man's feline, savage quality. Careful orchestration of color was as important to him as exaggeration in achieving a specific effect. In his *Portrait of Milliet* (p. 39), van Gogh coordinated the whole composition around the complementary color contrast of red and green, the soldier's red cap standing out against an intensely green background. The greenish hue continues even into the sitter's face and jacket.

Van Gogh assigned to brushstroke as important a role as color. Besides offering a method for using pure color, neo-impressionism provided a new technique for the application of paint. Van Gogh experimented with pointillism in Paris, but found it unsuited to his temperament; he was too impatient to systematically apply dots throughout a painting in the manner of Seurat. Nevertheless, van Gogh used dots selectively in drawings and paintings after he left Paris. Frequently, he combined the *pointille* with other types of brush- or penwork, creating compositions that seem very carefully conceived and organized (e.g., pp. 36 and 37). In his efforts to create a highly individual interpretation of a scene or model, he used brushwork as thoughtfully, and with as much exaggeration, as he used color. The presence of the pointillist dot also associated him with a rather prominent avant-garde movement—an advantage not lost on him.

Stylized brushwork came to play an increasingly important role in van Gogh's oeuvre. Indeed, through his exchange with Paul Gauguin at the end of 1888 it grew in significance. During his two-month visit to

Arles, Gauguin tried to convince van Gogh that he should not paint from nature, but base his compositions on memory.[50] Only then could the artist use his imagination to create a truly modern work of art that was an abstraction from nature instead of its representation. Van Gogh experimented with this approach for a while, but came to realize that with it he was incapable of achieving the effects he was after.[51] If he was unable to achieve abstraction from memory and insisted on nature as a basis for his work, he would need to find another way to create a modern painting. He decided to concentrate on color and stylized brushwork, continuing to employ an impasto that contrasted pointedly with Gauguin's thin application of paint.

He sought sources of inspiration in motifs that were familiar and comfortable. He referred to paintings such as *The Olive Trees* (p. 153) as "exaggerations in terms of the drawing" and he compared his brushwork to "old woodcuts."[52] This comment has been interpreted as referring to popular prints of the nineteenth century,[53] but it is more likely that van Gogh meant the old German woodcuts that he admired as expressions of a more primitive era when art was pure and unspoiled by centuries of polished civilization. Van Gogh's references to Giotto in his letters also have to be considered in this context; they reflect a typically nineteenth-century view of the Middle Ages and early Renaissance as times of truthful and simple artistic expression. The pronounced, often heavy lines and simplified rendering of old woodcuts may have helped van Gogh develop the distinctive, highly stylized strokes of his drawings and paintings. With such an approach, he achieved compositions in which the stylization of execution informed and supported its expressive force. Interpretations of such paintings as *The Starry Night* (1889; New York, The Museum of Modern Art, F612) or *Road with Cypress and Star* (p. 191) offer complicated reasons for van Gogh's extraordinary brushwork, but fail to recognize that the artist had carefully considered their execution beforehand.[54] A subtle and controlled reference to old woodcuts can also be found in the striped jacket of the sitter in his

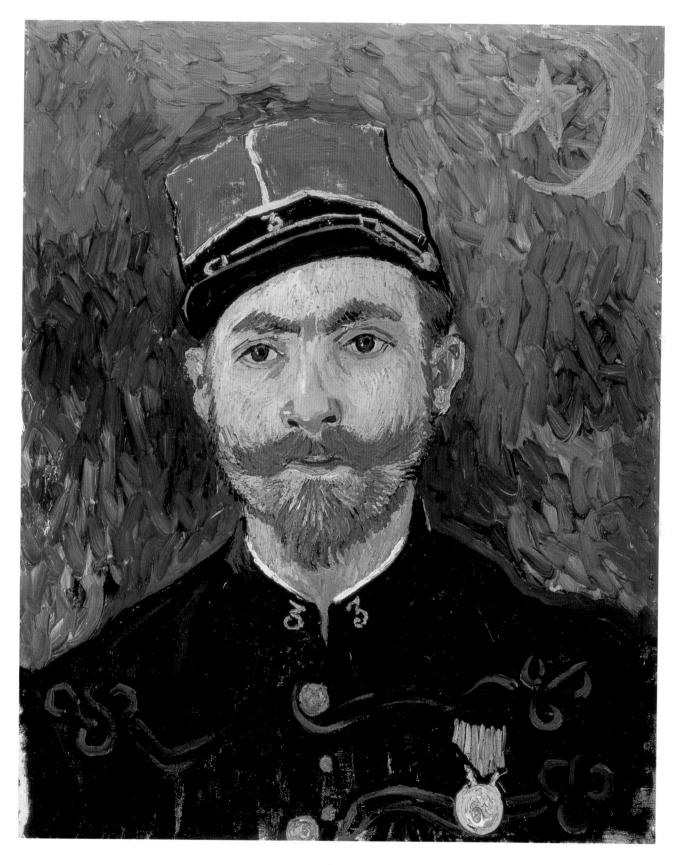

PORTRAIT OF MILLIET, 1888 Oil on canvas, 60 x 49 cm

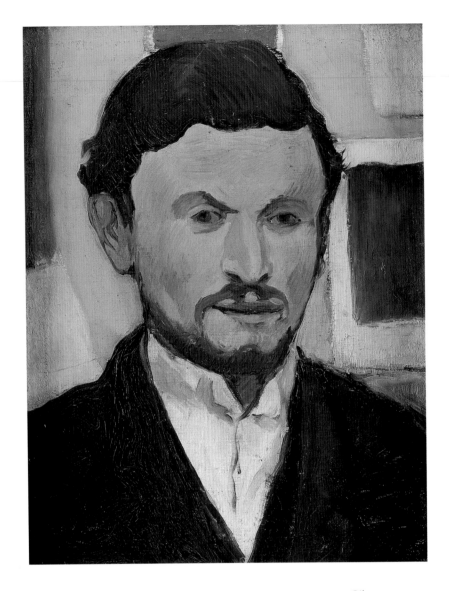

PORTRAIT OF A MAN (SAID TO BE THEO VAN GOGH), 1888 Oil on canvas, 41.5 x 32.5 cm

Portrait of Trabu (p. 41), an attendant at Saint-Paul Hospital, where the black lines create an active pattern against the calm and smooth background of the portrait. In *Stairway at Auvers* (p. 12), a work that contrasts startlingly with the flatness of paintings by Bernard or Gauguin, van Gogh used heavy, agitated brushwork to produce a dramatic depth in a simple street scene. A more weave-like brushstroke, which suggests similarities to a tapestry in its decorative effect, was used in *Two Pear Trees with the Château at Auvers (Landscape at Twilight)* (p. 42). These examples show how much the artist experimented with paint application to achieve a variety of effects.

After years of relative isolation in the Netherlands, van Gogh found his sojourn in Paris to be inspiring and invigorating, but also exhausting. He retreated to Arles, a small town in the countryside of southern France. Arles offered the opportunity to relax and recover. It also offered the experience of the southern light and colors that his heroes Delacroix and Monticelli had made use of in brilliant paintings. Van Gogh went to the South of France with a supply

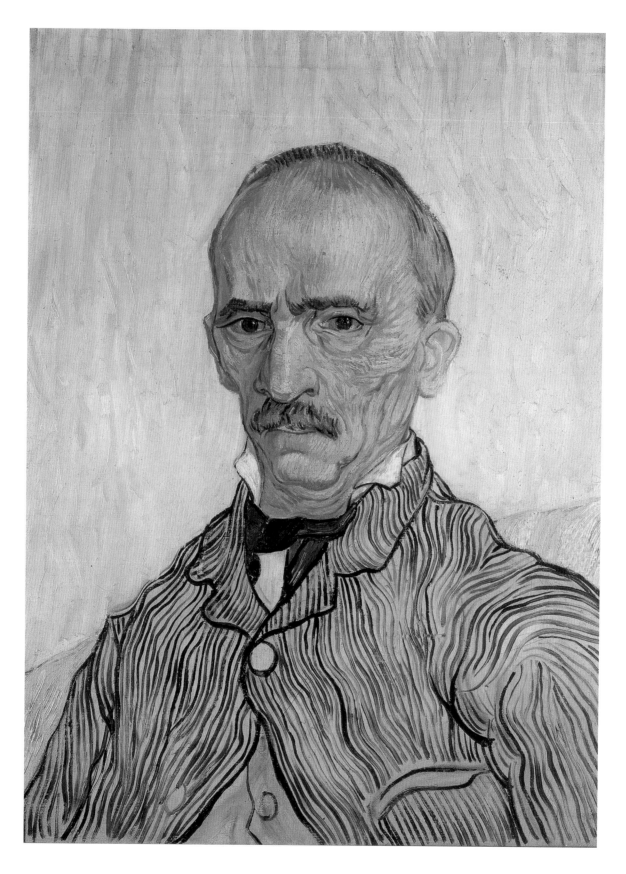

PORTRAIT OF TRABU, 1889 Oil on canvas, 61 x 46 cm

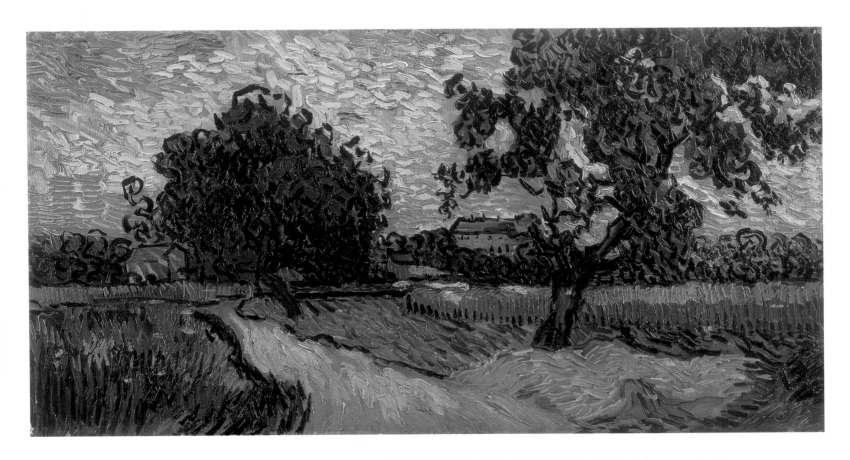

TWO PEAR TREES WITH THE CHATEAU AT AUVERS (LANDSCAPE AT TWILIGHT), 1890 Oil on canvas, 50 x 100 cm

of new ideas and ambitions and a group of contacts in Paris that he intended to maintain. He would combine the lessons he had learned in Paris with his experiences of country life and focus on two of his grand passions: landscape and portraiture.

The Character of Provence

Just as Gauguin and Bernard used the Breton landscape to create characteristic paintings that distinguished their work from what other avant-garde artists were making in Paris, van Gogh claimed the characteristics of Provence as his own. Even though he repeatedly invoked the names of artists who had worked in this area before him, he strove to stake his own claim.[55] After depicting flowering trees in the spring of 1888 and generally exploring an area whose seasonal changes were much more dramatic than those he was used to, van Gogh set out to identify specific subjects that were characteristic of Provence. He chose the rolling hills of the Alpilles, the people of the region, the cypresses, and the olive orchards.[56]

Van Gogh had never seen cypresses before he arrived in Provence. Considering them a motif as important as the sunflowers he had painted the year before, he was keen to paint the cypresses "because it astonishes me that they have not yet been done as I see them." He was fascinated by their intense color and marveled, "The green has a quality of such distinction. It is a splash of *black* in a sunny landscape, but it is one of the most interesting black notes, and the most difficult to hit off exactly that I can imagine. But then you must see them against the blue, *in* the blue rather."[57] Van Gogh tried to capture those extraordinary hues and color contrasts in a series of paintings and drawings. He compared the shape of the cypress to an Egyptian obelisk,[58] referring not only to the tree's slender height, but also associating it with ideas of primitivism, which he discussed repeatedly with Gauguin and Bernard. The branches of the trees invited the stylized brushwork that van Gogh was attempting to develop as part of his own avant-garde style, in paintings like *The Starry Night*; *Road with Cypress and Star* (p. 191); or *Wheat Field with Cypresses*

(p. 158). While he never counted *The Starry Night* among his most successful paintings, he was convinced that the other two were truly important compositions. They illustrate beautifully how much variation van Gogh brought to his interpretation of the motif. *Wheat Field with Cypresses*, a daylight picture, places the undulating forms of the cypresses at the right edge of the composition, where they stand out against the sky. The decorative swirling forms of white clouds, which echo the shapes of the Alpilles, balance the greenish tint of the sky. While the wheat field in the lower part of the composition is more descriptive, van Gogh chose a rather flat and highly decorative treatment for the upper part of the canvas. About half a year later the artist placed a cypress prominently at the center of *Road with Cypress and Star*, a night scene with a crescent moon and star. Two laborers, a horse-drawn carriage, and an inn in the background give it a human dimension. When van Gogh described the composition to Gauguin, he called it "very romantic, if you like, but also *Provence*, I think."[59]

Olive orchards, too, presented a useful and fascinating subject. The gnarled trees were a new motif he found around Saint-Rémy, an area that looked somewhat different from Arles. Olive groves that had been cultivated for hundreds of years were still an important source of income for the region. Van Gogh's letters reflect his deep interest in the subject matter and the opportunities he saw for interpretation:

…olive trees are very characteristic, and I am struggling to catch them. They are old silver, sometimes with more blue in them, sometimes greenish, bronzed, fading white above a soil which is yellow, pink, violet-tinted or orange, to dull red ocher. Very difficult though, very difficult. But that suits me and induces me to work wholly in gold or silver. And perhaps one day I shall do a personal impression of them like what the sunflowers were for the yellows.[60]

Observing the orchards at different times of the day and exploring a range of color combinations, van Gogh produced a significant body of work. While his

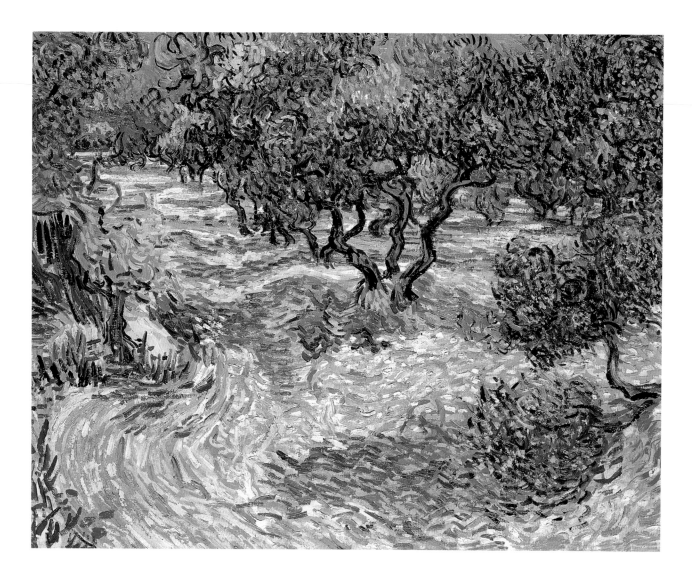

OLIVE ORCHARD, 1889 Oil on canvas, 73 x 93 cm

attention to the varying appearances of the trees seems to reflect an impressionist attitude, the resulting canvases are radically stylized, almost abstract compositions of undulating lines. Sometimes he rendered the landscape in colored bands; other times he reduced the colors to warm reddish-browns or cool blue-greens. In *Olive Orchard* he added complementary red dots like warm highlights to an otherwise cool color scheme. The scene can be read quite literally as trees with red flowers, but at the same time the red dots seem to hover on top of the paint layers, emphasizing the decorative effect of the swirling brushwork.

The olive orchards also provided a way to respond to the biblical compositions that Bernard and Gauguin began to make in 1889. Van Gogh became more than a little uneasy when he saw sketches and photographs of their paintings of biblical scenes such as Christ in the Garden of Olives. Not only was he ambivalent about Christianity and its subject matter, but he was unable to paint a religious scene for which he could not find a model in nature. Already in Arles van Gogh had tried twice to paint a Christ in the Garden of Olives, but had destroyed the paintings because he was dissatisfied with the figures.[61] Feelings of competition

and frustration led van Gogh to criticize his friends' efforts sharply — he was so harsh to Bernard that their correspondence broke down. Van Gogh's only solution was to paint a secular subject that could be used as an answer to his colleagues' projects. The olive orchards offered a perfect motif:

The thing is that this month I have been working in the olive groves, because their Christs in the Garden, with nothing really observed, have gotten on my nerves… morning and evening these bright cold days.… I have been knocking about in the orchards, and the result is five size 30 canvases, which along with the three studies of olives that you have, at least constitute an attack on the problem.[62]

This frustration was paired with his belief that he should represent nature in a personal and innovative way. To be able to do so, he believed that he needed to study the real thing before being able to create his own interpretation of the subject.

Portraits

Throughout his artistic career van Gogh was deeply committed to painting figures and portraits. He would have preferred to focus more on the figure, but a chronic lack of models — usually because he did not have the means to pay for them — thwarted that focus and led him to make landscape one of his primary themes. Van Gogh held that the representation of the figure constituted the highest achievement for an artist, and his identity as an avant-garde painter was closely bound to his belief that portraiture was the art form of the future. "We must win the public over later on by means of the portrait; in my opinion it is *the* thing of the future."[63]

Portraiture allowed van Gogh to address and define all areas of his interest and ambition: the characteristic types of Provence such as the peasants and the Arlésiennes; the profound imagery of comforting women and secular madonnas; the representation of types like the postman (p. 138); and self-portraits. For him a portrait did not merely represent a specific sitter; it had to achieve an iconic quality that would outlive the subject.[64] His goal was to represent people who would be recognized as types that would transcend the portrayal of an individual. Van Gogh believed that his identity as a modern artist was only partially connected to the impact he was able to make during his lifetime. He wanted his portraits to have an effect a hundred years later; indeed, he strove to achieve something that could define and establish his fame within the history of art:

I *should like* to paint portraits which would appear after a century to the people living then as apparitions. By which I mean that I do not endeavor to achieve this by a photographic resemblance, but by means of our impassioned expressions — that is to say, using our knowledge of and our modern taste for color as a means of arriving at the expression and the intensification of the character.[65]

Such aspirations were partly a convenient way to ignore the fact that recognition in the present was proving to be difficult, but they also indicate van Gogh's acute awareness of his own contribution and place within the art of his time. This statement, made towards the end of his life when he had just painted the portrait of Dr. Gachet in Auvers, was a proclamation of an artistic credo that embraced his ambitions as a portraitist.

Among the most important portraits for van Gogh was his painting of Madame Roulin, the wife of the postman Joseph Roulin, whom he called *La Berceuse* (p. 47). The artist considered this composition particularly successful as it not only exemplified his approach to stylization, but also achieved his ambition to evoke an iconic quality. Van Gogh interpreted Madame Roulin as a mother figure — she had recently given birth to another child — and he saw the portrait as a consoling and protecting image.[66] Since he was reluctant to paint overtly religious subject matter, *La Berceuse* took on the function of a secular madonna. He wrote that "… the idea came to me to paint a picture in such a way that sailors, who are at once children and martyrs, seeing it in the cabin of their

Icelandic fishing boat, would feel the old sense of being rocked come over them and remember their own lullabies."[67] To create an image that would endure, van Gogh projected a specific type of character onto the woman he knew, and through this process arrived at an iconic figure that could be appropriated for other contexts as well. In *The Raising of Lazarus* (p. 48), a work from May 1890, the figure of *La Berceuse* appears again as one of the women witnessing the miracle. In contrast to his usual avoidance of religious subject matter, for this composition van Gogh took a scene from the Bible and portrayed one of Christ's miracles in which he raises someone from the dead. The composition is copied from a print by Rembrandt, but eliminates the figure of Christ seen there. Van Gogh transports the scene into the human sphere by casting himself as Lazarus and using two of his favorite models, Mme. Roulin and Mme. Sirony, whom he had portrayed as the characteristic Arlésienne, for the roles of the women witnessing the miracle. In May of 1890 van Gogh was ready to move back to the north of France, hoping for better health and a bright future. By using *La Berceuse* in this particular image, he not only included a friend in this scene of a new beginning, but also evoked again the characteristics of consolation and protection that he had accorded his portrait of *La Berceuse*, thus underlining the truly iconic nature of his portraiture.[68]

The decorative brushwork that enhanced the interpretation of Madame Roulin as *La Berceuse* constituted van Gogh's answer to Gauguin's decorative canvases and clearly proclaimed his membership in the avant-garde. In comparing van Gogh's *La Berceuse* with Gauguin's portrait of the same sitter (p. 49), it is apparent that Gauguin also created an iconic portrait, but he carried it out with a thin application of paint on an extremely rough canvas. Instead of the pattern of flowers that van Gogh used in the background of his picture, Gauguin inserted one of his own highly decorative and flattened images, *Blue Tree Trunks, Arles* (p. 109).

Van Gogh's interest in creating types rather than representing individuals is evident in many of his paintings. His portrait of Eugène Boch (p. 35) casts the painter as a poet. Vincent wrote to Theo: "You will soon see him, this young man with the look of Dante.... Well, thanks to him I at last have a first sketch of that picture which I have dreamed of for so long—the poet."[69] With his portrait of Patience Escalier (p. 172), he sought to create a painting of the quintessential peasant working in the burning heat of the South. Such works marked a return to the subject matter of peasants, which had been a strong focus during his Dutch years and had led to many portraits as well as the ambitious *Potato Eaters* of 1885 (Amsterdam, Van Gogh Museum, F82). In Arles he used color to evoke the circumstances in which the farmers lived and worked. The extraordinary contrast of orange and blue evokes an intense heat and bright sunlight that seem to engulf the model.

If the impressionists had started to represent friends and family in relaxed settings, in nature, or in the privacy of their homes, the next generation of artists concentrated on a specific interpretation of the sitter. Sometimes that meant that a particular characteristic would be singled out, but more often the sitter became a starting point or a vehicle for a type of interpretation that the artist wanted to convey. Portraiture was a popular genre by the end of the century, and many of the painters of the *petit boulevard* were attempting to create iconic images similar in intent to the portraits of Madame Roulin by van Gogh and Gauguin. That emphasis on interpretation is exemplified in the two very different portraits by Gauguin and Bernard that depict Bernard's sister Madeleine (pp. 50 and 51). Gauguin's enigmatic, almost flirtatious representation starkly contrasts with Bernard's iconic, saint-like image of his sister. Lucien Pissarro's portrait of his rather bored, slouching sister Jeanne (p. 54) and Toulouse-Lautrec's prim and upright *Portrait of Justine Dieuhl* (p. 57) further illustrate the range of interpretations. All these images were carried out in the individual style of each artist, using color and paint handling very much in concert with the latest avant-garde techniques.

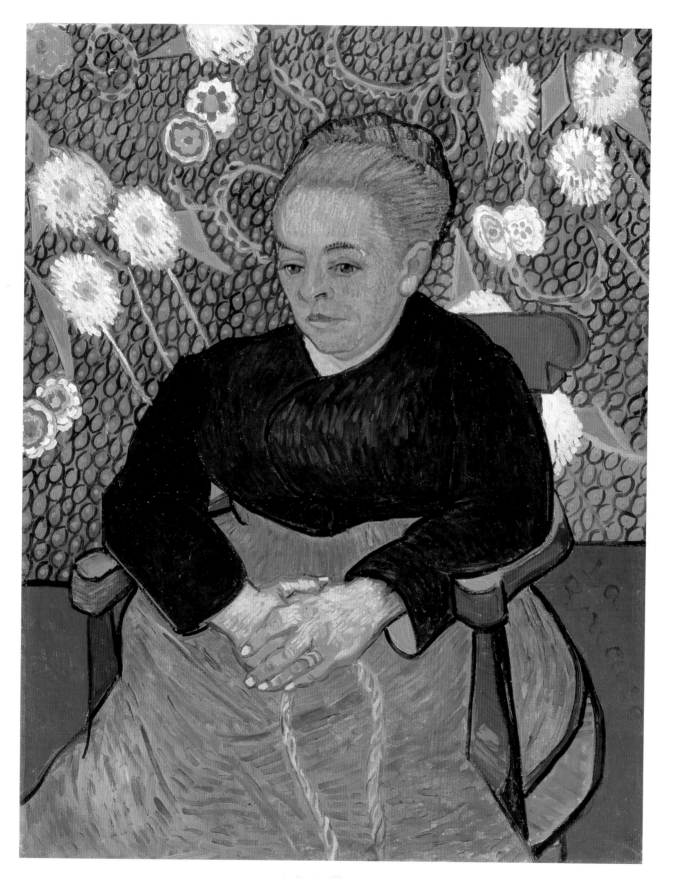

LA BERCEUSE (AUGUSTINE ROULIN), 1889 Oil on canvas, 92.7 x 72.8 cm

While van Gogh often turned to self-portraits because he lacked other models, he also used the genre to create an image of himself as a modern painter. Many of his self-portraits from his Paris years present the artist as a type—the elegant gentleman, the laborer, the painter.[70] By the time he was in Arles, however, the self-portrait had become more a representation of artistic identity. The most prominent example is van Gogh's self-portrait from 1888 (p. 112), which he made for an exchange with his colleagues Gauguin and Bernard. The work is very modern in its intense color contrasts and daringly simplified composition. Taking advantage of his recently shaved head and beard, van Gogh styled himself as the dedicated artist who had banned all pleasures of life to concentrate completely on his work.[71] His competitive spirit was relieved and reassured when he saw the portraits that Gauguin and Bernard traded with him. Convinced that his own work was as good if not better, van Gogh concluded that he could compete comfortably on the avant-garde stage and claim a strong position among his contemporaries: "So now at last I have a chance to compare my painting with what the comrades are doing. My portrait, which I am sending to Gauguin in exchange, holds its own, I am sure of that.... And when I put Gauguin's conception and my own side by side, mine is as grave, but less despairing."[72]

Van Gogh's preference for casting himself as a type rather than an individual is representative of the other painters of the *petit boulevard*. Gauguin associated himself with the figure of Victor Hugo's Jean Valjean in his self-portrait made for the exchange with van Gogh,[73] and in 1889 Gauguin made a forceful statement about his position in the art world with his *Self-Portrait with Halo* (p. 111). Portraying himself ironically as a saint, using apples and a snake to recall the expulsion from Paradise, Gauguin expressed his dedication to his métier in a different way than van Gogh had done. His confident pose, illustrating his leading role among the artists in Brittany, is in startling contrast to the reclusive, religiously dedicated role van Gogh had chosen for himself the year before. It is a daringly modern composition, flattened by the decorative rendering of the snake in the foreground, in which Gauguin's head seems to float in areas of intense red and yellow.

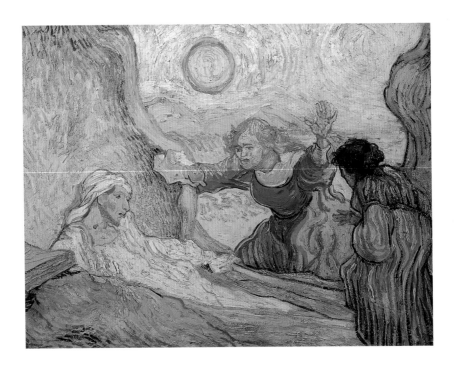

THE RAISING OF LAZARUS, 1890 Oil on paper, lined with canvas, 50 x 65 cm

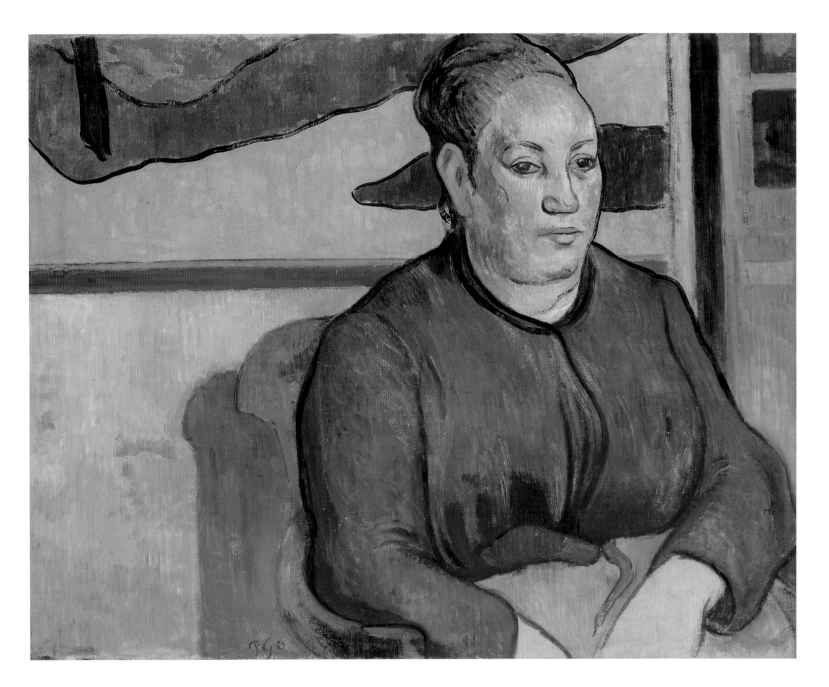

PORTRAIT OF MADAME ROULIN, 1888 Oil on canvas, 48.2 x 62.2 cm

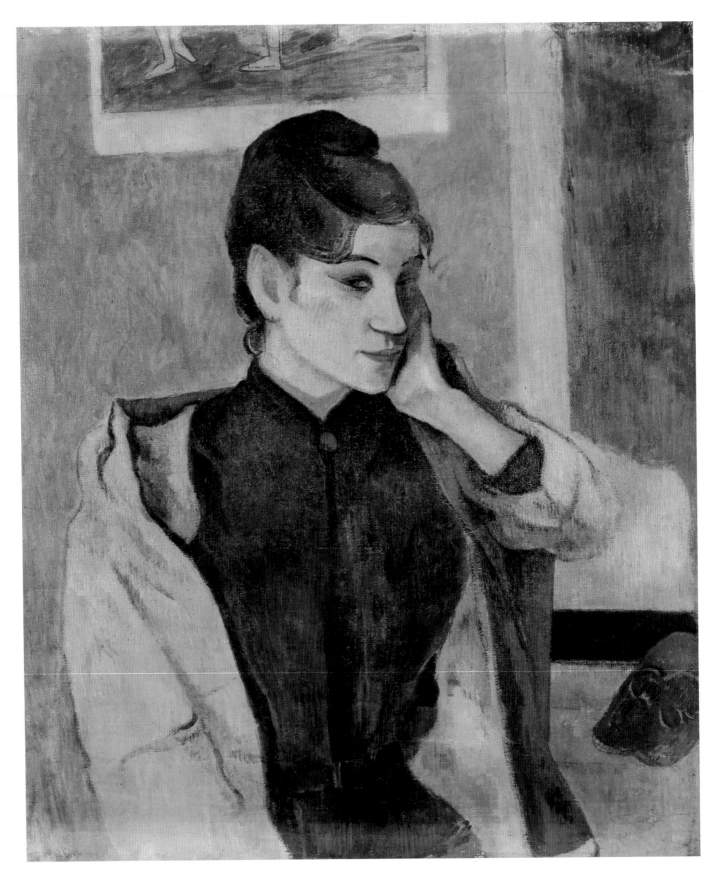

PORTRAIT OF MADELEINE BERNARD, 1888 Oil on canvas, 72 x 58 cm

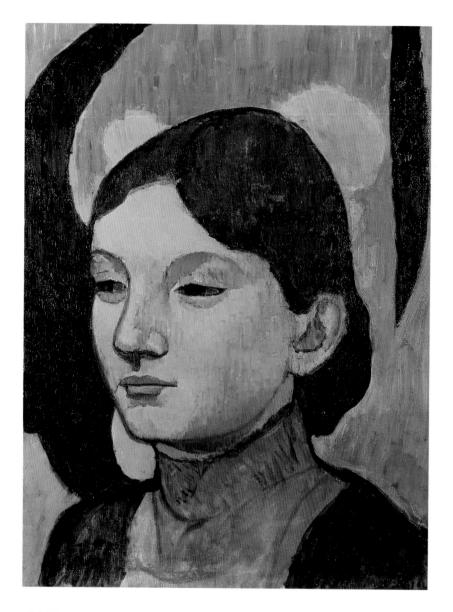

PORTRAIT OF MADELEINE BERNARD, 1887–88 Oil on canvas, 41 x 32 cm

Fame

The exchange of self-portraits shows the competition among van Gogh and his colleagues, and the urge to portray and define themselves illustrates how much the image of the modern artist was crucial to their identity. Like Gauguin or Seurat, van Gogh was intent on carving out his own niche, his unique position among his peers. In his mind, other artists were as much fighters for the same cause as rivals in the battle for recognition. Van Gogh's relationship with Gauguin was especially shaped by this dichotomy. The competition is apparent in van Gogh's annoyance with Gauguin when the latter appropriated his idea of an artists' association to help the painters of the *petit boulevard*, as it was in the exchange of self-portraits.[74] Even though van Gogh was rather careful not to challenge any of his contemporaries directly, he worked to gain his own recognition whenever possible. When he began to receive some critical acclaim in Paris towards the end of 1889, he had difficulty accepting it, especially

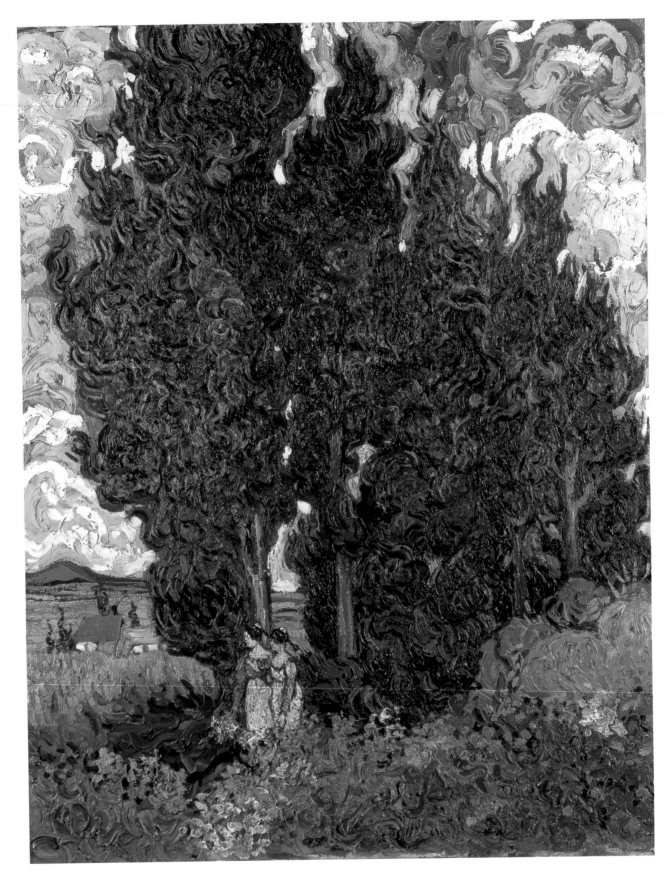

CYPRESSES, 1889 Oil on canvas, 92 x 73 cm

when attacks of illness weakened his self-confidence. Nevertheless, he used the interest of critics to his advantage whenever possible. While he dissuaded the Dutch critic J. J. Isaäcson from writing a major article on him, van Gogh referred to Isaäcson's suggestion in many of his letters at the time. A similar situation occurred when the French critic Albert Aurier wrote a long and influential article about van Gogh in his avant-garde journal *Mercure de France*.[75] Van Gogh claimed he was not worth this attention and, in his letter of thanks to Aurier, he argued that praise should go to others, particularly Gauguin.[76] Yet van Gogh was so proud of the article that he mentioned it in every letter he wrote for weeks. As a thank you, he presented Aurier with a composition of cypresses (p. 52) that showed the elements of his avant-garde identity: stylized brushwork, heavy impasto, color contrast, and, as subject, the cypress, one of the emblems of Provence that he had chosen for himself.

Van Gogh's aspiration for posthumous fame has to be viewed in the context of these ambitions. To Theo, Vincent repeatedly suggested keeping important versions of all of his works; this was not only a way to compensate his brother for all his support, but also an expression of his intention to create a cohesive oeuvre.[77] The artist often conceived his work in series to present a specific idea or a particular range of color contrasts. For him it was not an individual masterpiece but a whole range of successful works that would define his career.

Van Gogh's concept of his own oeuvre suggests that he recognized the importance of the retrospective exhibitions that had become popular in the 1870s and 1880s, honoring such major figures as Manet, Millet, Daumier, and Delacroix. These shows focused public attention on the artists, and the prices for their work went up. Van Gogh knew that visitors were coming to see his work at his brother's home in Paris with increasing frequency. He believed that a true appreciation of his work would depend on experiencing the entire oeuvre, which would fully represent his choice of subject matter and technical approach. In this way

visitors could see a wide range of his work—and also perceive its uniqueness.

In the final years of his career, van Gogh gained growing attention for his work. His brother reported praise not only from his colleagues of the *petit boulevard*, but also from Monet, the leader of the *grand boulevard*, for the pictures van Gogh was showing at the Indépendants. Critics wrote about his paintings there.[78] These signs that van Gogh's career was finally taking off gave the artist an incentive to foster and refine the image he wanted to present. In the last years of his life van Gogh may even have written Theo with the vague idea that his brother might publish his letters at some later date.[79] He knew that Theo saved all of them, and Vincent had advised Theo repeatedly to keep certain letters by other artists.[80] In the 1870s and 1880s the personal writings of artists had received wide attention, and van Gogh had enjoyed reading them. Alfred Sensier's biography of Millet included numerous letters in addition to much (partly fictional) information about the artist's life. Philippe Burty had published the letters of Delacroix.[81] Nor was this ambition to be published for posterity unique to van Gogh: Seurat's letters to Maurice de Beaubourg[82] that explain his theory of art-making fall into the same category, as do Gauguin's repeated attempts to publish his journal *Noa-Noa*. Gauguin published his later reminiscences in *Avant et après*, which contain his version of the events in Arles and emphasize van Gogh's dependence on his guidance. It was written at a time when van Gogh had already achieved significant posthumous acclaim, while Gauguin was still having to fight for recognition.

It is without question that van Gogh's fame was fostered by his early and dramatic death. Yet in retrospect his desire to prepare a public image for himself appears to have been justified. Theo asked Albert Aurier to write his brother's biography and offered not only the study of works in his home but also to make the artist's letters available. Aurier was deeply interested in this project, but it never came to fruition due to Theo's death.[83] In the early 1890s Bernard chose to emphasize the personal side of van

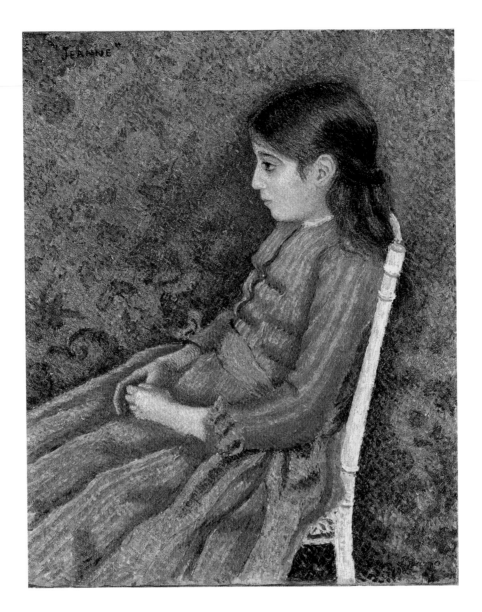

PORTRAIT OF JEANNE, 1889 Oil on canvas, 73 x 59 cm

Gogh, as well as his own friendship with him, when he published Vincent's letters to him in the *Mercure de France*.84

Van Gogh had prepared the groundwork for his own acclaim. His letters make clear that he was aware of and concerned with his image as a modern artist. From his time in Paris, van Gogh wanted to be a member of the avant-garde in France and was keen to make his ideas known and his contributions respected. His ambitions were not very different from those of

his contemporaries. With and through them, van Gogh became aware of ways he could achieve success, and he recognized Paris as the influential metropolis and vast market it was in the late 1880s. Intent on developing his own work within the parameters of modern art, he was no less keen to nurture his own individuality. Like Seurat, Signac, Gauguin, and Bernard, Vincent van Gogh was aware of the strategies that helped to launch an artistic career, and this awareness was very much part of his artistic development.

Notes

References to Vincent van Gogh's letters, unless otherwise noted, are from *The Complete Letters of Vincent van Gogh* (Greenwich: New York Graphic Society, 1958).

1 The term appears first in van Gogh's letters from Arles when he refers to activities and contacts in Paris (see *Complete Letters* 468, 473, 500).

2 Van Gogh used the term "impressionist" inconsistently, sometimes referring to the impressionist generation of Claude Monet and at other times indicating the innovative artists of his generation.

3 Critics played an influential role in defining new movements and groups. Most prominent was Félix Fénéon, who coined the term "neo-impressionism." See, for example, Martha Ward, "The Neo-Impressionist Avant-Garde: Critics, Spaces, Histories," in Ward, *Pissarro, Neo-Impressionism, and the Spaces of the Avant-Garde* (Chicago: University of Chicago Press, 1996), pp. 49–63.

4 See John Rewald, *Post-Impressionism: From van Gogh to Gauguin*, 3rd ed., rev. (New York: The Museum of Modern Art, 1978), pp. 102ff.

5 See, for example, Vojtěch Jirat-Wasiutyński, "Emile Bernard and Paul Gauguin: The Avant-Garde and Tradition," in Mary Anne Stevens et al., *Emile Bernard, 1868–1941: A Pioneer of Modern Art*, exh. cat., trans. J. C. Garcias et al. (Mannheim: Städtische Kunsthalle; Amsterdam: Van Gogh Museum; Zwolle, Netherlands: Waanders Publishers, 1990), pp. 48–67. Gauguin was also intensely displeased when the critic Edouard Dujardin hailed Louis Anquetin as the founder of cloisonnism in *Revue indépendante* (1 March 1888).

6 "So if you have already thought that Signac and others who use pointillism quite often do very fine things for all that, instead of slandering them you must respect them and speak sympathetically of them, especially if there has been a quarrel. Otherwise one becomes a sectarian, narrow-minded oneself, and the equal of those who utterly despise all others and believe themselves to be the only just ones." *Complete Letters* B1.

7 For early criticism, see Carol M. Zemel, *The Formation of a Legend: Van Gogh Criticism, 1890–1920* (Ann Arbor: UMI Research Press, 1980).

8 Quoted from Theo's letter to his sister Wil on 14 March 1887 (published in Jan Hulsker, *Vincent and Theo van Gogh: A Dual Biography* (Ann Arbor: Fuller Publications, 1990), pp. 245–46. The problems were not new, as can be seen in A. Bonger's letters to his parents in the summer of 1886; see *Complete Letters* 462a.

9 For more on the relationship between van Gogh and Bernard, see Roland Dorn, "Emile Bernard and Vincent van Gogh," in Stevens et al., *Emile Bernard*, pp. 30–47.

10 See Henri de Toulouse-Lautrec, *The Letters of Henri de Toulouse-Lautrec*, ed. Herbert D. Schimmel (Oxford: Oxford University Press, 1991) and van Gogh's *Complete Letters*.

11 See Anne Roquebert, "Oeuvres de jeunesse," in *Toulouse-Lautrec* (Paris: Réunion des Musées Nationaux, 1992), pp. 67–73.

12 Gale B. Murray, *Toulouse-Lautrec: The Formative Years, 1878–1891* (Oxford: Clarendon Press, 1991), p. 123.

13 See, for example, *Complete Letters* 457: "With regard to Cormon, it is decidedly better for me to go on drawing from the plaster casts than to work out-of-doors."

14 Murray, *Toulouse-Lautrec*, p. 170; also Richard Thomson, "Illustrations, caricatures et types," in *Toulouse-Lautrec* (Paris: Réunion des Musées Nationaux, 1992), pp. 175, 202.

15 Arsène Alexandre, *H. Daumier: L'Homme et l'oeuvre* (Paris: H. Laurens, 1888).

16 Emile Bernard, "Louis Anquetin: Artiste peintre," *Mercure de France* (1 November 1932), pp. 592–93.

17 "I remember Van Gogh coming to our weekly gatherings at Lautrec's. He arrived carrying a heavy canvas under his arm, put it down in a corner but well in the light, and waited for us to pay some attention to it. No one took notice. He sat across from it, surveying the glances, seldom joining in the conversation. Then, tired, he would leave, carrying back his latest work. But the next week he would come back, commencing and recommencing with the same strategem." Suzanne Valadon interviewed by Florent Fels in 1928, trans. in Susan Alyson Stein, ed., *Van Gogh: A Retrospective* (New York: Park Lane, 1986), p. 87.

18 *Complete Letters* 505, 520.

19 Toulouse-Lautrec, *The Letters of Henri de Toulouse-Lautrec*, 139, 158, 160; *Complete Letters* 505.

20 See "Letter from Paul Signac to Gustave Coquiot" 1923, quoted in Stein, ed., *Van Gogh: A Retrospective*, p. 89.

21 For van Gogh's ideas about a Studio of the South see the essays by Elizabeth C. Childs and John House in this book.

22 *Complete Letters* 501.

23 See, for example, *Complete Letters* B10.

24 For literature on the art market in Paris, see Ward, *Pissarro*, chapter 2; and John Milner, *The Studios of Paris: The Capital of Art in the Late Nineteenth Century* (New Haven: Yale University Press, 1988).

25 *Complete Letters* 473.

26 *Complete Letters* T10.

27 *Complete Letters* 510.

28 See, for example, *Complete Letters* 464, 465, 468, 471, 473.

29 *Complete Letters* 479.

30 *Complete Letters* B10.

31 *Complete Letters* 468.

32 Van Gogh repeatedly declared Seurat to be the leader of the *petit boulevard*, for example in *Complete Letters* 500.

33 *Complete Letters* 469.

34 "Allez donc aussi voir mon frère (Goupil et Cie 19 Boulevard Montmartre) il a dans ce moment un très beau de Gas. J'ai encore revue chez Tanguy votre jeune fille aux poules, c'est justement cette étude là que j'aimerais bien à vous échanger. Si inclus une carte de mon frère si vous ne le trouviez pas là vous pourriez donc toujours monter voir les tableaux." See facsimile in Musée d'Orsay, *Van Gogh à Paris*, exh. cat. (Paris: Réunion des Musées Nationaux, 1988), p. 378.

35 See, for example, *Complete Letters* 471.

36 "Has that confounded Tersteeg written you yet? All to the good if he has. If he doesn't answer, he will hear of us all the same, and we shall see to it that he can find no fault with our actions. For instance, we will send a picture to Mrs. Mauve in memory of Mauve, with a letter from both of us, in which, supposing Tersteeg does not reply, we shall not say a word against him, but we will manage to convey that we do not deserve to be treated as if we were dead." *Complete Letters* 467. Only several weeks later van Gogh reports that he has inscribed his picture "Souvenir de Mauve." *Complete Letters* 472.

37 *Complete Letters* 473.

38 *Complete Letters* 578.

39 "After what you told me about him, I am going to see him this afternoon." *Complete Letters* 505.

40 Van Gogh had read with great interest Théophile Silvestre, *Eugène Delacroix: Documents nouveaux* (Paris: M. Levy Frères, 1864). Also published in *Les Artistes français* (1878), pp. 31–107; Charles Blanc, "Eugène Delacroix," *Gazette des Beaux-Arts* 16 (1864), pp. 5–27, 97–129; Blanc, *Grammaire des arts du dessin, architecture, sculpture, peinture* (Paris: Ve J. Renouard, 1867); and Blanc, *Les Artistes de mon temps* (Paris: Firmin-Didot, 1876).

41 *Complete Letters* 482.

42 *Complete Letters* 555.

43 *Complete Letters* 533.

44 Ibid. Van Gogh quotes a comment by Mantz about work by Delacroix.

In the same letter he referred to Katsushika Hokusai, who achieves a similar emotional result by way of line.

45 *Complete Letters* 539.

46 *Complete Letters* 503.

47 *Complete Letters* 607. See also Cornelia Homburg, *The Copy Turns Original: Vincent van Gogh and a New Approach to Traditional Art Practice* (Amsterdam and Philadelphia: John Benjamins, 1996), especially part 2.

48 *Complete Letters* 520.

49 *Complete Letters* B8.

50 Gauguin wrote about these ideas in a letter to Emile Schuffenecker dated 14 August 1888: "Do not copy too much from nature. Art is an abstraction; derive it from nature whilst dreaming in front of nature, and think more of the creation than of the result…" Trans. by John House in his essay in this book, p. 189. Merlhès letter 159.

51 "As you know, once or twice, while Gauguin was in Arles, I gave myself free rein with abstractions…and at the same time abstraction seemed to me a charming path. But it is enchanted ground, old man, and one finds oneself up against a stone wall." *Complete Letters* B21.

52 "The 'Olives' with a white cloud and a background of mountains, as well as the 'Moonrise' and the night effect, are exaggerations from the point of view of arrangement, outlines accentuated like those in old woodcuts." *Complete Letters* 607 (translation corrected from the original French).

53 See Evert van Uitert, Louis van Tilborgh, and Sjraar van Heugten, *Vincent van Gogh: Paintings* (Amsterdam: Meulenhoff/Landshoff, 1990), p. 214.

54 Explanations of the appearance of these paintings have ranged from visions during his illness to particular constellations in the night sky.

55 It is interesting to see how he referred to Paul Cézanne as also working in the South without really knowing and understanding what the latter was doing. Nevertheless, there seems to have been a question of possible competition, but not close enough to be threatening. See, for example, *Complete Letters* B9.

56 See Vojtěch Jirat-Wasiutyński, "Vincent van Gogh's Paintings of Olive Trees and Cypresses from St.-Rémy," *Art Bulletin* 75, no. 4 (December 1993), pp. 647–70.

57 *Complete Letters* 596.

58 Ibid. A little later he asked Bernard for a sketch of the Egyptian house on view at the World's Fair: *Complete Letters* B20.

59 *Complete Letters* 643.

60 *Complete Letters* 608.

61 *Complete Letters* 505, 540. For a more detailed discussion of van Gogh's attitude towards religious subject matter see Homburg, *The Copy Turns Original*, especially chapter 8, "The significance of religious subject matter," pp. 62ff.

62 *Complete Letters* 615.

63 *Complete Letters* B19.

64 On van Gogh's portraits, see, for example, most recently Roland Dorn's essay, "The Arles Period: Symbolic Means, Decorative Ends," in Dorn et al., *Van Gogh Face to Face: The Portraits*, exh. cat. (Detroit: Detroit Institute of Arts, 2000), pp. 134–71.

65 *Complete Letters* W22.

66 For this well-known interpretation, see Evert van Uitert et al., *Vincent van Gogh: Paintings*, pp. 195–99; Carol Zemel, *Van Gogh's Progress: Utopia, Modernity, and Late-Nineteenth-Century Art* (Berkeley and Los Angeles: University of California Press, 1997), pp. 117–21; and Judy Sund, *True to Temperament: Van Gogh and French Naturalist Literature* (Cambridge and New York: Cambridge University Press, 1992), pp. 216–21. See also Elizabeth C. Childs's essay in this volume.

67 *Complete Letters* 574.

68 See Homburg, *The Copy Turns Original*, p. 76.

69 *Complete Letters* 531.

70 For example F344, F526, F522.

71 See the interpretations in Vojtěch Jirat-Wasiutyński et al., *Vincent van Gogh's Self-Portrait Dedicated to Paul Gauguin: An Historical and Technical Study* (Cambridge: Harvard University Art Museums, Center for Conservation and Technical Studies, 1984). For further discussion, see Childs's essay in this volume.

72 *Complete Letters* 545.

73 For an interpretation of the painting, see Evert van Uitert and Michael Hoyle, eds., *The Rijksmuseum Vincent Van Gogh* (Amsterdam: Meulenhoff, 1987), p. 110.

74 See *Complete Letters* 496, 498. See also Evert van Uitert, *Vincent van Gogh in Creative Competition: Four Essays from Simiolus* (Zutphen, 1983).

75 Gabriel-Albert Aurier, "Les Isolés—Vincent van Gogh," *Mercure de France* 1, no. 1 (January 1890), pp. 24–29.

76 He also made sure that Gauguin got a copy of this letter. *Complete Letters* 626.

77 Van Gogh distinguished between a "tableau" (a fully successful, finished painting) and a "study" (often a first version done on the spot, or a work he was not completely pleased with). He envisioned an oeuvre made up primarily of his "tableaux" and felt it was important that Theo keep them together. For further details see Evert van Uitert et al., *Vincent van Gogh: Paintings*, especially the introduction.

78 See Stein, ed., *Van Gogh: A Retrospective* for translations of critical commentaries on the exhibitions of the Indépendants: Gustave Kahn, "Painting: Indépendants Exhibition," *Revue indépendante* (April 1888); Félix Fénéon, "The Fifth Exhibition of the Société des Artistes Indépendants," *La Vogue* (September 1889); Julien Leclercq, "Fine Arts at the Indépendants," *Mercure de France* (May 1890); Georges Lecomte, "Salon of the Indépendants," *L'Art dans les deux mondes* (28 March 1891); Octave Mirbeau, "Vincent van Gogh," *L'Echo de Paris* (31 March 1891); Emile Verhaeren, "The Salon of the Indépendants," *L'Art moderne* (5 April 1891); Eugène Tardieu, "The Salon of the Indépendants," *Le Magazine français illustré* (25 April 1891); and Jules Antoine, "Exhibition of the Indépendants," *La Plume* (1 May 1891).

79 This possibility was discussed first in a conversation between Evert van Uitert and the author in the early 1990s.

80 *Complete Letters* 544.

81 Alfred Sensier, *La Vie et l'oeuvre de J.-F. Millet* (Paris, 1881); and Philippe Burty, *Lettres d'Eugène Delacroix* (Paris, 1870).

82 See Seurat's letters in Robert L. Herbert et al., *Georges Seurat, 1859–1891*, exh. cat. (New York: The Metropolitan Museum of Art, 1991), pp. 381–83.

83 See Theo's letter to Aurier of August 1890, *Complete Letters* T55, and Aurier's letter to Bernard of 27 August 1890, translated in Stein, ed., *Van Gogh: A Retrospective*, pp. 234–35.

84 "Vincent van Gogh, extraits de lettres à Emile Bernard," *Mercure de France* (1893–95).

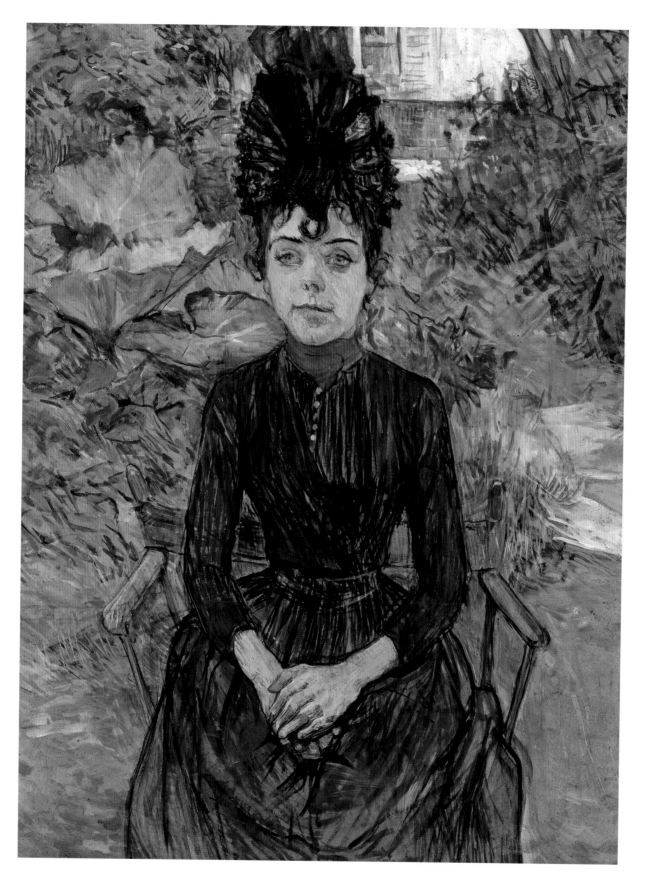

PORTRAIT OF JUSTINE DIEUHL, C.1891 Oil on cardboard, 74 x 58 cm

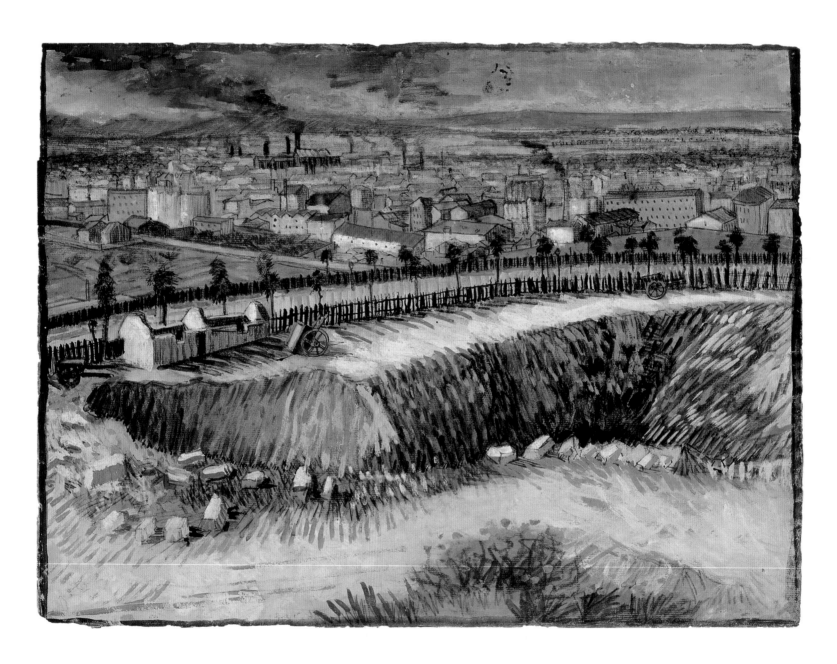

INDUSTRIAL LANDSCAPE/ENVIRONS OF PARIS NEAR MONTMARTRE, 1887 Pastel and gouache on green paper, 39.5 x 53.5 cm

THE BRASSERIE, C.1885–86 Pen and ink and watercolor on paper, 13.3 x 16.2 cm

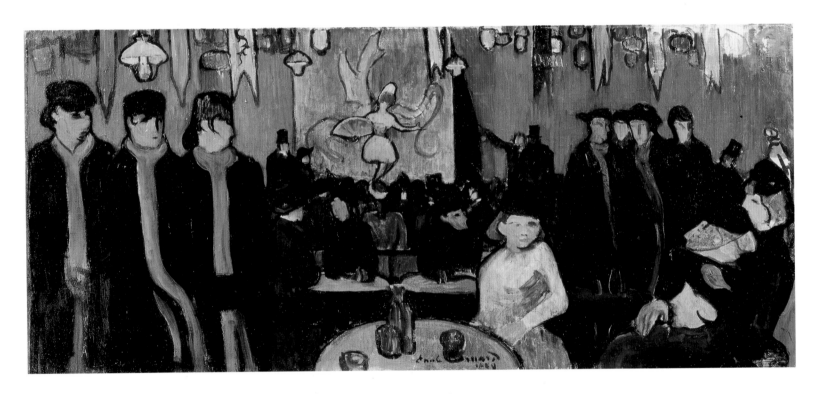

THE CAFE CONCERT (AU CABARET), 1889 Oil on canvas, 27 x 61 cm

AT THE CAFE-CONCERT, 1889 Gouache on silk, 18.4 x 22.5 cm

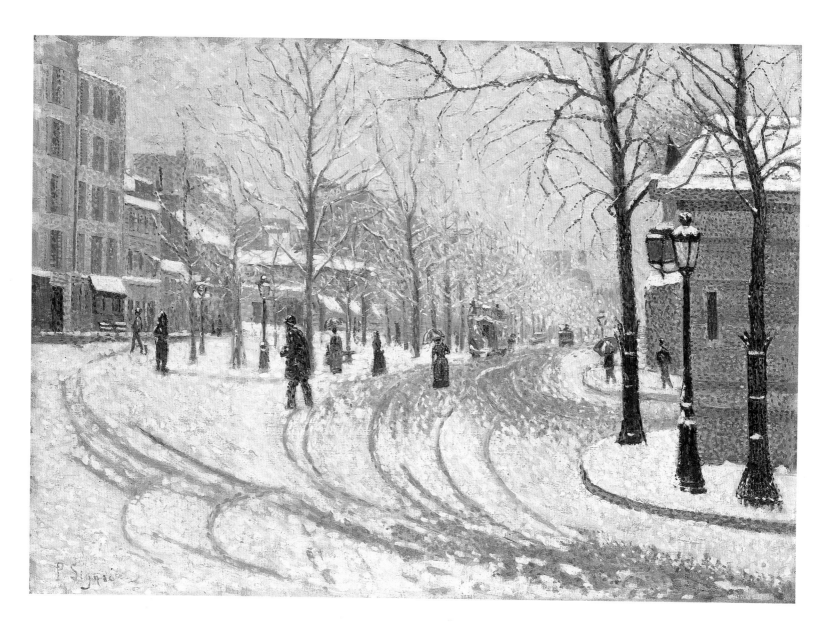

SNOW, BOULEVARD DE CLICHY, PARIS, 1886 Oil on canvas, 45.7 x 65.4 cm

The Cultural Geography of the Petit Boulevard

Richard Thomson

Defining the Petit Boulevard

The term *petit boulevard* was coined — it seems — by Vincent van Gogh and used in his discussions with his brother Theo as shorthand, a means of understanding the complexities of the Parisian art world of the late 1880s. Theo had worked in the French capital since 1878, first as an assistant and then, from 1881, as *gérant* (manager) of a branch of the international art dealing and publishing company Goupil at 19, boulevard Montmartre. He knew the Paris scene far better than Vincent, who had arrived in the city from Antwerp in March 1886, having recently admitted that he knew nothing about the impressionists,[1] the name given to a group of artists at their first exhibition a dozen years before. Still, both the experienced dealer and the enthusiastic painter were faced with a metropolitan art world that was enormously complex and constantly changing.

The protean and labyrinthine character of that art world was formed by a variety of pressures of fluctuating intensity. Among them were the vitality of the French economy and the willingness of collectors to speculate and buy; encouragement or intervention by the successive governments of the Third Republic, whether via direct action such as commissions and purchases or by indirect means such as censorship, for example, which was liberalized in 1881; and changes in public taste or shifts in artistic creativity that might cause styles or reputations, of individuals or of groups of artists, to rise or fall in general esteem. Faced with such flux, what did the two brothers mean by *petit boulevard*?

Originally, in Vincent and Theo's understanding, it was an economic reality. The term surfaces in their correspondence shortly after Vincent's departure from Paris for Arles in February 1888. Its currency in his letters suggests that it had been common in conversations between them, and perhaps with others, over the previous months. In a letter of 10 March, Vincent imagined a scheme for a society of painters, in which prices would be fixed at the same level and profits shared.[2] Those he envisaged being involved were Edgar Degas, Claude Monet, Pierre-Auguste Renoir, Alfred Sisley, and Camille Pissarro, all of whom had shown regularly at the eight exhibitions held between 1874 and 1886 that had given the term "impressionism" its public identity. Vincent called them "the great impressionists of the Grand Boulevard," meaning that their work, represented by such art dealers as Georges Petit and Paul Durand-Ruel, whose galleries were just off the central boulevards on the rue de Sèze and rue Lafitte, respectively, was established on the Parisian art market. Henri de Toulouse-Lautrec used a similar shorthand in his conversations with Théo van Rysselberghe in late 1887 about possible invitees to the next year's Les XX exhibition in Brussels, referring to Monet, Renoir, and those who had shown with Petit as "some rue de Sèze," and emergent young artists such as Georges Seurat and Paul Signac, who had been featured in the last impressionist exhibition, as "some rue Lafitte," alluding to the location of the event.[3]

Vincent's division was ingenuously exclusive — his stratification gave no consideration to the artists whose

prices and reputations were far above those of the impressionists — and rather reductive even within the group he mentioned. Degas and Monet had increasingly marketable identities. Monet, for instance, had held one-man shows at the gallery of the magazine *La Vie moderne* in 1880 and at Durand-Ruel's in 1883; the latter was favorably reviewed in the prestigious *Gazette des Beaux-Arts.* He had exhibited regularly at Petit's annual Expositions Internationales since 1885 and had had his work shown abroad: at Les XX in Brussels, the Society of British Artists in London, and by Durand-Ruel in New York. By contrast, their *grand boulevard* colleagues Sisley and Pissarro, whose canvases Petit and Durand-Ruel also marketed, found the going hard and prices lower.

Vincent hoped that in his new society these more recognized figures would welcome their less-established colleagues: Armand Guillaumin and the two young painters whose work had caused a stir at the last impressionist exhibition in 1886, Seurat and Signac. A letter van Gogh sent to Paul Gauguin in early October 1888, which the latter sent on to another painter, Emile Schuffenecker, also argued for setting up a company, an idea generated "in the poverty-stricken studios and the cafés of the *petit boulevard.*"[4] For Vincent, the *petit boulevard* as a socioeconomic reality included more than the art world; in May 1888 he wrote to Emile Bernard about its cheap prostitutes and pimps.[5] The concept, then, had a certain back-street dynamic to it.

By its name, the *petit boulevard* implied a geographical area. The *grands boulevards* were the fashionable streets constructed under the Second Empire, with the place de l'Opéra as their hub: chic thoroughfares lined with banks, elegant shops, cafés, and upmarket art galleries conveniently close to the Bourse. Paris changed within a mile or so to the north. Passing through blocks of apartments that gradually became less smart, one would climb to the outer boulevards de Clichy and de Rochechouart and beyond, up the southern slopes of Montmartre. These boulevards housed the cafés in which the artists in Vincent's circle met, among them

the Restaurant du Chalet and Café du Tambourin at 43 and 62, boulevard de Clichy; several important entertainment venues, including, on the boulevard de Rochechouart, the Cirque Fernando at no. 63, the Elysée-Montmartre dance hall at no. 80, and the Mirliton cabaret at no. 84; as well as artists' studios, including those of Seurat and Signac on the boulevard de Clichy, at nos. 128 bis and 130, respectively. Running east-west, these boulevards marked a frontier in the class geography of Paris. To the south, along with the Chat Noir cabaret on the rue Laval, were the apartments and studios of such senior artists as Gustave Moreau, Alfred Stevens, and Degas. In contrast to this respectable middle-class *quartier*, the steep streets to the north took one into increasingly proletarian territory. These streets included the rue Lepic, on which Vincent and Theo lived at no. 54, in the same building as the dealer Alphonse Portier; the street led up to the Moulin de la Galette dance hall. In geographical terms, the *petit boulevard* was a clustering of diverse, even antagonistic, social classes.[6]

By *petit boulevard* Vincent surely meant more than just the geographical proximity of the artists with whom he associated or identified during his two-year period in Paris from March 1886 to February 1888. Some of these, notably Gauguin and Guillaumin, were slightly older than Vincent, but most — Seurat, Signac, Charles Angrand, Louis Anquetin, Bernard, Toulouse-Lautrec — were younger. In Vincent's first months in Paris, their careers were at very different stages. Gauguin and Guillaumin had exhibited with the impressionists since the 1870s, but neither had a strong identity, let alone a following, as an artist. Seurat's large canvas *A Sunday Afternoon on the Island of La Grande Jatte — 1884* (p. 77), along with the paintings of Signac, had made a considerable impact at the impressionist exhibition in May 1886, but their divisionist "neo-impressionism" was controversial and, while praised by young writers, as yet had scant market presence. Angrand, a teacher and part-time artist, and the teenage Bernard had, like the academically trained Anquetin and Toulouse-Lautrec, still to

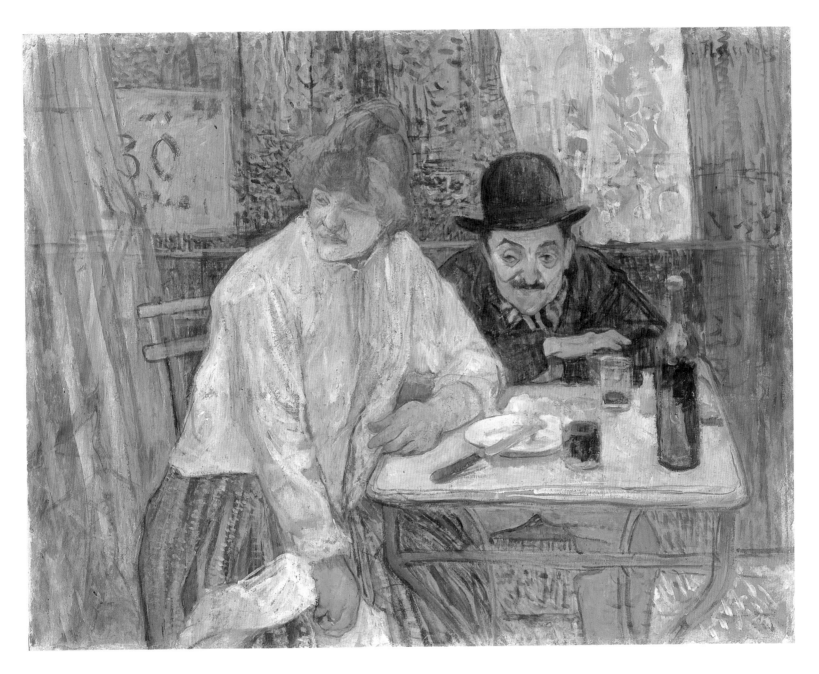

AT THE CAFE LA MIE, 1891 Watercolor on paper, mounted on millboard, mounted on panel, 53 x 67.8 cm

find their artistic personalities. The *petit boulevard*, from that point of view, was a stylistic laboratory for testing pictorial problems and solutions, for probing new ideas of what painting might become. And not just painting. The cabaret culture of Montmartre preceded the notional coinage of the term *petit boulevard*, the Chat Noir having opened in 1881, the Mirliton in 1885. They housed and gave voice to a primarily literary subculture that emphasized "decadence." Taking their cue from the naturalism of Emile Zola and his colleagues, which upheld the right of the artist to deal with material however base or unappealing, "decadents" such as Maurice Rollinat and Emile Goudeau went further, exploring extremes of human behavior — lechery, alcoholism, and insanity — in neologistic or demotic language.[7] By the mid-1880s, as decadence transformed into the new symbolist movement, suggestive rather than descriptive in expression and often arcane in language, the literature of the young generation was equipped with a developing style and with a subject matter emphasizing the strange, corrupt, and alienating in the modern city. For young painters, here was both an example and a climate fruitful for the development of new pictorial styles and iconographies. Thus the *petit boulevard* was not just a matter of economics and physical geography; it embraced a cultural geography as well.

By *petit boulevard* Vincent and Theo meant a quite particular cluster of painters; broadly speaking, those who, like Vincent, had studied at Fernand Cormon's atelier: Anquetin, Toulouse-Lautrec, and Bernard; several neo-impressionists: Seurat, Signac, Angrand, and Camille and Lucien Pissarro; and a couple of older independents: Gauguin and Guillaumin. Like many avant-gardes, these diverse artists had a loosely linked set of objectives — an instinct towards simply drawn forms, a willingness to exaggerate chromatic and textural effects in their paintings, a desire to put their work before the public and, if possible, sell it. But they also had distinct differences, perhaps the chief of which was over neo-impressionism: Vincent, Bernard, and even Anquetin and Toulouse-Lautrec flirted with it in

the later 1880s, only to reject it as slow and dogmatic, rather than luminous and personal, as Seurat and Signac found it.

The fragility of the *petit boulevard* is apparent in the brevity and fortuitousness of the relations Vincent had with other painters. For example, he worked with Signac in the spring of 1887 and Bernard in the autumn, but met Seurat only once, shortly before leaving for Arles in February 1888.[8] The fragmented character of the *petit boulevard*, as competitive as it was collaborative, might be seen as typical of an avant-garde community, but it achieved some kind of coherence in Vincent's mind. He imagined himself as a bridge builder, a moderator. However, his vision of an artistic society was diplomatically and commercially naive. By the mid-1880s, when Monet and Degas were no longer even exhibiting together, they certainly could not have been persuaded to peg their prices at a set level to suit others. The differentials were too great; in 1888 Camille Pissarro's canvases sold well at five hundred francs and Monet's for five times the amount. Nor would they be tied to junior, even antagonistic, artists such as Seurat. As if to underline his ineffectualness, van Gogh's attempt to arbitrate in a personal squabble between Bernard and Signac during the summer of 1887 came to nothing.[9] The *petit boulevard* was thus one of Vincent's fantasies of artistic fraternity, like the "Studio of the South."[10] His friends were aware of his capacity for enthusiastic projection: Gauguin responded to the Arles collective as "your dream house"; and Bernard wrote, in a posthumous tribute, "The dreams, ah!, the dreams! giant exhibitions, philanthropic phalansteries of artists, foundations of colonies in the Midi…"[11]

As fragile and personalized a construct as it was, the *petit boulevard* nevertheless had a degree of coherence as a description of commercial position, stylistic ambition, and status in the hierarchy of the art world. It designated a modest presence in the Parisian cultural panorama, and a frame of mind — combative, experimental, subversive — that was shared by clusters of young, creative talents in the 1880s, whether centered

A GUST OF WIND ON THE BRIDGE OF SAINTES-PERES, 1889 Black ink and watercolor over black chalk on paper, 49 x 39 cm

VIEW FROM THE BRIDGE OF ASNIERES, 1887 Oil on canvas, 38 x 46 cm

on or reacting against Paris. The *petit boulevard* abutted, overlapped, or paralleled the cabaret culture of places like the Chat Noir, with its shadow plays staged by Henri Rivière or Caran d'Ache; the decadent literature of Joris-Karl Huysmans, Jean Lorrain, and Rachilde; the emergent symbolist poetry of Gustave Kahn, Jean Moréas, Jules Laforgue, and René Ghil that appeared in a plethora of new periodicals; André Antoine and the Théâtre Libre; the burgeoning of caricatural illustration in magazines such as *Le Courrier français*; the hilariously subversive exhibitions of the Arts Incohérents; the radical artists gathered in small regional outposts such as Pont-Aven in Brittany or Lagny-sur-Marne. Vincent's *petit boulevard* had its place in a kaleidoscopic pattern of avant-garde activity — fluid, fragmented, and characterized by rivalry and competition as much as community and mutual aid.

That diversity of progressive activity needs to be understood in a wide context, beyond its opposition to the dominant bourgeois culture of the Third Republic. After the disasters of the Franco-Prussian War and the Commune of 1870–71, the success of the Exposition Universelle, or World's Fair, of 1878 made Paris "herself again" as the cultural capital of Europe. In the visual arts, reinvigorated self-confidence manifested itself in upmarket cultural forms, for example, the mural decoration of the Panthéon by leading history painters begun in 1874, and the establishment of the chic Société des Aquarellistes and the fashionable illustrated weekly *La Vie moderne*, both in 1879. That year also saw genuinely republican politicians take the helm of the Republic, with the election of Jules Grévy as president. Changes followed. In 1880 Bastille Day became the national holiday; in 1881 a new press law ended censorship on caricature; in 1884 divorce was liberalized and trade unions legalized. However, the momentum towards reform of a Republic dominated by business and professional interests was not considered to be rapid enough either by leftist politicians speaking for the lower classes or by many young intellectuals. As *La Vogue* put it in its first issue: "Without being a prophet, one can predict great upheavals at

this fin de siècle. The social question imposes itself on us as the political question did on the eighteenth century."[12] The Republic favored congenial artists like the painter Alfred Philippe Roll or the sculptor Jules Dalou and commissioned grand schemes such as the decoration of the Parisian town halls in order to promote its ideology, but the younger generation responded to this kind of cultural programming with a subversive counterculture. The Third Republic had pledged to widen the political base by supporting the *nouvelles couches sociales*, essentially the lower middle classes. Many voiced dissatisfaction over its inability to deliver on this promise, including those in the Parisian avant-gardes. The young man coming to the capital to make his fortune was an old tale, but it had a new spin as replayed in the 1880s in the avant-garde circles of Montmartre — by Anquetin, the butcher's son from Etrépagny; Aristide Bruant, the apprentice jeweler from Courtenay; Paul Adam, the son of a postal inspector from Arras; and Bernard, a textile salesman's boy from Lille. These were the *nouvelles couches sociales* making their presence felt, using painting, song, poetry, and caricature to jostle the self-satisfied republican bourgeoisie. In this broad sense, at least, the *petit boulevard* was political.

Underlying this selective overview of the *petit boulevard* and the Parisian avant-gardes of the later 1880s, we might usefully detect and bear in mind a pattern, which sees 1886 as a year of emergent possibilities; 1887 as one of collaborative and energetic mutual support capitalizing on new developments; 1888–89 as a phase of growing suspicion and rivalry; and 1890–91 as the time when the fragmentary elements of the *petit boulevard* definitively disappeared. Vincent's optimistic notion of the *petit boulevard* was generated at the high point of this interplay.

Exhibitions and Dealers

As an economic term *petit boulevard* defined the lowly rung on the ladder of economic prosperity on which the young artist of progressive tendencies stood. The avant-garde had to make its mark among a plethora

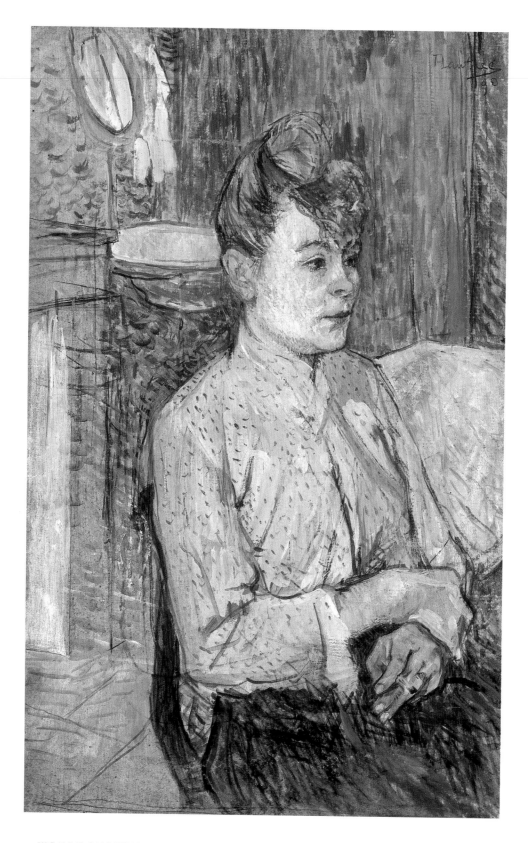

WOMAN SMOKING A CIGARETTE, 1890 Black chalk and gouache on cardboard, 47 x 30 cm

of exhibitions. By the 1880s dozens of art exhibitions were held every year in Paris. The annual Salon, which exhibited some forty-five hundred paintings, sculptures, and other works during the early summer, was the great forum in which artists hoped to win acclaim. Around that central event clustered specialist societies such as the Aquarellistes and the Pastellistes, founded in 1883, and private clubs such as the Cercle Volney and the Cercle de l'Union Artistique, all of which showed the smaller but eminently marketable works of the successful Salon artists. The commercial art dealer was increasingly a force. The most elegant among them, notably Georges Petit, staged events in lavish rooms decorated in red plush and presented one-man shows of major artists, mixed exhibitions of well-known and up-and-coming talents, and they might even display single important pictures by recognized celebrities, such as Michael Munkàcsy's *Mozart Composing His Requiem,* which the Galerie Sedelmeyer showed in early 1886.[13] Even large department stores sold paintings, often pastiches of old masters.[14] This plenitude of work on display disturbed even the reviewers of the conservative art press: A. de Lostalot of *Le Chronique des arts* complained in 1888 of "not the least trace of originality or the least effort towards the undiscovered, the new," and the following year Dargenty of *Le Courrier de l'art* noted "a superabundance of works, the bulk of which gleam with a total absence of conviction."[15] For Jules Claretie, writing in *Le Temps,* declining taste and rising prices were symptomatic of *l'américanisme.*[16] This situation presented a double challenge to progressive painters. On the one hand, it forced them to develop strategies by which they could win themselves a niche in that cluttered but lucrative market and, if possible, expand their reputation within it. On the other, it offered them something to stand against — either by making their work identifiably different — and so perhaps aiding an entry into the wider market — or by producing art that vehemently opposed the norms.

Between 1885 and 1890 most of the leading impressionist painters, who had been the controversial figures of the previous decade, established themselves on the market. They achieved this by a variety of means. Degas's method was to avoid major group exhibitions and to cultivate the mystique of a reclusive master. By allowing work to seep onto the market via various dealers, he seduced buyers. By 1890 some of his recent, rapidly executed pictures sold for about two thousand francs, and highly finished ones for up to eight thousand.[17] By contrast, Monet preferred to play dealers off against one another to raise his stock. Having been given a one-man show by Durand-Ruel in 1883, he joined Petit's Exposition Internationale group in 1885, serving on its jury in 1887. The following year Theo staged an exhibition devoted to Monet's recent paintings of Antibes, and in March 1889 he mounted another show. But Monet accepted a more prestigious offer from Petit, and during the Exposition Universelle he shared an exhibition at Petit's rue de Sèze gallery with the sculptor Auguste Rodin, its catalogue prefaced by the critic Gustave Geffroy.[18] Over this period his prices rose consistently, from an average of two thousand francs in 1887 to four thousand francs by 1891. Such success made him a target for the avant-garde, Félix Fénéon hinting that the 1888 Antibes work had been contrived for New York taste.[19] Pissarro was not so lucky. His conversion to neo-impressionism in 1885–86 had undercut his prices, with canvases typically selling in the late 1880s for less than one thousand francs. In February 1890 Theo van Gogh put on a critically successful Pissarro show, with some sculpture by Gauguin. Its catalogue preface by Geffroy and the inclusion of sculpture suggest that the dealer was emulating, in modest but radical terms, the formula Petit had used for the Monet-Rodin exhibition the previous year.[20]

In this uncertain climate, how were the artists of the *petit boulevard* to make their presence felt on the market? What were their outlets and chances of getting sales and support? Clearly there would be no help from the dealers of the *grand boulevard* like Petit and Durand-Ruel; the former had a broad stable of artists to which he had recently added Monet, Renoir, and other impressionists, and the latter was struggling to

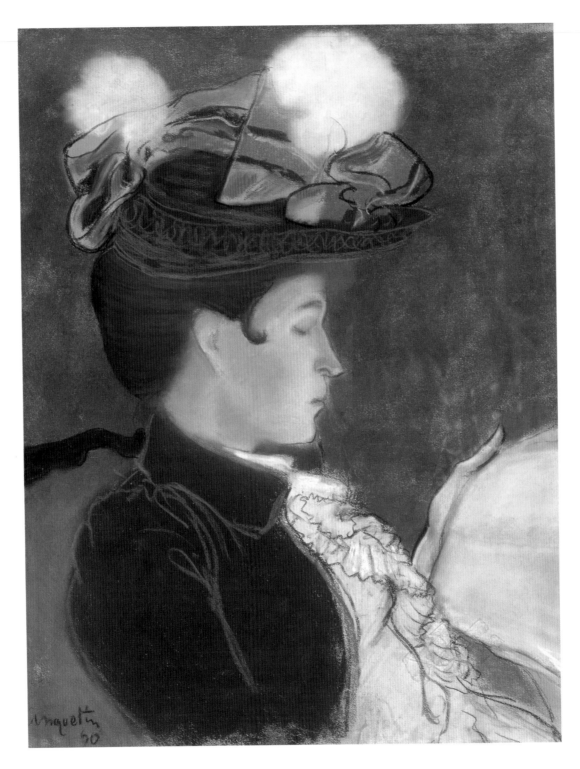

GIRL READING A NEWSPAPER, 1890 Pastel on paper, 54 x 43.2 cm

win those painters back. One outlet was the Boussod and Valadon gallery at 19, boulevard Montmartre, managed by Theo van Gogh. His original employer had been Goupil, a large international company with branches in the main European capitals and New York that did not just sell paintings, drawings, prints, and sculpture, but also published illustrated books and reproductions of celebrated works of art. In the 1880s the company was restructured. The founder, Adolphe Goupil, retired in 1884. Its new directors, Etienne Boussod and René Valadon, took steps to bring it up to date. They channeled their publishing resources into lavishly illustrated magazines, producing *Les Lettres et les arts* from 1886 to 1889 and taking over *Paris illustré* in 1888. The crucial changes in the art-dealing business came in 1887. The contract with the elderly Salon celebrity Adolphe William Bouguereau was not renewed after twenty years; one was signed with Léon Lhermitte, his naturalistic images of rural life replacing Bouguereau's idealized ones. A three-day sale was held in May 1887 at which 546 items were sold, a stock clearance to signal a change of direction and raise capital for new ventures.

In Boussod and Valadon's premier gallery on the rue Chaptal—actually closer to the boulevard de Clichy than to the central thoroughfares—they exhibited top-of-the-range artists such as Edouard Detaille and Gustave Moreau. But it must have been evident to them that their company lagged behind Petit and Durand-Ruel in the market for new art, and from early summer 1887 Theo began to buy impressionist paintings, particularly by Monet and Degas, and ones by Pissarro and Sisley more cautiously, for the gallery at 19, boulevard Montmartre. Theo continued to trade a varied stock of landscapes by Camille Corot and Charles Daubigny, anecdotal pictures, and Antoine Louis Barye bronzes, but he was able to leaven these with impressionist canvases, which he usually showed upstairs in the low-ceilinged entresol.[21] This was a long-term strategy. It was a commonplace in 1880s art writing to point out that the mid-century generation of painters—Corot, Jean-François Millet, Théodore

Rousseau, Daubigny, and others—had struggled and been criticized at the outset of their careers but had eventually been recognized as major figures, with prices to match. This pattern was apparently being repeated by the impressionists. For Boussod and Valadon it made sense to have work by Monet and Degas in stock while prices were relatively low.

Theo took this strategy the next logical step by showing work by artists the next rank down. In December 1887, for instance, Fénéon noted that he had on view a Martinique landscape and *The Bathers* (1886; private collection, W167) by Gauguin and a *Reader* by Guillaumin.[22] Theo had not purchased these paintings; he had merely taken them on commission. Boussod and Valadon would have received a percentage of the sale when *The Bathers* was bought by a young collector, Jean-Baptiste Dupuis, on 28 December. Gauguin, for one, was alert to this gradualist strategy and conscious of his own *petit boulevard* status, writing to Schuffenecker at the time of the show of Monet's Antibes canvases: "I'm not angered if Claude Monets have become expensive; that'll be yet another example for the speculator who compares yesterday's prices with today's. And from that point of view it's not too much to ask 400 francs for a Gauguin in comparison with 3,000 for a Monet."[23]

It would be wrong to consider Theo an avant-garde dealer. As a manager, he was obliged to follow the commercial policy laid down by his directors, which he successfully did. While he supported Pissarro during his commercially difficult neo-impressionist phase, purchased a handful of paintings from Guillaumin, and gave significant help to Gauguin, Theo actually bought for Boussod and Valadon stock only a single Gauguin, a still life, in 1890. These were all artists who had shown at the impressionist exhibitions. For the younger painters of the *petit boulevard*, he did little as a dealer.[24] He sent a canvas by Toulouse-Lautrec in a mixed group of pictures dispatched to The Hague in 1888, but would not follow Vincent's suggestion that he include one by Bernard.[25] Only a single sale by Toulouse-Lautrec is registered in the Boussod and

Valadon stock books. The reasons for this limited support are unclear. Theo may have felt he was doing as much as he could, given commercial constraints. From another perspective, it should be remembered that Seurat, Signac, Anquetin, and Toulouse-Lautrec all had financial support from their families; with no immediate need to solicit support from a dealer — unlike Gauguin or Pissarro — they could choose other outlets for their work.

There was little support from other dealers. The *petit boulevard* artists could only expect to trade with small operators, working privately or out of shops. Pissarro gave a hint of this lower commercial level, at which he could sell lesser work, when in 1886 he told Lucien that as Durand-Ruel was not keen on his paintings, he would have to sell or leave on consignment worked-up drawings to the dealers Adrien Beugniet and Achille Heymann, and even his framer, Clozet.[26] There were other small dealers who, often by virtue of their addresses, as well as their limited financing and modest stock, should count as *petit boulevard*. Among them were Alphonse Portier, who had been the administrator for the fourth impressionist exhibition in 1879 and worked from his apartment in the same building where the van Gogh brothers lived at 54, rue Lepic; Pierre-Firmin Martin, a long-standing supporter of modern painting, especially landscape, whose address at 29, rue Saint-Georges was midway between the *grands boulevards* and the boulevard de Clichy; and George Thomas, a former wine merchant with a gallery at 43, boulevard Malesherbes whose main support for the avant-garde developed after 1890.[27] It was expedient for the *petit boulevard* artists to keep in touch with such dealers. Toulouse-Lautrec, for whom sales were a matter of pride if not necessity, made one of his first sales to Thomas, and Vincent's portrait of Martin's niece (and inheritor) may have been an attempt to strengthen relations with the dealer.[28] Even when out of Paris it was desirable to stay in contact. Thus Gauguin wrote to Theo from Arles in November 1888 to ask what "the ballsy man [probably Félix Fénéon] and the sad Portier" thought of his recent painting.[29]

Vincent's closest relations in this sphere seem to have been with Père Tanguy, who hung work by painters he admired in his art supplies shop at 14, rue Clauzel, three blocks south of the outer boulevards. Vincent was visiting this rendezvous for avant-garde painters at least by October 1886. In late July of the following year, Tanguy placed one of Vincent's canvases in his shop window — an expression of support — and was on friendly enough terms with these artists to sit for portraits by Vincent and Bernard in the latter's studio in suburban Asnières (pp. 122 and 123).[30] Vincent's culminating portrait is not easy to interpret. It does not overtly show a commitment to *petit boulevard* painting, for the pictures behind the sitter are Japanese prints rather than canvases by the avant-garde artists that Tanguy had on display. By placing Tanguy in a Japonist context, Vincent seems to have been casting the color merchant in his own terms, rather than Tanguy's. Yet by showing Tanguy in a candid frontal pose, his face honest and uncomplicated, hands clasped with gauche but inhabitual correctness and spectacles stuffed into his top pocket, Vincent presented the frank portrait of an artisan rather than an explicit celebration of an avant-garde dealer. This would probably have pleased Tanguy, who had been deported after the 1871 Commune.

The primary arena for radical painting in the later 1880s was the Salon des Indépendants. First staged in the spring of 1884, in the wake of the official Salon jury's harsh rejection of many artists, the Société des Artistes Indépendants had been given an exhibition venue by the municipality of Paris, keen to show its republican credentials. Democratic and juryless, the Indépendants gave space to painters of all kinds: the amateur, the rejected, and the radical. If the last were in the minority, they moved swiftly to secure their advantage. Internal squabbles to oust a corrupt committee meant that the reconstituted Indépendants did not hold a second Salon until August 1886.[31] Signac engineered his way on to the hanging committee, explaining to Lucien Pissarro that the other four members were "very hostile" to their

A SUNDAY AFTERNOON ON THE ISLAND OF LA GRANDE JATTE—1884, 1884–86 Oil on canvas, 207.6 x 308 cm

neo-impressionist work.[32] As a result the "neos" were grouped together — just as they had been at the eighth impressionist exhibition that spring — in the last room, a concentration that gave aesthetic coherence to the pictures and political weight to their group, both helping to attract critics' attention.[33] By showing his major painting *A Sunday Afternoon on the Island of La Grande Jatte—1884* for the second time that year, Seurat was able to stress the importance of his picture as setting a new style and the prominence of the Indépendants as the arena in which to see challenging art. Thus entrenched, the growing neo-impressionist group could protect its own: Fénéon's account of the opening of the third show in March 1887 listed "the

young clan" of Seurat, Signac, Lucien Pissarro, and Albert Dubois-Pillet.[34]

There were still problems for the avant-garde at the Indépendants—Lucien Pissarro reported dissatisfaction with the hanging of the 1889 show[35]—but also a measurably developing public profile. The 1890 Indépendants was, in Angrand's view, the most successful to date. President Carnot opened the exhibition, taking an hour and a half to view the work and hearing an explanation of neo-impressionism from Seurat and Signac. Politically expedient as the President of the Republic's presence may have been — Carnot's predecessor Grévy had visited the 1884 show — it marked the Indépendants as a substantial

VOYER — D'ARGENSON PARK AT ASNIERES, 1887 Oil on canvas, 75 x 112.5 cm

presence on Paris's cultural calendar. Angrand delight-edly reported 1,700 visitors in a single day and press coverage from the *Mercure de France* to the *New York Herald*.[36] Theo echoed this success in a letter to Vincent, telling him that his paintings were well hung and attracting admiration.[37] Gauguin, who disdained the Salon des Indépendants as the fiefdom of his neo-impressionist rivals, nevertheless felt it necessary to keep an eye on it, and he let Vincent know how much he admired his work that year.[38]

Gauguin may have opted for self-exile from its salon, but the Société des Artistes Indépendants was not merely a mass of amateurs with a highly visible neo-impressionist faction appended. Its dinner in February

1890, for instance, was attended not only by Seurat, Signac, and Maximilien Luce but also by the Mont-martre decorator and caricaturist Adolphe Willette and two of Seurat's old student colleagues, Alexandre Séon and Alphonse Osbert, whose work combined Pierre Puvis de Chavannes's simplification with modern chromatics.[39] If radical painting at the second and third Indépendants exhibitions in August 1886 and March 1887 had been predominantly neo-impressionist, greater diversity was soon introduced, with Anquetin and Vincent showing from 1888 and Toulouse-Lautrec from 1889. Whether by exhibiting shocking realism or experimental styles, the Salon des Indépendants swiftly became a feature in the Parisian art world. For those

same reasons it attracted both middle-class curiosity and disdain and, in a spirit of inevitable contrariness, the admiration of the younger generation. "A certain provocative swagger, a perfect disdain for convention," the self-consciously antibourgeois *Le Décadent* explained, would always win its sympathy.[40]

The Indépendants was not the only venue for cultivating such a position. The Arts Incohérents exhibitions, which, benefiting from the liberalized censorship laws, had begun in 1882, displayed humorous paintings and caricatures with the explicit intention of using puns, satire, and bawdy to ridicule and provoke the establishment.[41] Angrand, for one, exhibited at the Incohérents in 1888 with a landscape, *La belle Nature*, undoubtedly ironic.[42] Although a loyal member of the neo-impressionist group, Angrand chose to show his work in varied and contrasting exhibitions, unlike Seurat and Signac, who showed their main groups of work at the Indépendants and with the Brussels-based Les XX. Angrand amused himself with the Arts Incohérents, remained true to his Norman roots by sending work to exhibitions in Rouen, and at the end of 1887 had nine neo-impressionist canvases with the 33, a very diverse group that included Emile Friant, Fernand Khnopff, Jacques-Emile Blanche, and Odilon Redon, which the Galerie Georges Petit displayed in a gambit to win a niche in the market for "new" artists.[43] Different painters in the *petit boulevard* thus had different exhibition strategies. The Indépendants may have been the epicenter, but it was not the only option.

The *petit boulevard* painters were helped by colleagues in other cultural forms to find exhibition spaces. Perhaps the most important of these was the *Revue indépendante*. A literary monthly founded in 1884, it had interrupted publication the following year, then was revitalized by the capital of Edouard Dujardin in November 1886. Based in offices at 72, rue Blanche, running south from the boulevard de Clichy, its first editor was Fénéon, with Jean Ajalbert as editorial secretary. Kahn took over the editorship in October 1887, the month before the *Revue* moved to 11, rue de la

Chausée d'Antin.[44] This move closer to the *grands boulevards* was to premises that could hold not just the editorial offices but also a bookshop and a gallery. The conjunction of a magazine and a gallery was not new (*La Vie moderne* had opened a gallery in 1880), but it gave practical expression to the real interest in the visual arts among the editorial team, for Dujardin was a close friend of Anquetin, and Fénéon of Signac. Immediately they began to show work they admired, which Fénéon praised in reviews he wrote for the *Revue*. The selection was modern and eclectic. On view in December 1887 were pastels and a watercolor by Paul Helleu; a fan and two landscapes by Anquetin; sculpture by Rodin and Henry Cros; an interior by Berthe Morisot; an 1885 marine by Seurat; etchings by Jean-François Raffaëlli, Camille Pissarro, Dario de Regoyos, and the late Edouard Manet; and an unfinished painting by the latter. In early 1888, the *Revue indépendante* exhibited drawings of the café-concert by Seurat, paintings by Signac and Angrand, and watercolors by Albert Besnard.[45]

The modest, accessible scale of these exhibits suggests that they were a genuine commercial venture. Indeed, the exhibitions became even more focused as 1888 progressed, with a succession of small one-man shows. Beginning in March with an exhibition of sketches and unfinished canvases by Manet, the *Revue* put on shows for Guillaumin in May, Luce in June, and Dubois-Pillet in September.[46] But sales of the more radical artists seem to have been scant. Guillaumin wrote to Theo, thanking him for going to see his show but fearing that there would not be "many results"; in another letter he asked the dealer to collect the pictures and try to make sales, presumably on commission.[47] In late 1888 the *Revue indépendante* offered an exhibition to Gauguin. He refused. Gauguin informed Theo that he disliked the gallery ("that hole"), that to show after Signac and Dubois-Pillet would make him look like a newcomer, and that their clientele was different than his. He told the *Revue* another story: that they had refused to show his friend Schuffenecker, and that the pace of change in the avant-garde required him to

work alone for the time being.[48] In this he was being both practical and jealous. Recent sales via Theo to Dupuis and Léon-Marie Clapisson — *grand boulevard* collectors who purchased work by Degas and Monet — gave Gauguin some confidence about commercial progress, which showing at the *Revue indépendante* could not match.[49] On the other hand, the lack of strong identity in his current work made him fear being seen at a disadvantage to the neo-impressionists. Theo seems to have suggested to Vincent in September 1888 that he show at the *Revue*,[50] but with Gauguin in Arles some weeks later Vincent changed his mind. Offended by Dujardin's requirement of a canvas in payment for a showing, Vincent — who likewise complained about the light at the rue Chausée d'Antin — also felt that his work was not ready for a substantial exhibition; however, he was willing for a canvas or two to be displayed by Tanguy or Thomas, an altogether more modest manifestation.[51]

The Théâtre Libre also offered its premises as an exhibition space for the painters of the *petit boulevard*. Devoted to naturalist and experimental plays under the direction of André Antoine, the theater presented a one-act play by Oscar Méténier and a verse-play by Emile Bergerat on its first night on 31 May 1887.[52] Situated in the passage de l'Elysée des Beaux-Arts, a little backstreet just off the boulevard de Clichy, the Théâtre Libre was in fact next door to Seurat's studio. Avant-garde good-neighborliness probably explains Antoine's preparedness to use his foyer for ad hoc displays of pictures. At some point during his last months in Paris, Vincent hung there his *Voyer — d'Argenson Park at Asnières* (p. 78), a somewhat "pointillist" canvas with which he may have intended to attract Seurat's attention.[53] Seurat and Signac also displayed work there, and Signac's drawing of Paul Alexis at a rehearsal of his play *La Fin de Lucie Pellegrin* was published in *La Vie moderne* in June 1888 (right).[54] As we shall see, it was quite common in the wider Montmartre artistic community to stage events and show work in places of public entertainment. Antoine later recollected that in 1888 Willette launched his illustrated paper *Le Pierrot*

"in some kind of hall on the rue de la Rochechouart, a skating rink or swimming pool," and three years later *Le Courrier français* staged an exhibition of its caricaturists' drawings at the Elysée-Montmartre dance hall.[55]

While he was in Paris, Vincent also used for exhibitions informal venues without immediate art world associations. On at least two occasions he exhibited works of art in cafés. This seems to have been something of an ideal for him. The notion of showing work in a public place like a café, rather than a more elitist locale such as the *Revue indépendante's* premises, may have been connected to the utopianism that colored part of his imagination, for showing in a café was an egalitarian gesture of "art for all." This dream stayed with Vincent, who wrote to Theo in June 1890 that he hoped to have another exhibition in a café, which he would like to share with Jules Chéret, the leading poster designer, whose work was much praised for being an effective combination of the artistic and the democratic.[56] We know very little about Vincent's activities in this sphere, but in a letter to Theo from Arles in late summer 1888 he explained how he had

Paul Signac, *M. Paul Alexis, aux répétitions de "Lucie Pellegrin,"* published in *La Vie moderne,* 17 June 1888

always wanted a café showroom and recalled two exhibitions he had organized. The first was a display of the brothers' Japanese prints in the Café du Tambourin at 62, boulevard de Clichy, and the second at the end of the year at the Grand Bouillon, Restaurant du Chalet, on the avenue de Clichy, no. 43.[57] It seems likely that in early 1887 Vincent was having an affair with Agostina Segatori, proprietress of the Tambourin and a former model for Corot and others. He painted her portrait seated at one of the café's tambourine-like tables; on the wall behind her a closely hung group of Japanese prints is just visible (p. 84).[58] Vincent's relations with La Segatori had soured by summer and the exhibition was not repeated, but in his letter the following year he expressed pride that the prints had influenced Bernard and Anquetin and satisfaction at his contribution to avant-garde progress.[59] He was retrospectively pleased with the second exhibition, too, at which Bernard sold his first picture. According to Bernard's later recollections, well over fifty paintings were exhibited at the Restaurant du Chalet by himself, Vincent, Anquetin, Toulouse-Lautrec, a friend of Vincent's, Arnold H. Koning, and perhaps Guillaumin.[60] It seems extraordinary that such a manifestation should have gone so unnoticed, both by the artists involved and by contemporary critics. We know nothing specific about what was shown, or what the exhibition looked like, though a painting by Vincent, made in the second half of 1887, shows a restaurant interior, not necessarily the Restaurant du Chalet, that gives some idea of how such a display might have appeared (p. 105). That these exhibitions have left so little trace demonstrates how marginal they were even in the world of the *petit boulevard*, itself a cluster of artists on the fringes of the established art world.

The most successful — and most divisive — of the *petit boulevard's* café exhibitions came in 1889. That year saw Paris host its fourth Exposition Universelle, this time honoring the centenary of the French Revolution. The centerpiece was the Eiffel Tower, at three hundred meters the tallest structure in the world and a celebration of France's modernity. Over thirty million visitors flocked to the city during the summer to visit the Exposition's vast Salle des Machines, the electrically lit fountains, the foreign pavilions, the Javanese dancers and other colonial attractions, and the extensive art exhibitions. One of these was a survey of French art of the last hundred years. Its catalogue included fourteen Manets, a single Cézanne, and, of the impressionists of the *grand boulevard,* only three Monets and two Camille Pissarros. Nothing by Renoir or Sisley was shown; Degas withdrew his paintings.[61] The *grand boulevard* journalist Octave Mirbeau, a columnist for *Le Figaro* and a friend of Monet and Pissarro, and Albert Aurier, a *petit boulevard* critic writing in *La Pléïade* and an admirer of Gauguin and van Gogh, could agree not only that such representation was inadequate but also that the exclusion of newer art, such as that of Seurat and Gauguin, was a failure on the selectors' part.[62]

Gauguin, Bernard, Anquetin, and some others arranged to hang about a hundred paintings in the Café Volpini, one of the accredited facilities within the Exposition Universelle site. Adjacent to a brasserie enlivened by female musicians costumed as Hungarian hussars, the Volpini, with its avant-garde paintings, "absolutely detonated" in the touristic propriety of the Exposition.[63] By this guerrilla tactic, Gauguin, now reckoning his work ready for a substantial Paris showing, had infiltrated the very Exposition Universelle with *petit boulevard* art and stolen a march on his neo-impressionist rivals. Theo was unimpressed and, having originally suggested that Vincent's work might be included, withdrew the offer. He told his brother he disliked the triumphalist attitude of participants such as Schuffenecker who had, after all, got in "by the back stairs." Theo was also uncomfortable about the exclusion of Toulouse-Lautrec on the grounds that earlier that year he had exhibited with the Cercle Volney, an elitist act that, in Gauguin's eyes, jeopardized his avant-garde credibility.[64] Gauguin wrote to Theo, arguing that the end justified the means and, most important, that he had shown Pissarro and the others that he could act for himself. This was necessary because their

"rhetoric about artistic *fraternity* does not correspond with their acts."[65] For his part, Vincent considered it right that Gauguin and his group should have made a showing.[66] Fénéon reviewed the exhibition, explaining the difficulty of seeing the work among the café clutter of tables, bars, and beer pumps, and—if he was so brief as to be dismissive about the other exhibitors—he wrote warmly of Gauguin's work, evenhandedly explaining that he worked towards "an analogous end" to the neo-impressionists, but "by other methods."[67]

Despite Fénéon's fairness and Vincent's approbation from distant Arles, the Volpini show further weakened any lingering notion of a *petit boulevard* community. The neo-impressionists were a unified group with a leading figure in Seurat, a demonstrably collective style, and a registered annual presence at the Salon des Indépendants. Gauguin, Bernard, and their colleagues now considered their individual work and group identity strong enough for a showing, but for personal as well as stylistic reasons they were not prepared to appear at the Indépendants, so they would have to make other arrangements. With Theo van Gogh working within and trying to extend the gradualist commercial policy of Boussod and Valadon, he was in no position to give a one-man show to a little-known radical artist, let alone a group. Nor would any other dealer. The Gauguin group was thrown back on the ad hoc, rather conventionally bohemian, gambit of a show in a café. That was always going to be a makeshift solution: the space inappropriate, the audience unspecific, the arrangement temporary. Much of the momentum behind the concept of the *petit boulevard* was its determination to be more than marginal; to do that, to attract substantial critical and public attention, such artists needed to show at the Indépendants, a recognized institution by the end of the decade. This divide, interestingly enough, parallels the contemporary debate on the left of French politics, between those like Jules Guesde and Jean Allemane who wanted to achieve socialism by parliamentary means and those like the anarchists who advocated revolutionary methods. Ironically, most neo-impressionists supported anarchism.

Artists and Writers

A web of connections linked the *petit boulevard* artists to young novelists, poets, journalists, and critics. The new laws enacted by the Third Republic in the 1880s created a climate of *laisser-aller* that encouraged publishers, but the result was a slackening of quality and a glutting of the market; at high tide in 1889, 14,849 titles were published.[68] Young intellectuals who saw themselves as a cut above mere producers of copy developed their own languages. The Hydropaths, a group of humorists and satirists, started out on the Left Bank in the late 1870s, but in the early 1880s moved to Montmartre, where they formed the basis of the community around the Chat Noir cabaret, poking fun at the dominant bourgeois culture with beer and bawdy. The decadents took their lead from Joris-Karl Huysmans's 1884 novel *A Rebours* (*Against Nature*) and Paul Verlaine's poetry; they chose to extend the already inclusive range of subjects exposed by the naturalist writing of novelists such as Emile Zola into even more louche and clandestine crannies of the human condition. The second half of the decade saw the emergence of symbolism, essentially a poetic movement, which reacted against both naturalism and the frivolity or perversity of recent literature by cultivating *vers libre* and arcane, neologistic language. Young literature in the Paris of the 1880s formed shifting and complex sets of communities, sometimes fraternal, sometimes rival. Radical literature and radical painting burgeoned in parallel, nurtured by the same soil of experiment and anti-establishment audacity, on a trellis of mutual support.

Something of the flavor of this can be conveyed by instances in which the artistic *petit boulevard* intersected with what might equally be called the literary *petit boulevard*. A Monday salon was held by the novelist and former Communard Robert Caze—until his death in a duel in 1886—at which Camille Pissarro, Guillaumin, Seurat, or Signac might mix with Fénéon, the novelist Paul Adam, or Jean Moréas, the author of the symbolist manifesto.[69] Signac himself held soirées in his studio at 20, avenue de Clichy, at which poets

like Henri de Régnier met neo-impressionist colleagues.[70] Events such as the dinners of the Société des Artistes Indépendants gave painters like Seurat, Signac, and Angrand the opportunity to rub shoulders with journalists, literate men such as Gustave Geffroy and Arsène Alexandre, from politically progressive papers such as *La Justice, Le Radical,* and *L'Evénement.*[71] The Café d'Orient on the rue de Clichy was a rendezvous, the poet and policeman Ernest Reynaud recalled, for the writers who ran the *Revue indépendante* and the *Revue wagnérienne*—Téodor de Wyzewa, Dujardin, Kahn—and the neo-impressionists.[72] It is significant that in both contemporary accounts and later recollections Vincent's name is almost totally absent and Gauguin's rare. There are personal, more than artistic, reasons for this. The neo-impressionists were effective at promoting their own interests by networking, in this led by the sociable and well-read Signac. Gauguin, who had fallen out with Signac in 1886, was arrogant and touchy enough not to try to ingratiate himself with his rival's friends. By contrast, Vincent did want to be involved in the *petit boulevard*. However, his literary taste was for the novel and the work of the French naturalists, especially Zola, Gustave Flaubert, Guy de Maupassant, the Goncourts, Jean Richepin, Alphonse Daudet, and Huysmans; he was envious of Theo's meeting Maupassant when the writer visited Boussod and Valadon the following year.[73] His correspondence does not even mention the next generation of naturalist writers who emerged in the mid-1880s—Octave Mirbeau, Paul Adam, or Jean Ajalbert—let alone the more radical symbolist poets. Content with a literary taste that was no longer at the cutting edge, Vincent, a foreigner to boot, was unable or unwilling to make the most of the wider systems of mutual support that the extended *petit boulevard* could provide.

Writers owned works by painters. These were probably more often gifts rather than purchases, as the writers were not necessarily better off than their artist friends. In 1886 Paul Alexis, a naturalist of the older generation, described his collection, which included three oil sketches by Seurat and a canvas by Signac,

in the slang column he wrote under the pseudonym Trublot in the leftist *Le Cri du peuple.*[74] If such a gesture was the public espousal of what might be taken as a shared principle—radical art and radical politics should go hand in hand—other instances suggest that writers' collections were sometimes enhanced by gifts that were tokens of gratitude. Did Arsène Alexandre receive Seurat's *Pont de Courbevoie* (1886–87; London, Courtauld Gallery, H178) because he was an up-and-coming critic writing for *grand boulevard* papers such as *L'Evénement* and *Paris,* or did Paul Adam acquire Signac's 1888 canvas *Le Pont d'Asnières* (1888; private collection) in gratitude for his enthusiastic review of that year's Indépendants in *La Vie moderne*?[75] While we may suppose that such gifts were essentially fraternal, if not without self-interest, there were certainly incidents when a writer was especially venal, seeking to trade a flattering article for a canvas whose value might rise over the years. When the unscrupulous Félicien Champsaur—who was regarded with distaste in the wider *petit boulevard* community—tried this with Gauguin in 1889, he was snappily disabused of the idea.[76]

Specific collaborations between artists and writers took place in the field of illustration. In 1887 Signac provided a conté crayon drawing for publication with Ajalbert's long poem *Sur le Talus* (p. 86), and the following year a drypoint by Anquetin was used as a frontispiece for Dujardin's deluxe edition of his poem *La Vierge au rocher ardent.*[77] Not only did Seurat design the cover for Victor Joze's 1890 novel *L'Homme à femmes,* but he featured in it as the character Georges Legrand.[78] Having one's work published as an illustration was a way of getting the work seen as well as cementing an alliance. Toulouse-Lautrec had his drawings published in Montmartre periodicals such as *Le Courrier français* and *Le Mirliton,* as well as in the *grand boulevard* magazine *Paris illustré,* before he showed paintings publicly, while the appearance of a figure from Seurat's 1888 *Models* (private collection, H184) in *La Vie moderne* both publicized the painting he had on view at the Indépendants and supported the

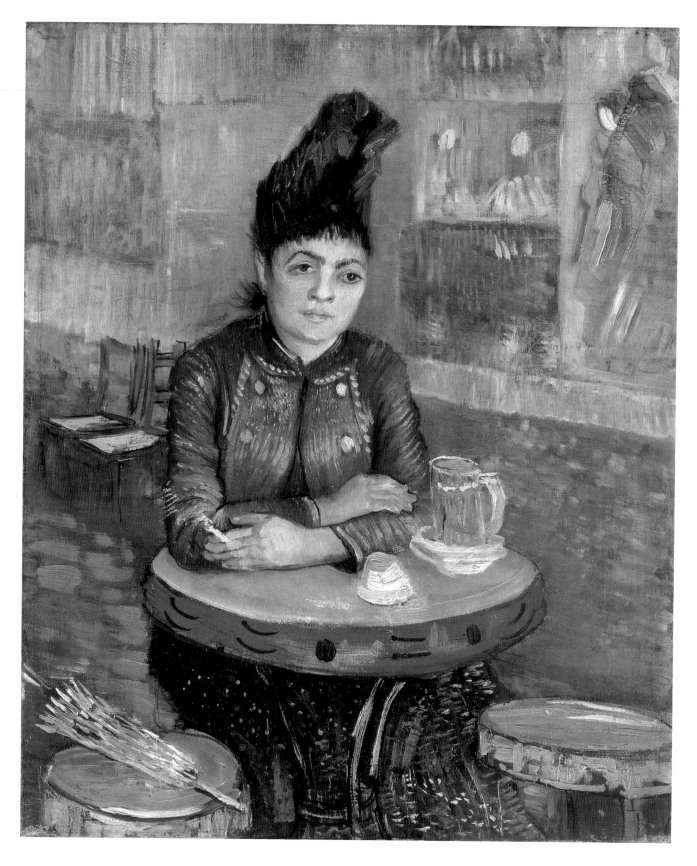

WOMAN AT A TABLE IN THE CAFE DU TAMBOURIN, 1887 Oil on canvas, 55.5 x 46.5 cm

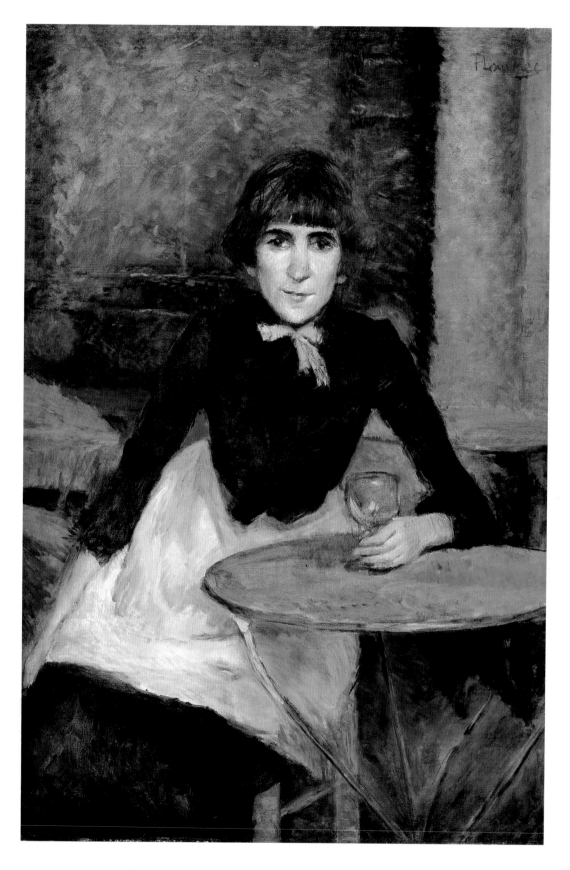

PORTRAIT OF JEANNE WENZ, 1888 Oil on canvas, 72 x 49 cm

periodical, for which his friends Adam and Kahn were then writing.[79] If none of these artists were forced to undertake such applied artwork for financial reasons, they differed from Lucien Pissarro, who throughout this period produced illustrations for periodicals such as *Le Chat noir* and *La Vie moderne* out of need. For all the importance of illustration — Fénéon devoted an extensive section of his November 1888 survey of the art scene to it[80] — it was not a genre that enticed Vincent. This is curious, given its prevalence among the *petit boulevard* artists and his long-standing admiration for the medium. He remained interested, regretting from Arles that he had missed the Willette exhibition and thanking Theo for sending him Toulouse-Lautrec's *Paris illustré* work.[81] Nevertheless, the drawings he made in Paris served his painting as *académies* (figure studies), explorations of motifs, or preliminary studies for planned canvases.

Aware of the complexity of their literary ambitions, keen to distinguish themselves from the previous generation of writers, and anxious to define their own territory in relation to or in competition with their peers, the young symbolist writers were swift and prolific in publishing their aims. Moréas's initial manifesto,

Paul Signac, *The Bench*, illustration for Jean Ajalbert, *Sur le Talus*, 1887

which appeared in *Le Figaro littéraire* on 18 September 1886, was rapidly followed on the twenty-eighth by Kahn's "Réponse des symbolistes" in *L'Evénement*, both urging suggestive rather than descriptive poetry, while the same year René Ghil published his *Traité du verbe*, arguing for the equation of colors and the sound of words. This jostling for literary position continued over the next few years; Georges Vanor's book *L'Art symboliste* of 1889 was an attempt to provide an inclusive view of the debates. From the outset, in 1886, the symbolist movement drew parallels with the visual arts. Kahn argued that the aim of symbolism was "to objectify the subject (the exteriorization of the Idea) instead of subjectifying the objective (nature seen through a temperament)," and he saw an analogous effort in the new neo-impressionist painting.[82] In Fénéon's review of the second Indépendants exhibition, also published in September 1886, he specifically identified the same sensibility in both the landscape paintings of Dubois-Pillet and in two sentences he quoted from Adam's newly published novel, *Soi*.[83] These parallels continued to be drawn — in Dujardin's baptizing of Anquetin's new cloisonnist style; in Fénéon's review of Huysmans's collection of art criticism, *Certains*; in the assessment of Fénéon's own criticism in Vanor's *L'Art symboliste* — until it became a commonplace.[84] There were moments when painters felt that writers had been misguided or had overstated the case; Camille Pissarro, for example, objected to Albert Aurier's account of Gauguin's work, and Vincent disagreed with some of Aurier's views on his own paintings.[85]

The solidarity young writers and painters shared was founded in part on their mutual desire to differentiate themselves from the work of the previous generation, but the writers' community was no more harmonious, no less liable to fragment, than the painters'. Painters on the margins of acceptance were glad of critical support and seem to have generally welcomed the analogies the writers drew between their different means of expression; indeed, the articulation of those analogies probably first took place in dialogues at cafés or soirées. Once again, the broad picture shows

that exchange and mutual support coalesced around neo-impressionism. Although Fénéon had been fair, Gauguin had to wait until Aurier's article of March 1891 for an extended defense of his work.[86] For his part, Vincent was once again an outsider. Aurier, trying to make his name as an avant-garde critic by finding artists to support who were not neo-impressionists, also wrote at length about him. While claiming van Gogh as a symbolist painter, Aurier did not do so in terms of analogies with writing; by 1890 the time

for that tactic had passed, another symptom of the friability of the *petit boulevard*.[87]

There were links between the *petit boulevard* painters and their writer colleagues in the themes they chose for their pictures, poems, or prose. This was not a simple matter of subject: a preference for incidents from Parisian life, a commitment to modernity. That was as good as given, and the modernity with which either a painter or a poet was concerned elided the subject with the means of expression. The rich,

THE REFRAIN OF THE SONG OF THE LOUIS XIII CHAIR AT LE MIRLITON, 1886

Oil and conté crayon on paper, mounted on canvas, 78.5 x 52 cm

sonorous language, rhythms both clipped and lyrical, free verse, and forays into casual parlance found in symbolist writing had their analogies in the painters' ordered textures and chromatics, supple "synthetic" contours, and neglect of detail in favor of sparse, strongly ordered compositions. But these techniques, these means of conveying emotion and a response to the inner patterns of life, required subjects that evoked a response from artist or writer.

One of these was the Parisian suburbs, especially those to the northwest of Paris where the curve of the Seine is flanked by Clichy and Asnières. The forces that drew young artists and writers there were manifold. Convenience and experience played a part. For painters with studios around Montmartre and the boulevard de Clichy, it was a reasonable walk, and in some cases there were stronger connections: Jean Ajalbert had been brought up in Levallois-Perret, while both Signac's and Bernard's families lived in Asnières.[88] The previous generation — writers such as Richepin, Huysmans, and François Coppée, and in particular the painter Raffaëlli — had traded on the suburban theme, and they provided an example to surpass, or to oppose: Signac even refused to be introduced to Raffaëlli.[89] The suburbs were in a constant state of flux, with growing and shifting populations; the class structure was volatile, with communities of ragpickers and beggars, proletarians and artisans, and bourgeois both thrifty and prosperous living in not-too-distant proximity; and the physical environment, neither quite city nor country, offered evocative contrasts of cultivation and squalor, verdant open spaces and engineered order, set in stone and iron. All this provided a sharp sense of modernity — peripheral, uncertain, rooted in the compromised realities of social change — which affected writer and painter alike. Ajalbert's long poem *Sur le Talus*, first published in 1887, sets its love story in the melancholy suburbs, where he records images of nature constrained by man's constructions: the trees "in corsets of iron," the railway line "plunging like a jetty," the landscape transformed into a busy port.[90]

Such restraint and structure found pictorial form in the hard surfaces and angled perspectives of Bernard's and Signac's paintings of such subjects made that same year (e.g., pp. 89 and 28).

Erected during the 1840s, the fortifications surrounding Paris provided a rich source of inspiration for writer and artist. In places penetrated by the railway lines entering and leaving the city, ringed by an area of waste ground called the *zone*, the wall of the *fortifs* was surmounted by grassy slopes that gave a vantage over the suburban panorama, a view enjoyed by off-duty workers and artists alike. In one of a pair of paintings made from the top of the *fortifs* in 1886, Angrand showed a worker watching the busy switchyards. The following summer Vincent made a number of highly resolved watercolors of the *fortifs*, one of which represents the grassy angle of one of the fortified bastions beneath his feet as his view stretches out towards the industrial suburbs, an expanse of tenements and factories recalling the metaphor of the sea so often used by Ajalbert in his poems on the same theme.[91] Neither artist strove for such literary metaphors, nor did they depict the suburbs as a playground for a contented proletariat or as a dangerous scene of backstreet crime, notions commonly associated with the suburbs and seen in contemporary illustrations by Lucien Pissarro or Adolphe Willette, for example.[92] But the artists' very attraction to such sites, their response to the angular, exploited environment, and their glimpses of its disadvantaged populations suggest a powerful shared response — coalescing in 1887 in the work of Signac, van Gogh, and Bernard — to a modernity in which both nature and humanity are compromised by transformations wrought by powerful social forces.

Metropolitan life also provided shared subjects. For the *petit boulevard* generation these could be given added piquancy by association with the idea of decadence that so gripped fin-de-siècle society. France was troubled by the memory of its defeat by Germany in the Franco-Prussian War of 1870–71, questioning whether its national virility would ever allow it to gain parity with, let alone revenge against, its power-

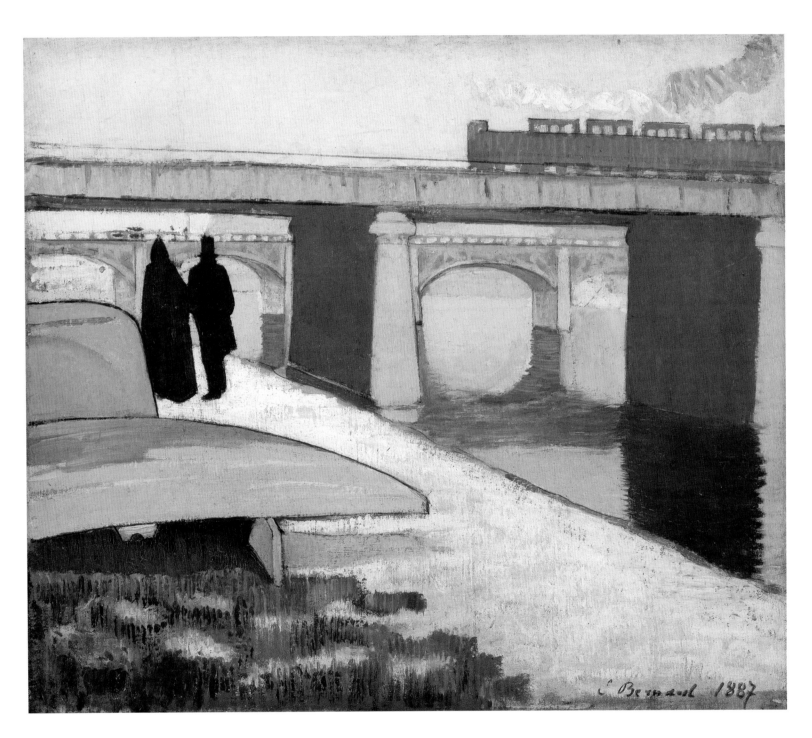

IRON BRIDGE AT ASNIERES, 1887 Oil on canvas, 45.9 x 54.2 cm

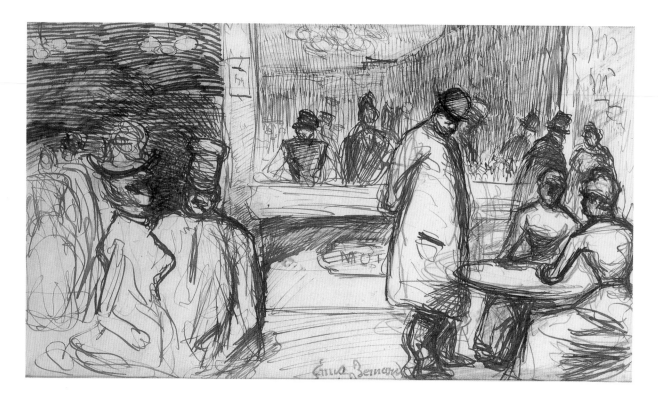

CAFE SCENE (STUDY RELATED TO THE HOUR OF THE FLESH), 1885–86 Ink on paper, 17 x 33 cm

ful neighbor. The nation's symptoms were found in a declining birthrate, the prevalence of social diseases from alcoholism to syphilis, and the criminality of a restless proletariat.[93] Young artists and writers—albeit often middle-class and even comfortable—were inclined to take a critical view of the "decadent" social fabric of the France they were inheriting from their parents' generation: a republic of easily fractured administrations, corrupt and slow to reform. To articulate this they sometimes sought images that exposed these symptoms of decay. The underworld of prostitution that so troubled the authorities at this period was an obvious focus of young artists' attention.[94] Emile Bernard played out the struggle between his strict Catholic upbringing and his youthful desires in a series of drawings on the subject. Some are small, cartoonlike images capturing the seedy ambiance of the *brasseries de femmes*, cafés doubling as brothels, images that exemplify the *petit boulevard* culture's fluency in the language of caricature. A large work,

The Hour of the Flesh (p. 93), and a related drawing (above), on the other hand, seem to have been studies for a major painting: shadowy faces, dim lighting, and furtive glances describe venal exchanges in a sordid locale. In a poem he sent to Vincent in Arles, Bernard articulated the ambivalence typical of his generation: "I like to recreate myself in the horrible."[95] In image and verse he both resented and reveled in the corruption of the modern city, the archetypal decadent dilemma. The louche couple in Toulouse-Lautrec's *At the Café la Mie*, 1891 (p. 67) and Anquetin's sexually equivocal *Woman with a Veil*, 1891 (p. 94) chart territory shared with countless decadent poets scribbling verses for periodicals such as *Le Courrier français* and *La Plume*. The scent of clandestine vice and malleable morality within a corrupt metropolitan society lingers in the atmosphere of much *petit boulevard* imagery.

The circus was an important theme in *petit boulevard* circles. The poet Jules Laforgue, who had been at the Ecole des Beaux-Arts with Seurat and whose

LE BOUGRE (THE JOHN), C.1885–86 Pen and ink and watercolor on paper, 20.3 x 10.9 cm

funeral the painter attended in the summer of 1887, adored the circus and told a friend he wished he had been a clown.[96] Like the brothel, the circus was a common theme in contemporary poetry and prose, while writers such as Fénéon, Dujardin, and Georges Lecomte reported on the performances regularly in the *petit boulevard* periodicals.[97] Another Ecole acquaintance of Seurat's was Theo Wagner, an extra-

ordinary individual who worked both as an acrobat and a painter and whose mysterious persona Signac outlined in a letter to *La Cravache* in 1888.[98] With the excellent Cirque Fernando at the junction of the boulevard de Rochechouart and the rue des Martyrs, the spectacle was at hand. The circus blossomed in the iconography of the *petit boulevard* in 1887, in a large pastel by Anquetin (p. 101) and in Toulouse-Lautrec's

first major canvas, which he had ready to exhibit at Les XX in February 1888 (p. 102).[99] Seurat had in train *La Parade* (1887–88; New York, The Metropolitan Museum of Art, H187), an eerie nocturnal image of the crowd outside the Cirque Corvi, a traveling circus, which he showed at the 1888 Indépendants in March.[100] While the subject then slid out of the others' repertoire (only Toulouse-Lautrec reprised it later in the 1890s), Seurat tackled it soon after in *Cirque* (1890–91; Paris, Musée d'Orsay, H213), a large, poster-like canvas presented at the 1891 Indépendants, again representing the Cirque Fernando.[101]

The attractions of the circus were multiple. It was a spectacle of garish color and frenetic movement, gymnastic skill and ludicrous behavior, quintessentially stylized and artificial. As such, it held no appeal for Vincent. But for those of more symbolist turn of mind, the fated pranks of the clowns, the domineering bombast of the ringmaster, and the graceful somersaults of the flying acrobats masked inner truths about the tragic alienation of the artist, the rigidity of the bourgeois mindset, the perfectibility of art. What could be found in the suburbs, on the streets, and in the spectacles of the Paris of the late 1880s was raw matter that in the imagination of the *petit boulevard* painter or writer could be transformed into an image richly resonant of modern decadence.

Cabaret Culture

The 1880s saw the emergence of a new wave of entertainment culture in Paris, sited around the *petit boulevard* and, to an extent, defining it. The new form was the *cabaret artistique*, a café or bar that, as well as providing food and drink, encouraged songs, poetry, and other performances. The idea was to provide an atmosphere, simultaneously cultural, bawdy, and subversive, that would appeal to the young generation of artists and students who inhabited the cheap lodgings of the outer boulevards. The pioneering *cabaret artistique* was the Chat Noir, which opened in 1881. Developed from the meetings of the Hydropaths, the Chat Noir gave them a base in the boulevard

Rochechouart, centering on the dominant personality of the proprietor, Rodolphe Salis, who boomed abuse at visitors, loudly urging them to drink, and demanded that poets such as Maurice Donnay and Emile Goudeau declaim their verses.[102] The Chat Noir carefully crafted its identity. By barring unaccompanied women, it kept out trawling prostitutes, setting it a cut above the ordinary sidewalk café; by dressing its waiters in the distinguished uniform of the Académie Française, it expressed contempt for the establishment — the academicians John Lemoinne and Alexandre Dumas *fils* refused to go there for that reason — and set a tone of anti-establishment irreverence that appealed to its young audience.[103] Exploiting its opportunities and thinking of its profits — behind the bluster Salis was an astute businessman — the Chat Noir took advantage of the relaxation of the laws on caricature by publishing its eponymous journal, which included some of the earliest strip cartoons, drawn by Willette and Théophile-Alexandre Steinlen. Almost seven hundred editions were published between 1882 and 1895. Following some earlier attempts, a shadow theater was introduced in 1886, under the direction of Henri Rivière; its presentation of the *Temptation of St. Anthony* in 1888 made an enormous impact in the Parisian press. By the end of the decade guidebooks were listing the myriad artists and writers, established and avant-garde, who visited the Chat Noir, among them Puvis de Chavannes, Degas, and Seurat, plus Zola, Maupassant, and Albert Samain.[104] Eventually the Chat Noir became a victim of its own success. Having spawned many imitators, Salis was forced in the 1890s to take the Chat Noir on the road in the French regions and abroad, in utter contradiction to the premise on which the cabaret had been founded, that "Montmartre is everything." Nevertheless, during the 1880s the Chat Noir was a lightning rod, attracting electric talent: visual, poetic, humoristic, innovative, and subversive.

When the Chat Noir moved to larger premises on the rue Laval in June 1885, the boulevard Rochechouart site was taken over by one of its performers, Aristide

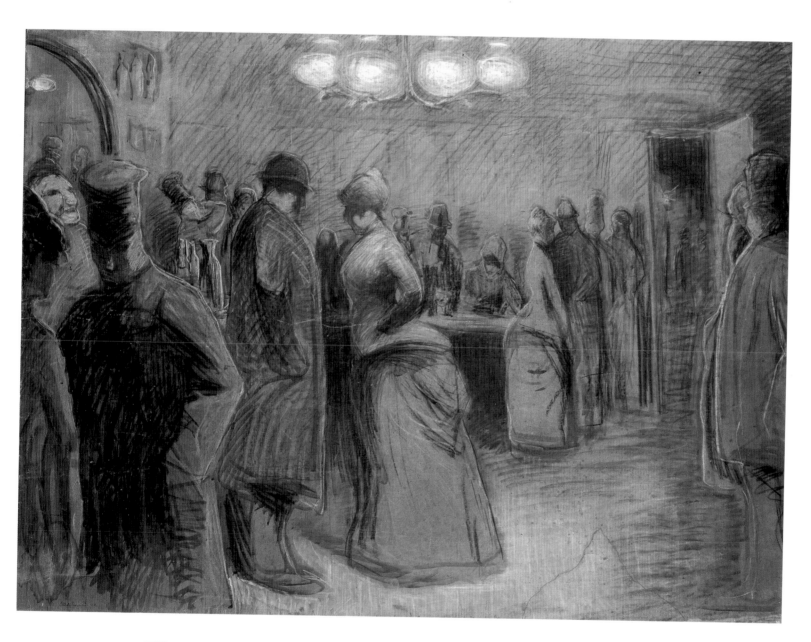

THE HOUR OF THE FLESH, 1885–86 Pastel and gouache on wrapping paper, mounted on linen, 125 x 170 cm

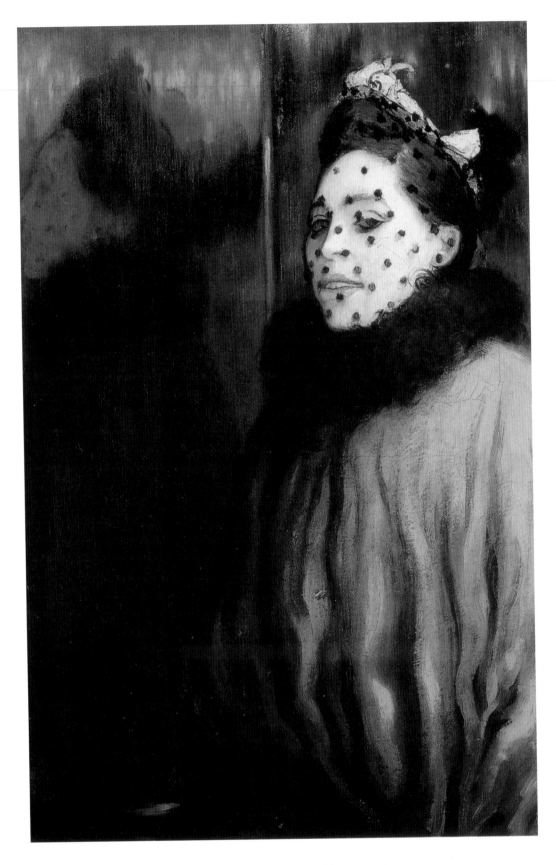

WOMAN WITH A VEIL, 1891 Oil on canvas, 81 x 55 cm

Bruant, for his own cabaret. Named Le Mirliton, it too was dominated by its proprietor. Bruant came from *petit bourgeois* stock in the Loiret, but he made the most of his youthful experience in the army and on the railways to craft a stage persona that played up his identification with the proletariat. Using the slang of the slums for songs that told tales of pimping and mugging, prostitution and the guillotine, Bruant barked out his repetitive verses in a rough voice, with a coarseness of lyric, music, and delivery that matched the coarseness of subject.[105] Although he copied the Chat Noir by intermittently producing his own illustrated periodical, *Le Mirliton*, he deliberately pitched his cabaret at a social and cultural level below his predecessor's. His clientele in 1887 was essentially Montmartrois: the writer Georges Courteline and painters Steinlen, Willette, Anquetin, and Toulouse-Lautrec.[106] But by the beginning of the 1890s, not only had Bruant's audience expanded notably to include many tourists and Parisian bourgeois who relished the lash of his class-war abuse, he was also appearing for high fees at elegant Champs-Elysées café-concerts like Les Ambassadeurs and at the soirées of wealthy grandees such as the publisher Georges Charpentier.

Cabarets artistiques like the Chat Noir and Le Mirliton were an essential aspect of Montmartre culture, as hubs for certain kinds of interests and activities. Their identities shifted as they responded to commercial opportunity, and their politics were equivocal. The Chat Noir on rue Laval was decorated with a large stained-glass window, *Te Deum laudamus*, an extraordinary allegory that represented a performance including workers in revolt and figures identified as Power, Poetry, and Virginity, all presided over by the porcine deity Israel.[107] Its designer, Willette, ran as a candidate in the 1889 municipal elections on an anti-Semitic ticket.[108] If the Chat Noir's supposedly antibourgeois identity could coexist with such right-wing nationalism, Bruant's own ostensible sympathies with the proletariat were suspected by some as being skin-deep; the journalist Marcel Schwob commented in 1892 that while Bruant might appear at an event for the unemployed

with the socialist politician Jean Allemane, he was nevertheless more a boss (*patron*) than one of the disadvantaged (*peinard*).[109]

The dance halls trace a similar trajectory of commercial exploitation within the Montmartre entertainment economy. Paris had always had its popular locales for dancing—in mid-century the Bal Bullier and Bal Mabille were favored. However, as Montmartre, incorporated into the city in 1860, began to shape its own sociocultural identity in the 1880s, that identity was reflected in its dance halls. The Moulin de la Galette, near the summit of Montmartre at the top of the rue Lepic, was a well-established venue with a clientele that was essentially lower-class. That is how Toulouse-Lautrec represented it in his large canvas shown at the Indépendants in 1889. The decade saw the emergence of new forms of dance, above all the *chahut* (p. 99), a frenetic variation on the can-can sometimes rendered extravagantly lewd by the dancers' wearing no underwear beneath their frothing petticoats. These women performed under stage names such as La Goulue (the glutton) and Grille d'Egout (sewer grating), both their lax morals and their proletarian origin signified by the use of argot, the parlance Bruant had appropriated. As a territory on the frontier between respectable metropolitan Paris to the south and rougher proletarian suburbs to the north, Montmartre, specifically the area around the boulevard de Clichy, was enhanced by the presence of the *cabarets artistiques*, which added a satirical voice and sophisticated new attractions such as the shadow play to the area's developing character.

With the growth of Paris as a tourist destination—more than thirty-two million people visited the 1889 Exposition Universelle, compared to its 1878 predecessor's sixteen million—and expenditure on entertainment spiraling, entrepreneurs sought to harness this matrix of commercial opportunity, youth culture, class curiosity, and sexual tourism for maximum profit. Toulouse-Lautrec's *The Englishman at the Moulin Rouge* encapsulates this efficiently (p. 97). The Moulin Rouge, located on the place Blanche on the boulevard

de Clichy, was the quintessential example of this phenomenon. The brainchild of Joseph Oller and Charles Zidler, highly experienced entertainment entrepreneurs, it combined a dance hall where *chahut* stars like La Goulue performed, bars, a garden with a stage for other acts including the illustrious farter Le Pétomane, shooting alleys, masked balls, and both gas and electric lighting.[110]

The different cabarets, performers, and dance halls served various if overlapping clienteles and conveyed an array of social or ideological views. But they all paralleled, as well as shaped, a conception of modern life that was *petit boulevard.* This comprised different elements. One was bourgeois interaction with proletarian cultures, whether by appropriating working-class forms like argot or the *chahut* for middle-class amusement, by visiting venues on the outer boulevards for a whiff of labor and deprivation, or by representing in verse, prose, or images something of the life of that less articulate populace. Another was that culture and commerce went hand in hand, so that pioneering a shadow theater, packaging the *chahut* for bourgeois delectation, drawing an illustration for *Le Courrier français, Le Chat noir,* or a friend's book of verse, or exhibiting a canvas of the Moulin de la Galette at the Indépendants were all gambits for establishing a market reputation and making money. A third was that, as the likely result of this process, the culture that had begun as *petit boulevard* would go upmarket and eventually become *grand boulevard* — Bruant performing at Charpentier's soirées, for example, or Gauguin getting a one-man show at the Galerie Durand-Ruel in 1893.

The painters of the *petit boulevard* had creative interconnections with the culture of the *cabaret artistique* and the dance hall. These did not just take the form of illustrations for house periodicals, although Toulouse-Lautrec made drawings for *Le Mirliton* and Lucien Pissarro for *Le Chat noir.* Among Willette's decorations for the Chat Noir were his large painting *Parce Domine* and stained glass, such as the *Green Virgin* (p. 98). The former was a baroque confection of fantastic figures flying over the Paris rooftops, leaving behind them the windmills of Montmartre and a sinister skull in the sky. The cavorting crowd includes pistol-toting and guitar-strumming Pierrots, amorous wenches, a bevy of naked first communicants, a runaway bus, and, of course, a crazed black cat. By combining this decadent iconography in a vertiginous composition employing the conventional devices of decorative painting, *Parce Domine* deliberately spoofed the murals being commissioned at the time by the Paris city council for its constituent town halls, grand decorations promoting sober republican virtues such as Family and Labor, which were disparaged by avant-garde critics like Fénéon.[111] *Parce Domine* was an allegory for the Montmartre counterculture, of which the Chat Noir stood in for the *mairie,* the town hall. Willette was not the only painter to recast major public decorations with irony. In 1884 a group of students at Cormon's atelier, led by Toulouse-Lautrec, knocked out a hilarious variant on Puvis de Chavannes's *Sacred Grove,* with the Muses' dignity disrupted by the boorish intrusion of a bunch of bohemians, including Toulouse-Lautrec himself (p. 96).[112]

Henri de Toulouse-Lautrec and others, *Parody of Puvis de Chavannes's "Sacred Grove,"* 1884, oil on canvas, 172 x 380 cm

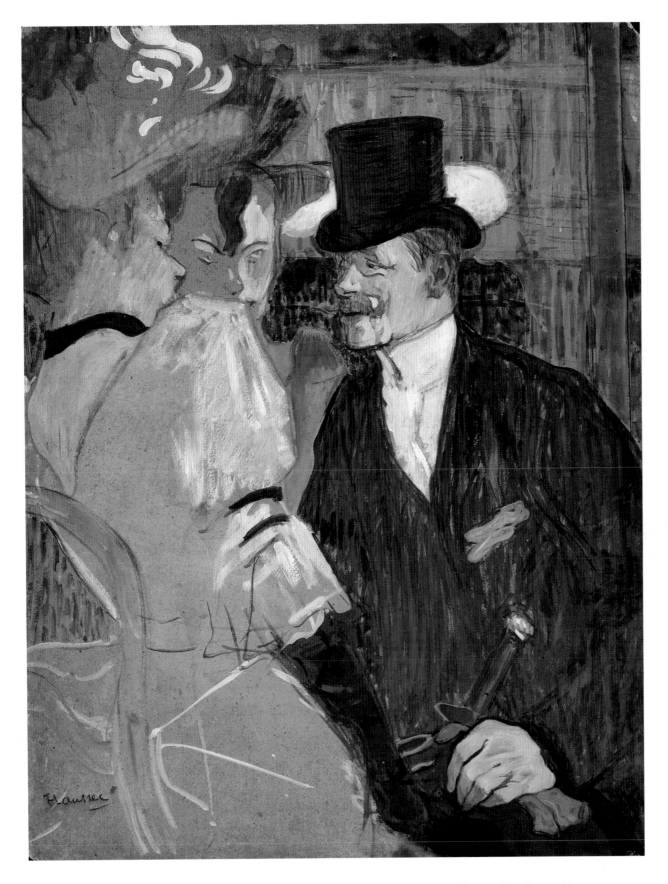

THE ENGLISHMAN AT THE MOULIN ROUGE, C.1892 Oil and gouache on cardboard, 85.7 x 66 cm

Adolphe Willette, *Green Virgin*, c.1881–82, oil on canvas, 198 x 37 cm

If Seurat's *Bathers at Asnières* (p. 167), exhibited at the first Salon des Indépendants in 1884, may have been intended to show the young artist's worthiness for public commissions, his next major canvas, *A Sunday Afternoon on the Island of La Grande Jatte—1884*, shown at the final impressionist exhibition in 1886, was clearly something different. Critics wrote about it in terms of its rigidity, its cut-out figures, its caricatural and hieratic qualities.[113] These are all characteristics that can be found in stained glass like *Green Virgin*, which Seurat would have seen at the Chat Noir. The *Grande Jatte* derived from a multiplicity of sources, for sure, but Seurat's experience of Willette's glass at the Chat Noir should not be discounted. The radical pictorial languages of the most advanced *petit boulevard* painting shared stylistic idioms with the visual culture of the *cabaret artistique*. In later years Bernard recalled how, about 1887, Anquetin had been stimulated to paint the *Mower at Noon: Summer* (1887; private collection), with its single dominant tone, by looking at a landscape through stained glass at his father's house.[114] While there is no reason to doubt that Anquetin's experience at home nudged him towards a particular experiment, his alertness to the pictorial possibilities of stained glass may well be owed to the Chat Noir, where Willette

was making something distinctly modern from the ancient medium.

Salis's inclusion in the Chat Noir of works of art that shared or promoted the cabaret's ethos was copied by Bruant at Le Mirliton. By late 1886 Toulouse-Lautrec was evidently well acquainted with Bruant, for he painted two grisaille panels depicting the "history" of the cabaret. When Bruant had moved into his new premises the year before, he had discovered that the Chat Noir had left a Louis XIII chair behind, and Toulouse-Lautrec's images show him celebrating this at Le Mirliton (p. 87) and a quadrille in its honor being performed at the Elysée-Montmartre dance hall (p. 208).[115] Toulouse-Lautrec painted a number of canvases of female Parisian types during the late 1880s that were given titles borrowed from Bruant's songs: *At Montrouge* (D305), *At Grenelle* (D308, D328), *At St. Lazare* (D275), and *At la Bastille* (now known as *Portrait of Jeanne Wenz*, p. 85). The first of these was *At Montrouge*, the canvas probably made after a drawing that had been published in *Le Mirliton* on 1 February 1886.[116] *At St. Lazare* specifically represents a Bruant song, with a prostitute writing to her pimp from the St. Lazare women's prison. Toulouse-Lautrec dated the picture 1886–89, the first year probably recording when it was painted and the second when he dedicated it to Bruant, who used it both to illustrate the song sheet of *At St. Lazare*, printed in 1888, and the song in *Dans la Rue*, a collection of his songs published about that time.[117] Toulouse-Lautrec's work certainly decorated Le Mirliton, but the arrangement seems to have been flexible; while Bruant owned some ten works by Toulouse-Lautrec, Oscar Méténier's account of the cabaret in 1891 lists only two paintings and a drawing.[118] Both gained, in any event: Bruant had his walls decorated and identified his clientele with artists of the *petit boulevard* who might have a future; Toulouse-Lautrec had his work seen and published under the aegis of an adept self-publicist.

Anquetin was also involved at Le Mirliton. He appears in both of Toulouse-Lautrec's Louis XIII decorations. In late 1887 and early 1888 he was at work on

STUDY FOR "CHAHUT," 1889 Oil on canvas, 55.5 x 46.5 cm

a substantial group portrait of artists with the cabaret as the setting. At the exhibition of Les XX in February 1888 and later at the Indépendants, he showed "Some Studies for *Chez Bruant*," possibly including one of Emile Bernard. The project, never completed, was evidently intended as an image of solidarity between the artists of the *petit boulevard* and the cabaret culture.[119] That sentiment could be reciprocated. At the Indépendants in March 1890 Toulouse-Lautrec showed *Training the New Girls, by Valentin le Désossé (Moulin Rouge)* (1890; Philadelphia Museum of Art, D361), a large recent painting of La Goulue's limber partner at work amid the milling prostitutes and bourgeois gentlemen at the recently opened venue.[120] That their dance hall had been taken up by a radical young painter must have suited Oller and Zidler, for they purchased the picture as well as another substantial Toulouse-Lautrec, *Equestrienne (At the Circus Fernando)* (p. 102), mentioned above, and hung them in the vestibule of the

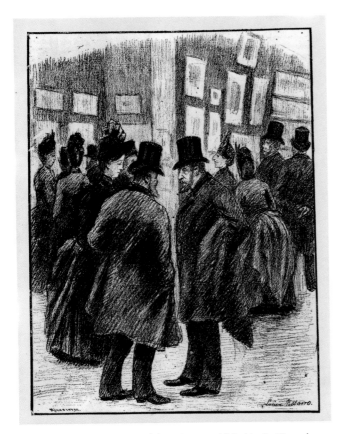

Lucien Pissarro, *A L'Exposition de la caricature*, published in *La Vie moderne*, 6 May 1888

Moulin Rouge, where they were noticed by Aurier, who brought them to the attention of the readers of *Mercure de France*.[121] In late 1891 Oller and Zidler commissioned Toulouse-Lautrec to produce a poster advertising La Goulue's residency at the Moulin Rouge, and the following year Bruant asked Toulouse-Lautrec to design a poster advertising his season at the chic city-center café-concert Les Ambassadeurs. In half a decade, Toulouse-Lautrec's position had changed. Just as Bruant had advanced from backstreet *chansonnier* to star of popular entertainment, so Toulouse-Lautrec had moved from obscure recorder of *petit boulevard* culture to high-profile Parisian image-maker.

Significantly, the neo-impressionists in the *petit boulevard* circle, as well as Vincent, had little connection with the cabaret culture. Signac had an active role in the first Chat Noir in 1882, but then became, like Seurat, an occasional visitor. For both the extroverted Signac and the fastidious Seurat, this reticence may have been because, after 1886, they had ambitious paintings to craft and careers to promote in parallel with symbolist poets rather than Montmartre humorists; their literary circle had become more *Revue indépendante* than Chat Noir. It may be that their ideological positions came to require a distance from Montmartre's cabaret culture. By 1890 Signac had articulated anarchist opinions, and Seurat too may have held left-wing views.[122] Their conception of the avant-garde artist was more purist; they regarded painting as creating an image of an ideal, distinct from capitalist enterprises such as explicitly commercial illustration, the cabaret, or the dance hall. (Gauguin's position, however antagonistic he was to the neo-impressionists, was very similar.) This is not to say that their intersection with that world, more limited than Toulouse-Lautrec's or Anquetin's, did not affect their art. The cabaret culture made jokes as well as money, subversion and mockery going hand in hand with profits. Youthful fun — in 1882 Signac had been one of the Chat Noir pranksters who had staged Salis's mock funeral[123] — barely masked chosen targets: republi-

AT THE CIRCUS, 1887 Pastel on buff card, 46.5 x 61.7 cm

EQUESTRIENNE (AT THE CIRCUS FERNANDO), 1887–88 Oil on canvas, 100.3 x 161.3 cm

can politicians, the Catholic Church, Jews, censorship, stuffy bourgeois sexual morality. Waiters in academicians' uniforms, Salis and Bruant abusing their customers, Willette painting naked first communicants were all symptomatic of a counterculture for which derision was idiomatic and hypocrisy a fair target.

The 1880s saw an explosion of caricature; the burgeoning of the illustrated press, the Arts Incohérents exhibitions, the publication of scholarly books, and the 1888 historical retrospective at the Ecole des Beaux-Arts all witness this.[124] If in this climate the cabaret culture hit hardest, the *petit boulevard* could also snipe. Of course this should be expected in the medium of caricature itself, such as Lucien Pissarro's drawing of the bourgeoisie at the Ecole's exhibition: all of them down in the mouth, none even smiling at the caricatures on display (p. 100). But it must be traced in more ambitious pictures as well. Substantial images and exhibition works as different as Bernard's *The Hour of the Flesh* (pp. 93 and 90), Toulouse-Lautrec's *At the Café la Mie* (p. 67), Anquetin's *Roundabout of the Champs-Elysées* (1889; Saint-Germain-en-Laye, Musée Départemental Maurice Denis "Le Prieuré"), and Seurat's *Le Chahut* (1889–90; Otterlo, Kröller-Müller Museum, see study, p. 99) all have in common an instinct to exaggerate the features of the human body or face, to simplify drawing to better emphasize the ridiculous, smug, or lewd, and the urge to represent contemporary Parisians at moments when they are apt for derision. This is certainly the way their work was often read, from "Trublot" finding the *Grande Jatte "très farce"* in 1886 to Fénéon praising the "*bons spectateurs porcins*" in Toulouse-Lautrec's 1892 poster of La Goulue.[125]

Van Gogh and the Petit Boulevard: Profit and Loss

A stocktaking of the benefits and advantages Vincent derived from his association with the *petit boulevard* circle he himself had defined, together with a realistic assessment of his failure to capitalize on opportunities, is an interesting exercise. Above all, it reveals a complex

of connections and disjunctions. Let us concentrate on the two years between March 1886 and February 1888 when Vincent was in Paris, in situ on the *petit boulevard*. If Vincent, and no doubt Theo, too, had initially conceived of the *petit boulevard* in economic terms, it had not brought lasting financial results. Painters such as Seurat and Toulouse-Lautrec might rely on private resources, but colleagues like Angrand had to earn a living — in his case as a teacher — while painting part-time; Vincent was fortunate enough to have the support of his brother. Theo himself, pursuing the gradualist commercial strategy of Boussod and Valadon, was unable to give appreciable support to most of the *petit boulevard* artists, keen as he was to promote the work of Monet and Degas, both *grand boulevard* figures in Vincent's terminology. Indeed, while Theo viewed the avant-garde work of his brother's colleagues with serious sympathy, he nevertheless voiced distinct anxieties about it. His account to Vincent of the 1890 Indépendants explains that he found Seurat's *Le Chahut* very unorthodox, while the previous year he had reported that Gauguin's carved wooden relief *Be in Love and You Will Be Happy* (*Soyez amoureuses, vous serez heureuses*) (1889; Boston, Museum of Fine Arts, G76) was both "sonorous" and "difficult."[126] Theo was conscious that there was a very limited clientele for such work, a realization shared by the artists themselves. Gauguin reckoned that it was not worth sending his *Christ in the Garden of Olives* to Theo as it would not be understood, presumably by neither the dealer nor his clientele.[127] Vincent left Paris in early 1888 having made many contacts with other artists and having exchanged work with several, but having made no impact on the market.

Van Gogh, of course, had not pushed his work forward in exhibitions. By placing the occasional canvas in Tanguy's window and arranging ad hoc displays at the Tambourin and the Restaurant du Chalet, he had chosen to operate on the furthest, most casual fringes of the art world, attracting no critical attention and no purchasers. By showing at neither the *Revue*

indépendante offices in late 1888 nor the Café Volpini the following summer, van Gogh excluded himself from particular alliances within the wider *petit boulevard* community. Although he did not exhibit with them until he had left Paris for Arles, Vincent favored the Salons des Indépendants as the prime outlet for his work. This was practical; the neo-impressionists had given the exhibition an avant-garde identity, which drew critical and public attention. It was also idealistic; a juryless show open to all, the Indépendants was an active example of the fraternity of artists, a dream to which Vincent was very attached. Nevertheless, even that open fraternity was liable to fracture, the separatist manifestation of the Gauguin faction at the 1889 Volpini show being followed by Anquetin's maneuverings to set up an alternative salon in 1891.[128]

The *petit boulevard* was a creative space through the fictive dimensions of which many orbits passed and intersected. Shadow plays and can-cans; satire and caricature; the political ideologies of left and right; smutty songs and *vers libre*; linguistic elitism side by side with popular argot; the organization of exhibitions, theater, and performances as a counter to those of the Third Republic's dominant bourgeoisie; a shared sense of energy, ambition, and radicalism: all this made Montmartre in the 1880s a counterculture of remarkable creativity. Vincent's passage through this dynamic space avoided some of the intersections one might have expected. Despite his deep interest in literature, his taste was not developed by his experience in Paris. In terms of subject matter, his interest in the suburbs already had a literary basis in his reading of the Goncourts; the immediately contemporary writing of Ajalbert did not touch him. His literary imagination rooted in prose, symbolist poetry seems to have passed him by. And for all Vincent's fascination with illustration, not least because it was a popular art, he showed in Paris little interest in caricatural imagery and made very few "illustrative" drawings. These limitations, these apparent failures to trace important routes in the cultural geography of the *petit boulevard*, may be explained by his being a foreigner and an older man

with tastes already formed. In retrospect, 1887, the year in which Vincent was most active in the *petit boulevard*, was its most cohesive moment, when the concept of a mutually supportive avant-garde had its best chance of being realized. Boussod and Valadon began a more adventurous commercial policy; young writers used their columns to support new painting and draw analogies between radical literature and art; the premises of the *Revue indépendante* emerged as an exhibition venue; coteries of artists collaborated on displays in cafés; and painters shared not only the subject of the suburbs but also stylistic means by which to synthesize their responses to the modernity that ungiving terrain evoked.

Vincent's experience of the *petit boulevard* was not a failure. His contribution to it may have been partial, but its impact on him was substantial. The very fact that the term remained so vital in his correspondence from Arles suggests how closely he identified with the *petit boulevard* and what he understood its best characteristics to be: the fraternity of artists, the universal value of expressing an emotional reaction to lived experience and of finding new ways to convey it. Vincent's immersion in that world between 1886 and 1888 made crucial things clearer to him, beliefs that would be absolutely fundamental to the flowering of his art over the next two and a quarter years. The first was a deeper commitment to portraiture and landscape as the kernels of "modern" art. The second was an emphasis on expression and experiment in paint, which became at least as important for him as subject, if not more so. As Bernard pointed out after Vincent's death, his dreams were vital to him. If in practice the Montmartre-based avant-garde was a febrile and constantly shifting set of communities, van Gogh tried to maintain for himself a belief in the harmony and worth of his *petit boulevard*.

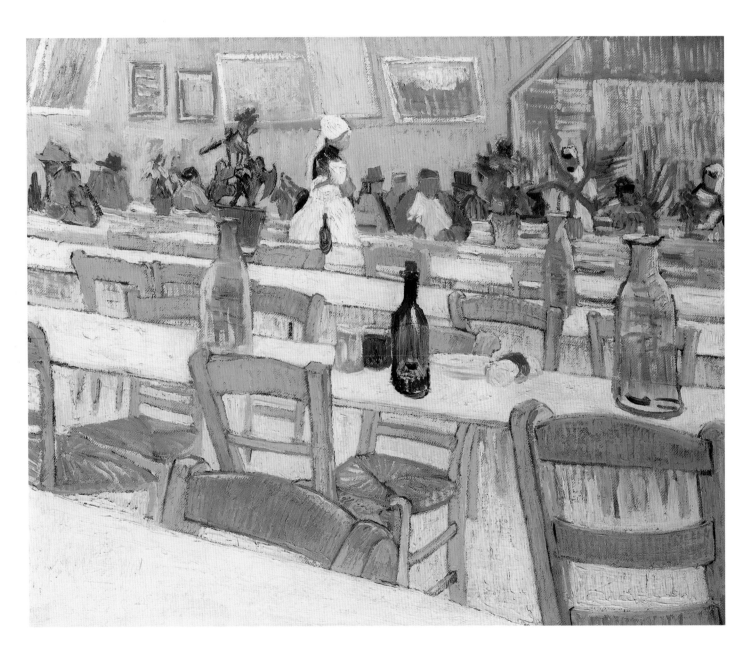

INTERIOR OF A RESTAURANT, 1887 Oil on canvas, 54 x 64.5 cm

Notes

References to Vincent van Gogh's letters, unless otherwise noted, are from *The Complete Letters of Vincent van Gogh* (London: Thames and Hudson, 1958).

1 *Complete Letters* 459a.

2 *Complete Letters* T468.

3 Letter from Théo van Rysselberghe to Octave Maus, late 1887, in M.-J. Chartrain-Hebbelinck, "Les lettres de Théo van Rysselberghe à Octave Maus," *Bulletin des musées royaux des beaux-arts de Belgique*, nos. 1–2 (1966), letter 7, p. 65.

4 *Complete Letters* 544a.

5 *Complete Letters* B5.

6 For discussions of this material, see inter alia: Phillip Dennis Cate and Patricia Eckert Boyer, *The Circle of Toulouse-Lautrec: An Exhibition of the Work of the Artist and of His Close Associates*, exh. cat. (New Brunswick, N.J.: Jane Voorhees Zimmerli Art Museum, 1985); and Bogomila Welsh-Ovcharov, essay in Musée d'Orsay, *Van Gogh à Paris*, exh. cat. (Paris: Réunion des Museés Nationaux, 1988).

7 On these literary milieux, see inter alia Philip Steven, *Paul Verlaine and the Decadence, 1882–90* (Manchester: Manchester University Press, 1974); Jennifer Birkett, *The Sins of the Fathers: Decadence in France, 1870–1914* (London: Quartet, 1986); and James Kearns, *Symbolist Landscapes. The Place of Painting in the Poetry and Criticism of Mallarmé and His Circle* (London: Modern Humanities Research Association, 1989).

8 Welsh-Ovcharov, in *Van Gogh à Paris*, pp. 31–34.

9 *Complete Letters* B1.

10 I am grateful to Belinda Thomson for this observation.

11 Letter 32, to Vincent, c.22 September 1888, Douglas Cooper, ed., *Paul Gauguin: 45 lettres à Vincent, Théo et Jo van Gogh* (The Hague: Staatsuitgeverij; Lausanne: Bibliothèque des Arts, 1983), p. 239; Emile Bernard, "Vincent van Gogh," *La Plume* 57 (1 September 1891), p. 300.

12 "Sans être prophète on peut prédire pour cette fin-de-siècle de grands bouleversements. La question sociale s'impose à nous comme au dix-huitième siècle s'imposait la question politique." "Courrier social," *La Vogue*, no. 1 (4 April 1886), p. 27.

13 For the art market at this period see: Martha Ward, "Impressionist Installations and Private Exhibitions," *Art Bulletin* 73 (December 1991), pp. 599–622; Robert Jensen, *Marketing Modernism in Fin-de-Siècle Europe* (Princeton: Princeton University Press, 1994); Richard Thomson, "Theo van Gogh: An Honest Broker," in Chris Stolwijk and Richard Thomson, *Theo van Gogh, 1857–1891: Art Dealer, Collector, and Brother of Vincent* (Amsterdam: Van Gogh Museum; Paris: Musée d'Orsay, 1999), pp. 61–148; and "Concours et expositions," *La Chronique des arts*, no. 5 (30 January 1886), p. 3.

14 Jean Dolent, *Amoureux d'art* (Paris, 1888), pp. 154–55.

15 "Pas le moindre trace d'originalité, ni le moindre effort vers l'inédit, le nouveau." A. de L[ostalot], "Expositions d'aquarelles," *Le Chronique des arts*, no. 10 (10 March 1888), p. 74. "Une surabondance de productions dont le plus grand nombre brillent par une absence totale de conviction." G. Dargenty, "Chronique des expositions: Cercle Volney," *Le Courrier de l'art*, no. 12 (22 March 1889), p. 90.

16 Jules Claretie, *La Vie à Paris, 1883* (Paris, 1884), p. 215; *Le Temps* (4 May 1883).

17 Thomson, "Theo van Gogh," pp. 107–10.

18 Jensen, *Marketing Modernism in Fin-de-Siècle Europe*, pp. 64–65; Thomson, "Theo van Gogh," pp. 110–16.

19 Félix Fénéon, "Calendrier de juin: Dix marines d'Antibes, de M. Claude Monet," *Revue indépendante* (July 1888), quoted in Félix Fénéon, *Oeuvres plus que complètes*, ed. Joan U. Halperin (Geneva: Droz, 1970), vol. 1, p. 113.

20 Martha Ward, *Pissarro, Neo-Impressionism, and the Spaces of the Avant-garde* (Chicago: University of Chicago Press, 1996), pp. 161–84; Thomson, "Theo van Gogh," pp. 120–23.

21 Thomson, "Theo van Gogh," pp. 69–90.

22 Félix Fénéon, "Calendrier de décembre," *Revue indépendante* (January 1888), quoted in Fénéon, *Oeuvres plus que complètes*, pp. 90–91.

23 "Je ne suis pas fâché si les Claude Monet deviennent chers; ce sera toujours un exemple de plus pour le spéculateur qui compare les prix d'autrefois avec ceux d'aujourd'hui —Et dans ce sens ce n'est pas trop char de demander 400fr d'un Gauguin en comparaison de 3000 un Monet." Letter to Emile Schuffenecker, early June 1888, in Paul Gauguin, *Correspondance de Paul Gauguin, I, 1873–1888*, ed. Victor Merlès (Paris: Fondation Signer-Polignac, 1984), letter 147, p. 141.

24 Thomson, "Theo van Gogh," pp. 136–41.

25 Monique Nonne, "Les marchands de van Gogh," in Musée d'Orsay, *Van Gogh à Paris*, exh. cat. (Paris: Réunion des Musées Nationaux, 1988), p. 338.

26 Letter to Lucien Pissarro, 23 January 1886, in Camille Pissarro, *Correspondance de Camille Pissarro, II, 1886–1890*, ed., Janine Bailly-Herzberg (Paris: Editions du Valhermeil, 1986), letter 309, p. 19.

27 Nonne, "Les marchands de van Gogh," pp. 338–43; Gustave Coquiot, *Seurat* (Paris: Albin Michel, [1924]), pp. 161–62.

28 François Gauzi, *Lautrec et son temps* (Paris: David Perret, 1954), p. 154; Welsh-Ovcharov, in *Van Gogh à Paris*, p. 88.

29 "L'homme couillard." Cooper, ed., *Paul Gauguin: 45 lettres* (c.16 November 1888), letter 8, p. 73.

30 Welsh-Ovcharov, in *Van Gogh à Paris*, pp. 29–31, 33.

31 Richard Thomson, *Seurat* (Oxford: Phaidon, 1985), pp. 90–91, 127–28.

32 "Très hostiles." Letter to Lucien Pissarro, Les Andelys, 24 July 1886. Oxford: Ashmolean Museum, Pissarro Archive.

33 Louis Pilate de Brinn Gaubast, "L'exposition des artistes indépendants," *Le Décadent* (18 September 1886), n.p.; J. Le Fustec, "Exposition de la Société des Artistes indépendants," *Journal des artistes* (22 August 1886), p. 282.

34 Félix Fénéon, "L'impressionnisme," in Fénéon, *Oeuvres plus que complètes*, p. 64, first published in *L'Emancipation sociale* (Narbonne; 3 April 1887).

35 Letter to Esther Bensusan, Eragny, 12 September 1889. Oxford: Ashmolean Museum, Pissarro Archive.

36 Letters to Charles Frechon, c.20 April 1890, and Maurice Dezeville, 25 April 1890, in Charles Angrand, *Charles Angrand: Correspondances, 1883–1926*, ed. François Lespinasse (n.p., 1988), p. 40, n. 3, p. 41.

37 *Complete Letters* T29.

38 Letter to Vincent from Paris, c.1 April 1890, in Cooper, ed., *Paul Gauguin: 45 lettres*, letter 40, p. 305.

39 "Beaux-Arts," *Art et critique*, no. 36 (1 February 1890), p. 78.

40 "Une certaine crânerie provoquante, un parfait dédain du convenu." Gaubast, "L'exposition des artistes indépendants," n.p.

41 See Luce Abélès and Catherine Charpin, *Arts incohérents, académie du dérisoire*, exh. cat. (Paris: Musée d'Orsay, 1992).

42 Letter to Maurice Dezeville, c.June 1889, in Angrand, *Charles Angrand: Correspondances*, p. 35.

43 Angrand, *Charles Angrand: Correspondances*, p. 15.

44 Camille Pissarro, *Correspondance de Camille Pissarro*, p. 87, n. 3.

45 Félix Fénéon, "Calendrier de décembre," *Revue indépendante* (January 1888); "Calendrier de janvier," ibid. (February 1888); "Calendrier de février," ibid., (March 1888); in Fénéon, *Oeuvres plus que complètes*, pp. 91–94.

46 Félix Fénéon, "Calendrier de mars," *Revue indépendante* (April 1888); "Calendrier de mai," ibid. (June 1888); "Calendrier de juin," ibid. (August 1888); "Calendrier de septembre," ibid. (October 1888); in Fénéon, *Oeuvres plus que complètes*, pp. 102, 112, 114–17.

47 "Beaucoup de résultats." Letters to Theo van Gogh, May–June 1888

(Amsterdam: Van Gogh Museum), B.1171 v/1962; B.1170 v/1962.

48 Letter to Theo, c.8 December 1888, with letter to *Revue indépendante*, in Cooper, ed., *Paul Gauguin: 45 lettres*, letter 10, pp. 79, 81, 83.

49 *Bretonnes* (W201) on 22 October 1888 and *Prairie avec deux chiens* (W265) and *Vue de Pont Aven* (W195) on 12–13 November 1888 to Dupuis, and *Pêcheurs bretons* (W262) on 4 December 1888 to Clapisson. John Rewald, "Theo van Gogh as Art Dealer," in *Studies in Post-Impressionism* (New York: Harry N. Abrams, 1986), p. 90.

50 *Complete Letters* T534.

51 *Complete Letters* T561.

52 André Antoine, "*Mes Souvenirs*" sur le *Théâtre-Libre* (Paris: A. Fayard, 1921), pp. 40–41.

53 Evert van Uitert, Louis van Tilborgh, and Sjraar van Heugten, *Vincent van Gogh: Paintings*, no. 22 (Milan: Mondadori; Rome: De Luca, 1990), p. 76.

54 Lugné-Poe, *La Parade, I. Le Sot du tremplin. Souvenirs et impressions du théâtre* (Paris: Librarie Gallimard, 1930), p. 104; *La Vie moderne* 10, no. 24 (17 June 1888), p. 373.

55 Antoine, "*Mes Souvenirs*," p. 91 ("une espèce de hall de la rue Rochechouart, un skating ou une piscine"). X., "Choses et autres," *La Vie parisienne* (28 March 1891), p. 181.

56 *Complete Letters* 640; Roger Marx, pref., *Exposition Jules Chéret: Pastels, lithographies, dessins, affiches illustrés*, exh. cat. (Paris: Galeries du Théâtre d'Application, 1889), p. 11.

57 *Complete Letters* 510.

58 Welsh-Ovcharov, in *Van Gogh à Paris*, no. 24, p. 86; van Uitert et al., *Vincent van Gogh: Paintings*, no. 30, pp. 90–91.

59 *Complete Letters* 461, T462.

60 Welsh-Ovcharov, in *Van Gogh à Paris*, p. 33.

61 *Exposition Universelle de 1889. Catalogue illustré des beaux-arts, 1789–1889*, ed. F. G. Dumas (Lille and Paris: L. Daniel, 1889), nos. 124, 485–98, 526–28, 541–42.

62 Octave Mirbeau, "Impressions d'un visiteur," *Le Figaro* (10 June 1889); Albert Aurier, "La peinture à l'Exposition," *La Pléiade* (September 1889), p. 104.

63 Adolphe Retté, "Bars et brasseries à l'Exposition," *La Vogue* (August 1889), p. 155.

64 *Complete Letters* T10.

65 "Les discours de fraternité artistique ne correspondent avec leurs actes." Letter to Theo from Pont-Aven, c.1 July 1889, in Cooper, ed., *Paul Gauguin: 45 lettres*, letter 14, pp. 103, 105, 107.

66 *Complete Letters* 601.

67 Félix Fénéon, "Autre groupe impressionniste," *La Cravache* (6 July 1889), in Fénéon, *Oeuvres plus que complètes*, p. 157.

68 Venita Datta, *Birth of a National Icon: The Literary Avant-Garde and the Origins of the Intellectual in France* (Albany: State University of New York Press, 1999), p. 20.

69 Jean Ajalbert, *Mémoires en vrac* (Paris, 1938), pp. 117, 119.

70 Coquiot, *Seurat*, p. 39.

71 "Dîner du rouge et du bleu," *Journal des artistes* (14 November 1886), p. 382.

72 Ernest Raynaud, *En Marge de la mêlée symboliste* (Paris, 1936), pp. 20–21.

73 *Complete Letters* W1, 498.

74 "Trublot" [Paul Alexis], "Mon vernissage," *Le Cri du peuple* (2 May 1886), in B. H. Bakker, ed., "Naturalisme pas mort," *Lettres inédites de Paul Alexis à Emile Zola, 1871–1900* (Toronto: University of Toronto Press, 1971), p. 501.

75 Paul Adam, "Les impressionnistes à l'Exposition des Indépendants," *La Vie moderne* (15 April 1888), pp. 228–29.

76 Letter from Gauguin to Theo van Gogh, c.21 September 1889, in Cooper, ed., *Paul Gauguin: 45 lettres*, letter 20, pp. 139, 141, 143; Serena Keshavjee, "La Parisienne (1890): Un portrait de Claude-Emile Schuffenecker (1851–1934)," *Revue du Louvre* 2 (1997), pp. 71–76.

77 See Françoise Cachin, *Paul Signac* (Paris: Bibliothèque des Arts, 1972), p. 129; Frédéric Destremau, *Anquetin: La Passion d'être peintre*, exh. cat. (Paris: Galerie Brame et Lorenceau, 1991), p. 90.

78 Richard Thomson, *Seurat*, p. 214.

79 Richard Thomson, "Illustration, Caricature and the Type," in Richard Thomson, Anne Roquebert, and Claire Frèches-Thory, *Toulouse-Lautrec*, exh. cat. (London: Hayward Gallery; Paris: Grand Palais, 1991), pp. 186–201; *La Vie moderne* (15 April 1888), p. 229.

80 Félix Fénéon, "Calendrier d'octobre," *Revue indépendante* (November 1888), in Fénéon, *Oeuvre plus que complètes*, pp. 122–24.

81 *Complete Letters* 468, 505.

82 "D'objectiver le subjectif (l'extériorisation de l'Idée) au lieu de subjectiver l'objectif (la nature vue à travers un tempérament)." Gustave Kahn, "Réponse des symbolistes," *L'Evénement* (28 September 1886).

83 Félix Fénéon, "IIe Exposition de la Société des Artistes Indépendants," *L'Art moderne* (19 September 1886), in Fénéon, *Oeuvres plus que complètes*, p. 44; Paul Smith, "Paul Adam, soi, et les peintres impressionnistes: la Genèse d'un discours moderniste," *Revue de l'art* 82 (1988), pp. 39–50.

84 Edouard Dujardin, "Aux XX et aux Indépendants: Le cloisonisme," *Revue indépendante* (March 1888), p. 489; Félix Fénéon, "Certains," in Fénéon, *Oeuvres plus que complètes*, p. 172, first published in *Art et critique* (14 December 1889); Georges Vanor, *L'Art symboliste* (Paris, 1889), pp. 32–33.

85 Belinda Thomson, "Camille Pissarro and Symbolism: Some Thoughts Prompted by the Recent Discovery of an Annotated Article," *Burlington Magazine*, 124 (January 1982), pp. 14–23; Patricia Mathews, "Aurier and van Gogh: Criticism and Response," *Art Bulletin* 68 (March 1986), pp. 94–104.

86 Gabriel-Albert Aurier, "Le symbolisme en peinture: Paul Gauguin," *Mercure de France* (March 1891), pp. 155–65.

87 Gabriel-Albert Aurier, "Les isolés—Vincent van Gogh," *Mercure de France* 1, no. 1 (January 1890), pp. 24–29.

88 For the representation of the Paris suburbs see, inter alia, Richard Thomson, *Monet to Matisse: Landscape Painting in France, 1874–1914*, exh. cat. (Edinburgh: National Gallery of Scotland, 1994), pp. 27–37.

89 Ajalbert, *Mémoires en vrac*, p. 53.

90 "En corsets de fer: Va plonger comme une jetée." Jean Ajalbert, *Femmes et paysages* (Paris, 1891), pp. 50, 55.

91 Richard Thomson, "Van Gogh in Paris: The Fortifications Drawings of 1887," *Jong Holland*, no. 3 (September 1887), pp. 14–25; Welsh-Ovcharov, in *Van Gogh à Paris*, pp. 48–50, 70, 99.

92 Lucien Pissarro, "Sur les fortifs," *Le Courrier français* (4 August 1889), pp. 6–7; Adolphe Willette, in Rodolphe Darzens, *Nuits à Paris* (Paris, 1889), p. 259.

93 Ruth Harris, *Murders and Madness: Medicine, Law and Society in the Fin-de-Siècle* (Oxford: Oxford University Press, 1989), pp. 76, 78; Robert Nye, *Masculinity and Male Codes of Honour in Modern France* (Oxford: Oxford University Press, 1993), pp. 77, 222.

94 Hollis Clayson, *Painted Love: Prostitution in French Art of the Impressionist Era* (New Haven: Yale University Press, 1991).

95 Bogomila Welsh-Ovcharov, *Emile Bernard (1868–1941): The Theme of Bordellos and Prostitutes in Turn-of-the-Century French Art* (New Brunswick, N.J.: Jane Voorhees Zimmerli Art Museum, 1988), p. 24; Mary Anne Stevens, et al., *Emile Bernard, 1868–1941: A Pioneer of Modern Art*, exh. cat., trans. J. C. Garcias et al. (Mannheim: Städtische Kunsthalle; Amsterdam: Van Gogh Museum; Zwolle, Netherlands: Waanders Publishers, 1990), pp. 168–71, 242–44.

96 Letter to Madame Mullezer, February 1882, in Jules Laforgue, *Oeuvres complètes de Jules Laforgue, IV. Lettres, I (1881–1882)*, ed. G. Jean-Aubry, (Paris, 1925), letter XXVIII, p. 123.

97 E.g., Georges Lecomte, "Le Boulevard," *La Cravache* (16 June 1888), n.p.; E[douard] D[ujardin], "Premières représentations," *Revue indépendante*, no. 21 (July 1888), pp. 151–52.

98 Paul Signac, letter, 19 September 1888, in *La Cravache* (22 September 1888), n.p.

99 Hazlitt, Gooden, and Fox, London, *Nineteenth Century French Drawings*, no. 30 (London: Hazlitt, Gooden, and Fox, 1996); Richard Thomson et al., *Toulouse-Lautrec*, no. 62 (1991–92).

100 Gary Tinterow, "Parade de cirque, 1887–1888," in Robert L. Herbert et al., *Georges Seurat, 1859–1891*, exh. cat. (New York: The Metropolitan Museum of Art, 1991), pp. 305–17.

101 Anne Distel, "Cirque, 1890–1891," in Herbert et al., *Georges Seurat*, pp. 360–71.

102 Mariel Oberthür, *Le Chat noir, 1881–1897* (Paris: Musée d'Orsay, 1992); Phillip Dennis Cate, "The Spirit of Montmartre," in Cate and Mary Shaw, eds., *The Spirit of Montmartre: Cabarets, Humor, and the Avant-Garde, 1875–1905*, exh. cat. (New Brunswick, N.J.: Jane Voorhees Zimmerli Art Museum, 1996), pp. 23–39.

103 Charles Virmaître, *Paris impur* (Paris, 1889), p. 21; Jules Claretie, *Souvenirs du Dîner Bixio* (Paris, 1924), p. 46 (entry for 8 January 1886).

104 Charles Virmaître, *Paris-palette* (Paris, 1888), pp. 63–64; Camille Debans, *Les Plaisirs et les curiosités de Paris* (Paris, 1889), pp. 155–56.

105 Darzens, *Nuits à Paris*, pp. 77–84; Alexandre Zévaès, *Aristide Bruant* (Paris: Editions de la Nouvelle Revue Critique, 1943), pp. 13–45.

106 Paul Roinard, "Lanterne de cabaret," *Le Mirliton*, no. 32 (February 1887), p. 2.

107 Darzens, *Nuits à Paris*, pp. 99–100.

108 See his poster, reproduced in Michael R. Marrus, "Popular Anti-Semitism," in Norman L. Kleeblatt, ed., *The Dreyfus Affair: Art, Truth and Justice* (New York: The Jewish Museum; Berkeley and Los Angeles: University of California Press, 1987), p. 57, fig. 6.

109 Marcel Schwob, "Lettre parisienne," *Le Phare de la Loire* (2 May 1892), in Schwob, *Chroniques*, ed. John Alden Green (Geneva: Librarie Droz, 1981), pp. 123–24.

110 For Montmartre's dance-hall culture, see Richard Thomson, "Representing Montmartre," in Thomson et al., *Toulouse-Lautrec*, pp. 226–68.

111 Félix Fénéon, "Au Salon de 1887," *L'Emancipation sociale* (26 May 1887), in Fénéon, *Oeuvres plus que complètes*, p. 78.

112 Richard Thomson et al., *Toulouse-Lautrec*, no. 23.

113 Richard Thomson, "Seurat's Choices: The *Bathers* and Its Contexts," in John Leighton and Richard Thomson, *Seurat and the Bathers* (London: National Gallery Publications, 1997), pp. 99–102; Thomson, *Seurat*, pp. 114–26; Martha Ward, "The Rhetoric of Independence and Innovation," in Fine Arts Museums of San Francisco, *The New Painting: Impressionism, 1874–1886*, exh. cat. (Geneva: Richard Burton SA, Publishers, 1986), pp. 434–48.

114 Emile Bernard, "Louis Anquetin," *Gazette des Beaux-Arts*, 6th ser., 11 (February 1934), p. 113.

115 Gale B. Murray, *Toulouse-Lautrec: The Formative Years, 1878–1891* (Oxford: Clarendon Press, 1991), pp. 105–7; M.-G. Dortu, *Toulouse-Lautrec et son oeuvre*, vol. 2 (New York: Collectors Editions, 1971), pp. 260–61.

116 Murray, *Toulouse-Lautrec: The Formative Years*, p. 94. See also Dortu, *Toulouse-Lautrec et son oeuvre*, pp. 275, 305–7, 328.

117 Murray, *Toulouse-Lautrec: The Formative Years*, pp. 114, 117.

118 Oscar Méténier, "Aristide Bruant," *La Plume*, no. 43 (1 February 1891), p. 41.

119 *Catalogue de la Ve Exposition des XX*, no. 6 (Brussels, 1888); Dujardin, "Aux XX et aux Indépendants: Le cloisonisme," pp. 488, 492.

120 Richard Thomson et al., *Toulouse-Lautrec*, no. 65.

121 G. A[lbert] A[urier], "Choses d'art," *Mercure de France*, 11 (January 1891), p. 62.

122 [Paul Signac], "Impressionistes et révolutionnaires," *La Révolte* (13–19 June 1891), p. 4; Richard Thomson, *Seurat*, pp. 192–93. See also Paul Smith, *Seurat and the Avant-Garde* (New Haven and London: Yale University Press, 1997), chapter 3.

123 Oberthür, *Le Chat noir*, p. 47.

124 E.g., John Grand-Carteret, *Les Moeurs et la caricature en France* (Paris, 1888); Arsène Alexandre, *H. Daumier: L'Homme et l'oeuvre* (Paris, 1888).

125 Marcel Fouquier, "Les impressionnistes," *Le XIXe siècle* (16 May 1886); Fénéon, "Au Pavillon de la Ville de Paris: Société des Artistes Indépendants," *Le Chat noir* (2 April 1892), in Fénéon, *Oeuvres plus que complètes*, p. 213.

126 *Complete Letters* T29, T20.

127 Letter to Bernard, late November 1889, Le Pouldu, in Maurice Malingue, ed., *Lettres de Gauguin à sa femme et à ses amis* (Paris: B. Grasset, 1946), letter XCV, p. 178.

128 Frédéric Destremau, "Le Salon des refusés organisé par Louis Anquetin au Palais des arts libéraux du 29 mai au 30 juin 1891," in Destremau, *Anquetin*, pp. 142–47.

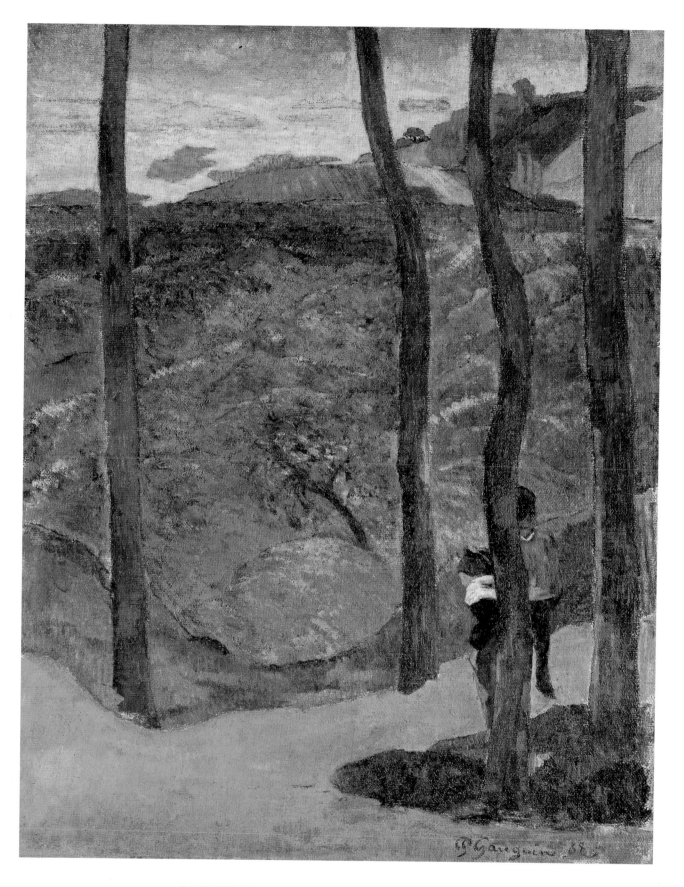

BLUE TREE TRUNKS, ARLES, 1888 Oil on canvas, 92 x 73 cm

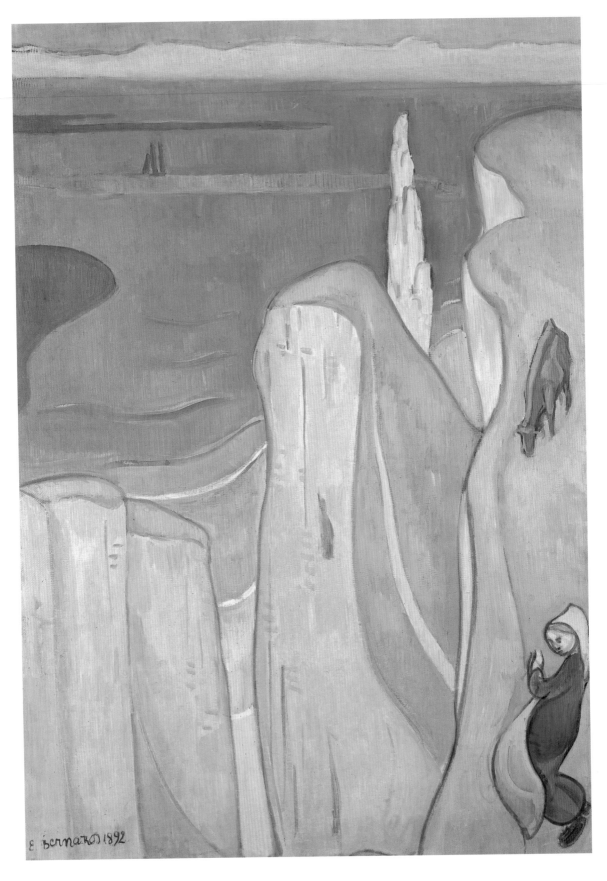

THE CLIFFS OF YPORT, 1892 Oil on canvas, 91.7 x 65.8 cm

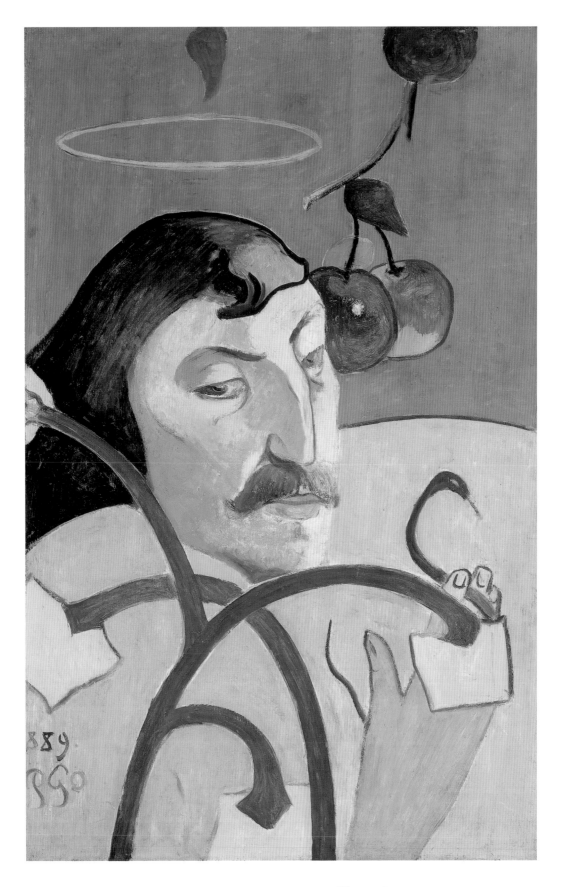

SELF-PORTRAIT WITH HALO, 1889 Oil on wood, 79.6 x 51.7 cm

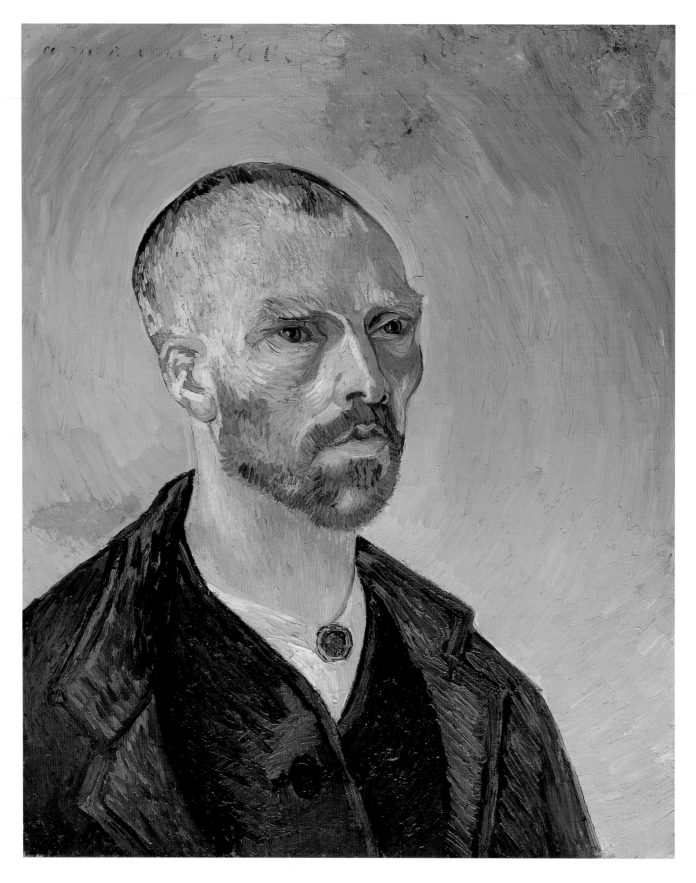

SELF-PORTRAIT, 1888 Oil on canvas, 23.7 x 19.7 cm

Seeking the Studio of the South:
Van Gogh, Gauguin, and Avant-Garde Identity

Elizabeth C. Childs

The avant-garde in France in the 1880s is easier to identify by shared attitudes than by a particular style, subject matter, or set of locations. The common ground is, above all, a set of assumptions about the city, bourgeois culture, academic art, and the goals of making modern art. The careers of Vincent van Gogh, Paul Gauguin, and Emile Bernard illustrate these aspects of avant-garde practice with particular clarity. Although these artists depended on circles of dealers, critics, and fellow artists in Paris to establish their reputations, each came, in his own way, to reject the city both as a subject and as the site of art production: Gauguin worked in Brittany and the Caribbean before emigrating to Polynesia in 1891; van Gogh moved to Provence; Bernard worked in Brittany before abandoning France for Egypt. Once these artists left Paris, they expelled from their art the urban, the industrial, and the modern and undertook a conscious retreat to the rural, to remote villages and small cities that held the allure of fresh subjects, a more direct engagement with nature, allegedly simpler lifestyles, and the potential of communion with like-minded artists.

Gauguin, van Gogh, and Bernard were participants in a larger cultural shift, away from the regulated, bureaucratic, materialistic, and class-bound sides of urban life in the 1880s and 1890s. Distancing themselves from industrial progress, rampant capitalism, and ever-increasing consumption of mass-produced articles, avant-garde and academic artists alike embraced the country with a sentimental nostalgia for the agrarian life. The fin de siècle spawned arts colonies: ideal communities where artists hoped to live and work together in productive harmony. The art they produced found its market not in the country but in the city. An affluent urban clientele, now used to impressionism, seemed ready to embrace more universalizing images of the stable, timeless cycles of nature that dictate the routines of humanity in the country. It was still Paris that conferred success on these artists, through the agencies of the marketplace, private patronage, critical reception, and the cultivation of individual reputations. Having rejected the official academy and the Salon in favor of the growing entrepreneurial dealer system, the avant-garde now counted heavily on the viewership and patronage of an urban cultural elite.

Pont-Aven

In the case of Paul Gauguin, the flight from the city began with a journey to Pont-Aven in 1886. Gauguin had just exhibited nineteen paintings at the last impressionist exhibition, but critics responded as if his art were merely a dull footnote to impressionism, and they passed him over to praise the neo-impressionists.[1] His future lay in Brittany, he thought, so he distanced himself from this Parisian cohort: after only one month in Pont-Aven, he refused to exhibit with the neo-impressionists in the August show of the Société des Artistes Indépendants. There were practical financial considerations, too; Gauguin once admitted that poverty alone had turned his steps towards Brittany.[2] He learned about the affordable Pension Gloanec, where artists traded art for lodging, not from a fellow

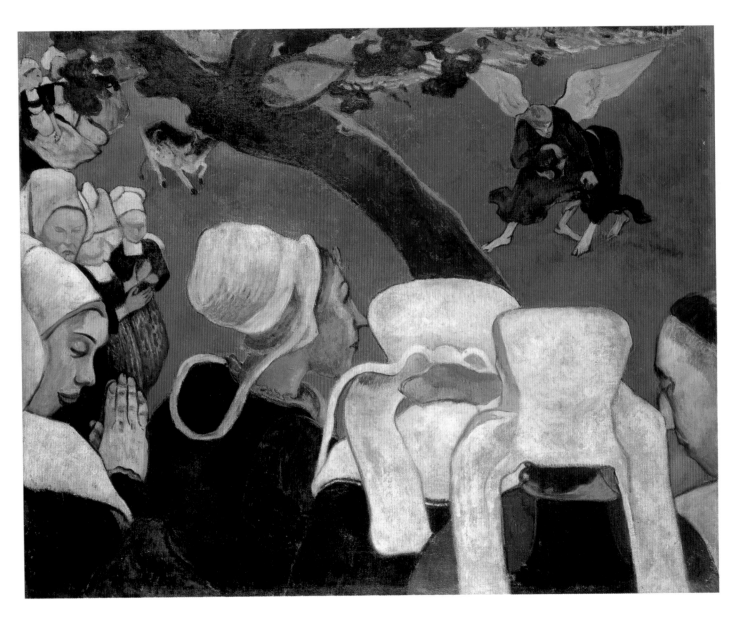

THE VISION AFTER THE SERMON, 1888 Oil on canvas, 73 x 92 cm

member of the avant-garde, but from Félix Jobbé-Duval, an academic painter who had returned from the country with a robust air that Gauguin envied.

Pont-Aven offered Gauguin a fresh start at a time when he was searching for both artistic direction and personal identity. His work provoked discussion there, and this attention energized his sagging career. The town became a base camp but not a home: he spent a total of seventeen months in Pont-Aven and Le Pouldu between 1886 and 1890, and he made a final visit in 1894, between two sojourns in Polynesia. He returned often to the city to maintain contact with dealers (including Theo van Gogh and Paul Durand-Ruel) and with artist friends such as Emile Schuffenecker, who helped promote his work in Paris.

Part of Pont-Aven's lure for Gauguin was its status as an artists' colony. There he could work in productive collaboration with artists like the young Bernard, who spent the summers of 1886, 1887, and 1888 in the town. Gauguin was shocked upon his arrival, however, by the number of artists already established there and complained that scarcely any were French, that the town was overrun with Danes and Americans.[3] Since the 1860s Breton subjects by conservative realists such as Jules Breton, Léon Lhermitte, and Pascal-Adolphe-Jean Dagnan-Bouveret had figured prominently in the annual Salons in Paris. Scenes of faithful peasants at pardons and prayer assured the urban viewer that faith, community, and simplicity endured in the country. The idea, if not the style, of these pictures appealed to Gauguin and his circle. As these artists imposed visual order and decorative harmony on rural landscapes, they invoked essentializing and ahistorical notions of Breton culture, screening out evidence of the well-established tourism and modern industry in the region.[4]

Central to Gauguin's and Bernard's idealization of Brittany was their interest in what they presumed to be a particularly pious and pure practice of Catholicism. In both *The Vision after the Sermon* (p. 114) and the later canvas *Young Christian Girl* (p. 141), Gauguin mythologized the piety and faith of these women, whose headdresses identify them as Breton. The color

and space in both pictures is boldly anti-naturalistic. This visionary color intensifies the anti-empirical nature of the women's religious vision. Gauguin conjured a landscape that resonates with "the rustic and superstitious simplicity" he sought.[5] Throughout his Breton work, and even later in the Tahitian oeuvre, the artist presented faith and spirituality as a gendered experience: the women serve as mediators to the spiritual, and their devotional energy embodies the very possibility of pure belief. Gauguin here reiterated the urban stereotype that among peasants Christian faith remained at its purest and strongest.[6]

The young Emile Bernard, a lapsed Catholic who had rejected the organized religion in which he was raised, participated in this essentializing of spirituality. In his memoirs he admits his infatuation with the medieval spirituality he associated with the region: "Atheist that I was, it made of me a saint.… It was this gothic Brittany which initiated me in art and God."[7] His revolutionary cloisonnist painting *Breton Women at a Pardon*[8] (1888; Paris, private collection, L114), and his later Breton pictures, such as *The Cliffs of Yport* (p. 110) naturalize religious practice in the landscape. In the latter work, a Breton woman in characteristic coif and sabots kneels at the edge of a high cliff, her reverence in the face of the sublime recalling the romantic convention of the sensitive believer facing the awesome works of the Creator. The cow grazing on the precipice, daringly flattened against the picture plane, is a reminder of the challenges of wresting an agrarian livelihood from so rugged a terrain. Yet this sober message is mediated by the soothing pastel palette of the picture, which subsumes the primitivizing content into a harmonious decorative scheme.

Gauguin's and Bernard's images of religious women celebrate the country while echoing contemporary debates about the present and future of Catholicism. In Paris the spiritual maintenance of home and nation had increasingly come to be seen as the mission of faithful middle-class women, bourgeois men being viewed as having lost touch with their faith.[9] The Pont-Aven

artists responded to this anxiety, transforming the era's belief in an innate feminine spirituality into iconic images of seemingly classless, timeless, and ageless female peasants. Gauguin's and Bernard's Breton women serve as vehicles of spiritual instinct, embodying not only a symbolist aesthetic, but also the artists' primitivistic ideals about the superiority of rural and preindustrial societies. That such pictures were not appreciated by the artists' Breton subjects but by Parisian dealers and collectors indicates how marginal these avant-garde artists were in the provincial society they depicted.[10]

Medieval religious art, and particularly stained glass, informs the portrait styles developed by Gauguin and Bernard. Bernard's *Portrait of Madeleine Bernard* (p. 51) was probably finished in Paris over the winter of 1887–88, at the time he and Louis Anquetin were conducting their first experiments in the cloisonnist style.[11] Madeleine often posed for her brother, yet this unfinished portrait belies their intimacy. Bernard endows her with a coolness and sobriety that transform her into an icon. The dark line that encloses her face, hair, and neckline imitates the defining contours of the metal strips used in cloisonné or the lead cames that join pieces of stained glass. The background is particularly enigmatic. Though probably based on some ordinary tapestry or wallpaper in the studio, the large dark-blue forms embrace the head like the mullions of a cathedral window, and the organic yellow shapes around her head glow as if sanctifying her with a mystical radiance.

Gauguin's *Young Brittany Girl* (p. 117) of 1889 expands on this fusion of progressive style with iconic portraiture. His model has been tentatively identified as a young woman in Le Pouldu known as Madeleine Delorme, but the facial similarities to Madeleine Bernard should be noted.[12] The painting is less a portrait than an emblematic composition that draws on diverse cultural traditions. Window mullions suggest a cross behind the woman's head while the vibrant landscape beyond is divided into patches of clear, luminous color that enframe her like a saint in a stained-glass window. To the left are mysterious emblems that con-

note ancient France — the fleur-de-lys of the royal family and a heraldic crest surmounted by a lion rampant. To the right, behind her back, Gauguin places a Peruvian pot in the shape of a kneeling woman — a symbol of his own heritage. The model's girlish face and thin frame suggest a young, chaste saint, even as her tailored blouse fixes her within contemporary French culture. It is perhaps Gauguin's respectful tribute to the inaccessible but desirable Madeleine Bernard, whose image he juxtaposes with the ceramic sign of his ideal "primitive" woman.

The quest for an authentic spiritual experience in the country, and rejection of conventional religious practice in the city, linked the artistic enterprises of Bernard, Gauguin, and van Gogh. For Gauguin and Bernard, Catholic ceremony and tradition in Brittany held the nostalgic lure of a primitive faith practiced in a rugged natural environment. Van Gogh preferred the Midi, which he thought offered a more direct experience of both the natural and the spiritual. While Bernard and Gauguin traveled west in search of their utopia, van Gogh went south.

Arles

Van Gogh's decision to move to the South was based on many factors: a rejection of Paris; an embrace of the South of France; and a desire to found his Studio of the South, a utopian community of modern artists. While Arles could not offer van Gogh an already existing artists' colony, it was nonetheless at the heart of a thriving tourist area in Provence. Located where the Rhône River divides to form its delta above Marseille, it was a commercial center (called Arelas or Arelate) under the Roman Empire and a site of religious importance in the Middle Ages. The legacy of Rome was still evident throughout the region: just north of Arles is the massive aqueduct called the Pont du Gard, a wonder of the ancient world that was celebrated in eighteenth-century art by such masters of the picturesque as Joseph Vernet.

Arles was a small city, numbering only about twenty-three thousand inhabitants in the 1880s, but it offered a

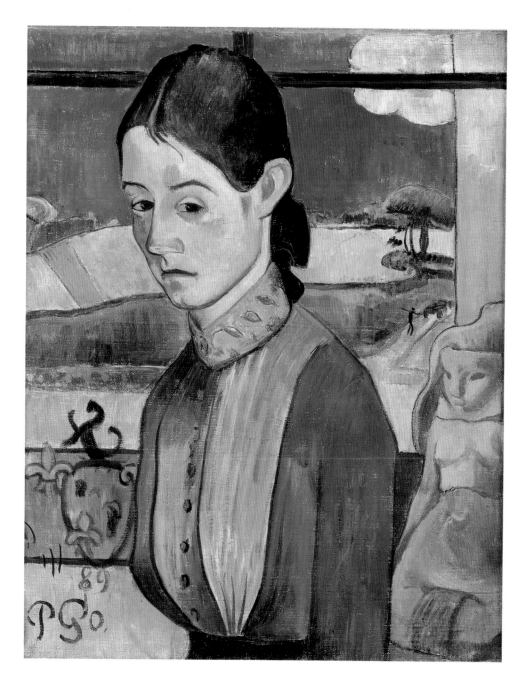

YOUNG BRITTANY GIRL, 1889 Oil on canvas, 46 x 38 cm

dramatic mix of classical heritage and modern technology, in a city rich with antiquities that were both accessible and charming.[13] With the exception of the Alyscamps necropolis, Roman ruins were no attraction for van Gogh, who never mentions them in his letters. Although he sought in Provence an alternative to the pressing modernity of Paris, ancient Roman culture must have seemed too obvious or too conventional; from his "Yellow House" on the place Lamartine, he had a direct view of the sixteenth-century Porte de la Cavalerie and some of the late Roman ramparts that still circled the city, but these impressive monuments seem to have left no mark on his art. Another ruin, the vast amphitheater, capable of seating more than twenty

A VIEW OF THE ARENA AT ARLES, 1888 Oil on canvas, 73 x 92 cm

thousand spectators in ancient times, dominated the center of Arles. Although he attended occasional bull-fights there, van Gogh featured this edifice in only one painting (above), in which the architectural framework of the ancient ruins is obscured by the bustling movement of the crowd evacuating their seats. Vincent's contempt for traditional history painting, which incorporated neoclassical motifs inspired by Greco-Roman culture, emerges in a letter to Theo in which he dismisses "all those historical paintings that they keep on painting and painting, by yards and yards. What is the use of it and why do they do it? After a few years it generally gets musty and dull, and becomes less and less interesting."14

It was in the Public Garden, near his house, that van Gogh found one of his favorite motifs. In this spacious setting, one escaped Arles to repose in an enclave of nature, where foliage largely screened out the dominant architectural features of the city. But cultivated nature was here overlaid with history and literature for van Gogh: he recalled that Petrarch had lived in nearby Avignon, and he associated public gardens like this one with the Renaissance, noting that "the ordinary public garden contains plants and shrubs that make one dream of landscapes in which one likes to imagine the presence of Botticelli, Giotto, Petrarch, Dante, and Boccaccio."15

Arles was caught somewhere between a French agrarian village and a modern city. Small yet bustling, the city had entered the modern world of commerce and technology. Since mid-century, a railroad had linked it with Paris. Van Gogh's landscapes register the smokestacks of modern industry as readily as his pictures of Montmartre admit the visual evidence of industrial life in Paris suburbs (p. 58).[16] Local manufacturing included the production of railway engines, and the city boasted modern gasworks whose tall towers competed with church spires to dominate the skyline.[17]

The city's identity was also intimately linked with its countryside. In spite of the presence of industry and ample evidence of modernity, Arles was still the center of an agricultural region that produced almonds, olives, grain, and grapes. As a guidebook summed it up:

No countryside is better cultivated than that of Arles.... The activity is in the fields. As for the city [of Arles], it is always sunk in a profound calm.... Unlike Rome, where the tourist is shocked by the movement, activity, and fever of modern life that suppresses the archaeological wonders, Arles is never troubled in its meditations. The population, who successfully farm the area, is spread out around it. While the city itself is certainly not dead, it sleeps, and the artist can himself dream there at his leisure.[18]

Provence offered van Gogh not only a fresh start, but a cherished escape. The ambiance of the area soothed the anxieties that had so unsettled him in Paris. Arles would be a refuge for painters of the *petit boulevard*: "For many reasons, I should like to get some sort of little retreat, where the poor cab horses of Paris — that is, you and several of our friends, the poor impressionists — could go out to pasture when they get too beat up."[19] As he developed this dream of a colony, he imposed on Provence two complementary paradigms of artistic community. Neither was rooted in van Gogh's direct experience; rather, both were utopian fantasies of how artists might live productive lives in communities tied closely to nature. The first

paradigm was that of the traditional culture and nature of Japan; the second was van Gogh's mythologized idea of the Barbizon community of artists that had thrived in the Forest of Fontainebleau near Paris during the decades following the 1848 Revolution. Over the course of 1888, these two paradigms emerged sequentially in his formulation of the Studio of the South; the two models then developed simultaneously as he prepared for his communal experiment with Gauguin at the Yellow House.

For van Gogh, Japan was a mythic world where art and the spirit flourished, and where, he thought, man could thrive in harmonious balance with nature. Provence held out the promise of such a world and, during his first months there, van Gogh identified it with Japan — or at least, his shifting, idealized notion of it.[20] He arrived in an unusual snowstorm; we might expect him to have seen the landscape in terms of impressionist snow scenes, or as a variation of the Dutch countryside. But those visual frameworks represented worlds he had left behind. Instead, van Gogh imagined that "the landscapes in the snow, with the summits white against a sky as luminous as the snow, were just like the winter landscapes that the Japanese have painted."[21]

Van Gogh's vocabulary of Japanese landscape and aesthetic was based on a visual repertoire he had acquired largely in Paris. He had already begun to collect Japanese prints by 1885, while he was still in Antwerp, being attracted to their subjects: "Little women's figures in gardens, or on the beach, horsemen, flowers, knotty thorn branches."[22] The prints offered him a new frame for viewing the familiar and the mundane, like the docks and quays of Antwerp, which now became "fantastic, peculiar, unheard of... the figures are always in action, one sees them in the queerest surroundings, everything fantastic, and at all moments interesting contrasts present themselves." He even used this new "exotic vision" to distinguish himself from his brother, writing "I should like to walk there with you, just to know whether we see alike."[23] This exotic frame of reference was authenticated for

Vincent in the writings of such aesthetes as Edmond de Goncourt. De Goncourt's taste, evident in a novel such as *Chérie*, which Vincent read at this time, informed van Gogh's perceptions of Japanese art and reinforced the construction of his identity as an artist. Thus his love of Japan's art served as a kind of initiation into avant-garde identity and into the artistic eclecticism of the fin de siècle.

In Paris his interest in Japan had matured. This was certainly due in part to increased exposure to Japanese art in the collections of friends and in the print shop of Samuel Bing (and perhaps that of Tadamasa Hayashi as well). He and Theo assembled a collection of several hundred prints.[24] He was attracted to the stimulating array of bright colors, intriguing subjects (particularly women, flowers, and landscape), and new textures. He also used these prints as vehicles with which to mark his avant-garde identity and to assert his own agenda for creating a "new" painting.[25] In three instances van Gogh copied Japanese motifs in large scale in oil paint. Yet these copies, such as that of a Hiroshige print of

Vincent van Gogh, *Japonaiserie: The Flowering Plum Tree (after Hiroshige)*, 1887, oil on canvas, 55 x 46 cm

a flowering plum tree (below), are far more than reproductions: they clearly establish van Gogh's distance from his exotic source and declare an aesthetic hybrid of French and Japanese art.[26]

The exotic allows, encourages, and may even serve to authenticate an artist's experiments. In *Japonaiserie: The Flowering Plum Tree (after Hiroshige),* van Gogh intensified the colors of the print and transformed its matte surface into the uneven texture of the painting's surface. He enclosed the image in a brown border and superimposed it over a field of pungent orange to create the effect of a hanging scroll. On either side of the image, he copied a string of Japanese characters, which have no relation to the content of the picture: they appear to be borrowed at random from a Japanese print; they indicate the address of a brothel.[27] Van Gogh appropriated the calligraphy, both to reference the exotic culture and to participate in the avant-garde's investigation of margins and borders. While Seurat was painting borders in pointillist dots to emphasize the transition from field to support, van Gogh borrowed Japanese script to explore the autonomy of the painted mark. His inability to read the Japanese script freed him to engage in a process of semiotic exploration that anticipates Picasso's cubist experiments with letters and words.

For van Gogh the Japanese print was also a token of the activity of the painters of the *petit boulevard*. In the spring of 1887 he organized an exhibition of his own collection of Japanese prints at the Café du Tambourin at 62, boulevard de Clichy in Montmartre, a place frequented by the *petit boulevard* painters. Showing in this unconventional venue, colonized by impoverished artists seeking alternative spaces, was important to van Gogh as a marker of his contribution to the avant-garde community. He later recalled how the exhibition of his Japanese prints had influenced Anquetin and Bernard.[28]

Van Gogh used prints from his own collection in the background of an ambitious portrait of one of the central figures of the *petit boulevard*, his friend Père Tanguy, the art supplies dealer (p. 123). In Tanguy's shop

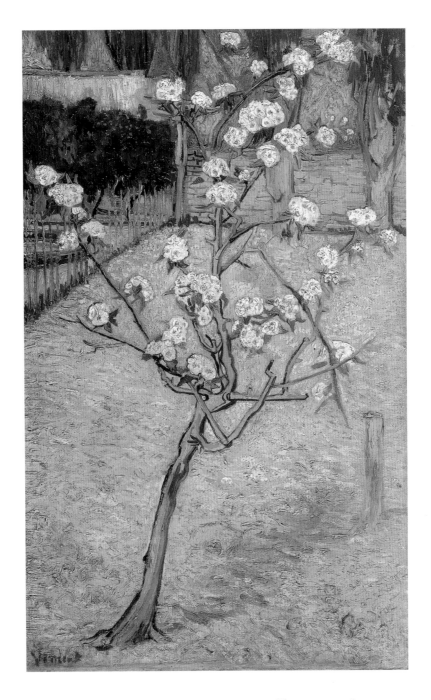

PEAR TREE IN BLOSSOM, 1888 Oil on canvas, 73 x 46 cm

on the rue Clauzel, which was on the way to Theo's gallery from the brothers' apartment, Vincent met Paul Signac, Bernard, Charles Angrand, and probably Paul Cézanne and Gauguin. The significance of Tanguy for Vincent is clarified by a letter to Theo sent from Arles: "Here my life will become more and more like a Japanese painter's, living close to nature like a petty tradesman. And that, as you well know, is a less lugubrious affair than the decadent's way. If I can live long enough, I shall be something like old Tanguy."[29] He resists the memory of Montmartre's brothels and nightclubs, with their associations of decadence, and embraces the ideal of the ordinary worker, productively suited to his job. Tanguy's socialist politics are reflected

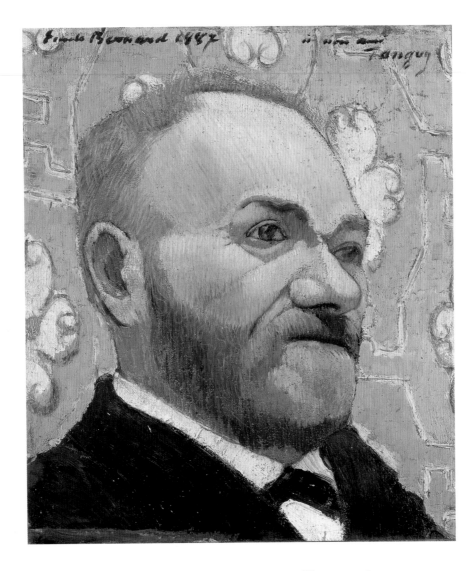

PORTRAIT OF PERE TANGUY, 1887 Oil on canvas, 36 x 31 cm

in his humble clothes and blue worker's jacket.[30] Yet his posture is dignified, even noble, with hands firmly clasped in his lap, conveying the serenity of a seated Buddha.[31] Tanguy is surrounded by Vincent's Japanese prints. These are not meant to evoke Tanguy's shop (which did not sell such prints), but rather are emblems of a utopia the artist had already begun to formulate: abundant nature, graceful femininity, and rich aesthetic diversity. Van Gogh idealized Tanguy both as a humble worker and as a leader of his small circle of artists; what he experienced in Tanguy's shop helped van Gogh formulate his vision of an artists' colony.

Van Gogh's idealization of Japan reached its zenith in the summer and early fall of 1888, as he was planning his Studio of the South, decorating the Yellow House, and anticipating the arrival of Gauguin, who would be his first and only collaborator there. His letters and art reveal that his idea of Japan as a cultural paradigm was based on a number of intersecting notions about a timeless, traditional culture: that Japan itself was a natural paradise; that the Japanese artist was more sensitive to and lived more closely with nature than did the modern European artist; that Japanese decoration was consistently harmonious and simple; that Japanese

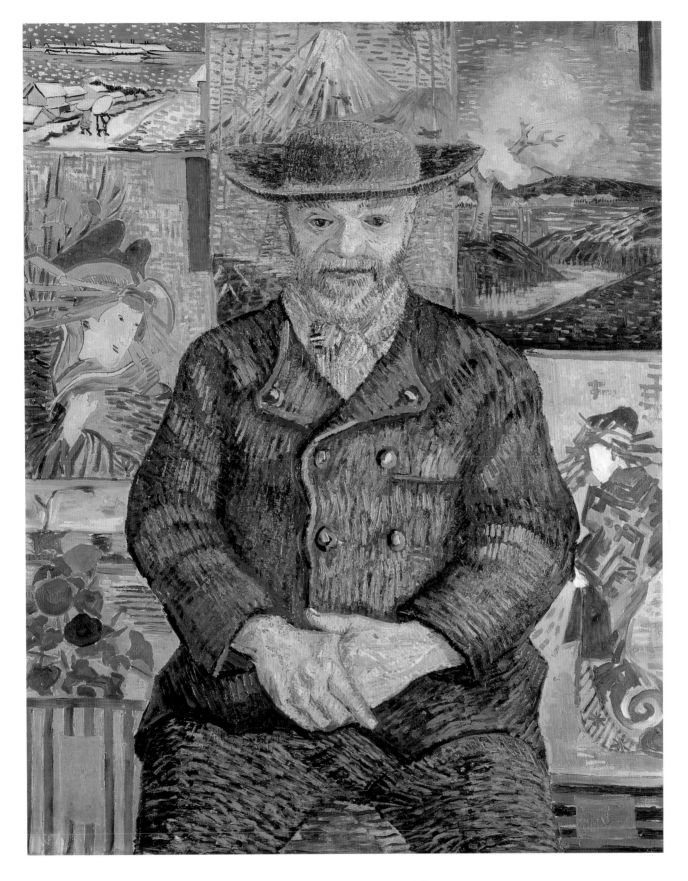

PORTRAIT OF PERE TANGUY, 1887–88 Oil on canvas, 92 x 75 cm

girls blossomed at an early age into appealingly docile and servile women; and that Buddhist monks lived an ideal life of simple meditation—a life that perhaps could be adapted by a humble artist in the monastery-like environment of the Studio of the South. Van Gogh had neither the means nor the inclination to travel to Japan itself. It was the idea of the place—malleable and contingent—that held the allure. He deemed moving to the South to be the perfect consequence of his Japanese period in Paris: "About this staying on in the South...consider: we like Japanese painting, we have felt its influence....then why not go to Japan, that is to say, to the equivalent of Japan, the South?"[32]

Vincent saw this equivalence in the brilliant colors and bright sun of Provence. He wrote to Theo, "...you know that I came to the South and threw myself into my work for a thousand reasons. Wishing to see a different light, thinking that looking at nature under a bright sky might give us a better idea of the Japanese way of feeling and drawing."[33] His concept of the stunning and varied nature of Japan had been reinforced by an article he had read in *Le Japon illustré*: "One of the wonders of the Japanese flora is the flowering cherry tree, which sometimes covers an entire mountain and which gives it the appearance of a pink cloud. The birds, the brilliant insects flying around the flowering trees: all in nature seems to be as if in a festival."[34] Vincent's depictions of flowering fruit trees in Arles indeed reflect the elegance and bold focus of the Japanese compositions he had collected, studied, and painted in Paris. His blossoming pear tree (p. 121), painted in early April as spring was spreading across Provence, is a delicate yet bold composition that emphasizes, in the manner of his copy of Hiroshige's plum tree (p. 120), a linear tangle of branches decked with floating orbs of fragile blossoms.

Here we may note the differences between the Japonism of van Gogh and that of Gauguin. Whereas van Gogh absorbed from his collection of prints a cultural and natural paradise, which he then grafted onto his experience in Arles, Gauguin looked to Japanese art more as a stimulating formal alternative

to the illusionistic conventions of European art. In *The Vision after the Sermon* (p. 114), for example, Gauguin appropriated from Japanese art the strong diagonal tree trunk that boldly bisects the middle ground of the picture, and in the wrestling figures of Katsushika Hokusai he discovered the prototypes for his painting's biblical wrestlers.[35] But Gauguin never saw Brittany as a new Japan: his primitivist ideals were incompatible with the refined, elegant, and ritualized world that inspired van Gogh. Gauguin's exoticism drove him further afield where he adopted paradigms of medieval or "savage" civilizations, where he could cultivate his relationship to both nature and culture far removed from the modern Europe he now thought of as *pourri*, or rotten.

Japonist[36] literature circulating in fin-de-siècle France generally focused on traditional culture, not on the social realities of a country undergoing rapid industrialization and opening up to international commerce. Most French authors saw Japan as frozen in a timeless premodern purity; it provided the perfect antidote to the ills of Europe's urban modernity. Such idealization was present in most of the widely read travel accounts published in the decades following the opening of Japan to the West, including a volume by Emile Guimet read by van Gogh: "How the Japanese are lovers of nature! They know how to profit well from its beauties. They know how to organize a life that is convenient, tranquil, happy, without grand needs, without struggles, and full of sweet impressions and wisdom...how they love art and beauty, and appreciate study and work."[37]

In such accounts the Japanese artist emerges as a sensitive artist-philosopher who lives harmoniously with a sympathetic nature. In his preface to *Le Japon artistique*, Samuel Bing asserted that the Japanese artist is:

at the one and the same time, the enthusiastic poet moved by the grand spectacles of nature, and the keen-eyed observer blessed with the ability to capture the intimate mysteries concealed in the infinitesimal.

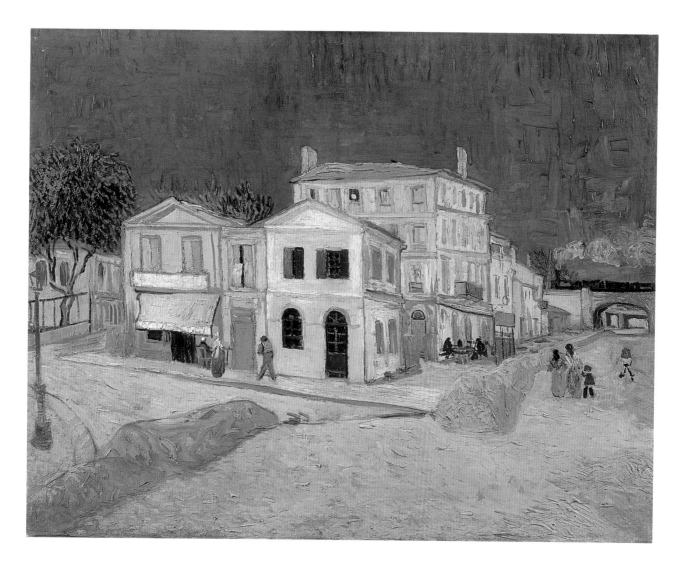

VINCENT'S HOUSE IN ARLES, THE "YELLOW HOUSE," 1888 Oil on canvas, 72 x 91.5 cm

In a word, he is convinced that nature contains the primordial elements of all this, and believes that there is nothing in creation, not even the smallest blade of grass, which does not deserve a place in the elevated conceptions of art.[38]

As Vincent contemplated the role of the artist in his Studio of the South in the weeks before Gauguin's arrival in Arles, he echoed this passage in his praise of the Japanese artist who "studies a single blade of grass. But this blade of grass leads him to draw every plant and then the seasons, the wide aspects of the countryside, then animals, then the human figure…. And you cannot study Japanese art, it seems to me, without becoming much gayer and happier, and we must return to nature in spite of our education and our work in the world of convention."[39] Van Gogh's ideas of the Japanese artist allowed him to authenticate his own experience of Provençal nature and to construct a role for himself as the sensitive student of nature living in harmony with a bountiful world. Van Gogh's primitivist impulse here participates in the larger nineteenth-century European concept of Japan as a land still able to provide natural, authentic,

and individual experiences.[40] Whereas Gauguin ultimately suffered extreme disappointment in not finding such satisfactions in Polynesia, van Gogh continued regenerating the dream throughout his two years in Provence. He could do this because, unlike Gauguin, he never moved to the exotic country that was the source of his vision of paradise.

Japan, to van Gogh, was also the home of beautiful, simple, and elegant design. It is one of the aesthetic models he clearly had in mind as he planned the Studio of the South, and as he subsequently decorated his house in Arles, the Yellow House (p. 125). He rented the two-story building at 2, place Lamartine on 1 May 1888 and spent the summer making needed repairs, repainting, and installing gaslights. He had the exterior painted a bright, sunny yellow; the interior walls became a crisp, clean white. Here would be his own bedroom, a studio, a kitchen, and a room for guest artists. He extended invitations generously: to the American painter Dodge MacKnight, to the Belgian Eugène Boch, to Bernard, to Charles Laval, and to the Danish painter Christian W. Mourier-Petersen.[41] Only Gauguin, after many invitations, and with financial encouragement from Theo in Paris, accepted the offer. Gauguin's arrival on 23 October initiated the first and only session of the communal Studio of the South; his abrupt departure on 26 December ended the experiment, and van Gogh returned only occasionally to work there following his hospitalization that winter. It was more a place of dreams than a home for actual artists.

Van Gogh expended great care on the furnishing and decoration of the Yellow House. Two essential concepts guiding him were the aesthetic of the Japanese interior and an idea of the communal lodgings of the Barbizon artists. Vincent's abundant ideas on Japan came from the interiors he saw depicted in his own print collection, but also from exotic literature, particularly the novel *Madame Chrysanthème* by Pierre Loti (see p. 128). He told Theo that this book "gave me the impression that the real Japanese have *nothing on their walls*, that description of the cloister or pagoda where there was *nothing* (the drawings and curiosities all being hidden in the drawers). That is how you must look at Japanese art, in a very bright room, quite bare, and open to the country."[42]

This idea, while indeed a response to a particular aesthetic, is also conceived as a critique of the bourgeois values that van Gogh, Gauguin, and other members of the avant-garde were at pains to disavow. The city, for them, was a place of rampant conspicuous consumption where social status was defined by wealth. The Studio of the South would be cleaner, purer. Significantly, the clean room so admired by Vincent is framed in *Madame Chrysanthème* by a comparison with the pointless materialism of curio collectors in Europe who have misunderstood the spirit of the Japanese aesthetic:

I cannot help smiling when I think of some of the so-called *Japanese* drawing rooms, overcrowded with knick-knacks and curios and hung with coarse gold embroideries on exported satins, of our Parisian fine ladies.... The true Japanese manner of understanding luxury consists in a scrupulous and indeed almost excessive cleanliness, white mats and white woodwork; an appearance of extreme simplicity, and an incredible nicety in the most infinitesimal details.[43]

As Vincent prepared his Yellow House in the summer of 1888, he received packages of Japanese prints from Theo to decorate the walls. He hung them in the studio amid prints by Honoré Daumier, Théodore Géricault, Eugène Delacroix, and Jean-François Millet. He kept the Japanese aesthetic in mind, complaining to Theo about the usual clutter of the artist's studio and striving to create an aura of tranquility: "You cannot think what peace of mind it gives me, I am so set on making an artist's home but one for practical use, and not the ordinary studio full of knick-knacks.... Have you read *Madame Chrysanthème* yet?"

Van Gogh's enthusiasm for Japanese decor came from his reading of French texts on Japan.[44] He strove for the brightness and lightness of the Japanese interior, which usually had bright white or yellow wood floors

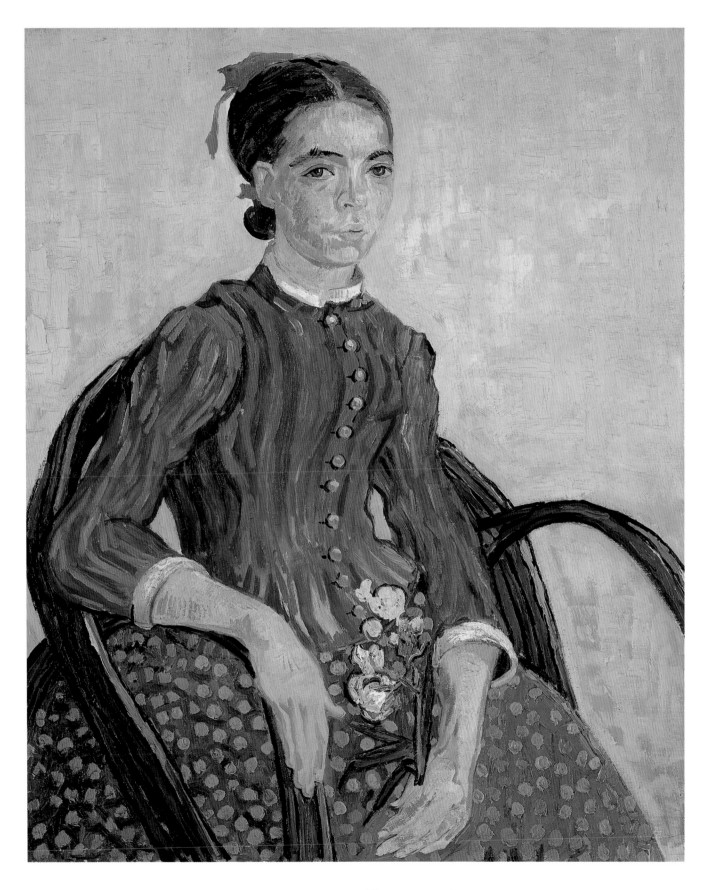

LA MOUSME, 1888 Oil on canvas, 73.3 x 60.3 cm

and wainscoting. He knew of the Japanese *kakemono*, a picture or writing on silk or paper often hung at the back of a niche in the wall of the Japanese home.[45] This niche, called a *tokonoma*, was described by Félix Régamey, an artist who accompanied Emile Guimet to Japan in 1878, and whose art incorporating Japanese motifs had been known to van Gogh since his time in Antwerp. In the *tokonoma,* explained Régamey in an account of his travels, there often "is placed, as in a sort of sanctuary, an object of art, or one of those bouquets of flowers which are veritable marvels of grace and composition."[46] This idea of a wall with a little domestic altar, decorated with an arrangement of flowers, may have encouraged van Gogh to decorate the walls of his studio with his brilliant paintings of sunflowers. In August 1888 he considered producing as many as twelve sunflower still lifes for the Yellow House; in the end, he painted only four, and he put the two best in Gauguin's bedroom.[47] A still life of flowers is not, of course, a Japanese idea, but van Gogh's idea of decora-

Lucius Rossi, illustration from Pierre Loti, *Madame Chrysanthème,* 1888

ting his *maison d'artiste* with these painted bouquets was consonant with his understanding of the Japanese style of interior decor.

Vincent focused his Japanese lens on typically Arlesian subjects, fusing his inventive exoticism with Provençal regionalism. A key example is his seemingly unlikely linkage between an adolescent Arlésienne and a Japanese girl. His subject was a village teenager in a brightly striped dress with a prim white collar, and with a pert red bow in her hair (p. 127). In her lap she holds a stalk of oleander, which Vincent associated with love, and which he had considered planting at the entrance of the Yellow House.[48] Her wide-eyed yet tentative gaze, thin torso, small chest, and extremely long hands indicate a still gawky young teenager. In July 1888 Vincent informed Theo that he had painted a *mousmé*: "And now, if you know what a 'mousmé' is (you will know when you have read Loti's *Madame Chrysanthème*), I have just painted one.... A 'mousmé' is a Japanese girl—Provençal in this case—12 to 14 years old. That makes two portraits now, the Zouave and her."[49]

This letter indicates, significantly, that he thought of his new portraits as being less of particular individuals than of social types he had encountered in Arles. The Zouave was a member of a regiment known for its battlefield performance and alleged sexual prowess. In opposition to such worldly masculinity, Vincent painted the *mousmé* as an ideal of feminine youth and innocence. Both figures correspond to the artist's new notion of the modern portrait, by which he sought to generalize about human experience through an icon-like figure. Significantly, Vincent did not refer to his model by her name: he reduced her to a type, an exotic and youthful example of the Arlésiennes he admired, but with whom he had had little direct contact. Tsukasa Kōdera has convincingly identified the model for the *mousmé* as a girl who had also posed for Mourier-Petersen.[50] A comparison between their two renderings indicates that van Gogh made the girl's mouth more pouting, her cheeks fuller, and her overall countenance less confident.[51] She holds the stalk of

oleander in a position over her lap that suggests her blossoming sexuality. Like the stereotyped Japanese women Loti wrote about, she is beautiful, docile, and full of promise.

Madame Chrysanthème is an egregiously racist variation on Loti's stock tales of romance between European sailors and indigenous young women. The novel essentializes the young Chrysanthemum as a servile exotic woman, describing her as timid, modest, dainty, and with a "charming pout…half sulky, half smiling."[52] Loti first uses the term *mousmé* to describe young girls working in a teahouse: "the word *mousmé* means a young girl, or very young woman. It is one of the prettiest words in the Niponese language; it seems almost as if there were a little *moue* [pout] in the very sound."[53] Loti, like many European authors discussing exotic women, generally infantilizes his subject, describing *mousmés* as having "little narrow eyes peeping between slit lids like those of a newborn kitten, fat pale little cheeks, round, puffed-out, half-opened lips. They are pretty, nevertheless, these little Niponese, in their smiles and childishness."[54] Van Gogh may have been inspired by the Loti book, but his young girl is not as openly childish, silly, and coy as is Loti's cliché of the *mousmé*. Rather, he has taken from Loti's tale the qualities of a young Japanese woman's growing self-awareness that are at once psychological and physical. Her talisman of beauty, the oleander, is perhaps the most obviously Japanese touch in the picture, as its budding pink leaves echo the simplicity of the *Pear Tree in Blossom* (p. 121) and van Gogh's other Japonist works from this period.[55]

Van Gogh's most direct identification of himself with a Japanese concept is also a manifesto for the Studio of the South. This is in his intense and iconic *Self-Portrait* (p. 112), painted in September 1888 and inscribed at the upper left "à mon ami Paul G[auguin]."[56] It is the first close-up self-portrait he painted in Arles, and he finished it just in time to

Félix Régamey, *Buddhist Priests*, 1878, published in Félix Régamey, *Japan in Art and Industry*

hang it in the Yellow House when he moved in. The picture is intense, compelling, and confident. In the emphatically simple pale malachite background, bands of green radiate from the artist's shaven head, concentric haloes of pure, vibrating hue. The energy here is one of mind; the message, one of sober determination and commitment. The painting documents rigorous self-examination.

What was important about this picture to Vincent emerged only gradually in his letters, suggesting that he developed the concept as he worked on the painting. When he first described the picture to Theo, he mentioned only questions of color. In a letter soon thereafter to his sister Wil, he revealed that in the new portrait he looks "like a Japanese."[57] While Vincent probably did not make the picture with the express intention of giving it to Gauguin, he did so once he, Gauguin, and Bernard agreed upon an exchange of self-portraits.[58] In early October Vincent revealed to Gauguin the more substantial association he had with this image:

I have a portrait of myself, all ash-colored. The ashen gray color that is the result of mixing malachite green with an orange hue, on pale malachite ground, all in harmony with the reddish-brown clothes. But as I also exaggerate my personality, I have in the first place aimed at the character of a simple bonze worshiping the Eternal Buddha…. It will even be

necessary for me to recover somewhat more from the stultifying influence of our so-called state of civilization in order to have a better model for a better picture.[59]

Van Gogh thus figured himself as a bonze, an artist-priest, who would found the Studio of the South as a monastery-like commune devoted to the study of art, not god. (The word *bonze* is not Japanese: it is a French term used in travel accounts to describe a Buddhist priest.[60]) Van Gogh's reading about Japan exposed him to concepts of the bonze that clearly inform his self-figuration. For example, he read in Guimet's *Promenades japonaises*: "The bonze has a shaved head like a Benedictine monk. He dresses in a gray robe. His appearance is intelligent, slightly mocking, and with an expression full of reserve."[61]

Similarly, in *Madame Chrysanthème*, van Gogh encountered both written and visual descriptions of bonzes, in Loti's text and in the accompanying illustrations by Lucius Rossi and Félicien de Myrbach. Loti's bonzes dress in black robes and have shaven heads; they inhabit "empty rooms spread with mats of the most unimpeachable whiteness"; they live in "elegance made out of nothing, of the most immaculate and incredible cleanliness."[62] An illustration of bonzes by Félix Régamey (p. 129), very likely known to van Gogh, exemplifies the physiognomic type that informs this self-portrait: the head is shaven, the face emaciated; the brows furrowed. Even if van Gogh did not set out to portray himself as a bonze, the resemblance must have occurred to him as he worked on the self-portrait. He may well have conceived it in tacit competition with Gauguin, matching his exoticist interest in Japanese Buddhism to Gauguin's primitivist resurrection of Celtic Catholicism in his works of the previous summer, like *The Vision after the Sermon* (p. 114).

The Studio of the South would, notionally, function like a monastery inhabited by artist-monks dedicated to their work. His proposal to Gauguin in June 1888 had been very precise: "…it would seem to me that if I could find another painter inclined to work in the South, and who, like myself, would be sufficiently absorbed in his work to be able to resign himself to living like a monk who goes to the brothel once a fortnight—who for the rest is tied up in his work…it might be a good job."[63] Van Gogh had no actual monastery to offer, as had the Nazarenes living in Rome around 1810. And he did not propose a secret brotherhood, as had the Pre-Raphaelites. But van Gogh shared with these idealists a belief that working in a community with a common aesthetic (if not moral) agenda would produce compelling new art. What he was not prepared for was how difficult it would be for two passionate, opinionated, and self-absorbed personalities to survive the mundane reality of living together.

The Studio of the South: Partnership in Practice

From late October to late December 1888, van Gogh and Gauguin lived and painted together at the Yellow House in Arles, and put to the test Vincent's ideal of a Studio of the South. Their collaboration was in many ways a stunning success: the artists worked productively, each trying out aspects of the other's style while confirming his own artistic direction. But the partnership was volatile and disappointingly brief. Theo and Vincent had hoped Gauguin would stay in Arles for six months, but the ménage suffered strain nearly from the outset. Neither artist was particularly suited to accommodating the needs of another person on a daily basis. The two engaged in heated debates over aesthetic and professional matters. They agreed on many points: the value of Japanese art, the inventiveness of Bernard's work, and the importance of such French artists as Eugène Delacroix, Pierre Puvis de Chavannes, Paul Cézanne, and (although Gauguin was loath to admit it in 1888), the liveliness of Daumier's line. Yet a trip to a museum at Montpellier, and the arguments that ensued, exposed essential differences. Vincent remained attached to nature and the model; Gauguin favored working from the imagination and memory. Vincent loved rich surfaces of thick impasto; Gauguin preferred a dry, thin application of paint. Vincent sought

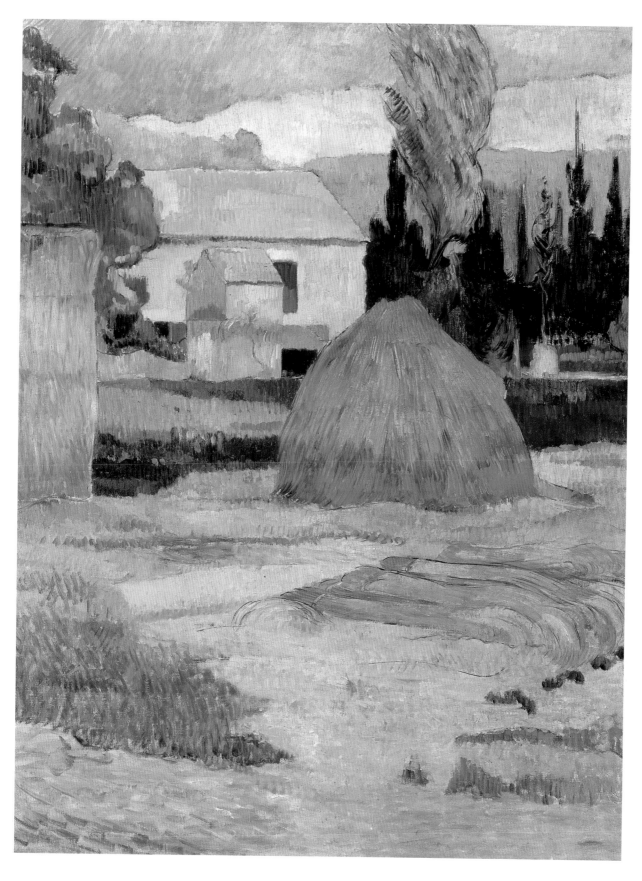

FARM AT ARLES, 1888 Oil on canvas, 90.2 x 70.5 cm

the universal in the quotidian; Gauguin searched for meaning in the exotic and esoteric. To clarify the contrast for Bernard, Gauguin wrote of van Gogh, "He is romantic, while I am rather inclined towards a primitive state."[64] Even had the dramatic episode not erupted in late December, it seems probable that the restless and dissatisfied Gauguin would have abandoned their mutual project sooner rather than later.[65]

A comparison of two portraits made by the artists of the same sitter exemplifies their successful working relationship, even as it offers insight into the distinction between their personal aesthetics (pp. 47 and 49).[66] The subject is Madame Augustine Roulin, the wife of Vincent's friend, the postman Joseph Roulin. She had recently given birth, and while Gauguin's portrait gives no indication of her family status, seven of Vincent's eight portraits of her endow her with a maternal identity.[67] The artists probably began their portraits at about the same time, in early December 1888; Vincent's was left unfinished at the time he was hospitalized, and he finished it in late January 1889. He then produced four other versions, an indication of the picture's importance for him.[68]

Gauguin's sober picture challenges the conventions of portraiture. The figure of Madame Roulin is on the right side of the image, looking out but not engaging the viewer. Here Gauguin follows the model of Edgar Degas's painting *A Woman with Chrysanthemums* (1865; New York, The Metropolitan Museum of Art), a sensitive rendering of a model whose position at the right edge of the pictorial field directs our attention away from her body and to the floral bouquet at her side. Madame Roulin's ample figure balances the arresting and colorful fragment of one of Gauguin's paintings, visible on the wall behind her (p. 109). The painting is a considered fusion of three areas of pictorial interest: the striking picture behind the sitter's head, an area made all the more emphatic by the vibrant red at the upper edge; to the left of the sitter, a pale blue wall rendered in thinly applied parallel strokes that imitate the brushwork of Cézanne; and the monumental figure of Augustine Roulin, which

conforms to the curved contours of her chair. The strong black outline reveals the impact of the cloisonnist style Gauguin and Bernard had developed earlier that year at Pont-Aven. The blue line that embraces her face and the rhythmic black line that encompasses her green dress and her pulled-back hair are reiterated by the contour lines in the foreground of *Blue Tree Trunks, Arles* behind her. Competing horizontal and vertical masses assert a rigorous geometric order that is softened and harmonized by a liberated calligraphic line and by the repetition of the dominant hues of blue, green, and red and yellow flesh tones.

In contrast, Vincent painted a monumental portrait in which Roulin's figure clearly plays the dominant role. His colors — saturated and rich red, yellow, and green — contrast with each other more boldly than do Gauguin's muted hues. The brushwork is thick and undulating in the clothing; the example of Cézanne echoes here as well in the striations that denote hair and in the bold spatial inconsistency generated by the disjuncture of the line where the floor meets the wall. Van Gogh invested far more interest in the subject, who becomes an icon of maternal comfort. He imagined hanging his picture as a decoration in a fishing boat in Loti's novel *Pêcheur d'Islande*, where it might comfort the lonely sailors as they go to sleep to the rocking of their own ship.[69] Roulin grasps the line that rocks the unseen cradle; as Carol Zemel has noted, the fragment of the cradle cord also suggests a rosary, reinforcing the religiosity of the picture.[70] The figure is enthroned before a dense background of floral wall-paper. Pink and white flowers emerge like glowing medallions, reminiscent of the jewels that decorate medieval icons. Writing about this picture, Vincent clarifies the religious connotations of his subject: "…you will see it in 'La Berceuse,' … if I had had the strength to continue, I should have made portraits of saints and holy women from life who would have seemed to belong to another age, and they would be middle-class women of the present day, and they would have had something in common with the very primitive Christians."[71]

Again he finds the archaic and the spiritual in the everyday. Months after he completed his pictures of Mme. Roulin, he proposed to Theo that *La Berceuse* might be hung in the style of a triptych, flanked by two of his sunflower paintings,[72] a fitting installation for a secular madonna who embodies both compassion and spiritual authority. Van Gogh's use of vibrant organic shapes in a decorative aura around his female model is a pictorial device Gauguin returns to later in his own work, most notably in his Tahitian painting *Manao tupapau (The Spirit of the Dead Keeps Watch)* (1892; Buffalo, Albright-Knox Art Gallery, W457). But for Gauguin, the challenge of locating the spiritual required more than admiration of a maternal wife of a postman. Gauguin's odyssey began in his exploration of the Celtic Catholicism of Brittany, and it would continue across the Pacific in his encounters with the more exotic religions of the Tahitians and Marquesans. The provincial inspirations of the Studio of the South were too limited to sustain him.

One of the most notorious episodes in the history of modern art is the charged disagreement between van Gogh and Gauguin, which culminated in van Gogh slicing off the tip of his own ear with a razor on 23 December 1888. Gauguin deserted Arles and his friend immediately thereafter.[73] The episode has long been at the core of the myth of van Gogh as a "mad" artist—a genius whose instability both inspired his art and cursed his life. It is useful to reconsider these events in the light of van Gogh's identification with Japanese culture.

A curious aspect of this episode is what van Gogh did with the fragment of his ear. While the various accounts tend to disagree over details and the exact chain of events, a brief article in a local newspaper probably represents an objective view. This document confirms that van Gogh took the severed ear fragment to a local brothel, asked for a prostitute named Rachel, and gave it to her, saying "Keep this object preciously."[74] For lack of any other plausible explanation, this act has usually been attributed, if not to perversion, then to the artist's "madness." Yet if we take van Gogh's statement at face value and think of the ear as, oddly enough, a precious gift presented ceremoniously to a particular prostitute, van Gogh's act may be understood, in some sense, as that of a devoted Japonist following certain time-honored practices of the Japanese brothel.

During the Tokugawa era (1603–1867), Japan had a culture of refined prostitution centered on Yoshiwara, an officially designated pleasure quarter of Edo (later Tokyo). Ritual and decorum circumscribed acts of sexual commerce, and some courtesans and their clients practiced *shinjū*, one meaning of which was, initially, a ritual exchange of love tokens between a courtesan and her client.[75] This probably began with a simple trading of love letters, sometimes sealed with drops of blood, which were saved by men in *shinjūbakos*, or "Testament Boxes," which could be shown to friends as tangible evidence of the devotion of their courtesans. As early as the seventeenth century, the practice escalated in the Yoshiwara quarter from the presentation of letters and snippets of hair to more extreme acts of physical self-sacrifice by courtesans who sometimes offered fingernails, and even severed fingers, to prove their devotion, particularly to one who was threatening to leave them for another.[76] The demand for such tangible reassurance increased to the extent that some courtesans who needed to satisfy more than one client offered them tokens of hair and nails taken from corpses, and some courtesans, desperate to save their fingers but eager to follow custom, sent lovers digits formed from rice flour. Some lovers performed self-mutilations as statements of love, stabbing their arms, legs, and even their genitals to declare their love. This culture of bodily sacrifice as a testament of love is the less extreme variant of the ultimate *shinjū*, a double love-suicide (achieved most often with daggers or razors), enacted in the face of thwarted romantic love and often connected with a loss of honor in an unsuitable love match. It is primarily with this violent demonstration of love through double suicide that the term *shinjū* is associated today in Japan.

While details of practices in the Yoshiwara quarter were not generally well known in France in the 1880s, accounts of violent acts of self-sacrifice and love-suicide by prostitutes and their lovers circulated in fin-de-siècle exotic literature, travel accounts, and popular magazines.[77] We might consider the tale of van Gogh's ear as a Japanophile's performance of *shinjū*, or a testament of love involving personal physical sacrifice.

I am not suggesting that van Gogh consciously enacted a Japanese practice; given what was apparently a state of considerable personal anguish, his self-mutilation probably was a spontaneous act that resulted from extreme anger or frustration over the imminent failure of the Studio of the South. Earlier that day Vincent had written to Theo that he knew Gauguin was disappointed in Arles, "the little yellow house where we work and especially with me," and that he feared Gauguin might soon leave.[78] At this moment, the culmination of several weeks of growing conflict between the two artists, the utopian dream of the Yellow House was imploding. Van Gogh may have turned to this extreme physical self-abuse as a way to express his immediate sense of loss. His decision to present the ear fragment to a particular prostitute — one of the few historically firm facts in this legend — suggests that at some point Vincent connected the self-mutilation with his sexual identity and probably with his deep yearning to secure, and to express, love. His view of himself as a lover was clearly tentative and vulnerable in the fall of 1888: not only was he confronted daily with the spectacle of Gauguin's swaggering and his profligate success with women, but he also envied the sexual prowess of his friend Milliet (p. 39), a second lieutenant in the Zouaves whose military career had, in van Gogh's view, improved his luck with women, while Vincent's occupation as a painter had compromised his own.[79] In presenting his body part as a gift "to be treasured" by the Arles prostitute (and, as with the *mousmé*, Vincent may easily have conflated the exotic Japanese courtesan with the provincial Arlésienne), he may have been deliberately demanding the respect and loyalty accorded in the cul-

ture of Yoshiwara to a lover who performs self-sacrifice in the face of love's frustrations, or of shame to one's public honor. And for van Gogh, there was probably no greater disappointment than the dissolution of the Studio of the South and no greater loss than that of Gauguin's friendship and approval. That his sacrifice apparently elicited more fear than empathy from the prostitute or from Gauguin is a sad irony of van Gogh's frequent inability to maintain social relations. The episode clearly frightened off Gauguin, who was no doubt already seeking an excuse to leave Arles, and the scandal fueled the local perception of the Dutch artist as unstable and potentially dangerous.

Of course, such a reading of this mythic episode is speculative. If van Gogh ever offered any explanation of his actions, it has been lost to history. But van Gogh's identification with Japan that winter is undeniable. Further clues are evident in one of the first two pictures he painted on his release from the hospital in Arles in January 1889 (p. 135). This is the only picture painted by van Gogh in Arles that includes a direct appropriation from Japanese art. The artist, wearing heavy winter clothes, his head swathed in white bandages, presents himself as subdued, thoughtful, and vulnerable. His furrowed brow and wan face clearly register the toll of the previous weeks. The picture is a document of his exile from the "Japanese" utopia he conceived the preceding year as he painfully confronts the loss of the Studio of the South. Van Gogh positions himself between an open window, a Japanese print from his own collection on the wall, and an apparently empty canvas on an easel. The Japanese print, by Saeto Torakiyo, depicts an idyllic scene of geisha and cranes in verdant nature.[80] From the original print, van Gogh has selected the two dominant female forms and moved them, as well as the cranes and the impressive mountain peak, to the right side of the painted image of the print. The Japanese women, emblems of cultivated beauty, contrast poignantly with the sunken hollows of his cheeks. The blue and white contours of the mountain echo in reverse the dominant shape of the large bandage cradling his wounded ear. The form of

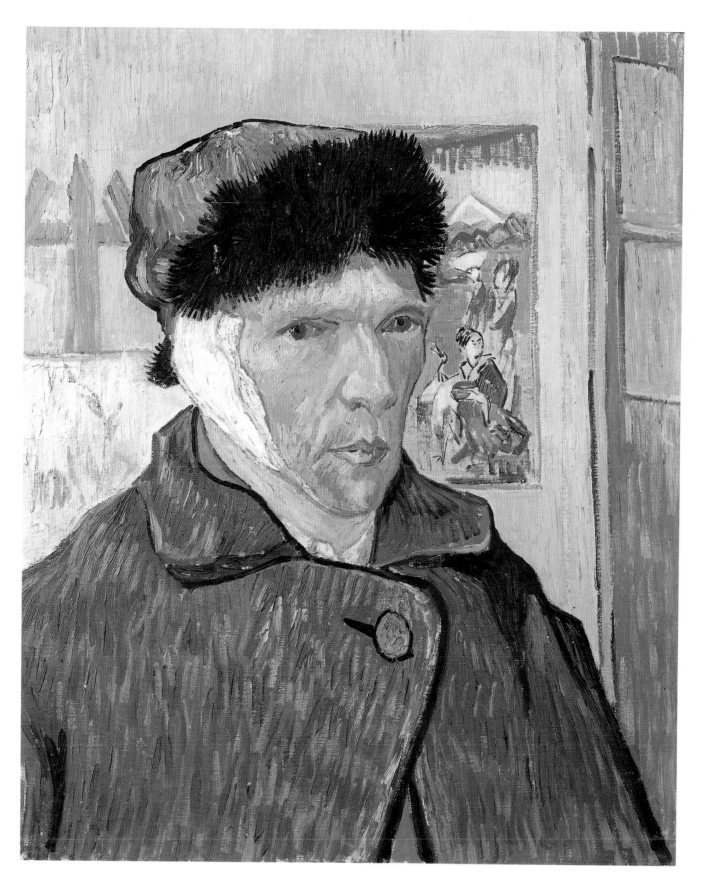

SELF-PORTRAIT WITH BANDAGED EAR, 1889 Oil on canvas, 60 x 49 cm

the artist's head is thus a painful counterpoint to the serene world of the Japanese print, itself a signifier of that utopian ideal he had tried to impose on the Provençal world outside his studio window. The canvas to his left at first appears empty. At the very least, it seems to refer to the difficulty of returning to work after the traumas of the previous month. But as a counterbalance to the Japanese print, the blank canvas registers far more—it expresses the exhaustion of the Japanese paradigm and van Gogh's decision to leave it behind. Close examination of the surface of the white paint applied to the image of the canvas on the easel strongly suggests that van Gogh first began to represent another Japanese figure on that surface.[81] His subsequent effacement of his own work, emphatically void in contrast with the natural plenitude visible in the print, marks his new distance and alienation from Japan/Arles, that once-fertile source of inspiration. The Provençal staging of his romance with Japan ended with this image of catharsis and lost ideals.

Legacies of the 1848 Generation: Barbizon and Daumier

Throughout the nineteenth century, the artistic practice of exoticism was often accompanied by an impulse to escape into Europe's own history. In conceiving the Studio of the South, van Gogh appropriated not only the exoticist paradigm of Japan, but also a historical model of what was in his view the apogee of avant-garde life in a rural French artistic community. This second ideal, the Barbizon community of the generation of 1848, predated his fascination with Japanese prints and also contributed significantly to the formulation of his utopian Studio of the South as an avant-garde colony. The particular role that Honoré Daumier played for van Gogh and Gauguin demands additional examination. His caricatures inspired both artists, and the myth surrounding his career in the late nineteenth century also played into van Gogh's conception of himself as a modern artist.[82]

The village of Barbizon, near the Forest of Fontainebleau in the countryside southeast of Paris, had flourished as an artists' colony since the early nineteenth century. Its fame increased at mid-century when artists such as Millet, Théodore Rousseau, and Charles Daubigny worked there. The Barbizon painters were models of artistic achievement: they had succeeded in the Salon and had worked within the expanding system of private dealers who marketed their idealized landscapes of the French countryside to a growing bourgeoisie that had a new interest in images of the country. Their fame was international; to the young van Gogh working in Holland and Belgium, they were better known than the less commercially successful impressionists of his own day. As early as 1880, Vincent yearned to join such a community of like-minded artists, and he expressed to Theo his "great and ardent wish to go to Paris or to Barbizon" because "certainly at Barbizon one would have more chance than anywhere else of meeting some more advanced artist, who would be as one of God's angels to me."[83] As he worked increasingly with peasant motifs and rural landscapes, his interest in the Barbizon artists increased. Gauguin's logic in choosing to work in Pont-Aven in the mid-1880s is echoed in a letter from Vincent to Theo in 1885: "To dwell and to live in the very midst of what one paints, for in the country nature has a new and different aspect every day. In short the two reasons for living in the country are: that one can work more there, and that one has less expenses."[84]

Vincent believed that these artists, whom he knew only by reputation, had formed not just a school of painting, but a kind of family, a community of kindred spirits. He imagined that they enjoyed a communal life that inspired great art and that they did not compromise their humanity by caring too much about their position in the social or artistic world. Van Gogh longed for such an extended professional family: "Now take, for instance, the painters of Barbizon.... The 'painter's family life,' with its great and small miseries, with its calamities, its sorrows and griefs, has the advantage of having a certain good will, a certain sincerity, a certain real human feeling. Just because of that *not* maintaining a certain standing, not even thinking about it."[85]

Honoré Daumier, *Le Vaudeville et le drame*, 1855, published in Loys Delteil, *Le Peintre-Graveur illustré: Daumier*

The model of Millet, as a painter who combined expressive description with painterly audacity in his pictures of peasants and farm life, had inspired van Gogh since his early career.[86] Millet was the essential touchstone for the fin-de-siècle painters who mythologized the country. Gauguin's *Harvest in Brittany* (p. 183), for example, echoes Millet's empathetic fusion of the contours of laboring bodies with the rhythms of the landscape. Young Emile Bernard shared in the avant-garde's growing praise for both the subjects and style of the "incontestable painter of the country and of peasants but also the grand poet of lines and values."[87]

Given the number of times Vincent copied Millet, and also the interest the two artists shared in conventional agrarian themes, it is hardly surprising that Millet was a central figure in Vincent's pantheon.[88] Yet it is also significant, although largely unacknowledged, that by the late 1880s van Gogh's utopia contained a great mid-century realist artist more associated with the city than the country, the caricaturist and painter Honoré Daumier. In his forty-year career in Paris Daumier had produced thousands of social and political caricatures, as well as paintings and drawings of daily life among the middle and lower classes of Paris. Although he was not a painter of the country himself, Daumier's social circle included the great Barbizon painters. His final years were spent in the town of Valmondois, and he was partially supported in his final years by the generous Camille Corot. His career as a prolific painter came to public light only in 1878 when Galerie Durand-Ruel in Paris staged a large retrospective of his work. It was at this exhibition that Theo van Gogh discovered Daumier the painter; later, in 1882, he recommended the paintings to Vincent, who had admired the artist's lithographs and wood engravings.[89] Once Vincent could imagine Daumier as an *artiste-peintre* as well, all of Daumier's art rose in his estimation. From 1882 on he encouraged Theo to buy as many Daumier prints as he could.[90]

Daumier's art, and caricature in general, underwent a revival in Paris in the 1880s. Because by that time the Second Empire events addressed by some of Daumier's art were history and provoked little controversy, the political meaning of much of the caricature had been neutralized, and it was possible to discuss it on aesthetic terms. Major exhibitions at the Ecole des Beaux-Arts reintroduced Daumier's caricatures to Paris, and books by Champfleury and John Grand-Carteret expanded the criticism and history of caricature.[91] By 1888 the critic Paul Mantz, when reviewing an exhibition of French masters of caricature at the Ecole des Beaux-Arts, could write nostalgically that neither "Gavarni" (S. G. Chevalier) nor Daumier had been superseded by subsequent talents. After these masters, the level of French draftsmanship had fallen, and "drawing has now lost its breadth and seductive grace."[92]

Van Gogh valued Daumier's use of physiognomy, gesture, and facial expression to convey human emotion. Regarding the print *Le Vaudeville et le drame* (above), Vincent observed that Daumier "has pith and a staid profundity; he is witty and yet full of sentimen-

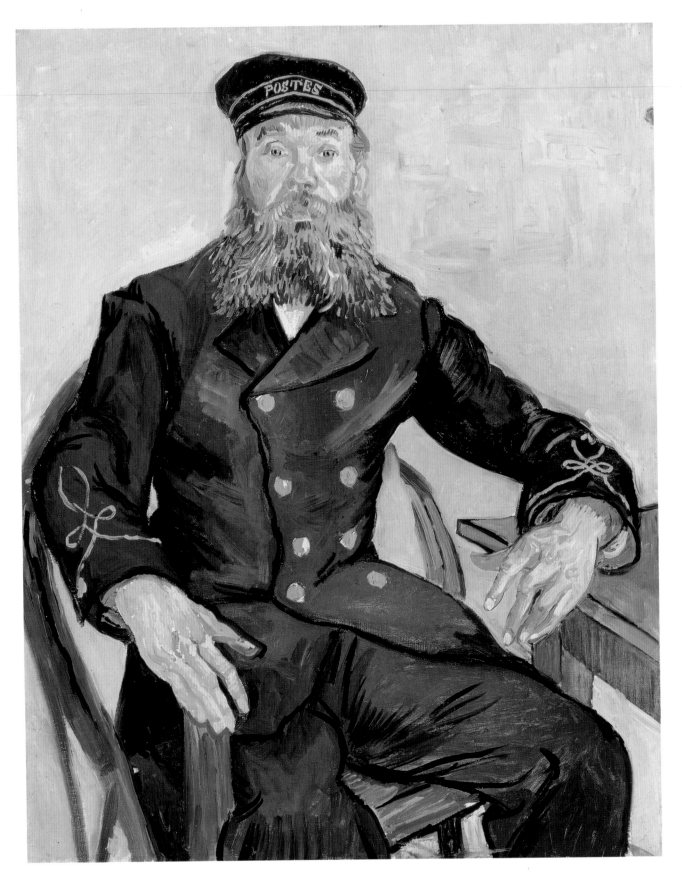

THE POSTMAN JOSEPH ROULIN, 1888 Oil on canvas, 81.2 x 65.3 cm

tal passion." The caricaturist was capable of an expressive distortion that Vincent admired. "People like Daumier—we must respect them, for they are among the pioneers."[93]

Not only Daumier's art but his career (or at least various myths surrounding it) intrigued Vincent, who applauded Daumier's anti-academicism: "... the proportions will sometimes be almost *arbitrary*, the anatomy and structure often quite wrong 'in the eyes of the academician.' But it [the figure] will *live*."[94] He imagined Daumier living a life of poverty, and as Vincent grew despondent over his own failures with dealers, he took solace in his belief that Daumier's drawings had not been appreciated in his own time.[95] He identified with Daumier as an artist whose work was also passed over by dealers and patrons with no taste, and he likened the modern art dealer to the pompous M. Prudhomme of Daumier's lampoons.[96] To van Gogh, Daumier was a renegade like himself, working outside the official art systems; he ignored Daumier's modest success in the Salon, his considerable sales of watercolors to collectors and dealers in the 1860s, and his ability to make an adequate living over many years of his life from his lithographs. The avant-garde needed its legends.

Daumier became most important to Vincent after his move to Arles. Perhaps it seemed appropriate to bring along to "the country" the humble and more intimate side of Parisian life registered in Daumier's amusing and pithy drawings. Theo wrote to him about the new monograph on the artist just published by Arsène Alexandre, the art critic.[97] Just as Vincent could see Japan in the landscapes of Provence, he could see Daumier in the people around him, "in the public garden, the night cafés and the grocer's." He observed to Theo, "it isn't a superb, sublime country, this; it is only a Daumier come to life."[98] And while he could imagine that Gauguin might find Brittany more beautiful, Vincent boasted that nothing there could surpass the beauty of the Provençal figures, who were "absolutely Daumier."[99] One finds echoes of Daumier's draftsmanship in many of Vincent's works after Paris:

in the gnarled and expressive hands of Madame Roulin (p. 47); in the summary contours of the bustling figures moving up a street in Auvers (p. 12); and even in the anthropomorphic undulation of tree trunks and branches in the olive grove (p. 44). Van Gogh's line, like that of Daumier, invades and animates, composing linear patterns that at once serve and resist description.

In Vincent's portrait of M. Roulin, the postman, painted in July 1888, several aspects of Daumier's style emerge (p. 138). First, the subject himself was worthy of Daumier. The man, "a Socratic type," drank heavily and had sung the "Marseillaise" with a spirit that seemed to Vincent more suited to 1789 than to 1888. The man's wife had just had a child, "and the fellow was aglow with satisfaction. He is a terrible republican, like old Tanguy. Damn it, what a motif to paint in the manner of Daumier, eh!"[100] This working-class sitter, seen by van Gogh as a revolutionary type animated by drink and self-satisfaction, was a subject that also would have appealed to Daumier. The man's expressive hands, his casual but self-conscious pose, the smug tilt of his head, and the generous black outline that contains the navy-blue field of the uniform all echo Daumier's style. Vincent's appreciation for the essentializing language of caricature contributed to his development of a new expressive portraiture of types: a teenage girl rendered as a stock character from a Loti novel; a postman conceived in the style of Daumier.

If the paradigm of Barbizon seems to conflict with the dream of Japanese purity, it should be remembered that van Gogh's ambitions were multiple and simultaneous. His Studio of the South would not only emulate a Japanese monastery in the fellowship of communal living, but become a new Barbizon, where he would find both an artistic and a social home. The Auberge Ganne, the Barbizon inn that had been a home to many landscape artists, was probably one example he kept in mind as the ideal artists' community. Closed after the war of 1870, it had been celebrated by many authors, including Vincent's favorites, the Goncourts, whose 1867 novel *Manette Salomon* was set at the inn. At this modest hostel, artists had lived "family style,"

eating, sleeping, and carousing together before heading to the woods to paint and draw *en plein air*. Such artists as Narcisse Virgile Diaz de la Peña, Rousseau, Charles-François Nanteuil, and Corot had collaborated on the decoration of the furniture, walls, and room partitions.[101] As Vincent prepared his own painted interiors for Gauguin, he thought of the ambiance of conviviality, sociability, and simplicity enjoyed by these artists. His letters prior to Gauguin's arrival complained bitterly of his loneliness, of days when he spoke to no one. The success of the Studio of the South seemed to depend in large part on the ambiance he could create and the participants he could attract.

For someone with little money, Vincent spent lavishly on furnishings. The expenses "are only meant to make a good impression on him [Gauguin] at the moment he arrives. I would like him to feel it all harmonious.... It would be a good stroke, like the old days when Corot, finding Daumier on the rocks, made life so secure for him that he found everything easy...."[102] And while the main decorations of Gauguin's room were to be Vincent's own paintings — the sunflowers in particular — he asked Theo for more Japanese prints and Daumiers to decorate the walls. The final decor in the studio, furnished with rustic chairs and a simple white card table, would "have a feeling of Daumier about it."[103] The Yellow House would be the refuge, the center, the "country house" on the edge of a natural paradise. He wanted to "make it really *an artist's house*."[104] It would be like living in a beautiful and exotic Barbizon. Or such was the idea that faded, along with Vincent's hopes for the Studio of the South, in the year that followed. He returned to the ideal of Barbizon repeatedly in his many copies of Millet and Daumier done during the Saint-Rémy period, and at Auvers, when he painted Daubigny's famous house and garden in that village (1890; Rudolf Staechelin Collection, F777). In the last days of his life, he perhaps found comfort (or was it melancholy reverie?) in this motif of a Barbizon artist's home whose vibrant garden was appointed with inviting chairs and featured the amusing presence of a prowling cat.[105]

In one of his last letters to Theo he asserted that he was "trying to do as well as certain painters whom I have greatly loved and admired."[106]

The Studio of the Tropics

For Gauguin, the Studio of the South was but one of several geographical alternatives to the Parisian modernity he disdained. Provence clearly held some interest for him, particularly in the intensity of its sunlight and the range of its natural color, but the landscape would never be as ruggedly beautiful as the Breton coast. Nor did he feel compelled to impose the full range of his primitivist ideals about spirituality and rural life on the Arlésiennes. During his stay in Arles, Gauguin convinced van Gogh that Brittany had "a more solemn character" and that the scenery was "more definite than the shriveled, scorched, trivial scenery of Provence."[107] If Vincent chose to cultivate an image of himself as an artist-priest, guarding the temple of Provençal nature, Gauguin strove to fashion himself as the artist-sailor, moving through a series of ports of call. This identity was one that came easily to the former sailor in the merchant marine, and it helped eradicate the bourgeois persona he had assumed during the years he spent in the Paris business world. With rough clothes and a surly tongue he adopted in Brittany, Gauguin had a swaggering manner that reminded van Gogh of a "real able seaman and a true sailor" from the pages of *Pêcheur d'Islande*. In the face of Gauguin's spectacular display of masculine vigor in the fall of 1888, Vincent declared he felt "an awful respect" for Gauguin and "a still more absolute confidence in his personality."[108] The sailor's charisma dazzled the would-be Buddhist priest.

In Arles, Gauguin's preference for tropical climates surfaced in discussions about an ideal artists' community. With an exoticist's passion for the unknown and untried, Gauguin was never one to be content with the option at hand. Only weeks into the two-month trial of the Studio of the South, Gauguin convinced Vincent that the Yellow House should become a mere station en route to more exotic locales for artists' colonies:

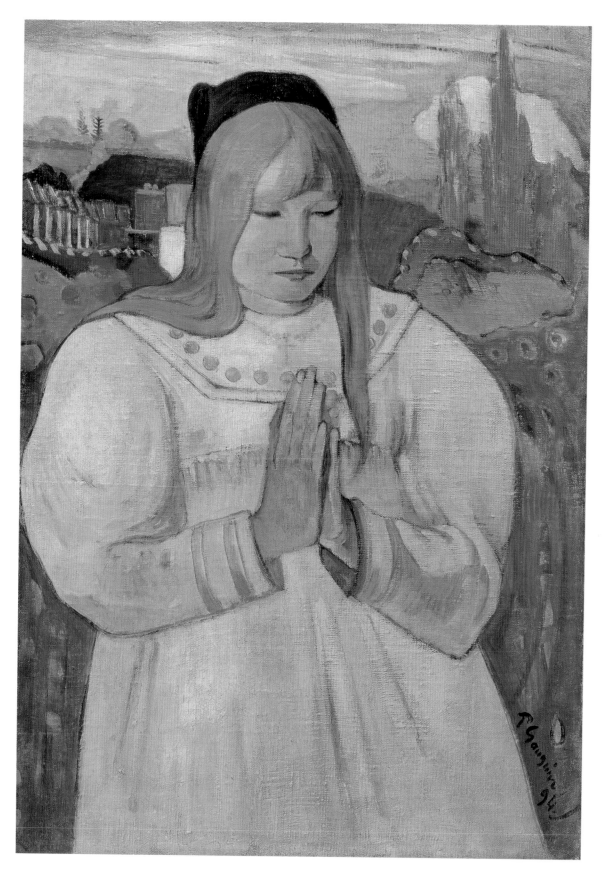

YOUNG CHRISTIAN GIRL, 1894 Oil on canvas, 65 x 46 cm

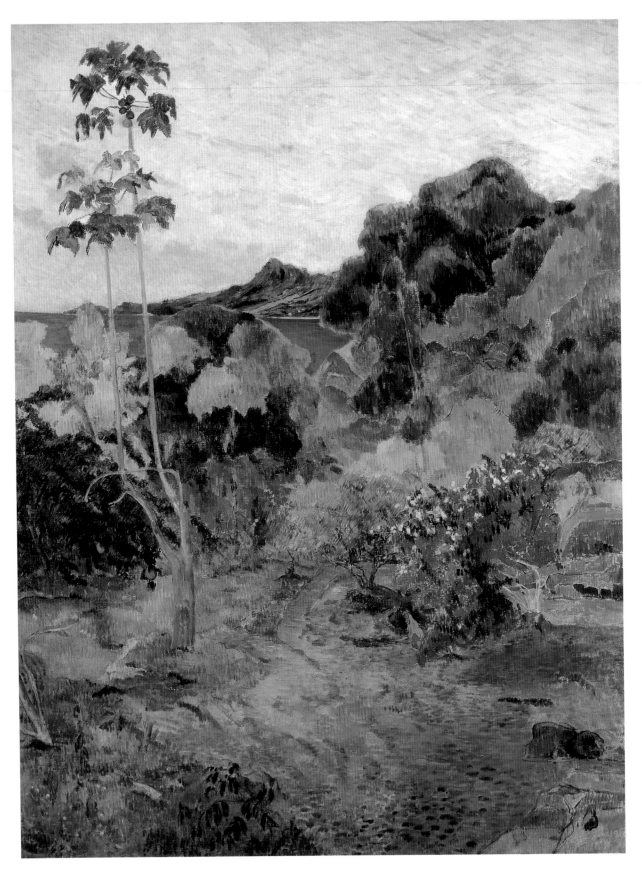

TROPICAL LANDSCAPE, 1887 Oil on canvas, 115 x 88.5 cm

What Gauguin tells of the tropics seems marvelous to me. Surely the future of a great renaissance in painting lies there. Just ask your new Dutch friends whether they have ever thought of how interesting it would be if some Dutch painters were to found a colorist school in Java. If they heard Gauguin describe the tropical countries, it would certainly make them desire to do it directly. Everybody is not free and [in] circumstances to emigrate. But what things could be done there! I regret I am not ten or twenty years younger, then I would certainly go there. Now it is most unlikely that I shall leave the shore to put to sea, the little yellow house here in Arles will remain a way station between Africa, the Tropics, and the people of the North.[109]

The two artists' ideas of utopia — van Gogh's Studio of the South and Gauguin's Studio of the Tropics — could perhaps have been complementary, but they did not mature at the same moment. In 1888 van Gogh had staked out his geographical and imaginative territory, while Gauguin, like a spinning bottle, was still searching for his.

Gauguin pursued his own variation of van Gogh's ideal of artistic community one more time after the failed attempt in the Yellow House at Arles in 1888. Retreating from Pont-Aven, Gauguin joined with fellow artists to live in a small auberge run by Marie Henry at Le Pouldu, which was a smaller, cheaper, and even more remote fishing village on the Breton coast. In November 1889 Gaughin worked with Jacob Meyer de Haan to decorate the ceiling of the dining room; the following summer, Paul Sérusier and Charles Filiger helped him decorate the rest of the room (p. 144).[110] The result recalls the collaborative decor of the Auberge Ganne at Barbizon as well as van Gogh's effort to decorate the Yellow House in a manner appropriate to his idea of an artists' colony. The room at Marie Henry's inn echoes the conviviality of Barbizon and poignantly refers to van Gogh, who died at Auvers-sur-Oise in July 1890, before the decoration campaign at Le Pouldu was completed. Vibrant sunflower motifs recalling Vincent's utopia appear in the two paintings by Gauguin and in the ceiling decorations by Sérusier

and Filiger.[111] Yet this Breton version of the Yellow House served only as a staging ground for Gauguin's more exotic dreams.

Gauguin's restlessness derived from two related and deeply felt convictions: a desire to define himself in opposition to the bourgeois Parisian culture he had self-consciously and dramatically discarded in the early 1880s, and a search for unique (or at least unusual) motifs and a style for his art that would establish for him a niche within the culture of avant-garde art in fin-de-siècle Paris. He thought he could accomplish both through the Studio of the Tropics, a concept that emerged in his discussions and correspondence with van Gogh and Bernard in 1888. His passion for exotic locales was a product of the colonialist era in which he lived and a result of his idealized recollections of his own childhood when he lived with members of his mother's Spanish family in Lima, Peru, in the lap of colonial luxury.[112] He called romantically on this background during the Breton years, asserting that the so-called "Indian" half of his nature now dominated the sensitive, civilized half. He introduced Peruvian motifs into his art, like the ceramic vase in Young Brittany Girl (p. 117), and sometimes juxtaposed such "savage" icons with emblems of the other exotic paradigms he admired, the Breton and the Japanese, for example, in La belle Angèle (1889; Paris, Musée d'Orsay, W315). The sheer eclecticism of his exotic references was an avant-garde pose of worldliness, knowledge, mystery, unconventionality, of a new and esoteric taste.

Gauguin had already tested his love of tropical color, flora, and cultures on the trip he made to Panama and Martinique in the company of the painter Charles Laval in 1887. "I am going away to Panama to live like a savage," he wrote then. "I am taking my paints and brushes and will find new strength in a place far removed from all men."[113] He spent five months (much of it quite ill with dysentery and malaria) living in a hut on a plantation near Saint-Pierre, Martinique. There he painted luxuriant landscapes and studies of the local inhabitants whose figures are notable more

as ornaments for pastoral scenes than as ethnographic descriptions. *Tropical Landscape* (p. 142), devoid of all human evidence, is an excellent example of the Edenic vision Gauguin imposed on the tropical landscape. The silhouette of a tall, fruit-laden papaya tree, the indigo-colored water, and the flowering plant in the right foreground all register the lush tropical environment. Gauguin's vision of an accessible and bountiful nature is informed by the practices of tourism: his scene replicates a typical tourist view that appeared in contemporary postcards and illustrations. Yet Gauguin excludes evidence of both the town of Saint-Pierre and the statue of Notre-Dame-du-Port that would have been visible from this point of view.[114] The artist assumes the posture of Adam, Columbus, and Pierre Loti at once. His slightly elevated perspective suspends the viewer at the entrance to this prelapsarian world, which, in spite of its actual habitation by the international world of French colonialism, appears ready to offer itself up to the commanding, possessing gaze of the first man.

Between his return from Martinique in late 1887 and his first departure for Tahiti in 1891, Gauguin adopted a persona of artistic homelessness. He was everywhere briefly and nowhere permanently. In addi-

tion to his flirtation with Arles, undertaken to satisfy the pressing requests of the van Gogh brothers, he moved back and forth between Pont-Aven, Le Pouldu, and Paris, as he pondered relocating to a variety of tropical locales. His choices were largely shaped by the parameters of French colonialism: he considered a return to Martinique, and then a move to Tonkin and Annam, or Java, or Madagascar, and he eventually decided on Tahiti. These options were encouraged by friends' recommendations, exoticist literature and journals, and the great colonial displays of the 1889 Exposition Universelle, or World's Fair.

Madagascar emerged as a leading choice for a time; it was recommended to Gauguin both by sailor acquaintances and by fellow artist Odilon Redon and his wife, a native of nearby Réunion. Madagascar offered resources such as varied cultural "types, religion, mysticism, symbolism."[115] At Mayotte, he imagined, women would be easy and food cheap.[116] By 1890 he declared himself "irrevocably" committed to moving to Madagascar, where he would build a country house of clay brick, plant crops, and live simply. There he would find "model[s] and everything I need to do studies. I will found the *atelier des Tropiques*."[117] At this point he still planned a commune: he hoped to bring Bernard and fellow artist Meyer de Haan along as colleagues.

The 1889 Paris World's Fair had opened up more alternatives to consider. On the one hand, the Fair celebrated the technological prowess of the European world: telephones and phonographs, for example, were products of a modern science that made the world seem smaller, more accessible, and more homogeneous. On the other, the colonial exhibits, while highlighting the debts owed by France's colonies to her science and business enterprise, nonetheless conveyed a romantic

Paul Gauguin and others, dining room decoration at the Maison Marie-Henry, Le Pouldu, Brittany, 1889–90

BRETON WOMEN AT THE SEAWEED HARVEST, 1888–89 Gouache and charcoal on cardboard, 27.5 x 41.1 cm

and antimodern view of the non-European world, underscoring its vastness, diversity, variability, and cultural idiosyncracy. In front of the Colonial Palace (p. 221), for example, Gauguin encountered displays of exotic fruits from Guadeloupe and Martinique, an Arab café, and Tahitian huts.[118] The nearby displays from Tonkin so impressed him that throughout the following year he tried to secure a colonial post in Indochina.[119] In the fairgrounds near Eiffel's tower, Gauguin also attended the History of Human Habitation exhibition organized by the architect Charles Garnier. Its range of primitive huts on display impressed him so much that he recalled them the next year when explaining to Bernard the kind of structure he would buy to house the Studio of the Tropics.[120] The Fair

also offered an important venue for the avant-garde: Gauguin and his colleagues participated in a modest exhibition of works, including Gauguin's paintings inspired by Arles, Brittany, and the recent Martinique trip, in the Café Volpini. Although the exhibition was neither a financial nor a critical success, it was an important touchstone for artists in the avant-garde group (including Anquetin, Bernard, Laval, Schuffenecker, and Gauguin), who wished to heighten Parisian awareness of their art.

The project of moving to a French colony occupied Gauguin during the year following the World's Fair. Gauguin's motivations were economic, artistic, and escapist: he had convinced himself that "the West is rotten," and that out there in the colonies one would

be renewed, like Antaeus, by touching the earth, and one could come back to France in one or two years restored, *solide*, or firmed up.[121] Of the many colonial venues Gauguin considered for his Studio of the Tropics, Tahiti was of course the final choice.[122] The idea of Polynesia had first come from Bernard, who had been reading Pierre Loti's Tahitian idyll, *The Marriage of Loti*. Gauguin did not take Bernard's first suggestions seriously: he considered Tahiti too far away and too expensive to travel to.[123] But by February 1890, inspired by Loti, colonial brochures, and what he witnessed at the Fair, Gauguin was considering Tahiti instead of Tonkin:

If only the day would come when I can escape into the forests of a lonely island in Oceania, to live there in ecstasy, and calm, for art alone. Surrounded by a new family, far from the European struggle after money. There, in Tahiti, I will, in the silence of beautiful tropical nights, listen to the sweet murmuring music of the movements of my heart.... Free at last, without need of money and able to love, to sing and to die.[124]

But the question of whether Gauguin would pursue the dream alone or with company remained open. Part of him longed to put distance between himself and the more troublesome members of his avant-garde circle.[125] But he wanted and expected Bernard's company, until their falling-out in November 1889 over their respective positions in the Parisian symbolist circles made a further collaboration unlikely.[126]

Ultimately, the Studio of the Tropics was a one-man affair since Gauguin, like van Gogh, was more successful as a loner than a collaborator. When Gauguin left for Tahiti, the only companions he took along were a few of his own works of art and a small collection of art reproductions, which, he informed Redon, would be "a whole little world of friends who will speak with me every day."[127] The only collegial friendships he developed with artists in Polynesia were with several colonial photographers, whose work, in confirmation of European expectations of Tahitian culture, sanctioned Gauguin's imagination and desires.[128] Memories of his relationship with van Gogh at Arles engaged him on occasion, and some of his Tahitian pictures echo the motifs of the Studio of the South. Ten years after his stay in Arles, he requested that sunflower seeds be sent to him so that he might grow the plants in exile. He painted them in a still life that was richly evocative of the interior he had once shared with his painter friend, although the Tahitian face hovering at the window reminds one of Gauguin's tropical displacement (p. 148). For Gauguin, a community of artists that existed in memory and reverie, rather than in active collaboration, better suited both his symbolist aesthetic and his contentious personality.

The Studio of the Tropics had not only its Polynesian incarnation with Gauguin, but an Egyptian chapter as well in the later career of Bernard. Following Vincent's death, Bernard helped Theo mount a small memorial exhibition in Paris and worked to enhance Vincent's posthumous reputation through the publication of several critical essays and a few of his letters. Bernard broke his relations with Gauguin in 1891, following a dispute over which artist had invented synthetism. Bernard followed his own exotic path, becoming an orientalist, in part to distinguish himself from Gauguin's Oceanic exoticism. In 1893 he moved to Cairo, married a Lebanese woman, and painted oriental studies that were less stylistically provocative than the cloisonnist works he had made in Brittany in 1888. Yet the romance of the exoticist's life eventually ran its course for Bernard. In contrast to the bohemian appearance of his life, he became increasingly conventional as he grew older: at the end of the 1890s he embraced a conservative form of Roman Catholicism, and in 1904 he returned to France, not coincidentally just after the death in Polynesia of his rival Gauguin. Bernard may have been most guilty of betraying van Gogh's ideal of communal artistic life, as he spent a disappointing amount of energy in his later years disputing Gauguin's claims and demanding credit for his own style's originality.

It is exactly this recurrent desire among the avant-garde to claim identity on issues of originality and individuality that undermined from the first van Gogh's

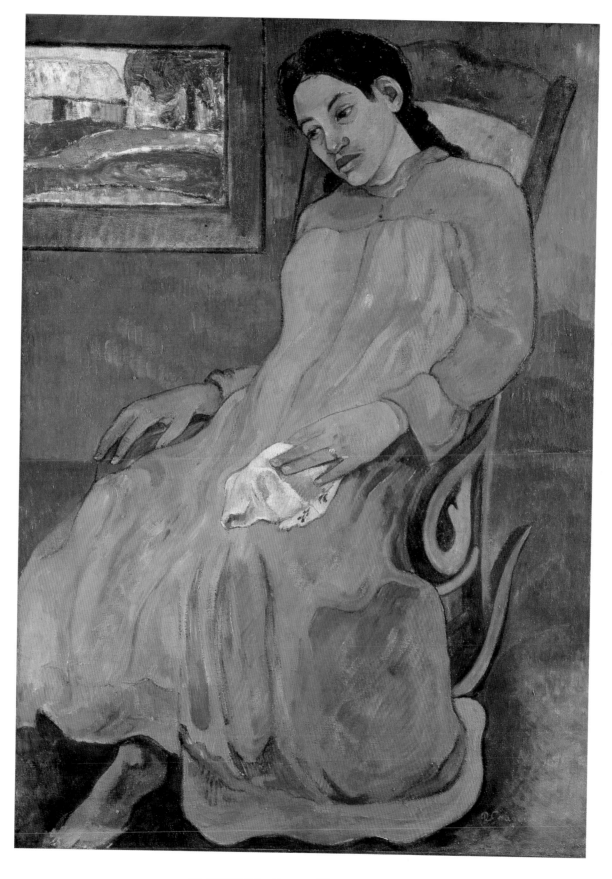

FAATURUMA, 1891 Oil on canvas, 92 x 73 cm

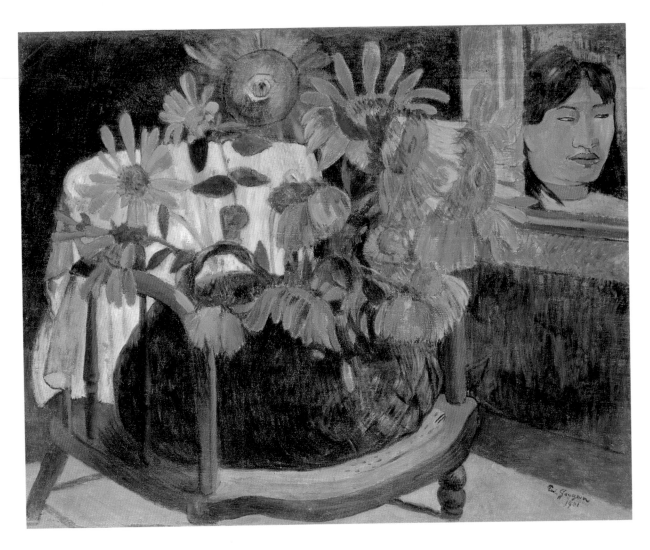

SUNFLOWERS, 1901 Oil on canvas, 73 x 92 cm

utopian ideal of an artists' community. At the fin de siècle the idea of artistic collaboration represented community, mutual appreciation, productive critical response, and opportunities to circulate work and ideas — much of what the dying academic system had once routinely provided for professional artists. But the ideal of cooperation had to be negotiated within an art world that was actually more responsive to the pervasive force of mythic individualism. The art market, art criticism, the growing emphasis on artistic biography, and the taste for artistic legends all fueled an ambitious artist's desire to establish an individual, autonomous identity. Artistic unity and collaboration were appealing concepts, but public success was increasingly judged on the strength of individual achievement. Van Gogh and Gauguin turned to exoticism, adopting various cultural templates to cultivate their own images as unique and innovative artists. The ongoing conflict between their genuine longing for community and partnership, and their perceived need to separate and individuate themselves, fueled the idiosyncratic and peripatetic careers of Gauguin, van Gogh, and Bernard. The Studio of the South served them briefly as a shared dream and, more substantially, as an ideal to debate among themselves and to adapt for their own individual artistic practices.

Notes

I would like to thank Cornelia Homburg for her generosity in sharing her knowledge of Vincent van Gogh; it has been truly rewarding and enjoyable to learn from her. In addition to those acknowledged in the notes, I am also grateful to John Klein for his comments on a draft of this essay; my fellow contributors John House and Richard Thomson for their ideas; my research assistant Brad Fratello for his excellent work, both in Paris and St. Louis; and the Department of Art History and Archaeology at Washington University for its support of some of the research conducted for this essay.

References to van Gogh's letters, unless otherwise noted, are from *The Complete Letters of Vincent van Gogh*, 2nd ed. (Greenwich: New York Graphic Society, 1959)

1 Martha Ward, "The Rhetoric of Independence and Innovation," in Fine Arts Museums of San Franscisco, *The New Painting: Impressionism, 1874–1886*, exh. cat. (Geneva: Richard Burton SA, Publishers, 1986), pp. 429–30.

2 Maurice Malingue, ed., *Lettres de Gauguin à sa femme et à ses amis* (Paris: B. Grasset, 1946), p. 91, n. 2.

3 Letter from Paul Gauguin to Mette Gauguin, June 1886, Pont-Aven, ibid., p. 91.

4 A classic analysis of the primitivist and antimodernist content of his pictures is Griselda Pollock and Fred Orton, "Les Données Bretonnantes: La Prairie de Représentation," *Art History* 3, no. 3 (1980), pp. 314–44.

5 For Gauguin's description of *The Vision after the Sermon* in a letter to van Gogh of September 1888, see John Rewald, *Post-Impressionism: From van Gogh to Gauguin* (New York: The Museum of Modern Art, 1956), pp. 181–82.

6 On this urban construction of rural piety, see Theodore Zeldin, "The Myth of the Peasant Democracy," *France 1848–1945, vol. 1: Ambition, Love and Politics* (Oxford: Clarendon Press, 1973), pp. 131–37.

7 Unpublished manuscript, as quoted by Mary Anne Stevens, in Royal Academy of Arts, *Post-Impressionism: Cross-Currents in European Painting*, exh. cat. (London: Royal Academy of Arts in association with Weidenfeld and Nicolson, 1979), p. 41.

8 For a good analysis of Bernard's development of this canvas, and its impact on Gauguin, see Mary Anne Stevens et al., *Emile Bernard 1868–1941: A Pioneer of Modern Art*, exh. cat., trans. J. C. Garcias et al. (Mannheim: Städtische Kunsthalle; Amsterdam: Van Gogh Museum; Zwolle, Netherlands: Waanders Publishers, 1990), pp. 143–47.

9 On the fin-de-siècle crisis in Catholicism, see Theodore Zeldin, *Conflicts in French Society: Anticlericalism, Education and Morals in the Nineteenth Century* (London: Allen and Unwin, 1970); and Ralph Gibson, *A Social History of French Catholicism, 1789–1914* (London: Routledge, 1989). I am grateful to Kellee Kramer for these references.

10 Gauguin offered *The Vision after the Sermon* to the parish church at Nizon, but the curate refused it. He then sent the picture to Theo van Gogh in Paris, exhibited it with Les XX in Brussels in 1889, and sold it to a Parisian in 1891. *The Maitland Gift: National Gallery of Scotland* (Edinburgh: National Gallery of Scotland, 1963), pp. 42–43.

11 Stevens et al., *Emile Bernard*, p. 194.

12 On the identification of Madeleine Delorme, see Ronald Pickvance, *Gauguin and the School of Pont-Aven* (London: Apollo Magazine for San Diego Museum of Art, 1994), p. 44. A comparison of Madeleine Bernard's dimpled chin, deep-set eyes, and the hairstyle shown in Bernard's 1887–88 portrait all suggest the face of Bernard's sister. Given Gauguin's well-known infatuation with the young woman, it seems likely he might have transposed some of her facial features onto a live model he worked with at Le Pouldu. For a photograph of Madeleine Bernard in 1887, see Chronology, p. 215.

13 "Arles est une des villes de France les plus visitées: d'accès facile, desservie par la plupart des trains express de Paris à Marseilles, riche en antiquités de différents âges, chantée par les poètes elle excite la curiosité de l'artiste…. C'est la ville des contrastes. Ici, le Rhône reflète la vieille tour silencieuse, ruine du palais de Constantin; là, il est traversé par un pont tubulaire de fer, sur lequel les trains circulent à tout vapeur, expression bruyante du génie moderne. Ici, c'est le champ de mort des Alyscamps, avec ses milliers d'auges funeraires, défoncées et béantes; à côté, et sur son emplacement même, les ateliers du chemin de fer, ou se fabriquent roues, rails et wagons." Hippolyte Bazin, *Arles Gallo-Roman: Guide touristique archéologue* (Paris: Hachette, 1896), pp. i–ii.

14 *Complete Letters* 418.

15 *Complete Letters* 544a.

16 See, for example, *Wheat Field with Setting Sun* (1888; Winterthur Kunstmuseum; F465, JH1473).

17 Ronald Pickvance, *Van Gogh in Arles* (New York: The Metropolitan Museum of Art and Harry N. Abrams, 1984), pp. 14–15.

18 "Pas de campagne mieux cultivées que celle d'Arles … L'activité est dans les champs…. Quant à la ville, elle demeure toujours plongée dans un calme profond…. A Arles, au contraire, rien ne vient le troubler dans ses méditations; la population, que se livre avec succès a l'exploitation agricole, est répandue dans les environs. Quant à la ville elle-même, certainement elle n'est pas morte, mais elle sommeille, et l'artiste peut, lui aussi, y rêver à son aise." Bazin, *Arles Gallo-Roman*, pp. i–ii.

19 *Complete Letters* 469.

20 Key articles on van Gogh's Japonism (*japonisme*) include Tsukasa Kōdera, *Vincent van Gogh: Christianity versus Nature* (Amsterdam and Philadelphia: John Benjamins, 1990), chapter 4; Kōdera, "Van Gogh's Utopian Japonisme," in Charlotte van Rappard-Boon, Willem van Gulik, and Keiko van Bremen-Ito, *Catalogue of the Van Gogh Museum's Collection of Japanese Prints* (Amsterdam: Van Gogh Museum; Zwolle, Netherlands: Waanders Publishers, 1991), pp. 11–46; Akiko Mabuchi, "Van Gogh and Japan," *Vincent van Gogh Exhibition* (Tokyo: The National Museum of Western Art, 1985), pp. 153–95; Fred Orton, "Vincent van Gogh in Paris 1886–1887, Vincent's Interest in Japanese Prints," *Vincent: Bulletin of the Rijksmuseum Vincent Van Gogh* 1 (1971), pp. 2–12.

21 *Complete Letters* 463.

22 *Complete Letters* 437.

23 Ibid.

24 Kōdera, "Van Gogh's Utopian Japonisme," p. 11.

25 The Scottish painter A. S. Hartrick recalled a visit to van Gogh's Paris apartment, where van Gogh "drew my attention specially to a number of what he called 'crêpes,' i.e., Japanese prints printed on crinkled paper like crêpe. It was clear they interest him greatly, and … what he was aiming at in his own painting was to get a similar effect of little cast shadows in oil paint from roughness of surface." A. S. Hartrick, *A Painter's Pilgrimage through Fifty Years* (Cambridge: Cambridge University Press, 1939), p. 46.

26 For the major study on van Gogh's copies, and his practice of copying to help define his own modern aesthetic, see Cornelia Homburg, *The Copy Turns Original: Vincent van Gogh and a New Approach to Traditional Art Practice* (Amsterdam and Philadelphia: John Benjamins, 1996), especially pp. 120–21 on Japanese models.

27 I am grateful to Karen Brock and Atsushi Yoshida for translating this border for me.

28 *Complete Letters* 510.

29 *Complete Letters* 540.

30 Musée d'Orsay, *Van Gogh à Paris*, exh. cat. (Paris: Réunion des Musées Nationaux, 1988), p. 169.

31 Tsukasa Kōdera suggests that van Gogh may have based the frontality of Tanguy's pose and his clasped hands on a statuette of a bonze (Buddhist priest) reproduced in a book owned by the van Gogh family, Louis Gonse, *L'Art japonais*, vol. 2 (Paris, 1883), p. 60. See Kōdera, "Japan as Primitivistic Utopia: Van Gogh's *Japonisme* Portraits," *Simiolus* 14 (1984), pp. 194–95.

32 *Complete Letters* 500.

33 *Complete Letters* 605.

34 See Hayashi Tadamasa, "Le Japon," *Le Japon illustré* (1886), pp. 66–67. This article makes spectacular claims for Japan, drawing comparisons between Japan and Europe that favor the former. A sample passage describing Japanese landscape is: "Un des merveilles, de la flore japonaise est le cerisier fleuri, qui couvre quelquefois un montagne entière et qui lui donne l'aspect d'un nuage rose. Les oiseaux, les brillants insectes voltigent autour des arbres en fleur; toute la nature semble en fête!"

35 A classic study of Gauguin's Japonism is Yvonne Thirion, "L'Influence de l'estampe japonaise dans l'oeuvre de Gauguin," *Gazette des Beaux-Arts*, 6th ser., vol. 47 (January–June 1956), pp. 94–114.

36 In its use here as an adjective, Japonist describes an activity or intellectual approach that derives from the European practice of Japonism, whereby a quality is understood to be characteristic of the Japanese or their products, especially their art.

37 Emile Guimet and Félix Régamey, *Promenades japonaises* (Paris: G. Charpentier, 1878), p. 165. Akiko Mabuchi asserts that van Gogh read this book. See Mabuchi, "Van Gogh and Japan," p. 171.

38 "Le japonais est à la fois le poète enthousiaste ému par les grands spectacles de la nature, et l'observateur attentif et minutieux qui sait surprendres les mystères intimes que recèle l'infiniment petit. En un mot, il est persuadé que la nature renferme les éléments primordiaux de routes choses et suivant lui, il n'existe rien dans la création, fût-ce un infime brin d'herbe qui ne soit digne de trouver sa place dans les conceptions élévées de l'art." Samuel Bing, "Programme," *Le Japon artistique* 1 (1888), preface, p. 7.

39 *Complete Letters* 542.

40 For a broader discussion of primitivist ideas about Japan, see Elisa Evett, "The Late Nineteenth-Century European Critical Response to Japanese Art: Primitivist Leaning," *Art History*, no. 1 (March 1983), pp. 82–106.

41 On other potential members, see Carol Zemel, *Van Gogh's Progress: Utopia, Modernity, and Late-Nineteenth-Century Art* (Berkeley and Los Angeles: University of California Press, 1997), p. 274, n. 74.

42 *Complete Letters* 509.

43 Pierre Loti, *Madame Chrysanthème* (Paris: Calmann Lévy, 1888); Loti, *Japan: Madame Chrysanthemum*, trans. Laura Ensor (London: Routledge; Boston: Kegan Paul, 1985), p. 202.

44 This reading included, but surely was not limited to the following: novels of the Goncourts; Guimet and Régamey, *Promenades japonaises* (1878); Ernest Chesneau, "Le Japon à Paris," *Gazette des Beaux-Arts* (September 1878); Louis Gonse, *L'Art japonais*, *Paris illustré, le Japon* (May 1886); Bing, ed., *Le Japon artistique* (May 1888); and Loti, *Madame Chrysanthème*. See Mabuchi, "Van Gogh and Japan," p. 171.

45 Van Gogh noted with envy that the *kakemono* could be rolled up easily for storage. He wrote of this in connection with a desire to make paintings that could be more easily accepted as decorations in middle-class houses, as they once had been in Holland. *Complete Letters* 512.

46 Félix Régamey, *Japan in Art and Industry* (New York and London: Putnam's Sons, 1893), p. 238.

47 Evert van Uitert, Louis van Tilborgh, and Sjraar van Heugten, *Vincent van Gogh: Paintings* (Amsterdam: Meulenhoff/Landshoff, 1990), pp. 191–94.

48 *Complete Letters* 587, 540. The identification of the flower as oleander is clear from an inscription on a drawing of "La Mousmé" in the Pushkin State Museum of Fine Arts, Moscow.

49 *Complete Letters* 514.

50 Kōdera, "Van Gogh's Utopian Japonisme," p. 30.

51 Her pouting expression may reflect van Gogh's knowledge of a print by Kaigetsudō Ando of a pouting courtesan, reproduced in *Le Japon artistique* in June 1888. See Shigemi Inaga, "Van Gogh's Japan and Gauguin's Tahiti Reconsidered," in Toru Haga, ed., *Ideal Places in History: East and West* (Kyoto: International Research Center for Japanese Studies, 1995), p. 158.

52 Loti, *Japan: Madame Chrysanthemum*, p. 61.

53 Ibid., p. 88.

54 Ibid., p. 182.

55 Van Gogh also references here the painting *Hope*, of an adolescent girl bearing a flower, by Pierre Puvis de Chavannes, an artist for whom he had long-standing admiration. The two versions of *Hope* (Baltimore, Walters Art Gallery; Paris, Musée d'Orsay) were both exhibited at the Galerie Durand-Ruel in Paris in November–December 1887, where van Gogh might have seen them.

56 The inscription has been partially effaced (perhaps by Gauguin), and has been replaced. There seems no doubt that it was originally inscribed to Gauguin. See Vojtěch Jirat-Wasiutyński et al., *Vincent van Gogh's Self-Portrait Dedicated to Paul Gauguin: An Historical and Technical Study* (Cambridge: Harvard University Art Museums, Center for Conservation and Technical Studies, 1984), pp. 18, 22–23.

57 Ibid., p. 3.

58 This exchange of pictures is thoroughly discussed elsewhere. See, for example, Mark Roskill, *Van Gogh, Gauguin, and the Impressionist Circle* (Greenwich: New York Graphic Society, 1970), chapter 4; and Stevens et al., *Emile Bernard*, pp. 198–99.

59 *Complete Letters* 544a.

60 I am grateful to Karen Brock for this information. The French word derived in the sixteenth century from the Portuguese word *bonzō*, which in turn came from the Japanese word *bonsō*.

61 "Le Bonze a la tête rasée comme un bénédictin. Il est vêtu d'une robe grise. Sa figure est intelligente, moqueuse, et d'une expression pleine de réticences." Guimet and Régamey, *Promenades japonaises*, p. 82. Akiko Mabuchi claims that this book by Guimet is among the studies of Japan read by van Gogh: Mabuchi, "Van Gogh and Japan," p. 171.

62 On bonzes, see Loti, *Japan: Madame Chrysanthemum*, pp. 85, 131, 223, 226–29.

63 *Complete Letters* 494a.

64 Letter from Gauguin to Bernard, undated (December 1888), in Maurice Malingue, ed., *Paul Gauguin: Letters to His Wife and Friends*, trans. Henry Stenning (New York: The World Publishing Company, 1949), letter 78, pp. 115–16.

65 Soon after Gauguin's departure from Arles, van Gogh wrote to him about his remorse at having caused his departure, "unless this departure was perhaps decided beforehand?" Douglas Cooper, ed., *Paul Gauguin: 45 lettres à Vincent, Théo et Jo van Gogh* (The Hague: Staatsuitgeverij; Lausanne: Bibliothèque des Arts, 1983), p. 265.

66 A thorough analysis of the working relationship between the artists is forthcoming in the exhibition *Van Gogh and Gauguin: The "Studio of the South,"* to be held at The Art Institute of Chicago, September 22, 2001–Jananuary 13, 2002.

67 Zemel, *Van Gogh's Progress*, p. 117. In seven portraits either the baby is visible, or the cord that rocks the cradle is evident. I would disagree with Zemel that the sprouting bulbs in JH1646 are necessarily a reference to Roulin's fertility.

68 These versions are in the Kröller-Müller Museum, Otterlo; The Art Institute

of Chicago; The Metropolitan Museum of Art, New York; and Stedelijk Museum, Amsterdam. See F504, JH1655; F505, JH1669; F506, JH1670; F507, JH1672.

69 For an interpretation of maternal comfort inherent in these images and their relationship to van Gogh's personal trauma that winter, see Zemel, *Van Gogh's Progress*, pp. 117–21.

70 Ibid., p. 119.

71 *Complete Letters* 605.

72 *Complete Letters* 592.

73 For a good account of these events, see Jan Hulsker, *Vincent and Theo van Gogh: A Dual Biography* (Ann Arbor: Fuller Publications, 1990), pp. 319–24.

74 "Gardez cet objet précieusement." *Le Forum Républicain* (30 December 1888), quoted in Henri Perruchot, *La Vie de van Gogh* (Paris: Hachette, 1955), p. 284.

75 I am grateful to Karen Brock and Diane Towle for drawing my attention to this practice. My account of *shinjū* is drawn from Cecilia Segawa Seigle, *Yoshiwara: The Glittering World of the Japanese Courtesan* (Honolulu: University of Hawaii Press, 1993).

76 A classic Japanese account of *shinjū* as a practice of sacrificing body parts is found in Hatakeyama Kizan, *Shikadō Ōkagami* (c. 1680), vol. 3.

77 It is difficult to determine precisely which types of *shinjū* were most frequently practiced in van Gogh's era and which particular Japanese brothel practices he might have learned about in France. The practice of sacrificing body parts to demonstrate love or loyalty has continued among the demimonde of Japan from the seventeenth century into the twentieth century, even though the term *shinjū* is used today to designate only the more drastic act of self-inflicted death, either a love-suicide, or a family *shinjū*, a group suicide undertaken in the shadow of financial crisis and dishonor. Evidence of the continuation of self-mutilation in the twentieth century, in the form of sacrifices of fingers by geisha to patrons to prove either fidelity or innocence, appears in two novels by Setouchi Harumi, *Kyo mandara* (Kodansha, 1976) and *Jotoku* (Shinchosha, 1968). These novels both refer to actual instances of finger sacrifice, probably from the pre–World War II era. On the episode recounted in *Kyo mandara*, see the interview of Setouchi by Maeda Ai, in *Meisaku no naka no onna-tachi* (Women in Masterpieces), p. 362; regarding the biographical novel *Jotoku* about the geisha Teruha, who cut off her finger to prove her innocence to her patron, see the commentary by Ozaki Hotsuki in the Shinchosha edition, p. 598. I am grateful to Dr. Cecilia Seigle, Professor Emerita of Japanese Studies at the University of Pennsylvania, for generously providing these references (personal communication, June 27, 2000). We can only speculate that van Gogh might have learned about *shinjū* and other aspects of Yoshiwara culture in Paris, perhaps in the print shops of Samuel Bing or Tadamasa Hayashi. In these shops, where he acquired some of his own prints, he might have engaged in discussions about life in the Japanese brothel, particularly since his own collection included many prints of the daily life of the courtesan. (Hayashi's expertise in Yoshiwara culture, for example, is indicated by his role as a translator for Edmond de Goncourt of a Japanese text about Utamaro's prints of the Yoshiwara. This text, quoted at length by Goncourt in 1891 in his *Outamaro: Le Peintre des maisons vertes*, includes no mention of *shinjū*.) The popular accounts of *shinjū* published in Europe in the fin de siècle emphasized melodramatic and lurid tales of love-suicides. These include a short story by N. T. Kanèko, "Mousmé Sets Yo, or Woman's Sacrifice," *Atlantic Monthly* 42, no. 249 (July 1878), pp. 81–91; my thanks to Bradley Fratello for locating this. Also of note are the slightly later accounts of *shinjū* (in the form of love-suicides) in Lafcadio Hearn, *Glimpses of Unfamiliar Japan* (Boston: Houghton Mifflin, 1894), pp. 289–93; and J. E. De Becker, *The Nightless City, or the History of the Yoshiwara Yūkwaku* (London: Probsthain, 1899), pp. 184–85, 276–78. I am grateful to Christine Guth for directing me to the latter publication.

78 *Complete Letters* 565.

79 "Milliet is lucky, he has as many Arlésiennes as he wants; but then he cannot paint them, and if he were a painter he would not get them. I must bide my time without rushing things." *Complete Letters* 542.

80 The print is reproduced in van Rappard-Boon et al., *Catalogue of the Van Gogh Museum's Collection of Japanese Prints*, p. 18.

81 While it is impossible to determine precisely which figure it is without the assistance of X-ray analysis, it seems clear that van Gogh sketched in a head, at least partly adorned with the long sticks characteristic of the courtesan's elaborate coiffure. Several possible sources in van Gogh's own Japanese print collection are possible. For reproductions of van Gogh's collection, see *Japanese Prints Collected by Vincent van Gogh* (Amsterdam: Rijksmuseum Vincent Van Gogh, 1978) and van Rappard-Boon et al., *Catalogue of the Van Gogh Museum's Collection of Japanese Prints*.

82 I presented some of my ideas on this topic in a lecture, "Drawing Lessons from Daumier: Seurat, van Gogh, and Gauguin" at The Metropolitan Museum of Art on 16 April 1993. I would like to thank Colta Ives for her encouragement of that research.

83 *Complete Letters* 136.

84 *Complete Letters* 397.

85 *Complete Letters* 336.

86 In the early 1880s van Gogh saw "Gavarni" (S. G. Chevalier) and Daumier as exhibiting malice in their caricatures and strongly preferred Millet, who "showed a warm heart for his fellow men" (*Complete Letters* 240). Indeed, his admiration for Millet informs many of the landscapes van Gogh painted in Provence, the robust workers in their sun hats and sabots echoing the laboring peasants of Millet's pictures (for example, *Wheat Field with Sheaves and Mower*, Toledo Museum of Art, F559, JH1479). And van Gogh here participated in a larger enthusiasm for the peasant painter among both academic and avant-garde circles at a time when the critical reputation of the master of Barbizon was being actively rehabilitated (and depoliticized) by politically moderate critics and biographers. Neil McWilliam has recently analyzed how, after 1875, Millet's career was reinterpreted in biography and criticism to neutralize his political identity and to refigure him, through discussion of his themes of religion and family, as a model of pious dedication to art. See "Mythologising Millet," Andreas Burmester et al., eds., *Barbizon: Malerei der Natur—Natur der Malerei* (Munich: Klinkhardt and Biermann, 1999), pp. 437–47. For a detailed study of Millet's critical reputation in the last third of the nineteenth century, see the forthcoming dissertation by Bradley Fratello, "Making a Tradition of Modern Art: The Case of Jean-François Millet," Washington University, St. Louis.

87 "Il est l'incontestable peintre de la campagne et des paysans mais aussi le *Grand poète des lignes et des valeurs*." Emile Bernard, "Au Palais des beaux-arts," *Le Moderniste*, no. 14 (27 July 1889), p. 108.

88 Van Gogh's numerous copies of Millet pictures, painted primarily at Saint-Rémy in 1888–90, when the artist worked from his collection of art reproductions, have been extensively examined. The most recent study is Musée d'Orsay, *Millet/Van Gogh*, exh. cat. (Paris: Réunion des Musées Nationaux, 1998).

89 *Complete Letters* 241.

90 *Complete Letters* 239, 490, 531.

91 In the *Exposition des peintres, aquarelles, dessins et lithographies des maitres français de la caricature et de la peinture de moeurs au XIXe siècle*, held at the Ecole des Beaux-Arts in 1888, Daumier was represented by eighty-five works in all media. In 1889 his paintings appeared in the Exposition Centennale at the 1889 Exposition Universelle. A vast literature on caricature appeared in the late 1880s. Champfleury's classic of 1865, *Histoire de la caricature moderne*, went into a third printing in 1885. In 1888 Champfleury also published *Le Musée secret de la caricature*; Armand Dayot published *Les Maîtres de la caricature française au XIX siècle*; and John Grand-Carteret published *Les Moeurs et la caricature en France*.

92 Paul Mantz, *Gazette des Beaux-Arts* (April 1888).

93 *Complete Letters* 418.

94 Ibid.

95 *Complete Letters* 362, 380.

96 *Complete Letters* 248, 380.

97 Arsène Alexandre, *Honoré Daumier: L'Homme et l'oeuvre* (Paris: H. Laurens, 1888).

98 *Complete Letters* 552.

99 *Complete Letters* 544a.

100 *Complete Letters* B14.

101 These works are now restored. See Marie-Thérèse Caille, *Ganne Inn: Municipal Museum of the Barbizon School* (Paris: Editions Gaud, 1994).

102 *Complete Letters* 544.

103 *Complete Letters* 534.

104 Ibid.

105 Hulsker claims this canvas may well be van Gogh's last. Hulsker, *The New Complete Van Gogh*, p. 478.

106 *Complete Letters* 651.

107 *Complete Letters* 558b.

108 Ibid.

109 Ibid.

110 For a detailed account of artistic activity at the Maison Marie-Henry, see Ghislaine Huon, *Les Quêteurs de rêve* (Le Pouldu: La Maison Marie-Henry, 1994).

111 One example of the decorations is Gauguin's canvas *La Femme caraïbe*, a painting of a dark-skinned nude standing in a hieratic, Cambodian-inspired pose, against a background composed of three giant sunflowers (New York, private collection; W330). In this instance, Gauguin super-imposed an emblem of the Studio of the Tropics over the fragmentary motifs of the Studio of the South.

112 The best account of Gauguin's childhood in Lima is David Sweetman, *Paul Gauguin: A Complete Life* (New York: Simon and Schuster, 1995), chapter 2.

113 Letter from Paul Gauguin to Mette Gauguin, early April 1887, Malingue, ed., *Lettres de Gauguin à sa femme et à ses amis*, p. 101.

114 Karen Kristine Rechnitzer Pope, "Gauguin and Martinique," Ph.D. diss., University of Texas, Austin, 1981, p. 125; Claire Frèches-Thory, in Richard Bretell et al., *The Art of Paul Gauguin*, exh. cat. (Washington, D.C.: National Gallery of Art, 1988), p. 78.

115 "En outre Madagascar offre plus de ressources commes types, religion, mysticisme, symbolisme." Letter from Gauguin to Bernard (1890), *Lettres de Paul Gauguin à Emile Bernard, 1888–1891* (Geneva: Pierre Cailler, 1954), letter XX, p. 135.

116 Gauguin to Bernard, 1890, Le Pouldu, ibid., letter XVI, pp. 118–20.

117 Gauguin to Bernard, 1890, Paris, ibid., letter XVII, p. 124.

118 See the account of the colonial displays at the fair in *L'Illustration* (7 September 1889).

119 See Gauguin to Bernard, August 1889, Le Pouldu, letter LXXXIV, p. 163; Gauguin to Bernard, November 1889, Le Pouldu, letter XCII, p. 174; and Gauguin to Bernard, June 1890, Le Pouldu, Malingue, ed., *Lettres de Gauguin à sa femme et à ses amis*, letter CVI, p. 193.

120 Gauguin to Bernard, June 1890, Le Pouldu, ibid., letter CV, p. 191.

121 Gauguin to Bernard, June 1890, Le Pouldu, ibid., letter CVI, p. 193.

122 For a more detailed discussion of the idea of Tahiti in French culture, and Gauguin's decision to move to Tahiti, see my forthcoming book *In Search of Paradise: Painting and Photography in Fin-de-Siècle Tahiti* (Berkeley: University of California Press).

123 Gauguin to Bernard, June 1890, Le Pouldu, Malingue, ed., *Lettres de Gauguin à sa femme et à ses amis*, letter CVII, p. 195.

124 Gauguin to his wife, February 1890, Paris, ibid., letter C, p. 184.

125 "Sale Pissarro, mais quand nous serons à Taiti, je me fous de Pissarro et consorts." Gauguin to Emile Bernard, September 1890, Le Pouldu, ibid., letter CXII, p. 203.

126 For an excellent discussion of the relationship between the two artists, see Vojtěch Jirat-Wasiutyński, "Emile Bernard and Paul Gauguin: The Avant-Garde and Tradition," Mary Ann Stevens et al., *Emile Bernard*, pp. 48–67.

127 Letter from Gauguin to Redon, September 1890, quoted in Marla Prather and Charles F. Stuckey, eds., *Gauguin: A Retrospective* (New York: Hugh Lauter Levin Associates, 1987), p. 132.

128 See Elizabeth Childs, "Paradise Redux: Gauguin, Photography, and Fin-de-Siècle Tahiti," in Dorothy Kosinski, ed., *The Artist and the Camera: Degas to Picasso* (Dallas: Dallas Museum of Art with Yale University Press, 1999), pp. 116–41.

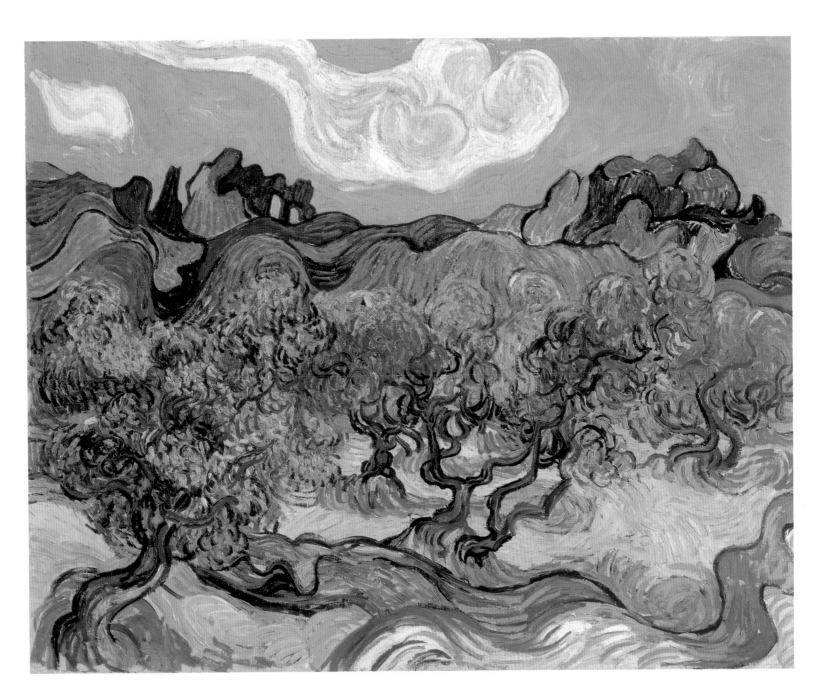

THE OLIVE TREES, 1889 Oil on canvas, 72.5 x 92 cm

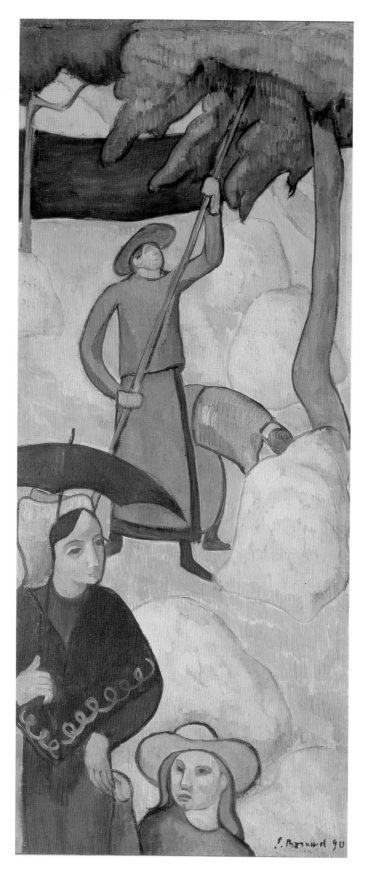

APPLE PICKING, 1890 Oil on canvas, 105 x 45 cm

APPLE PICKING AT ERAGNY-SUR-EPTE, 1888 Oil on canvas, 60 x 73 cm

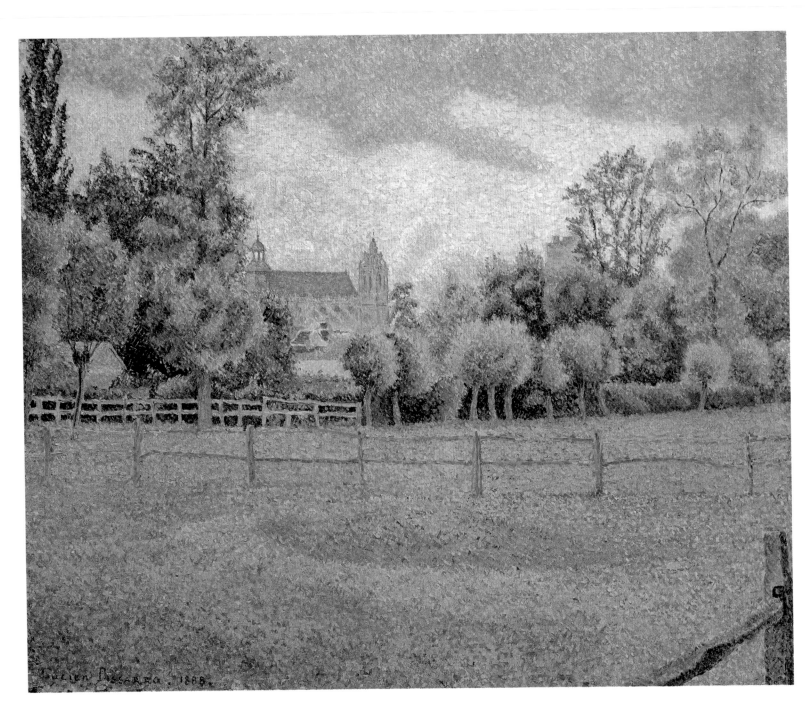

THE CATHEDRAL OF GISORS, 1888 Oil on canvas, 60 x 73 cm

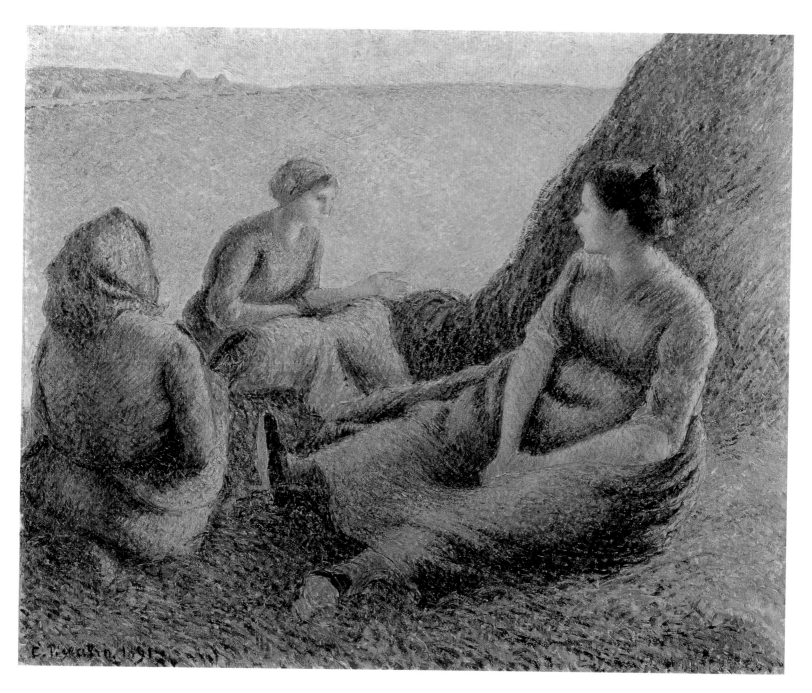

HAYMAKERS RESTING, 1891 Oil on canvas, 65.4 x 81.3 cm

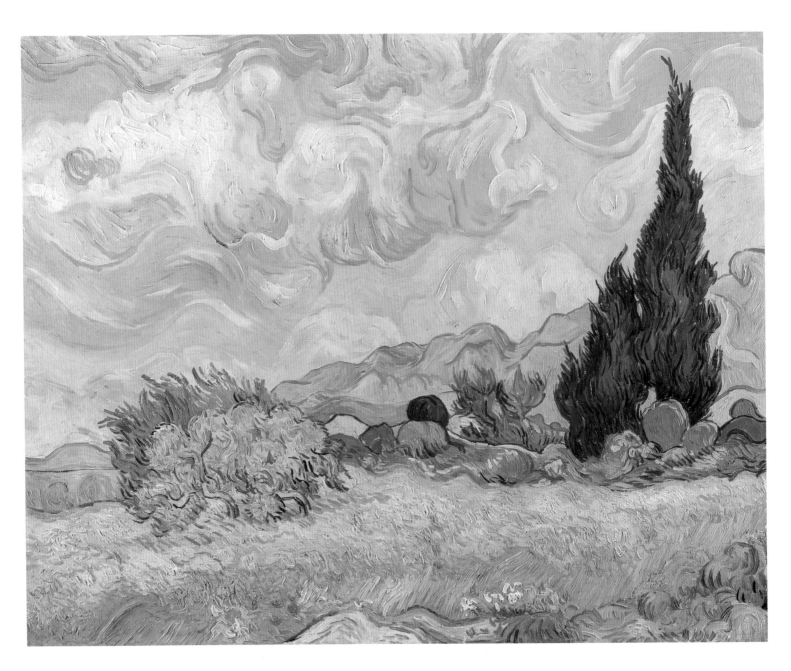

WHEAT FIELD WITH CYPRESSES, 1889 Oil on canvas, 72.5 x 91.5 cm

Towards the Modern Landscape

John House

Let us imagine that we are time travelers, visiting Paris in June of 1889 and wishing to discover the present state of landscape painting in France. Our first stop is the Salon held annually by the Société des Artistes Français in the Palais de l'Industrie (on the site of the present Grand Palais and Petit Palais, alongside the Champs-Elysées). Here disappointment awaits us. As seen at this exhibition, French landscape painting has "for the moment sunk to a low ebb"[1] — the works on view are a pale reflection of ones by mid-century masters such as Camille Corot, Jean-François Millet, Théodore Rousseau, and Charles Daubigny.[2]

However, this year the Salon is not the main attraction for most visitors to Paris. The Exposition Universelle, or World's Fair, of 1889, a vast international exhibition, will attract the astounding number of thirty-two million visitors, many of them, like ourselves, from overseas. In the exhibition park on the Champ de Mars, the Eiffel Tower has been built — an astonishing and very controversial technological achievement that overshadows (and, in the view of many, wrecks) the beauties of central Paris. The Exposition includes a Fine Arts section, and here we are presented with a choice between two French offerings: the *Exposition décennale*, surveying the previous ten years of French art; and the *Centennale*, which covers the whole period from the Revolution of 1789 to 1878, the date of the previous World's Fair in Paris. Clearly the *Décennale* should be our first goal, since it claims to show the best of recent

work, but here again our hopes will be dashed by the landscapes on view. One critic remarks:

There is little more than mediocre production, the end of a school scattering itself in petty analyses, incapable of raising itself above the accidental. . . . The painters that the official rites have consecrated continue to revive the works of the romantics on a small scale and to distribute it in small change.[3]

The *Centennale* reinforces this verdict with a spectacular display of forty-five works by Corot and representations of major paintings by Millet, Rousseau, Daubigny, and others — proof, if proof were needed, of the quality of French landscape painting earlier in the century.

Yet at the *Centennale* another element enters the story: the presence of fourteen canvases by Edouard Manet. A commentator tells us that his art is the final outcome of the long efforts of the landscape painters and asserts that the luminosity of his later works especially reveals this, though these works are not well represented at the exhibition.[4] And, tucked away in a corner of the *Centennale*, we find a very small group of paintings by the impressionists — three by Claude Monet, two by Camille Pissarro, and one by Paul Cézanne, a densely worked landscape strangely titled *The Hanged Man's House* (p. 160). The omission of the impressionists from the *Décennale*, ostensibly a survey of current trends, implies that their art belongs to the past, but many reviewers see their absence as evidence of the state's inability to

acknowledge the strength and authenticity of their vision:

They have renewed the art of landscape with a boldness of invention, a power of synthesis, a truthfulness of sensation, that one seeks in vain among [more conventional artists].... The new vision of the universe cannot be found in Bernier or Rapin, to be sure, but in Pissarro..., in Madame Morizot [*sic*]..., and most of all in Claude Monet, who in his vast oeuvre embraces with rapture the world of forms, colors, and luminous vibrations.[5]

Comments such as these and the few impressionist canvases in the *Centennale* do little to satisfy our curiosity, and we ask where more of their work can be seen. "Those who think that all of contemporary art is represented in the Palais de l'Industrie and the Champ de Mars would be well advised to make a trip tomorrow to the galleries of Georges Petit. There they will see the work of two great artists ... the painter Claude Monet, the sculptor Auguste Rodin."[6] Here we enter a different world:

It is not the crowds swarming round the side shows on the Champ de Mars that will make the detour to the rue de Sèze to see the exhibition of works by MM. A. Rodin and Claude Monet, organized by M. Georges Petit. However, a numerous public will visit it—an elite public, both French and foreign, composed of artists, collectors, and art-lovers....[7]

In contrast to the three quite staid works by Monet in the *Centennale*, here we find ourselves face-to-face with a retrospective of 145 canvases, many of them painted during the past decade; in these recent paintings, according to a review we later read:

... the painter's technique is so personal, so different from that of "conventional painters," that this rough flickering touch, these harsh little brushstrokes, this

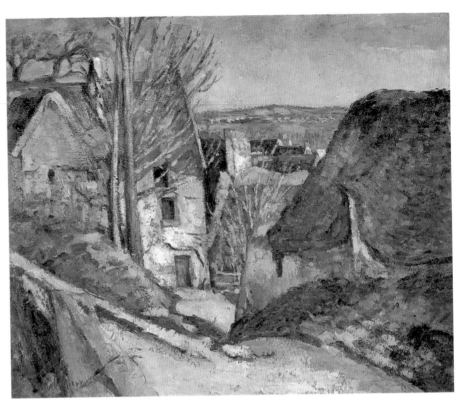

Paul Cézanne, *The Hanged Man's House*, 1873, oil on canvas, 55 x 66 cm

brutal mosaic, seem atrocious to you. But gradually one realizes that nothing in this intentional extravagance is left to chance, that the colors used so boldly by the artist are logical, that each of his brushstrokes results from a sincere vision. The longer one looks, the more one grows accustomed to this astounding way of spreading light. Everything becomes harmonious, complete, identifiable.[8]

At Petit's we view the exhibits in spacious, sympathetic surroundings, in contrast to the crowded, incoherent installations at the Exposition Universelle. Indeed, we learn, "The Georges Petit gallery is a favorite venue for art exhibitions. Nowhere else are paintings and marbles better presented to the visitor's gaze, and in this gallery the dazzling elegance of the Parisian women is set off deliciously against the deep red background of the carpets and the hangings."[9] Yet of course the Petit gallery differs from the Exposition in another respect too — it is a commercial space, the quintessential luxe gallery of the *grand boulevard*, its lavish premises designed to enhance the status of

the works displayed there.[10] Exhibiting at Petit's with Rodin marks the ultimate achievement of commercial success for Monet, despite his omission from the state's *Décennale*.

Petit's is the only significant exhibition of impressionist paintings during the summer of 1889, but now that our curiosity is aroused, we make further inquiries and pay a visit to Durand-Ruel's gallery to view some works that he has in stock by other impressionists. We then move on to the boulevard Montmartre branch of the *grand boulevard* firm Boussod and Valadon. Here we encounter a small display of recent works by Edgar Degas[11] and a helpful manager, a Dutchman named Theo van Gogh, who shows us more pictures by Monet that he has on hand. Van Gogh is keen to guide us in our explorations of the present state of French landscape and makes a number of recommendations.[12] He tells us that young artists are beginning to look hard at the paintings of Cézanne, and if we want to see more of this work, we must visit the art supplies shop of Julien Tanguy in a backstreet near the boulevard de Clichy.

In Tanguy's crowded little shop we are a far cry from Petit's smart premises and the hordes at the Exposition. Theo van Gogh told us that there are a number of small art dealers like Tanguy, selling inexpensive works by lesser-known artists who belong, as he put it, to the *petit boulevard*. But when we follow his next recommendation we are surprised to find ourselves heading back to the Exposition: in one of the cafés that service it, the Café des Arts, run by M. Volpini, there is a display of paintings that represent one of the latest tendencies: a reaction against impressionism in favor of "synthesis." The artists' aim is to reinstate the role of the creative imagination, in contrast to the impressionists' dependence on sensory experience of the external world. This exhibition, of the Groupe Impressionniste et Synthétiste, includes canvases by Paul Gauguin and Emile Bernard. Viewing these works is not easy, though. "The installation is somewhat primitive, quite bizarre, and—as will doubtless be said—*bohemian*."[13] In fact, "You are prevented from approaching these canvases by the sideboards, the beer pumps, the tables, the bosom of M. Volpini's cashier, and an orchestra of young Muscovites whose bows unleash in the vast room a music that bears no relation to these polychrome works."[14]

Before we left him, Theo gave us a further tip. If we are still in Paris in September, we should visit the exhibition of the Société des Artistes Indépendants, an annual unjuried exhibition. Here we will be able to see a different group of young painters, called neo-impressionists, who are seeking to impose greater order and rationality on the procedures that the original impressionists adopted informally and intuitively. At this show, we may see landscapes by Georges Seurat and Paul Signac. And, Theo added, we would also probably see a few paintings by his brother, Vincent, who also seeks to go beyond impressionism, but in a rather different way. A little hesitantly, he offered to show us some of Vincent's paintings stored in a back room, and we were soon facing a sequence of dazzlingly colored landscapes of southern France, whose bold, dynamic technique made even Monet's "brutal mosaics" seem quite restrained.

Any visitor to the Exposition Universelle might have made the first part of this journey that we have imagined. But relatively few would have penetrated beyond the Salon and the Exposition itself; of the art elite who reached Petit's Monet exhibition, fewer still would have moved from *grand boulevard* to *petit boulevard*; and virtually none of the exhausted crowds who stopped for refreshment at Volpini's café would have looked past the cashier at the strange canvases that covered its walls.

This cross section of the Paris exhibition scene in 1889 reveals both a hierarchy of value—from the landscapes of Corot and the generation of the romantics, canonized by this time as part of the great tradition of French art, to the marginalized experiments of Gauguin and Vincent van Gogh—and also a history. In this history, the artifice of neoclassical landscape painting had been swept aside by painters of the romantic

THE RAILWAY JUNCTION, 1886 Oil on canvas, 33 x 47 cm

THE SEINE AT COURBEVOIE, 1888 Oil on canvas, 50 x 65 cm

generation who returned to nature; their emotive, overtly subjective vision of the Forest of Fontainebleau and the deep French countryside had been supplanted in turn by the more dispassionate observation of painters such as Daubigny, and by the impressionists, with their informal, richly colored images of the everyday landscapes surrounding Paris, shaped by modern life and technology.

Monet's *Railway Bridge at Argenteuil* of 1873 (p. 165) can be seen as the quintessential example of such a modern landscape. The railway bridge and the trains, the sailboats, the spectators by the river, and the fenced, well-trodden towpath — all of these are markers of contemporaneity. Open countryside is relegated to the background of this confident image of the natural world transformed by the forces of social change and technological progress. Yet by the later 1880s, Monet and the other impressionists had turned their backs on such imagery. Instead, Monet was exploring extreme effects of weather and light in the recent canvases in his exhibition at Petit's — canvases that paraded his virtuosity but also marked a return to a more conventional landscape subject, the noteworthy sites of the coasts of France.

For painters of the younger generation, impressionism — and especially the work of Monet — remained the yardstick by which they measured themselves. However, impressionism came to seem inadequate for two related reasons: its subjectivity and its apparent superficiality. The key issues were formulated very succinctly by the critic Gustave Kahn in 1886: "The essential aim of our art is to objectify the subjective (the exteriorization of the Idea) instead of subjectifying the objective (nature seen through a temperament)."[15] "Nature seen through a temperament" was the celebrated definition of the work of art propounded by Emile Zola twenty years earlier. This insistence on the essential subjectivity of the true work of art lay at the base of impressionist aesthetics: each artist was seeking to translate his or her unique personal experiences (*sensations*) of the external world into paint. To the younger artists of the mid-1880s, it was this pre-

occupation with the visual *sensation* that condemned the impressionists' art to superficiality. By concentrating on the eye, it excluded the painter's mind; by focusing on appearances, it prevented the artist from asking deeper questions about the meaning of the subject depicted. Moreover, the essential subjectivity of the *sensation* limited its potential, since this concentration on the individual's unique response excluded broader, more universal meanings.[16]

Kahn's alternative to Zola's slogan did not simply reverse its terms. It implied that the artist's goal is revealing the Platonic Idea (*Idée*) beyond an immediate perception. However, there was a central ambiguity in pursuing the aim of objectifying the subjective — an ambiguity that lies at the heart of symbolist aesthetics and is fundamental to any examination of the art of the generation that reacted against impressionism. Was the "idea" that this art sought to express an absolute, a universal, or was it still necessarily unique and personal, since the starting point of the artist's process was, as Kahn stated, "the subjective"? The relationship between subjectivity and the Idea had taxed philosophers from Plato on, and the theoretical writings of the symbolist period offer no unequivocal answer to this question. The ambiguities emerge particularly clearly in two essays written by the critic Albert Aurier in 1891, "Le Symbolisme en peinture: Paul Gauguin" and "Les peintres symbolistes."[17] Aurier writes of the *Idée* as if it were an absolute and cites Plato's theory of knowledge, contrasting true reality with superficial appearance.[18] At the same time, though, he recognizes that each artist can only work through his or her own individual temperament. Artists are urged to transcend their subjective vision in pursuit of the *Idée*, but Aurier acknowledges that each individual can only apprehend the *Idée* through his or her own subjectivity.[19] He is at pains to distinguish the new art, with its quest for the *Idée*, from academic idealism (itself based on a neo-Platonic vision of nature), which sought the perfected form of objects in the external world.[20]

These issues form the theoretical background to the problem that young painters faced in the later 1880s:

how to give a deeper, more lasting significance to their art without returning to the outworn values of the academic tradition. A modern art had to express the artist's personality and unique vision, and it also had to engage with broader issues about contemporary society. This was not simply a matter of painting contemporary subjects; the impressionists had already done that. Rather, the young painters were seeking an art that expressed the modern experience of the world and the modern sense of the self. The landscape paintings of Vincent van Gogh and his associates — the painters of the *petit boulevard* — reveal particularly clearly the range of different paths, in terms of both subject matter and technique, that artists took in their search for a form of modern painting that would be richer and more significant than impressionism.

Paris and its surroundings were one obvious focus for painters seeking a modern form of landscape. Young painters in the mid-1880s focused primarily on the edges of Paris itself and its immediate surroundings, in contrast to the pleasure grounds a little further from the city that the impressionists had favored. Between the built-up area of Paris and its ring of fortifications was an undeveloped expanse known as the *zone*, a no-man's-land that was neither city nor country; beyond

the fortifications, especially to the northwest of the city, was a set of industrialized satellite towns. It was these sites that the young painters explored, especially in the years 1885–88. By conventional standards, the scenes that they painted were utterly unpicturesque. These fragmented views, with harsh juxtapositions between natural and man-made elements — fields framed by factories, riverbanks traversed by new bridges — presented a dislocated, discordant world, remote from the unspoiled rural idylls of conventional landscape.

Yet the tone of these paintings is very diverse. Bernard's *View from the Bridge at Asnières* of 1887 (p. 70) is spare and somber, as is his *Iron Bridge at Asnières* (p. 89), also of 1887, in which the two figures are reduced to sinister black silhouettes. By contrast, Signac's *Quai de Clichy* of 1887 (p. 28), showing the road on the opposite side of the same stretch of the river, presents the recently planted trees and irregular little buildings in serene sunlight. Likewise, van Gogh's contemporary *Factories at Asnières, Seen from the Quai de Clichy* (p. 29), painted the same year, shows the industrial landscape as something vibrant and lively, bathed in sunlight, with the tiny figures of what seem to be a man and a woman delicately indicated beneath the central chimney.

In the writing of the period, the *zone* and the developing industrial areas around Paris were already an emblem of the sufferings of the working-class population.[21] Yet at the same time, in some of the radical political treatises of the period, industrialization was viewed as a potential passport to a more prosperous future, provided its potential was harnessed in the interest of the workers and not allowed to become an agent of their oppression.[22] French anarchist thought — a fundamental influence in

Claude Monet, *Railway Bridge at Argenteuil*, 1873, oil on canvas, 58.2 x 97.2 cm

intellectual and artistic circles in this period — was deeply divided about the relationship between technological progress and the rational, egalitarian, decentralized society of which the anarchists dreamed.[23] The images of peasants working the fields by Camille Pissarro, a committed anarchist supporter (e.g., p. 157), reflected his belief that the new society involved a return to the soil.[24] But at the same time, Maximilien Luce, perhaps the most dedicated anarchist in the neo-impressionist group, took much of his subject matter from the industrial landscapes and working-class population of Paris and, later, the Belgian coal-mining region. Some of these images present industrialization as an evil, destructive force, but in other images his vision of industrial labor seems optimistic.[25] Signac took an essentially positive view of such imagery in an essay published in an anarchist journal in 1891: "By their picturesque studies of the workers' blocks of Saint-Ouen and Montrouge, solid and dazzling, by the reproduction of the broad and curiously colored movements of a laborer next to a sandpile, of a smith in the incandescence of a forge…, they brought their testimony to the great social proceeding under way between workers and capital."[26] Even in his monumental utopian anarchist idyll, *In the Time of Harmony* of 1894−95 (Mairie de Montreuil), sited on the Mediterranean coast, there are small factories and machines in the background.

The pictures in that volume of the edges of Paris demand to be viewed in the context of these debates, as pictorial explorations of a quintessentially modern, antipicturesque landscape that epitomized the social problems of the period. However, it is much more difficult to reach a clear interpretation of individual pictures.[27] If Bernard's *Iron Bridge*, mentioned above, seems a pessimistic view, van Gogh's contemporary *Bridge at Asnières* (1887; Zurich, Bührle Foundation, F301), a view of the same scene in sparkling sunlight, can, like his *Factories at Asnières, Seen from the Quai de Clichy*, be seen as optimistic, even utopian, in the juxtaposition of leisure with industry, nature with technology. The generally sunlit effects in Signac's views of the edges of Paris suggest a similar mood; his *Snow, Boulevard de Clichy, Paris* (p. 64) is more equivocal in tone, since it can be viewed just as readily as a picturesque effect or in terms of the life experience of the figures in this working-class quarter of Paris.

Seurat's two monumental paintings of this stretch of the Seine, *Bathers at Asnières* of 1883−84 (p. 167) and *A Sunday Afternoon on the Island of La Grande Jatte — 1884* of 1884−86 (p. 77), explore these issues further. Although the relationship between them has been much debated, it is clear that they represent opposite banks of the same stretch of the river, with working-class and artisanal figures bathing and sitting on the bank at Asnières, against the backdrop of Clichy's factories, while the Ile de la Grande Jatte is peopled by a fashionable and demimondaine crowd. The contrast is not only one of class, but also of body language: the poses on the bank at Asnières are relaxed and informal, in contrast to the stilted parade on the island.[28] Taken together, the pictures suggest that Seurat was acutely aware of the relationship between the natural and the artificial. Most obviously, this appears in the different modes of self-presentation of the figures; but the settings and backgrounds — the landscape scenarios in which the figures are placed — also contribute to this. Paradoxically, we view the seemingly "natural" working-class figures against an industrial backdrop, while the artificial social parade on the Grande Jatte takes place in the carefully manicured "natural" setting of the island.

The contrasts between these and other interpretations in this volume of landscapes on the edges of Paris are not only in terms of tone and mood. Stylistically, too, they vary drastically, ranging from the meticulous *petit point* that Seurat and Signac had adopted by 1886 to van Gogh's accentuated impressionist touch and Bernard's simplified, schematic drawing and flat zones of paint. All three of these manners of painting, in their very different ways, represent attempts to find an appropriate pictorial language to express the essence of modern experience.

In Seurat's and Signac's neo-impressionist techniques there was a central ambiguity. For some,

BATHERS AT ASNIERES, 1883–84 Oil on canvas, 201 x 300 cm

including Signac, Camille Pissarro, when he adopted the method in 1886, and the critic Félix Fénéon, it was essentially a scientific method, designed to replace the intuitive approximations of Monet's impressionism with a method that based its representation of natural light and color on scientific principles, seeking to analyze the components of light effects and to re-create them in the eye of the viewer.[29] In these terms it could be seen as overtly modern—objective and impersonal—in contrast to the romantic subjectivity of Monet's vision and technique. Yet it has recently been argued that Seurat never committed himself to the view that their technique was scientific, and that there are aspects of his use of color that cannot be explained in terms of scientific theory.[30] Rather, his method should be regarded as essentially artistic, a means of generating pictorial effects. Viewed in this way, it seems far more consistent with the aim of symbolist art theory to get behind surface visual appearances in order to suggest the essential characteristics of a subject. Such an interpretation of Seurat's technique is strongly confirmed by the highly schematic drawing of his figures in *La Grande Jatte* and later paintings, which cannot readily be interpreted in naturalistic terms.[31]

Visually, Bernard's technique, with its simplified flat planes, could not be more different from Seurat's. Yet Bernard, too, was seeking a method of painting that transcended surface appearances. He had evolved his technique while working in close contact with Louis Anquetin, and it was in Anquetin's paintings of 1887, notably *Avenue Clichy, Five O'Clock in the Evening* (p. 59) and *Mower at Noon: Summer* (1887;

private collection), that this process of simplification and schematization was taken to its furthest degree. In addition to employing crisp outlining and flat color planes, Anquetin treated each scene in a single dominant color: deep blue for evening, golden yellow for noon. Bernard later remembered that the inspiration for this had been Anquetin's experience of looking at an outdoor scene through the stained-glass window in a door and noticing how the scene's effect was transformed when viewed through panels of different colors.[32] When *Avenue Clichy* and *Mower at Noon* were exhibited at the Indépendants early in 1888, the critic Edouard Dujardin used them as the basis for his discussion of the new movement in art that he named cloisonnism, discussing their significance in explicitly symbolist terms:

The point of departure is a symbolic conception of art.... What is the point of reproducing the thousand insignificant details that the eye perceives? One should grasp the essential characteristic and reproduce it — or, rather, produce it; a silhouette is enough to express a physiognomy; the painter... must seek only to fix, with the smallest number of lines and characteristic colors, the intimate reality, the essence of the object that he is examining.[33]

Yet of course how Anquetin presented these subjects was the result of a set of personal decisions about the composition and format of the scenes. In different ways, both canvases bring to mind current artistic conventions. *Avenue Clichy* is a rethinking of the oblique views of city sidewalks pioneered by Gustave Caillebotte and, by the mid-1880s, common in the work of artists such as Jean Béraud, while *Mower at Noon* looks back to the peasant paintings of Millet. Both of Anquetin's paintings, in turn, acted as catalysts for canvases painted by van Gogh in 1888.[34]

Van Gogh's technique, in contrast to those of the cloisonnists and neo-impressionists, remained dynamic and variegated — attentive to the diverse textures in the scene before him as well as to the play of natural light and color. Yet even in paintings of the summer of 1887

such as *Factories at Asnières* (p. 29), we feel the beginnings of a process of simplification and exaggeration; the forms of buildings are treated as simple geometrical solids with crisp outlines, and the brushwork of the foreground field, together with the smoke playing across the sky, infuse the scene with an inner energy that goes beyond visual description.

Though the surroundings of Paris provided motifs for one notion of a modern form of landscape painting at the end of the 1880s, this generation of artists had left Paris far behind. Many of them had explicitly rejected this contemporary imagery, when they executed their most significant landscape paintings. Yet in various ways they remained centrally concerned with the problem of giving new meaning and relevance to landscape, whether by their choice of subject, their technique, or the theoretical positions that they adopted.

During the summer Seurat regularly visited the northern coast of France, on the English Channel, seeking "to cleanse his eyes of the days spent in the studio and to translate as exactly as possible the luminosity of the open air, with all its nuances."[35] His concern, in these landscapes, with directly observed light effects marks a continuing link with impressionist aesthetics, in contrast to the stylization of the later figure paintings that he executed in the studio. However, his trips to the coast were not a complete escape from his interest in the modern landscape; he consistently chose subjects that included signs of the changes that were overtaking this region — whether from fishing, commerce, tourism, or technological advances. Often, too, these contemporary elements are placed in particularly prominent positions within his compositions, so that their disruption of the conventional picturesque is highlighted. Most of his paintings done at Port-en-Bessin in 1888, for instance, focus on the undistinguished little buildings around the port; in *Port-en-Bessin: The Outer Harbor, Low Tide* (p. 169), the only features in the bottom half of the picture are the awkward, blocky forms of the jetties and the cut-off

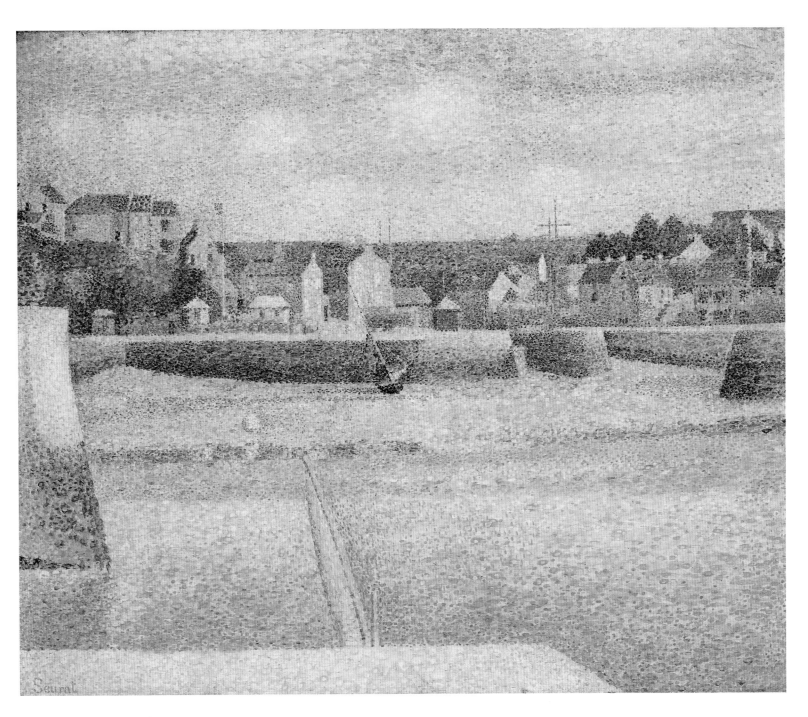

PORT-EN-BESSIN: THE OUTER HARBOR, LOW TIDE, 1888 Oil on canvas, 53.7 x 65.7 cm

VIEW OF COLLIOURE, 1887 Oil on canvas, 33 x 46 cm

form of the sail and mast of a small boat. Even when he did look away from the little port, in *Seascape at Port-en-Bessin, Normandy* (p. 15), the cliff top is crowned with distinctive man-made forms, perhaps a semaphore, in marked contrast to Monet's similarly composed Channel coast cliff scenes from the early 1880s, from which all traces of contemporaneity are excluded. However, the key landscape sites of the *petit boulevard* painters were still farther from Paris—in the South of France and in Brittany. It was in these regions

Claude Monet, *Antibes*, 1888, oil on canvas, 65.5 x 92.4 cm

that the painters explored most fully the range of possibilities that landscape painting offered, and the ways in which it might be developed beyond impressionism.

The South of France had long posed special problems for painters: the unfamiliar quality of the light; its dazzling luminosity; and the vividness of the colors under certain weather conditions. We can trace a consistent pattern in artists' responses to these problems. When they first arrived in the South, they sought to imitate these effects as closely as possible in paint, but they quickly realized that the painter cannot directly represent the light of the sun but must instead seek some equivalent for it in paint on canvas. Broadly speaking, the impressionist and post-impressionist painters all reached the conclusion expressed succinctly by Cézanne late in his life: "I wanted to copy nature, but I didn't succeed. But I was content with myself when I discovered that sunlight cannot be *reproduced*, but that it must be *represented* by something else—by color."[36] The dazzling color contrasts of Monet's Antibes canvases were his visual solution to the same problem (above).[37]

Signac, on his first two visits to the South of France, in 1887 and 1889, insisted that the light could

best be represented by emphasizing luminosity rather than bright color, since in the South "the orange-colored light of the sun, reflected everywhere, decolors the shadows, tones down the local colors and pales the purest skies."[38] However, in the canvases painted during these trips (e.g., p. 170) he did use sharper color contrasts along the lines of demarcation between warm and cool zones, within a dominantly pale, luminous tonal range. Only in the 1890s, after the period under discussion herein, did he come to use intense color throughout the canvas as a means of evoking the effect of this light.[39]

Van Gogh reached very similar conclusions about the need to use color as a means of conveying the essential quality of the South. From an early stage in his time at Arles in 1888, he stressed the need to use exaggerated color. Initially, he viewed this primarily as a response to his visual experiences and compared the effects that he sought with the way color is used in Japanese woodblock prints, of which he had amassed a large collection during his two years living in Paris (1886–88).[40] However, he soon came to view color more metaphorically, drawing an analogy between the heat and harshness that he felt in the South and

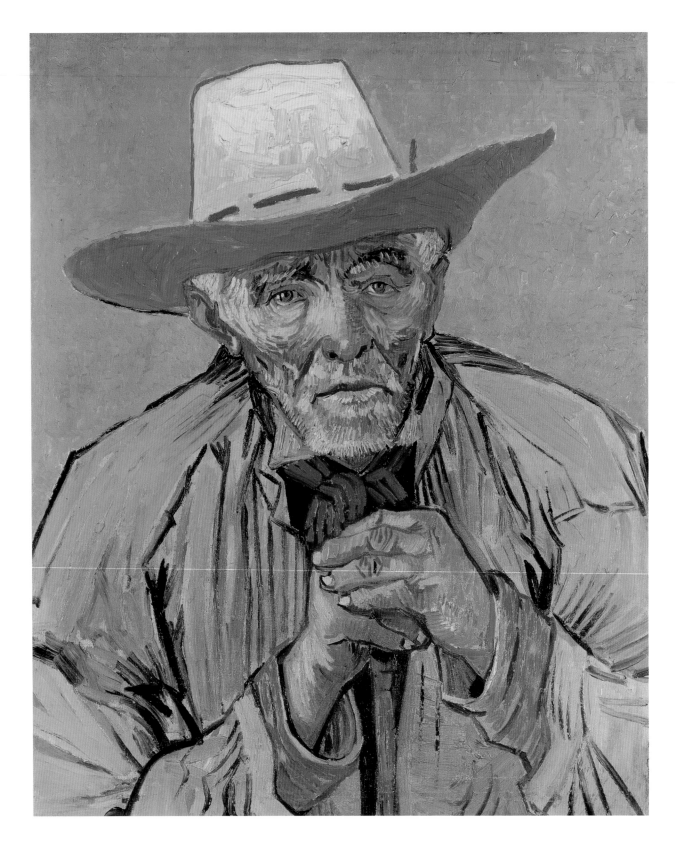

PORTRAIT OF PATIENCE ESCALIER, 1888 Oil on canvas, 69 x 56 cm

the colors that he saw there, and he felt justified in exaggerating contrasts of color in order to convey this.[41] By August 1888 he felt that he was moving beyond the lessons of impressionism:

What I learned in Paris is leaving me, and I am returning to the ideas I had in the country [in Holland] before I knew the impressionists. And I should not be surprised if the impressionists soon find fault with my way of working, for it has been fertilized by Delacroix's ideas rather than by theirs. Because instead of trying to reproduce exactly what I have before my eyes, I use color more arbitrarily, in order to express myself forcibly.

To illustrate what he meant, he described his recently painted portrait of the peasant Patience Escalier (p. 172): "I imagine the man I have to paint, terrible in the furnace of the height of harvest-time, as surrounded by the whole Midi. Hence the orange colors flashing like lightning, vivid as red-hot iron, and hence the luminous tones of old gold in the shadows."[42] Though fueled by direct observation of his surroundings, color has here become an autonomous, emotive mode of expression, released from direct dependence on the natural world. Moreover, by invoking Delacroix as his model, van Gogh was explicitly linking himself to the legacy of romanticism and rejecting the precepts of the forms of realism and naturalism that had dominated French painting for the past thirty years.[43]

Accounts such as these raise again the basic dilemma of symbolism that we have already discussed — the status of the *Idée*. On occasion, van Gogh wrote of his procedures in orthodox symbolist terms, speaking of "exaggerating the essential" in his canvases.[44] Yet his identification of the "essential" was inescapably subjective and often based on chains of association that were distinctively personal — and indeed unique to his own ways of seeing, thinking, and forging analogies. This emerges particularly clearly in the canvases of garden scenes at Arles with which van Gogh planned to adorn the walls of the room Gauguin was to occupy when he came to stay with him. He

painted a number of views of a local public garden without any idea of a further layer of meaning (e.g., p. 175); but soon, as the result of an article that he had read about the Provençal and Italian poets of the Renaissance, he formulated the plan of grouping a number of views of the garden together in order to express the idea of the Poet's Garden.[45] He evolved the idea that the poets had been inspired by gardens similar to that at Arles, and, when he learned that Gauguin would join him there, he wrote to him:

I have expressly made a decoration for the room you will be staying in, a poet's garden.... The ordinary public garden contains plants and shrubs that make one dream of landscapes in which one likes to imagine the presence of Botticelli, Giotto, Petrarch, Dante, and Boccaccio.... And what I wanted was to paint the garden in such a way that one would think of the old poet from here (or rather from Avignon), Petrarch, and at the same time of the new poet living here — Paul Gauguin.[46]

So, by this very personal chain of associations these images of a mundane local public garden were given a powerful metaphorical resonance, but one that, without added commentary, would have been wholly unintelligible to a viewer.

Van Gogh's attitude to literary inspiration was very equivocal. His voracious reading of recent fiction provided him with many images that, in his correspondence, he linked with the imagery of his paintings in order to infuse them with deeper layers of meaning. He associated the canvases of Madame Roulin titled *La Berceuse* (e.g., p. 47), for instance, with the description in Pierre Loti's novel *Pêcheur d'Islande* of an image of the Virgin Mary in a fishing boat,[47] and a painting of the stagecoach to the local town of Tarascon with a novel by Alphonse Daudet.[48] He also had a longstanding but unrealized project to paint the exterior of a Parisian bookshop in the evening: "It is such an essentially modern subject. Because it seems to the imagination such a rich source of light. Say, that would be a subject that would go well between an olive grove

and a wheat field, the sowing season of books and prints."[49] The idea of the bookshop, here, stands for a type of enlightenment that would lend extra meaning to the images of the natural world, the olive grove and the wheat field, that would flank the planned picture.

However, van Gogh remained adamant that art should not derive from literary sources — from texts — alone. Rather, he insisted that it must be grounded in direct observation of the external world. This insistence was at the heart of his artistic disagreements with Gauguin, when Gauguin came to stay with him at Arles in the last months of 1888. Though van Gogh painted a few canvases from his imagination during Gauguin's stay, he soon realized, as he put it later, that what he called "abstraction" was "enchanted ground ... one soon finds oneself up against a wall."[50] At the end of Gauguin's stay, van Gogh summed up their different approaches in two pictures of chairs (1888; London, The National Gallery, F498, and 1888; Amsterdam, Van Gogh Museum, F499). Gauguin's is set on an imaginary carpeted space in artificial light, with two books on the chair, in contrast to van Gogh's simple wicker seat with a pipe and a twist of tobacco on it, set in broad daylight in the corner of a humble tiled room, with freshly growing bulbs in a tray or trough behind it. The books in *Gauguin's Chair* represent a form of enlightenment that is thoroughly alien to van Gogh's vision. Gauguin's may be the larger, more luxurious room and chair, but only van Gogh's is viewed as a part of the natural world.

The contrast between their viewpoints was also stressed by Gauguin during his stay at Arles in a number of paintings executed expressly, it would seem, in order to reveal to van Gogh the limitations that his dependence on nature imposed on him. This emerges most vividly — and, we must assume, most painfully for van Gogh — in the garden painting that Gauguin executed in Arles, *Arlésiennes (Mistral)* (p. 177). This was presumably painted in Gauguin's room in the house that they shared, and thus in the very room in which van Gogh's Poet's Garden paintings, done from nature, were hanging. Gauguin's is an imaginary garden, calculatedly antinaturalistic in space and scale, and peopled by gaunt, mournful figures, in stark contrast to the little figures of lovers that van Gogh added to some of his garden pictures. In addition, many viewers have seen in the bush at the bottom left of Gauguin's canvas hints of a caricatural face, with eyes and moustache, that resembles Gauguin's own — possibly a comic reference to the presence of the artist in his own work.

A number of van Gogh's Saint-Rémy landscapes of 1889 were painted expressly as responses, counters even, to Gauguin's and Bernard's advocacy of painting from the imagination. Both Gauguin and Bernard had undertaken the subject of Christ in the Garden of Olives, and van Gogh felt that these attempts were deeply misguided. His own pictures of olive groves (e.g., p. 44) were an answer to the other artists' "abstractions": "If I stay here, I shall not try to paint a Christ in the Garden of Olives, but the harvesting of the olive trees as you still see it."[51] In another letter he wrote:

This month I have been working in the olive groves, because they so enraged me with their Christs in the Garden, with nothing really observed. Of course with me there is no question of doing anything from the Bible — and I have written to Bernard and to Gauguin too that I considered our duty is thinking, not dreaming.... Now the olive and the cypress here have exactly the same significance that the willow has at home. What I have done is a rather hard and coarse realism beside their abstractions, but it will have a rustic quality, and will smell of the earth.[52]

Olive trees could stand for Christ's agony in two ways, most obviously by association with the Garden of Olives, but also because the twisting patterns of their branches could evoke the mood of anguish. Van Gogh's association of natural forms and colors with states of mind emerges most clearly from a letter describing a canvas of the asylum garden at Saint-Rémy, with trees silhouetted against the sky (p. 178):

The nearest tree is an enormous trunk, struck by lightning and sawed off. But one side branch shoots

THE GARDEN OF THE POETS, 1888 Oil on canvas, 73 x 92.1 cm

up very high and then hangs down in an avalanche of dark green twigs. This somber giant — like a defeated proud man — contrasts, when considered in the nature of a living creature, with the pale smile of a last rose on the fading bush in front of him.... You will realize that this combination of red-ochre, of green gloomed over by grey, the black streaks surrounding the contours, produces something of the sensation of anguish, called *noir-rouge*, from which certain of my companions in misfortune often suffer. Moreover, the motif of the great tree struck by lightning [and] the sickly green-

pink smile of the last flower of autumn serve to confirm this idea [*Idée*]. Another canvas shows the sun rising over a field of young wheat...here, in contrast to the other canvas, I have tried to express calmness, a great peace. I am telling you about these two canvases, especially the first one, to remind you that one can try to give an impression of anguish without aiming straight at the historic Garden of Gethsemane; that it is not necessary to portray the characters of the Sermon on the Mount in order to produce a consoling and gentle motif.[53]

As his description of the Patience Escalier portrait suggests, it was not only the forms of nature in the South that van Gogh invested with metaphorical meanings and associations. The physical, bodily experience of the South, too, acquired a metaphorical dimension. This emerges most clearly from his descriptions of the mistral — the harsh hot wind that sweeps across this landscape for much of the year.[54] Initially, following his arrival in Arles in early 1888, he simply regarded this wind as a physical impediment to painting,[55] but he soon came to describe it in emotive terms, speaking of the "infuriating contrariness" of this "ill-natured, whining wind."[56] Beyond this, he came to see that painting in the wind gave his canvases a distinctive, "haggard" look, and compared this with the awkwardness of touch that he had seen in landscapes that Cézanne had painted in the South.[57]

Later in 1888 he came to view the mistral as a physical challenge that he had to confront and overcome, describing his work on *Summer Evening* (Winterthur, Kunstmuseum, F465): "I painted it with the mistral raging. My easel was fixed in the ground with iron stakes.... Then one ties the whole thing together with rope. In this way you can work with the wind blowing."[58] Monet had adopted similar expedients when painting on the storm-swept island of Belle-Isle off the coast of Brittany in 1886, as van Gogh would doubtless have learned when the Belle-Isle pictures were exhibited at Petit's gallery in 1887. However, for van Gogh the experience of the wind came to assume a more directly emotional significance, as he indicated in a later letter about *Summer Evening*: "I went out to do it expressly while the mistral was raging. Aren't we seeking intensity of thought rather than tranquillity of touch?" Later in the same letter he talked more generally about his studies of wheat fields: "The landscape's yellow — old gold — done quickly quickly and in a hurry, just like the harvester who is silent under the sun, intent only on his reaping."[59] The first association here is between the painted marks put on the canvas during the mistral and "intensity of thought"; the next one is between the act of painting and the

physical effort of an agricultural worker enduring the sun. The reaper's activity becomes a metaphor for the act of painting, and vice versa. In another letter van Gogh gave an ethical dimension to the mistral: "Unfortunately, along with the good god sun there is, three quarters of the time, the devil mistral."[60] So the struggle of the reaper, and of the painter, with the elements becomes a still more universal metaphor — for the struggle between good and evil.

In 1889–90 at Saint-Rémy, van Gogh returned to the image of the reaper in a significant group of paintings, giving this figure a central role in the life cycle:

I see in this reaper — a vague figure fighting like a devil in the midst of the heat to get to the end of his task — I see in him the image of death, in the sense that humanity might be the wheat that he is reaping. So it is — if you like — the opposite of the sower I tried to do before. But there's nothing sad in this death, it takes place in broad daylight, with a sun flooding everything with a light of pure gold.

Later in the same letter, he added: "It is an image of death as the great book of nature speaks of it — but what I have sought is the 'almost smiling.'"[61]

The linkage here is between the forces of the elements, the physical experience of human beings exposed to them — the reaper and of course also the painter — and the cosmic oppositions of life and death, good and evil. As with his struggles with the mistral at Arles in 1888, painting technique also played a part in these chains of connection. Writing from Saint-Rémy about a view of a mountain (p. 179), he associated it with a passage in a book by Edmond Rod, *Le Sens de la vie*,[62] and, when he sent the canvas to Theo, he commented: "They will tell me that mountains are not like that and that there are black outlines of a finger's width. But after all it seemed to me it expressed the passage in Rod's book ... about a desolate country of somber mountains, among which are some dark goatherds' huts where sunflowers are blooming."[63] Both drawing and color here contribute

ARLESIENNES (MISTRAL), 1888 Oil on canvas, 72 x 93 cm

A CORNER OF THE ASYLUM AND THE GARDEN WITH A HEAVY, SAWED-OFF TREE, 1889 Oil on canvas, 73.5 x 92 cm

to the creation of a mood that he felt was appropriate to the image that he had found in Rod's book.

In the context of the debates about subjectivity and objectivity in symbolist theory, van Gogh's art posed a fascinating problem. His art was clearly grounded in a unique and very distinctive personal vision; yet evidently it was seeking to go beyond superficial visual appearances. In Aurier's essay about van Gogh, published in January 1890, the only substantial discussion of his art to appear in print during his lifetime, these issues are confronted head-on, and van Gogh's tech-

nique plays a central role in the account. Zola's formula, "nature seen through a temperament," is discussed in detail, and Aurier stresses the subjectivity of van Gogh's vision—"his profound and almost childish sincerity, his great love for nature and for the truth—for his own personal truth." Yet he goes on to insist that more lay behind van Gogh's astonishing technique:

Most often, he considers this enchanting physical stuff [*matière*] only as a sort of marvelous language intended to translate the Idea [*Idée*]. He is almost always a sym-

THE ALPILLES WITH DARK HUT, 1889 Oil on canvas, 71.8 x 90.8 cm

bolist. Not, I know, a symbolist in the manner of the Italian primitives, those mystics who scarcely felt the need to give material form to their dreams, but a symbolist who constantly feels the need to clothe his ideas with precise forms that can be weighed and touched.... In almost all his works ... there is, for anyone who can see it, a thought, an Idea, and this Idea, the essential underpinning of the work, is also its effective and final cause. As for the brilliant and dazzling symphonies of colors and lines, whatever their importance for the painter, in his work they are

nothing more than expressive *means*, simple *procedures* of symbolization. If you refuse to admit the existence of these idealist tendencies beneath this naturalist art, a great part of the work that we are studying would remain incomprehensible.[64]

It is interesting that van Gogh, in his long letter to Aurier in response to this essay, found nothing to disagree with in this conclusion.[65]

 This discussion of van Gogh has focused on his development of a highly personal metaphorical vision

179

SUN OVER WALLED WHEAT FIELD, 1889 Black chalk and ink heightened with white on paper, 47.5 x 56 cm

of nature and landscape in the South. However, this was not the only way in which landscapes gained extra layers of meaning in the nineteenth century. For the regions and locations painted, and sometimes the specific sites, also brought with them a chain of historical and cultural associations that were integral to the way in which any image of a place was viewed. Then, far more than today, guidebooks expounded at length the history of a place and the significant events that had occurred there. Earlier in the century, it was such associations that gave a place its significance and made it worth painting at all. By the 1870s, as we have seen, mundane and seemingly trivial sites had become a legitimate focus for the impressionists in their quest to develop a modern form of landscape painting.[66] In the

1880s and 1890s, though, deeper cultural associations once again became significant as younger artists sought richer and more universal meanings in landscape.

The contrast between the South of France and Brittany, the region where Gauguin and Bernard regularly worked in the later 1880s, is particularly revealing here. The South was primarily associated with classical antiquity; Brittany, with a pagan, pre-Roman history and a primitive, medieval Christianity. Most visitors to the South — to Provence and to the Riviera — emphasized its classical heritage. Gauguin, when he arrived in Arles, compared the local women, with their "Greek beauty," to "Greek processions,"[67] and Signac, when in 1892 he first visited Saint-Tropez, where he was later to settle, was immediately reminded of Naples

and Capri.[68] These associations might also be deployed in support of political agendas. In 1894–95 Signac set his anarchist idyll, *In the Time of Harmony*, in a landscape derived from the coastline near Saint-Tropez, while Maurice Denis, increasingly allied to the political right after 1900, created idealized figure scenes on the southern beaches, sometimes with contemporary dress, but often overtly mythological.[69]

The exception here was van Gogh. As Gauguin commented when he arrived in Arles: "It's strange; Vincent sees Daumier to do here."[70] Van Gogh did recognize the Greek associations of the countryside,[71] but more often stressed the analogies that he saw with Daumier's images of the urban poor; as he wrote to Gauguin before his arrival: … here you will see nothing more beautiful than Daumier; for often the figures here are absolutely Daumier."[72] It is noteworthy, too, that van Gogh never painted Arles's remarkable classical monuments, apart from the avenue of the Alyscamps, a Roman necropolis converted to Christian use, which probably appealed to Vincent principally because of its associations with death.

These contrasting views of Arles closely mirror the ways in which the place was described in contemporary travel literature. Mention was constantly made of its Roman past, and its surviving antique monuments were always described. Sometimes, however, their splendor was contrasted with the decay of modern Arles. This was most famously expressed by Alexandre Dumas in the 1840s. Although he noted that there were signs of renewal there, he concluded: "Arles is a tomb, the tomb of a people and of civilisation, a tomb like those of the barbarian warriors, with whom were buried their gold, their weapons and their gods. The modern city is encamped upon a sepulchre; and the earth on which it stands contains as much wealth within its bosom as want and misery upon its surface."[73] Visiting the place in the 1870s, Henry James tried hard to discover the charm of the modern Arles and even took the same walk along the banks of the Rhône at night that would become in 1888 the subject of van Gogh's first canvas of *The Starry Night* (Paris, Musée d'Orsay); but despite his

efforts, James concluded: "It was not what I had looked for; what I had looked for was in the irrecoverable past."[74] More definitively, Louis de Laincel condemned the place to death in 1881: "Every day it loses its physiognomy, its originality, and its character. Its port is a virtual desert, its streets virtually deserted, its countryside bare and sad. Solitude and fever surround it. It is agitated without dignity, grows old without nobility, and expires without grandeur."[75]

Gauguin would have agreed with de Laincel; he wrote to Bernard: "I'm completely out of my element at Arles, I find everything so mean and paltry, the countryside and the people."[76] Soon after his arrival he made it clear to van Gogh that Brittany was a far preferable region, as van Gogh reported to Theo: "What he tells me about Brittany is very interesting, and Pont-Aven is a most marvelous country. Certainly everything there is better, larger, more beautiful than here. It has a more solemn character, and is more complete and more definite than the shriveled, scorched, trivial scenery of Provence."[77] But for van Gogh, the backstreets of the old town of Arles, evoking Daumier's work, retained their fascination.

Gauguin's view of Brittany, too, was inseparably linked to current cultural stereotypes. The region's remoteness and primitiveness were constantly stressed, in verbal accounts and also in the very many paintings of Breton peasant subjects that appeared at the Paris Salon, such as Pascal-Adolphe-Jean Dagnan-Bouveret's *Breton Women at Pardon* (p. 182), by general agreement the most notable painting at the Salon of 1889. There were a number of dimensions to this mythic image of Brittany: distinctive local costumes, an emphasis on the peasants' unquestioning religious faith and piety, and reminiscences of a superstitious, pagan past. Although it has been shown that contemporary society in Brittany was more complex and less unchanging than the standard accounts imply,[78] the stereotypes remained unchallenged in the representations of the place— both verbal and visual—that appeared in Paris. In stylistic terms, the vision of Brittany that Gauguin presented may be utterly unlike Dagnan-Bouveret's, but

the underlying idea of the essential qualities of the region is very similar.

Early in 1888 Gauguin wrote: "I love Brittany. I find here the savage and the primitive. When my clogs ring out on this granite soil, I hear the dull, muted, and powerful tone that I am seeking in painting."[79] The linkage here is synesthetic — between sound and sight; the increasingly simplified, schematic forms of his landscapes in 1888, such as *Seascape with Cow on the Edge of a Cliff* (p. 188), are the visual equivalent of the tone of wooden clogs on granite, and both are expressions of the "primitive." Beyond this, the religious dimension — so central to the stock public image of the region — became overt in Gauguin's work in *The Vision after the Sermon* (p. 114), painted in August and September 1888: "I think that I have attained in the figures a great rustic and *superstitious* simplicity. The whole thing is very severe."[80] This religious imagery was carried over into the local landscape in 1889 in *The Yellow Christ* (Buffalo, Albright-Knox Art Gallery) and *Breton Calvary — Green Christ* (p. 184). Some cryptic notes that Gauguin wrote in relation to the latter give an idea of his aims in this picture: "Calvary cold stone of the soil — Breton Idea of the sculptor who explains religion through his Breton *soul* with Breton costumes. Breton local color.... The whole thing in a Breton landscape, i.e. Breton poetry."[81] The constant reiteration of "Breton" emphasizes that he sees the locale as central to his vision, and also that he is seeking out its essential quality; he links the late medieval Breton sculptor who had carved the original calvary to his own vision and invokes poetry and religion to indicate that both works — the sculpture and his own painting — transcend visual appearance. In its execution, too, the picture turned its back on naturalistic representation; the original calvary on which Gauguin drew is far smaller than it is shown here and is sited outside the church at Nizon near Pont-Aven, not where Gauguin located it, down by the coast.

His mention of "poetry" in the notes about the picture highlights a key difference that Gauguin felt between his own and van Gogh's approaches to painting. In early September 1888, in reply to a now-lost letter from Vincent, Gauguin wrote:

Yes, you are right to want to make paintings with a coloration that is suggestive of poetic ideas, and in this sense I agree with you, but with one difference. I don't understand "poetic ideas" — this is probably a sense that I am lacking. I find EVERYTHING poetic and it is in the corners of my heart which are sometimes mysterious that I catch sight of poetry. Forms and colors combined into harmonies generate poetry of themselves.[82]

We do not know what Vincent had said that triggered this response, but Gauguin is clearly criticizing the imposition of extraneous literary and poetic resonances, derived from particular texts, onto an existing

Pascal-Adolphe-Jean Dagnan-Bouveret, *Breton Women at Pardon*, 1887, oil on canvas, 125 x 141 cm

HARVEST IN BRITTANY, 1889 Oil on canvas, 92 x 73.3 cm

BRETON CALVARY—GREEN CHRIST, 1889 Oil on canvas, 92 x 73 cm

image; indeed, this is just the type of literary dimension that, shortly afterwards, van Gogh was to invoke in his Poet's Garden imagery. Gauguin's "poetry," by contrast, was intrinsic to the objects that he scrutinized, as in the Breton resonances of his calvary project.

These resonances did not emerge only from images with the overtly evocative content of the calvary. Even scenes of everyday Breton life such as *Harvest in Brittany* (p. 183) might evoke rich veins of poetic response. Gauguin's patterns of thinking emerge par-

THE SEAWEED GATHERERS, 1889 Oil on canvas, 87 x 122.5 cm

ticularly clearly in a long letter that he wrote to
Vincent in autumn 1889, a letter that is also a remark-
able restatement of the stereotypical notions of the
essence of Brittany:

What I have mostly done this year are simple peasant
children walking indifferently by the sea with their
cows. But since open-air illusionism doesn't please me,
I'm trying to put into these desolate figures the sav-
agery that I see in them and that is in me, too. Here in

Brittany the peasants have a medieval look and don't
appear to think for one instant that Paris exists and
that it is now 1889. Quite unlike the Midi. Here
everything is rough like the Breton language, and
shut away — it seems for evermore. The costumes
are also almost symbolic, influenced by the super-
stitions of Catholicism. The backs of their bodices
have a cross shape on them, and their heads are
enveloped in a black kerchief like nuns. In addition,
their figures are almost Asiatic, yellow and triangular,

severe.... Still fearful of Our Lord and of the priest, Breton men hold their hats and their utensils as if they were in church; so I paint them like that, and not with a southern animation. At the moment I am painting a size 50 canvas [*The Seaweed Gatherers*, p. 185]: some women collecting seaweed by the sea.... Seeing this every day, I get a vivid sense of the struggle for life, of sadness and of obedience to unhappy laws. I'm trying to give a strong sense of this on my canvas, not haphazardly but rationally, by exaggerating, perhaps, a certain rigidity of pose, certain somber colors, etc. This is all perhaps *mannered,* but in a painting what is natural? *Everything* in paintings since the most remote past has been wholly conventional and deliberate throughout and very far from the natural — hence wholly mannered.[83]

This letter is worth quoting at such length because it highlights the differences between Gauguin's and van Gogh's approaches to meaning and expression in art. Unlike van Gogh, Gauguin makes no literary references. Visual appearances trigger a whole range of types of association: the forms of the costume have religious analogies, as does the body language of the men; the movements of the women on the beach evoke more general thoughts about the human condition. The population as a whole is both medieval and savage — remote in time and place from Paris in 1889; and the "rough" quality of the place is analogous to the aural qualities of the local language — a language that the central French government was at this date at pains to extinguish.[84] The synesthetic analogy here is with the language, rather than with the resounding clogs; but clearly Gauguin's responses are presented as a multisensory unity — a reading of the region that was triggered by and filtered through all his senses. In a sleight of hand that later became a keynote of his time in Tahiti, he can assume a double identity: he can view this world as a man who has knowledge of Paris in 1889 — where our own cultural odyssey in this essay began; but at the same time he can imagine himself as a savage, as one of "them."

These responses are presented as Gauguin's own; yet they also invoke the notion of universality and the timeless, unchanging qualities of Breton life. In these terms, they follow the path that symbolist theory advocated — the passage from the initial sensory stimuli that the individual subjectivity receives to the essential *Idée* that somehow transcends the individual. Yet this reading neglects one central issue that recent post-colonialist theory has highlighted: that such invocations of "essential" characteristics are inevitably value laden — generated by the values of the culture that accepts them as universals, as "natural."[85] What Gauguin viewed as timeless universals were frameworks that were dictated by the values of Parisian bourgeois culture. Certainly, he was able to reverse these values, by attributing special value to these shut-away people who knew nothing about Paris or about the year 1889 — a date that, as we have seen, had special significance because of the Exposition Universelle, which made the world's cultures visually available and located them in comparison or competition with each other in its various national pavilions. But at the same time his terms of reference — the frameworks and criteria that he used to define and classify the "essential" qualities of Breton life — were forged by the values of the modern urban culture upon which he had turned his back, and, more specifically, by the frameworks of comparative viewing that the colonial pavilions at the Exposition had engendered. Gauguin's experience of the Exposition, and of these pavilions, was to have a crucial influence on his plans to leave France for Tahiti in search of artistic and personal renewal and fulfillment.[86]

Both van Gogh and Gauguin, in their different ways, engaged with landscape as a social environment whose forms mirrored a vision of the nature of the life of the local inhabitants. By contrast, Signac's views of scenes remote from Paris make little of this. Each summer from 1887 until 1892 when he rented a property at Saint-Tropez that he subsequently purchased, he visited either Brittany or the Mediterranean coast, but he was primarily concerned, in the paintings that he brought back from these trips, with the forms and pat-

CONCARNEAU: FISHING BOATS, 1891 Oil on canvas, 64.8 x 81.3 cm

terns of the landscape. On his first visit to the South in 1887, he viewed the buildings of the port at Collioure and the boats on the beach as a cluster of geometric shapes (p. 170), while in Brittany at Portrieux in 1888, at Cassis on the Mediterranean in 1889, and at Saint-Cast in 1890, he focused primarily on the relationships between sea and shore, making little of the human content of the landscape. In a sequence of paintings done at Concarneau in Brittany in 1891, his central theme was the local fishing fleet, but the boats and the little figures in them are treated very schematically and subordinated to the overall decorative pattern of the compositions.

At the same time, Signac was exploring the analogies between painting and music. From 1887 to 1893 he gave his paintings opus numbers and later cited James McNeill Whistler's musical titles as a precedent for this.[87] Generally, in the catalogue accompanying an exhibition of his paintings, descriptive titles follow their opus numbers, but at the exhibition of Les XX in Brussels in 1888, he showed a sequence of paintings with opus numbers and dates alone, as if to stress that their formal qualities transcended their starting point in the external world. It was at the 1892 exhibition of Les XX that he made his most elaborate musical analogy for his paintings; he exhibited his five pictures

SEASCAPE WITH COW ON THE EDGE OF A CLIFF, 1888 Oil on canvas, 73 x 60 cm

of the Concarneau fishing fleet under the collective title *The Sea, the Boats (Concarneau 1891)*, but specified the individual canvases by opus number and musical title alone: *Scherzo, Larghetto, Allegro maestoso, Adagio,* and *Presto (finale)*. These were replaced by descriptive titles when the paintings were exhibited at the Indépendants in Paris. Signac may have felt that the musical titles better suited an avant-garde venue like Les XX (the exhibitions of Les XX were accompanied every year by performances of vanguard music), than they did the jury-free mixed bag of the Indépendants.

Yet there is a central paradox in Signac's preoccupation with musicality. For, as we have seen, his suburban landscapes engaged directly with social and political concerns and treated themes that he himself associated with anarchist political aspirations. Yet, in the same article in which he wrote of subjects that bore witness to "the great social proceeding under way between workers and capital," he also provided a rationale for viewing the quest for pure aesthetic beauty as a legitimate form of art in anarchist terms:

It would...be a mistake...to make it a standard demand that works of art have a precise socialist thrust, for that thrust will appear more strongly and eloquently in the pure aesthetes, revolutionaries by temperament, who leave the beaten path to paint what they see, as they feel it, and who very often unconsciously deal a solid blow of the pick to the old social edifice... only artists gripped by pure art, and in particular the Impressionist painters, whose technique is the negation of old artistic routines, deserve the entire accord of those who applaud the collapse of outmoded prejudices.[88]

By 1890 Signac's art could be analyzed in broadly symbolist terms. Fénéon commented in that year: "M. Paul Signac has been able to create exemplary specimens of an art of great decorative development, which sacrifices anecdote to arabesque, nomenclature to synthesis, the fugitive to the permanent, and... confers on Nature, which has finally been exhausted by its precarious reality, an authentic Reality."[89] The

distinction here between levels of reality, contrasting the transitory with the "authentic," together with the emphasis on synthesis and the decorative, is close to the ideas put forward by Aurier in his discussion of Gauguin's art and his definitions of symbolist painting in the following year.[90] However, Signac himself was at pains to distinguish his own art from that of the "Symbolist-impressionists, who, confining themselves to retrograde subjects, fall back into the old vagaries and forget that art consists much more in searching into the future than disinterring the legends of the past, no matter how golden they may be."[91] His insistence on artists painting "what they see" is closer to van Gogh's position; but the dynamic pulse that van Gogh felt running through nature is a far cry from the measured decorative patterning of Signac's coastal scenes of these years.

In Gauguin's pictorial language, the physical execution and "style" of the painting are crucial. His calculated "exaggeration" was a means of avoiding "open-air illusionism," and of highlighting the interpretative presence of the painter and the painter's role as mediator. Along with this "exaggeration" came a repudiation of painting outdoors in front of the motif. As he put it in a letter to the painter Emile Schuffenecker in August 1888: "Do not copy too much from nature. Art is an abstraction; derive it from nature whilst dreaming in front of nature, and think more of the creation than of the result; that is the only way to rise up towards God, by doing what our divine master does — creating."[92] In practical terms, even when working out of doors, Gauguin advocated a procedure of radical simplification, as he explained to the young painter Paul Sérusier in the same year: "How do you see that tree? It's green? Then paint it the most beautiful green on your palette; and that shadow? It's more like blue? Don't be afraid to paint it as blue as possible."[93] While at Arles, Gauguin said that the place was providing him with "a source of beautiful *modern style*."[94] The phrase *style moderne* later became the standard French term for what is paradoxically known in English as art nouveau.[95] Gauguin's

FISHING BOATS AT SAINTES-MARIES-DE-LA-MER, 1888 Pen and ink and graphite on wove paper, 24.3 x 31.9 cm

use of it in 1888 precedes its adoption as a stock term, but he must have meant something very similar to its later use — a schematized mode of painting that rejected precise detail and illusionistic space in favor of a decorative two-dimensional surface.

Van Gogh, too, under the influence of Gauguin's urgings, at times voiced similar aims, writing in 1889 of his search for "style" and for "a more virile, deliberate drawing"[96]; indeed, on one occasion he repeated, virtually verbatim, the instructions that Gauguin had given to Sérusier, and doubtless also to van Gogh himself when he visited him in Arles.[97] But a fundamental difference remained, in both aims and methods. For van Gogh, the physical paint mark was itself an expressive medium, whereas Gauguin's process of "abstrac-

tion" was designed to rid his paintings of such effects, in favor of the pursuit of the essential *Idée*, uncompromised by such contingencies.

When van Gogh wrote in August 1888 that the impressionists "might soon find fault with my way of working," he was referring to his ideas on emotive, expressive color.[98] A few days later he returned to this issue, in relation to his *Sunflowers*: "I am beginning more and more to seek a simple technique that is perhaps not impressionist. I would like to paint in such a way that everybody who has eyes would be able to see it clearly."[99] Certainly, as we have seen, he could describe this simplification in symbolist terms, as a process of exaggerating the essential. But at the same time the expressive touch remained absolutely central

ROAD WITH CYPRESS AND STAR, 1890 Oil on canvas, 92 x 73 cm

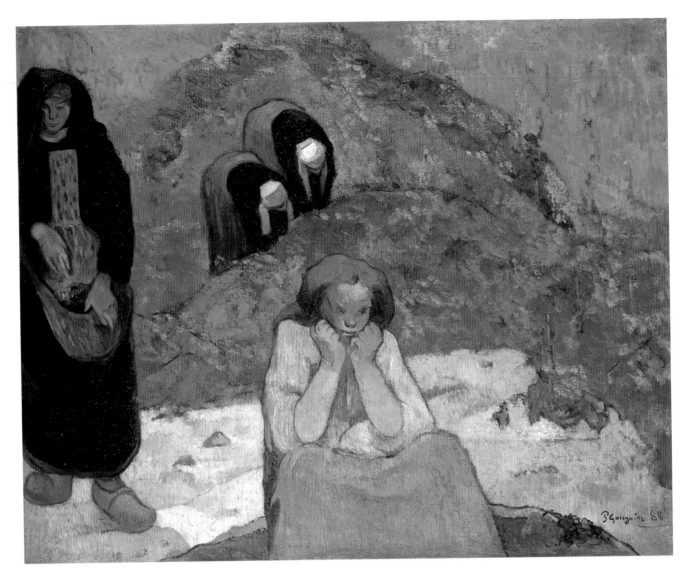

THE GRAPE HARVEST AT ARLES. MISERES HUMAINES, 1888 Oil on canvas, 73.5 x 92.5 cm

to his art, both as a means of conveying what he saw as the essence of his subject and as a marker of his own intensely physical engagement with both the subject and the act of painting itself.

Contrast this with Gauguin's declared aim in 1888 to develop a manner of painting *sans exécution*.[100] By this phrase he meant to reject the informality of impressionist plein-air procedures and the accidental effects of paint that they engendered; but the phrase also highlighted his belief that the creative synthesis that he was seeking was incompatible with the physical

effects of informal mark-making and impasto. These issues were clearly a central focus of debate while Gauguin was staying at Arles. As he reported to Bernard: "He [van Gogh] is a romantic whereas I am drawn towards a primitive state. From the point of view of color he views the chance effects of impasto as in Monticelli, but I detest messy, incoherent handling."[101] Late in 1889 he wrote to van Gogh describing his current projects, reiterating this message and reasserting the linkage between execution and meaning: "I painted a canvas a bit like this while I was with you at Arles —

the Grape Harvest [p. 192].... Degas doesn't understand this one. In this register of abstract ideas I am drawn to seek synthetic form and color. As little technique [*métier*] as possible and the accessories very lightly worked in order to allow the figure to make as powerful an impression as possible and in order not to fall into childish triviality."[102] We must assume that, for Gauguin, van Gogh's own technique represented just this "childish triviality."

In a sense, the portrait that Gauguin painted of Vincent in Arles (p. 198) was a commentary on these issues. It shows him painting a group of sunflowers in a vase—the subject of one of the decorative schemes in the house they shared, and a subject in which van Gogh set great store. However, Gauguin's picture is painted in simplified, flat color, quite unlike the sumptuous surfaces of van Gogh's sunflower canvases, and the picture itself was not painted from nature: the sunflower season was long over when Gauguin executed it in late 1888. Moreover, there is a strange ambiguity about what van Gogh is doing. We cannot see the front of his canvas, and his brush, as we view it, seems to be touching the flowers themselves. This can well be seen as a critique of his technique, for its illusionism, its attempt to re-create the actual flowers, and its neglect of the processes of simplification and abstraction by which, Gauguin felt, the true work of art should be created. For Gauguin, painting came from the head, not the hand.

In Gauguin's view, Vincent's "romanticism" prevented him from being a true artist. However, van Gogh came to feel that this romanticism was integral to his vision. Shortly before he died, he wrote from Auvers to Gauguin, describing *Road with Cypress and Star* (p. 191):

I still have a cypress with a star from down there [from Saint-Rémy], a last attempt—a night sky with a moon without radiance, the slender crescent barely emerging from the opaque shadow cast by the earth—one star with an exaggerated brilliance, if you like, a soft brilliance of pink and green in the ultramarine sky,

across which some clouds are hurrying. Below, a road bordered with tall yellow canes, behind these the blue Basses Alpines, an old inn with yellow lighted windows, and a very tall cypress, very straight, very somber. On the road, a yellow cart with a white horse in harness, and two late wayfarers. Very romantic, if you like, but also *Provence*, I think.[103]

The painting was created from imagination, not done in front of nature. But its ebullient, dynamic brushwork is inseparable from its imagery. It is the medium for expressing this pulsating image of nature as a meeting point between the cosmic forces seen in the sky; the cypress, associated with death; and the vision of homely domesticity represented by the figures, the cart, and the lighted inn. Its "romantic" quality was integral to its meaning.

All of the artistic experiments that we have explored in this essay were concerned with giving fresh meaning and relevance to the art of landscape. Superficially, modernity is most evident in the paintings of the edges of Paris and in Seurat's views of the Channel ports. However, as we have seen, idyllic rural scenes such as those by Camille Pissarro could carry a strong contemporary political message when viewed within the framework of anarchist ideas, and Signac's "pure" landscapes could also be viewed as revolutionary and forward-looking in their overthrow of conventionality in favor of a fresh vision of nature.

Beyond this, both van Gogh and Gauguin were engaging central issues about the experience of the modern world in their landscapes. Both men, in leaving Paris, were seeking a purer and healthier life experience, in social and psychological terms. Van Gogh recurrently wrote of the countryside as a site of escape and refuge from the pressures of the modern city, and also as a place of physical regeneration.[104] In Arles, though, canvases testifying to his continued pursuit of urban preoccupations, like his attempt to build on the legacy of Daumier, appeared alongside his images of the sunbathed Provençal countryside. At Auvers, too, he could combine the old with the new, the unspoiled with the

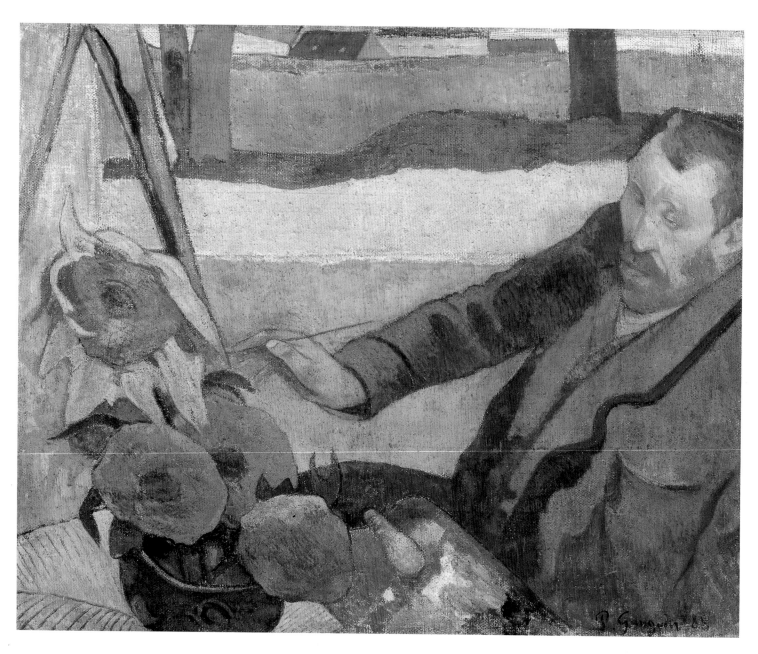

PORTRAIT OF VAN GOGH PAINTING SUNFLOWERS, 1888 Oil on canvas, 73 x 91 cm

changing; in one of his last letters he wrote of the "well-being" there, with new cottages and middle-class houses amid the older buildings, "just at the moment when a new society is developing in the old."[105]

However, the central element in van Gogh's modernity was his search for an expressive form of art. As Gauguin realized, in some senses this harked back to romanticism. But at the same time, van Gogh's preoccupations—both thematic, in his choice of subjects, and stylistic, in his wish to reach the widest possible audience—were forward-looking in their insistence on the value and resonance of everyday experience—the experience of the painter as well as the life experiences of the human subjects who gave his landscapes their meanings. In another sense, too, his sensibility was essentially modern, in the intensely felt private world of emotional resonances that dominated his consciousness.

Gauguin's creativity, by contrast, looked inwards, fueled by his inner vision, while in his subject matter he pursued imagery that explicitly excluded markers of change and contemporaneity in favor of evocations of the "primitive." Yet his project can be viewed as contemporary in a number of ways. In political terms, it reflects a widespread sense of disillusion in the late nineteenth century with the achievements of western "progress," and it also expresses the power that a representative of bourgeois urban society and of a colonial power could wield in order to appropriate—or exploit—what other cultures had to offer. Artistically, Gauguin's *style moderne* belonged to the latest vogue in richly colored, decorative art, but, more significantly than this, it was this style *sans exécution* that allowed him to find a visual language that could convey an essentially modern notion of artistic creativity—an inner creativity that transcends visual observation. For him, art was the product of a uniquely personal vision that invokes universals in order to make sense of human existence.

Notes

References to Vincent van Gogh's letters, unless otherwise noted, are from *The Complete Letters of Vincent van Gogh* (Greenwich: New York Graphic Society, 1958).

References to Paul Gauguin's letters, unless otherwise noted, are from either *Correspondance de Paul Gauguin, 1, 1873–1888*, ed. Victor Merlhès (Paris: Fondation Singer-Polignac, 1984) or *Paul Gauguin: 45 lettres à Vincent, Théo et Jo van Gogh*, ed. Douglas Cooper (The Hague: Staatsuitgeverij; Lausanne: Bibliothèque des Arts, 1983).

1 Walter Armstrong, "Current Art: The Salon," *Magazine of Art* (1889), p. 420.

2 See, e.g., Alfred de Lostalot, "Salon de 1889—II," *Gazette des Beaux-Arts* (July 1889), p. 17.

3 "On n'y trouve guère qu'une fabrication médiocre, une fin d'école qui se disperse en de mesquines analyses, incapable de s'élever au-dessus de l'accidentel…. Les peintres consacrés selon les rites officiels continuent de reprendre en petit l'oeuvre des Romantiques et de la distribuer en menue monnaie." Maurice Hamel, "Exposition décennale de l'art français: Le paysage," in F. G. Dumas and L. de Fourcaud, *Revue de l'exposition universelle de 1889*, II (Paris: 1889), p. 154.

4 L. de Fourcaud, "Exposition centennale de l'art français, IV," in Dumas and Fourcaud, *Revue de l'exposition universelle*, pp. 49–52.

5 "Ils ont renouvelé le paysage avec une hardiesse d'invention, une puissance de synthèse, une vérité de sensation que l'on cherche en vain chez les intermédiaires. La neuve vision de l'univers, elle n'est pas chez Bernier ni chez Rapin, à coup sûr, mais chez Pissarro…; chez Mme Morizot…; surtout chez Claude Monet, qui, dans son oeuvre immense, embrasse avec ivresse le monde des formes, des couleurs, des vibrations lumineuses." Hamel, "Exposition décennale de l'art français," p. 159. Edouard Manet's *Boating* of 1874 (New York, The Metropolitan Museum of Art) can be seen hung in a prominent position, between works by Adolphe William Bouguereau and Jules Bastien-Lepage, in a photograph of the central space of the *Centennale* in *1889: La Tour Eiffel et l'exposition universelle*, exh. cat. (Paris: Musée d'Orsay, 1989), p. 67, fig. 48.

6 "A ceux qui pensent que tout l'art contemporain est représenté au Palais de l'Industrie et au Champ de Mars, nous conseillerons d'aller demain faire un tour à la salle Georges Petit. Ils y verront l'oeuvre de deux grands artistes…le peintre Claude Monet, le sculpteur Auguste Rodin." Arsène Alexandre, "Claude Monet et Auguste Rodin," *Paris* (21 June 1889), reprinted in *Claude Monet—Auguste Rodin: Centenaire de l'exposition de 1889*, exh. cat. (Paris: Musée Rodin, 1989–90), p. 220.

7 "Ce n'est pas la foule, qui se presse aux amusettes du Champ de Mars, qui se détournera pour aller, rue de Sèze, voir l'exposition des oeuvres de MM. A. Rodin et Claude Monet, organisée par les soins de M. Georges Petit; mais un public nombreux la visitera, un public d'élite, français et étranger, composé d'artistes, d'amateurs, d'amoureux de l'art…." "Exposition des oeuvres de MM. A. Rodin et Claude Monet," *Le Moniteur des arts* (28 June 1889), repr. in *Claude Monet—Auguste Rodin*, p. 230.

8 "Le faire matériel du peintre est si personnel, si différent de celui des 'peintres habituels,' que ce papillotage fruste, ces petits coups de pinceau heurtés, cette sorte de mosaïque brutale vous semble atroce. Mais, peu à peu, on s'aperçoit que rien dans cette bizarrerie voulue, n'est laissé au hasard, que les tons employés hardiment par l'artiste sont logiques, que chacun de ses coups de pinceau est dû à une vision sincère. Plus on regarde, plus on s'habitue à cette étourdissante façon de disséminer la lumière. Tout s'harmonise, se complète, s'identifie." Fernand Bourgeat, "Chronique parisienne," *L'Entr'acte* (26 June 1889), repr. in *Claude Monet—Auguste Rodin*, pp. 227–28.

9 "La galerie Georges Petit est une salle d'élection pour les expositions d'art. Nulle part les tableaux et les marbres ne se présentent mieux aux regards des visiteurs, et les chatoyantes élégances des Parisiennes y ressortent délicieusement sur le fond pourpre des carpettes et des tentures." Alfred Ernst, "Claude Monet et Rodin," La Paix (3 July 1889), repr. in Claude Monet — Auguste Rodin, p. 233.

10 See Martha Ward, "Impressionist Installations and Private Exhibitions," Art Bulletin (December 1991), pp. 614–16.

11 See "Chronology," in Degas, exh. cat. (Paris: Grand Palais; Ottawa: National Gallery of Canada; New York: The Metropolitan Museum of Art, 1988), p. 391.

12 On Theo van Gogh and Boussod and Valadon, see Chris Stolwijk and Richard Thomson, Theo van Gogh, 1857–1891: Art Dealer, Collector, and Brother of Vincent, exh. cat. (Amsterdam: Van Gogh Museum; Zwolle, Netherlands: Waanders Publishers, 1999).

13 "L'installation est un peu primitive, fort bizarre et, ainsi qu'on dira sans doute, bohême!" Gabriel-Albert Aurier, "A propos de l'exposition universelle," repr. in Aurier, Textes critiques, 1889–1892: De l'Impressionnisme au symbolisme (Paris: Ecole Nationale Supérieure des Beaux-Arts, 1995), p. 129; see also John Rewald, Post-Impressionism: From van Gogh to Gauguin (New York: The Museum of Modern Art; London: Secker and Warburg, 1978), pp. 256–65.

14 "L'approche de ces toiles est défendu par des buffets, des pompes à bière, des tables, le corsage de la caissière de M. Volpini et un orchestre de jeunes Moscovites dont l'archet déchaîne dans le vaste halle une musique sans relation avec ces polychromies." Félix Fénéon, "Autre groupe impressionniste," La Cravache (6 July 1889), in Fénéon, Oeuvres plus que complètes, ed. Joan U. Halperin (Geneva: Droz, 1970), pp. 157–59; also trans. in Rewald, Post-Impressionism, p. 261.

15 "Le but essentiel de notre art est d'objectiver le subjectif (l'extériorisation de l'Idée) au lieu de subjectiver l'objectif (la nature vue à travers un tempérament)." Gustave Kahn, "Réponse des symbolistes," L'Evénement (28 September 1886), repr. and trans. in Sven Lövgren, The Genesis of Modernism: Seurat, Gauguin, van Gogh and French Symbolism in the 1880's, rev. ed. (Bloomington: Indiana University Press, [1971]), pp. 82–84.

16 On the subjectivity of the Impressionist sensation, see especially Richard Shiff, "The End of Impressionism," in Fine Arts Museums of San Francisco, The New Painting: Impressionism, 1874–1886, exh. cat. (Geneva: Richard Burton SA, Publishers, 1986), and Shiff, Cézanne and the End of Impressionism: A Study of the Theory, Technique, and Critical Evaluation of Modern Art (Chicago: University of Chicago Press, 1984). Shiff stresses the continuity of language between impressionist and symbolist theory, but does not place enough emphasis on the implications of Kahn's reversal of the terms "objective" and "subjective."

17 Gabriel-Albert Aurier, "Le Symbolisme en peinture: Paul Gauguin," first published in Mercure de France (March 1891); "Les Peintres symbolistes" (1891), first published in Aurier, Oeuvres posthumes, III (Paris: Mercure de France, 1893); both repr. in Aurier, Textes critiques.

18 Aurier, Textes critiques, e.g., pp. 33–34, 102–5.

19 Ibid., e.g., pp. 35, 99–101.

20 Ibid., p. 32.

21 See, e.g., Edmond and Jules de Goncourt, Germinie Lacerteux (Paris, 1865), chapter 12; Joris-Karl Huysmans, "Vue des remparts du Nord-Paris," in Croquis parisiens (first published in Paris, 1881), repr. in Huysmans, En Rade/Un Dilemme/Croquis parisiens 10/18 (Paris: 1976), pp. 398–400.

22 See, e.g., Kropotkin, Paroles d'un révolté (Paris, 1885; new ed., Paris: Flammarion, 1978), pp. 59–60.

23 For a recent overview of French anarchism in the period, see John Hutton, Neo-Impressionism and the Search for Solid Ground (Baton Rouge: Louisiana State University Press, 1994), pp. 46–81.

24 See letter from Camille Pissarro to Lucien Pissarro (8 July 1891), and letter from Camille Pissarro to Octave Mirbeau (21 April 1892), in Pissarro, Correspondance de Camille Pissarro, ed. Janine Bailly-Herzberg, vol. 3 (Paris: Editions du Valhermeil, 1988), pp. 102, 217.

25 See Hutton, Neo-Impressionism, pp. 175–190, and Royal Academy of Arts, Post-Impressionism, exh. cat. (London: Royal Academy of Arts, 1979), pp. 90–91.

26 "Un impressionniste camarade" [Paul Signac], "Impressionnistes et révolutionnaires," La Révolte (13–19 June 1891), trans. in Hutton, Neo-Impressionism, p. 251.

27 For a thoughtful exploration of the problems of interpreting this imagery, see Hutton, Neo-Impressionism, pp. 170–90.

28 See John Leighton and Richard Thomson, Seurat and the Bathers (London: National Gallery Publications, 1997); "Special Issue: The Grande Jatte at 100," The Art Institute of Chicago Museum Studies 14, no. 2 (1989). For the argument that the two pictures should be viewed as a pair, see John House, "Meaning in Seurat's Figure Paintings," Art History (September 1980), pp. 346–49.

29 See, e.g., letters from Camille Pissarro to Lucien Pissarro, 8 May and 30 November 1886 (in both of which the original impressionists are called "romantiques"), and to Paul Durand-Ruel, 6 November 1886, in Pissarro, Correspondance de Camille Pissarro, ed. Janine Bailly-Herzberg, vol. 2 (Paris: Editions du Valhermeil, 1986), pp. 45, 75, 77. Fénéon's articles of 1886, "Les Impressionnistes en 1886" and "L'Impressionnisme scientifique," are reprinted in Fénéon, Oeuvres plus que complètes, pp. 27–58.

30 See Paul Smith, Seurat and the Avant-Garde (New Haven and London: Yale University Press, 1997), pp. 23–48; Smith's is the most searching analysis of Seurat's approach to color.

31 Smith, Seurat and the Avant-Garde, 1997, is a thorough exploration of Seurat's links with symbolism.

32 Emile Bernard, "Notes sur l'école dite de 'Pont-Aven'," Mercure de France (December 1903), repr. in Bernard, Propos sur l'art, ed. Anne Rivière (Paris: Séguier, 1994), pp. 63–64.

33 "Le point de départ est une conception symbolique de l'art.... Dès lors, à quoi bon retracer les mille détails insignifiants que l'oeil perçoit? Il faut prendre le trait essentiel, le reproduire — ou, pour mieux dire, le produire; une silhouette suffit à exprimer une physionomie; le peintre…ne cherchera qu'à fixer, en le moindre possible nombre de lignes et de couleurs caractéristiques, la réalité intime, l'essence de l'objet qu'il s'impose." Edouard Dujardin, "Aux XX et aux Indépendants: Le Cloisonisme," Revue indépendante (March 1888), p. 489. I am indebted to Richard Thomson for a copy of this text.

34 Café Terrace at Night (Otterlo, Kröller-Müller Museum, F467) is evidently indebted to Avenue Clichy, Five O'Clock in the Evening, and Wheat Field with Sheaves and Arles in the Background (Paris, Musée Rodin, F545) to Mower at Noon: Summer.

35 "Se laver l'oeil des jours d'atelier et traduire le plus exactement la vive clarté, avec tous ses nuances." Emile Verhaeren, "Georges Seurat," La Société nouvelle (April 1891), repr. in Verhaeren, Sensations (Paris: G. Crès, 1927), p. 199.

36 "La nature, disait Cézanne, j'ai voulu la copier, je n'arrivai pas. Mais j'ai été content de moi lorsque j'ai découvert que le soleil, par exemple, ne se pouvait pas reproduire, mais qu'il fallait le représenter par autre chose…par de la couleur." Maurice Denis, "Paul Cézanne," L'Occident (September 1907), repr. in Denis, Du Symbolisme au classicisme: Théories (Paris: Hermann, 1964), p. 165.

37 See John House, Monet: Nature into Art (New Haven and London: Yale University Press, 1986), especially pp. 123–25.

38 "L'orangée lumière solaire, reflétée de toutes parts, décolore les ombres, atténue les couleurs locales et pâlit les ciels les plus purs." Signac, open letter to Trublot [critic Paul Alexis], Le Cri du peuple (29 March 1889), quoted in Signac, exh. cat. (Paris: Musée du Louvre, 1963), p. 23.

39 For further discussion, see John House, "That Magical Light: Impressionists and Post-Impressionists on the Riviera," in Kenneth Wayne, *Impressions of the Riviera*, exh. cat. (Portland, Maine: Portland Museum of Art, 1998).

40 E.g., *Complete Letters* W3, B2. For van Gogh's collection of Japanese prints, see Charlotte van Rappard-Boon, Willem van Gulik, and Keiko van Bremen-Ito, *Catalogue of the Van Gogh Museum's Collection of Japanese Prints*, (Amsterdam: Van Gogh Museum; Zwolle, Netherlands: Waanders Publishers, 1991).

41 E.g., *Complete Letters* 497, 500, W4.

42 *Complete Letters* 520.

43 Van Gogh's knowledge of Delacroix's ideas came primarily from the writings of Théophile Silvestre and Charles Blanc; see *Complete Letters* 428–30, 451.

44 E.g., *Complete Letters* 490, B3.

45 The article was by Henry Cochin, "Boccace d'après ses oeuvres et les témoignages contemporains," *Revue des deux mondes* (15 July 1888).

46 *Complete Letters* 544a.

47 See *Complete Letters* 574, 582, 592; see also John House, "Letter: Van Gogh's 'La Berceuse,'" *Burlington Magazine* (July 1993), p. 485.

48 *Complete Letters* 552. On these literary references, see Judy Sund, *True to Temperament: Van Gogh and French Naturalist Literature* (Cambridge and New York: Cambridge University Press, 1992), chapter 5.

49 *Complete Letters* 615; see also *Complete Letters* 634 and Sund, *True to Temperament*, p. 146.

50 *Complete Letters* B21.

51 *Complete Letters* 614.

52 *Complete Letters* 615.

53 *Complete Letters* B21.

54 For a previous discussion of this, see John House, "Post-Impressionist Visions of Nature," *The Royal Society of Arts Journal* (August 1980), pp. 575–76.

55 E.g., *Complete Letters* 472, 481.

56 *Complete Letters* 509, W5.

57 *Complete Letters* 512, 518, B9.

58 *Complete Letters* B7.

59 *Complete Letters* B9.

60 *Complete Letters* 520.

61 *Complete Letters* 604.

62 *Complete Letters* 601.

63 *Complete Letters* 607.

64 "Le plus souvent, cette enchanteresse matière, il ne la considère que comme une sorte de merveilleuse langage destinée à traduire l'Idée. C'est presque toujours un symboliste. Non point, je le sais, un symboliste à la manière des Primitifs italiens, ces mystiques qui éprouvaient le besoin de désimmatéria-liser leurs rêves, mais un symboliste sentant la continuelle nécessité de revêtir ses idées de formes précises, pondérables, tangibles.... Dans presque toutes ses toiles..., gît, pour l'esprit qui sait l'y voir, une pensée, une Idée, et cette Idée, essentiel substratum de l'oeuvre, en est, en même temps, la cause efficiente et finale. Quant aux brillantes et éclatantes symphonies de couleurs et de lignes, quelle que soit leur importance pour le peintre, elles ne sont dans sa peinture que de simples moyens expressifs, que de simples procédés de symbolisation. Si l'on refusait, en effet, d'admettre sous cet art naturaliste l'existence de ces tendances idéalistes, une grande partie de l'oeuvre que nous étudions demeurerait fort incompréhensible." Aurier, "Les Isolés —Vincent van Gogh," *Mercure de France* (January 1890), repr. in Aurier, *Textes critiques*, pp. 68–70.

65 *Complete Letters* 626a.

66 For further discussion, see *Impressions of France/Landscapes of France*, exh. cat. (Boston: Museum of Fine Arts; London: Hayward Gallery, 1995), especially John House, "Framing the Landscape."

67 "Leur beauté grecque...des défilés grecques." Merlhès letter 176.

68 See Richard Thomson, *Monet to Matisse: Landscape Painting in France 1874–1914*, exh. cat. (Edinburgh: National Gallery of Scotland, 1994), p. 78.

69 For further discussion, see Thomson, *Monet to Matisse*, pp. 65–92.

70 "C'est drôle Vincent voit ici du Daumier à faire." Merlhès letter 176.

71 E.g., *Complete Letters* 539.

72 *Complete Letters* 544a.

73 Alexandre Dumas, *Pictures of Travel in the South of France*, English trans. (London: National Illustrated Library, [c.1850]), p. 234.

74 Henry James, *A Little Tour in France* (London: Heinemann, 1900; 1922), pp. 246–51; for another description of the Rhône at night, "all poetry and romance," see Charles W. Wood, *In the Valley of the Rhone* (London: Macmillan, 1905), pp. 210–15.

75 "Elle perd chaque jour sa physionomie, son originalité et son caractère. Son port est à peu près désert, ses rues presque vides, sa campagne nue et triste. La solitude et la fièvre l'environnent. Elle s'agite sans dignité, vieillit sans noblesse et s'éteint sans grandeur." Louis de Laincel, *La Provence* (Avignon: Seguin; Paris: Oudin, [1881]), p. 306.

76 Merlhès letter 182.

77 *Complete Letters* 558b.

78 See Fred Orton and Griselda Pollock, "Les Données Bretonnantes: La Prairie de Représentation," *Art History* (September 1980), repr. in Orton and Pollock, *Avant-Gardes and Partisans Reviewed* (Manchester: Manchester University Press, 1996), pp. 53–88.

79 "J'aime la Bretagne, j'y trouve le sauvage, le primitif. Quand mes sabots résonnent sur ce sol de granit, j'entends le ton sourd, mat et puissant que je cherche en peinture." Merlhès letter 141.

80 "Je crois avoir atteint dans les figures une grande simplicité rustique et superstitieuse—Le tout très sévère." Merlhès letter 165.

81 "Calvaire froide pierre du sol—Idée bretonne du sculpteur qui explique la religion à travers son âme bretonne avec des costumes bretonnes. Couleur locale bretonne. Le tout dans une paysage breton [*sic*] cad [c'est à dire] poesie [*sic*] bretonne..." Reproduced in facsimile in Bogomila Welsh-Ovcharov, *Vincent van Gogh and the Birth of Cloisonism*, exh. cat. (Toronto: Art Gallery of Ontario; Amsterdam: Rijksmuseum Vincent Van Gogh, 1981), pp. 214–16.

82 "Oui vous avez raison de vouloir de la peinture avec une coloration suggestive d'*idées poétiques* et en ce sens je suis d'accord avec vous avec une différence. Je ne connais pas d'idées poétiques c'est probablement un sens qui me manque. Je trouve *TOUT* poétique et c'est dans les coins de mon coeur qui sont parfois mystérieux que j'entrevois la poésie. Les formes et les couleurs conduites en harmonies produisent d'elles-mêmes une poésie." Merlhès letter 163.

83 "Moi ce que j'ai fait surtout cette année, ce sont de simples enfants de paysan, se promenant indifferents [*sic*] sur le bord de la mer avec leurs vaches. Seulement comme le trompe-l'oeil du plein air...ne me plaît pas je cherche à mettre dans ces figures désolées, le sauvage que j'y vois et qui est en moi aussi. Ici en Bretagne les paysans ont un air du moyen âge et n'ont pas l'air de penser que Paris existe et qu'on soit en 1889. Tout le contraire du Midi. Içi tout est rude comme la langue Bretonne, bien fermé (il semble à tout jamais). Les costumes sont aussi presque symbolique [*sic*] influencés par les superstitions du catholicisme. Voyez le dos corsage une croix, la tête enveloppée [*sic*] d'une marmotte noire comme les religieuses. Avec cela les figures sont presque asiatiques jaunes et triangulaires, sévères.... Encore craintifs du seigneur et du curé les bretons tiennent leurs chapeaux et tous leurs ustensils comme s'ils étaient dans une église; je les peins aussi dans cet état et non dans une verve méridionale.... En ce moment je fais une toile de 50; des femmes ramassant du goëmon sur le bord de la mer.... En voyant cela tous les jours il me vient comme une bouffée de lutte pour la vie, de tristesse et obeissance [*sic*] aux lois malheureuses. Cette bouffée je cherche à la mettre sur la toile, non par hazard

[sic], mais par raisonnement en exagérant peut être certaines rigidités de pose, certaines couleurs sombres etc.… Tout cela est peut être *maniéré* mais dans le tableau où est le naturel. *Tout* depuis les âges les plus reculés est dans les tableaux, tout à fait conventionnel, voulu, d'un bout à l'autre et bien loin du naturel par conséquent bien maniéré." Cooper letter 36.

84 See Eugen Weber, *Peasants into Frenchmen: The Modernisation of Rural France, 1870–1914* (Stanford: Stanford University Press, 1976), chapter 6, "A Wealth of Tongues," especially pp. 82–84.

85 In this context, Edward W. Said, *Orientalism* (New York: Pantheon Books, 1978) has been a key text. For applications of this range of issues to Gauguin's experiences in Tahiti, see Abigail Solomon-Godeau, "Going Native: Paul Gauguin and the Invention of Primitivist Modernism," *Art in America* 77 (July 1989), pp. 118–29; Peter Brooks, *Body Work: Objects of Desire in Modern Narrative* (Cambridge: Harvard University Press, 1993), chapter 6, "Gauguin's Tahitian Body," pp. 162–98; Stephen F. Eisenman, *Gauguin's Skirt* (London: Thames and Hudson, 1997).

86 See Bengt Danielsson, *Gauguin in the South Seas* (London: George Allen and Unwin, 1965), pp. 22–25. Gauguin's decision to go to Tahiti was also much influenced by an official handbook published by the French Colonial Department in 1889; see Danielsson, pp. 29–31.

87 Paul Signac, *D'Eugène Delacroix au néo-impressionnisme* (1899; new ed., Paris: Hermann, 1964), p. 159.

88 "Un impressionniste camarade" [Paul Signac], "Impressionnistes et révolutionnaires," pp. 251–52.

89 "… M. PAUL SIGNAC put créer les exemplaires spécimens d'un art à grand développement décoratif, qui sacrifie l'anecdote à l'arabesque, la nomenclature à la synthèse, le fugace au permanent, et…confère à la Nature, que lassait à la fin sa réalité précaire, une authentique Réalité." Félix Fénéon, "Signac," *Les Hommes d'Aujourd'hui*, no. 373 (1890); repr. in Fénéon, *Oeuvres plus que complètes*, p. 177; also trans. in Robert L. Herbert, *Neo-Impressionism* (New York: Solomon R. Guggenheim Museum, 1968), p. 138.

90 Aurier, "Le Symbolisme en peinture."

91 "Un impressionniste camarade" [Paul Signac], "Impressionnistes et révolutionnaires," p. 252.

92 "Un conseil, ne copiez pas trop d'après nature. L'art est une abstraction; tirez-là de la nature en rêvant devant et pensez plus à la création qu'au résultat c'est le seul moyen de monter vers Dieu en faisant comme notre divin maître— créer…" Merlhès letter 159.

93 "Comment voyez-vous cet arbre…il est bien vert? Mettez donc du vert, le plus beau vert de votre palette; - et cette ombre, plutôt bleue? Ne craignez pas de la peindre aussi bleue que possible." As reported by Maurice Denis, "L'Influence de Paul Gauguin," *L'Occident* (October 1903), repr. in Denis, *Du symbolisme au classicisme: Théories* (Paris: Hermann, 1964), p. 51.

94 "Une source de beau *style moderne*." Merlhès letter 176.

95 See, e.g., Emile Bayard, *Le Style moderne* (Paris: Garnier, 1919).

96 *Complete Letters* 613.

97 *Complete Letters* 607.

98 *Complete Letters* 520.

99 *Complete Letters* 526.

100 Merlhès letter 158; see also Merlhès letter 157.

101 "Il est romantique et moi je suis plutôt porté à un état primitif. Au point de vue de la couleur il voit les hasards de la pâte comme chez Monticelli et moi je déteste le tripotage de la facture etc." Merlhès letter 182.

102 "J'ai fait chez vous à Arles un tableau un peu dans ce sens. Les vendanges.… Degas ne comprend celui-là. Dans cet ordre d'idées abstraites je suis amené à chercher la forme et la couleur synthétiques. Le moins de métier possible et par ci par là des accessoires très peu exécutés pour laisser à l'impression d'une figure toute sa puissance et ne pas tomber dans la babiole enfantillage." Cooper letter 37.

103 *Complete Letters* 643; this letter is known only from a draft found among van Gogh's papers after his death.

104 E.g., *Complete Letters* 463, 481, 489, 521.

105 *Complete Letters* 637; see Carol Zemel, *Van Gogh's Progress: Utopia, Modernity, and Late-Nineteenth-Century Art* (Berkeley and Los Angeles: University of California Press, 1997), chapter 6, "The Real Country: Utopian Decoration in Auvers."

Chronology 1886–1892

Lynn DuBard

This chronology focuses on the activities of the ten artists highlighted in the exhibition and their interaction with each other during the years 1886 to 1892. The year 1886 was chosen as the starting point for several reasons. Vincent van Gogh arrived in Paris in 1886. That same year saw the eighth and final impressionist exhibition, which signaled a changing of the guard in the world of modern art.

The new generation of painters, who came to be known as neo-impressionists, made their debut at that final show of impressionist works. During the years under consideration, the avant-garde was divided into several antagonistic groups, most notably the neo-impressionists led by Georges Seurat and Paul Signac and the synthetists by Paul Gauguin and Emile Bernard. Van Gogh took it upon himself to befriend both groups, and he encouraged his artistic contemporaries to unite for the purpose of supporting their efforts to be professional artists.

The chronology terminates with the year 1892 because by then both van Gogh and Seurat had died, and others, including Gauguin, Bernard, and Lucien Pissarro, had chosen to move away from Paris to pursue their own interests.

Following a brief biography of each of the ten artists, the chronology is arranged by year. Each year begins with a general section consisting of exhibition history and related avant-garde literature, followed by the activities, achievements, and interactions of the individual artists in alphabetical order. Entries under each artist are organized by month when possible.

Primary sources, such as the artists' correspondence and contemporary art reviews, were used when available. Otherwise, secondary sources were relied on for information or clarification. Sources for individual entries are given in code form in parentheses and are keyed to the legend that follows the chronology.

Biographies

CHARLES ANGRAND

Charles Angrand was born in Criquetot-sur-Ouville, France, in 1854. He studied to become a teacher and moved to Paris in 1882 to teach at the Collège Chaptal in Montmartre. He quickly became acquainted with various artists and critics who frequented the Montmartre cafés. In 1884 he helped found the Société des Artistes Indépendants, which would later host the unjuried *Exposition de la Société des Indépendants*. Although Angrand began painting in an impressionist manner, after meeting Georges Seurat he quickly adopted a neo-impressionist technique. He turned away from color in the early 1890s in favor of producing black-and-white conté crayon drawings. Angrand left Paris in 1896 and lived in Rouen until his death in 1926.

LOUIS ANQUETIN

Louis Anquetin was born in Etrépagny, France, in 1861. He moved to Paris in 1882 and entered the studio of the Ecole des Beaux-Arts professor Léon Bonnat. There he met and became friends with Henri de Toulouse-Lautrec. When Bonnat's studio closed, Anquetin moved to Fernand Cormon's studio, where he met Emile Bernard in 1884 and Vincent van Gogh in 1886. Anquetin was considered Cormon's most promising student and successor until he abandoned academic painting for new avant-garde techniques and modern subjects in 1886. By the mid-1890s, however, Anquetin turned away from modern art subjects and returned to more traditional themes. He died in Paris in 1932.

EMILE BERNARD

Emile Bernard was born in Lille, France, in 1868. When his parents moved to the suburbs of Paris, he was able to seek art instruction in Paris. In September 1884 he entered the studio of Fernand Cormon, where he soon became friends with Louis Anquetin and Henri de Toulouse-Lautrec, both of whom introduced him to the colorful nightlife of Montmartre. In 1886 Bernard rejected the academic teaching of Cormon and began experimenting with impressionist and neo-impressionist techniques. After being dismissed from Cormon's studio in the spring of 1886, he journeyed on foot through Normandy and Brittany. He met Vincent van Gogh sometime in 1886, most probably in the fall after his return to Paris. Over the next several years Bernard returned repeatedly to Brittany to work with Paul Gauguin. In addition to his painting, Bernard contributed critical reviews of modern art to contemporary publications and provided important information on the avant-garde artists with whom he was associated. In 1893 Bernard traveled to Italy, Greece, the Middle East, and Egypt, settling in Cairo for the next ten years. He returned to France in 1904, dividing his time between Paris and Tonnerre-sur-Yonne. Bernard died in Paris in 1941.

PAUL GAUGUIN

Paul Gauguin was born in Paris in 1848. He spent the first seven years of his childhood in Lima, Peru, and returned to France in 1855. He began his career as a stockbroker in Paris, painting only in his free time. After attending the first impressionist exhibition in 1874, he met Camille Pissarro, who befriended him and brought him into the impressionist circle. Gauguin turned completely to painting in 1882, but was unable to support his family. He relocated them to Copenhagen where his wife's parents lived, returning to Paris by himself in 1885. In 1886 he moved to the rural village of Pont-Aven in Brittany, where he could live much more inexpensively and pursue his art career. Back in Paris in November 1886 he met Vincent van Gogh. He traveled to Martinique in 1887 and visited Arles, where he worked with van Gogh for two months in 1888. Gauguin left for Tahiti in the summer of 1891, where he hoped to establish a "Studio of the Tropics." He made only one trip back to France and returned to Tahiti in 1895. In 1901 he left Tahiti for the Marquesas Islands, where he died in 1903.

VINCENT VAN GOGH

Vincent van Gogh was born in Zundert, the Netherlands, in 1853. He was essentially self-taught with brief periods of formal instruction at the art academies in Brussels and Antwerp. In 1886, he moved to Paris where his brother Theo worked as an art dealer for the gallery Boussod and Valadon. Later that year van Gogh enrolled at Fernand Cormon's studio, where he met Henri de Toulouse-Lautrec. He also met Emile Bernard, with whom he worked in the suburb of Asnières and who introduced him to Louis Anquetin. During his two-year stay in Paris, van Gogh became acquainted with various members of the avant-garde, such as Paul Gauguin and the neo-impressionist painters Paul Signac and Camille and Lucien Pissarro. Van Gogh left Paris for Arles in the South of France in early 1888. He maintained contact with his friends both in and outside

Paris and succeeded in persuading Gauguin to join him in Arles for two months in the fall of 1888. Van Gogh left southern France in May 1890 for Auvers-sur-Oise, just north of Paris. He died in 1890.

CAMILLE PISSARRO

Camille Pissarro was born on Saint Thomas in the Virgin Islands in 1830. In order to pursue his artistic interests, he moved to Paris in 1855 and a year later enrolled in classes at the Ecole des Beaux-Arts. In 1859 he studied at the Académie Suisse in Paris, where he met Paul Cézanne and Claude Monet. Although Pissarro exhibited paintings in the official Salons from 1859 to 1870, he and his friends began working in an impressionist style around 1869. Pissarro helped establish the first independent exhibition of impressionist work in 1874 and was the only artist to participate in all eight impressionist shows. He befriended many younger artists, including Paul Gauguin, Vincent van Gogh, Paul Signac, and Georges Seurat. His interest in new ideas and different painting techniques led him to insist on including the younger artists Seurat and Signac in the last impressionist exhibition in 1886. He briefly adopted neo-impressionist techniques, but returned to impressionism after 1890. Pissarro died in Paris in 1903.

LUCIEN PISSARRO

The oldest son of Camille Pissarro, Lucien Pissarro was born in 1863 in Paris. Lucien's artistic development was supported and encouraged by his father. He and Camille met Paul Signac in 1885 and were subsequently introduced to Georges Seurat, the founder of neo-impressionism. Lucien became interested in Seurat's theories and pointillist technique and produced a significant number of neo-impressionist paintings. Although Lucien exhibited his paintings in the avant-garde exhibitions of the *Exposition de la Société des Indépendants* and Les XX in Brussels, he showed great interest throughout his career in printmaking and book illustration. In 1890 he moved permanently to London, where he married Esther Bensusan two years later. In the early 1890s he abandoned the neo-impressionist technique and focused his attention on printmaking, founding the Eragny Press in England in 1894. Pissarro died in 1944.

GEORGES SEURAT

Georges Seurat was born in Paris in 1859. He received a formal arts education, studying in the studios of various Ecole des Beaux-Arts professors. He was greatly affected in 1879 by the work of Claude Monet and Camille Pissarro and began to explore impressionism. His interest in color theory and the publications of Eugène Chevreul led him to develop a divisionist painting technique, which came to be known as neo-impressionism. He presented his first pointillist work, *A Sunday Afternoon on the Island of La Grande Jatte — 1884* (p. 77), at the last impressionist exhibition, creating a stir among avant-garde painters. Seurat actively promoted neo-impressionism and exhibited regularly in the annual *Exposition de la Société des Indépendants* and with the Belgian group Les XX. He died in Paris in 1891.

PAUL SIGNAC

Paul Signac was born in Paris in 1863. He decided to become a painter after seeing an exhibition of Claude Monet's works in 1880, and his early work reveals impressionist influences. In 1884 he made the acquaintance of Georges Seurat and became greatly interested in color theory and Seurat's divisionism. Shortly thereafter he turned to neo-impressionism and became an active promoter of the new technique, participating in the annual *Exposition de la Société des Indépendants* and with the Belgian symbolist group Les XX. Having discovered southern France and the Mediterranean in 1887, Signac settled in Saint Tropez in 1892. He died in 1935.

HENRI DE TOULOUSE-LAUTREC

Henri de Toulouse-Lautrec was born in Albi, France, in 1864. He moved to Paris in 1882 to pursue his artistic interests. He first entered the studio of the Ecole des Beaux-Arts professor Léon Bonnat and quickly became friends with Louis Anquetin. Later he moved to Fernand Cormon's studio, where he met Emile Bernard in 1884 and Vincent van Gogh in 1886. His Montmartre studio became a gathering place for many young avant-garde artists. Toulouse-Lautrec engaged in a bohemian lifestyle, frequenting the cafés, nightclubs, and brothels of Montmartre with his friends. There he found abundant subject matter for his paintings as well as venues for the display of his work. In the last ten years of his life, Toulouse-Lautrec designed and produced approximately thirty posters that greatly influenced contemporary graphic art. He died in 1901.

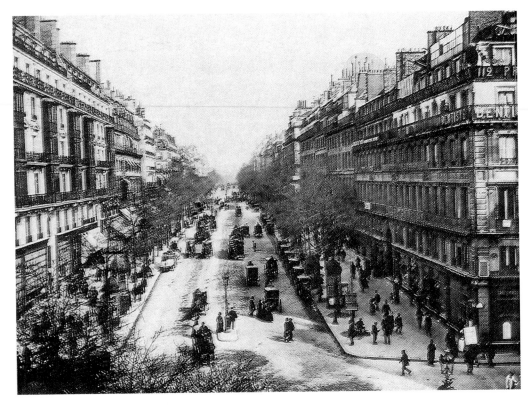

1886

GENERAL

December 1885–March 1886

Emile Zola's *L'Oeuvre*, a novel whose hero is a
painter, appears in *Gil Blas*, 23 December
1885–27 March 1886 (CP/LP, p. 68).
Charles Henry's pamphlet *Introduction à une
esthéthique scientifique* is published (LP/CP,
p. 72).

April

Gustave Kahn and Félix Fénéon found
La Vogue, a symbolist review, first issue 11 April
(LP/CP, p. 74).

15 May–15 June

8me Exposition de Peinture at Maison Dorée,
1, rue Lafitte, corner of Boulevard des Italiens,
Paris. Final impressionist exhibition includes
Gauguin, Camille and Lucien Pissarro, Seurat,
and Signac. The older generation of painters
does not consider the younger artists, who
were allowed to participate at the insistence
of Camille Pissarro, to be true impressionists
(CP 334; 335, n. 1). Monet, Renoir, Sisley,
and Caillebotte withdraw. Seurat and Signac
exhibit their first neo-impressionist works
(CP 331). Octave Mirbeau reviews show for
La France, 20 May; Fénéon for *La Vogue*,
13 June; and Jean Ajalbert for *Revue moderne*,
20 June.

Félix Fénéon

15 June–July

*Exposition internationale de Peinture et de
Sculpture* at Galerie Georges Petit, 8, rue de
Sèze, Paris; fifth international exhibition
includes Monet and Renoir who refused to
exhibit in the *8me Exposition de Peinture*
(P-I, p. 282).

21 August–21 September

Exposition de la Société des Indépendants at
temporary building (Bâtiment B) next to
the Pavillon de Flore, rue des Tuileries
(RH, p. 404), includes Angrand, Lucien
Pissarro, Seurat, and Signac (INDE, 1886).
Arsène Alexandre reviews show for *L'Evéne-
ment*, 23 August; and Paul Adam for *La Vogue*,
6–13 September. Fénéon first uses the
term "neo-impressionist" in his review for
L'Art moderne, 19 September.

September

Jean Moréas publishes the "Manifeste du
symbolisme" in *Figaro littéraire*, 18 September
(JR, p. 13).
Gustave Kahn publishes "Réponse des

symbolistes," *L'Evénement*, 28 September
(JR, pp. 134–35).

October

La Vogue publishes Fénéon's pamphlet
"Les Impressionnistes en 1886," the first serious
study of the neo-impressionist technique
(RH, p. 404).

17 October–19 December

Exposition des Arts incohérents at Eden Théâtre,
7, rue Boudreau, Paris, includes Toulouse-
Lautrec (GM, p. 265).

November

The *Revue indépendante*, a journal favorable
to the neo-impressionists, is taken over
by Edouard Dujardin; it had been originally
begun by Fénéon in 1884 (JR, pp. 87, 136).
Gustave Kahn, Paul Adam, and Jean Moréas
found the journal *Le Symboliste* (P-I, p. 282).

December

Gustave Kahn and Jean Ajalbert transform
the format of *La Vogue*, using only neo-
impressionist work as illustrations (CP 364).

CHARLES ANGRAND

May–June

Accompanies Seurat to paint on the island of La Grande Jatte (unpublished letter to his parents, n.d.; NB, p. 34).

August–September

Shows six paintings at the Indépendants that receive positive review from Fénéon in *L'Art moderne*, 19 September (BWO 1, p. 52). Begins to experiment with the neo-impressionist technique (BWO 1, pp. 57–59).

October

Meets van Gogh at Père Tanguy's shop, 14, rue Clauzel (SS, p. 89; BWO 1, pp. 37–39). Receives 25 October letter from van Gogh who proposes an exchange of paintings (BWO 1, p. 60).

November

Meets van Gogh at Café du Théâtre, across from the Collège Chaptal where Angrand teaches. Van Gogh, who is interested in Angrand's painting *Les Poules*, 1884, again suggests an exchange of works. Angrand does not agree to the exchange (SS, p. 89).

LOUIS ANQUETIN

Mid-September

Visits the Indépendants with Bernard, where they encounter Camille Pissarro (LA, p. 104). Expresses an interest in pointillism and desire to work in this manner (CP 353); however, few if any of Anquetin's known works can be labeled "neo-impressionist."

October

Meets van Gogh through Bernard, possibly at Père Tanguy's (EB, p. 114).

EMILE BERNARD

April

Is dismissed from Fernand Cormon's studio for painting the background behind the model in streaks of vermilion and *vert veronese* instead of traditional gray-brown (SS, p. 81). His father burns his brushes and forbids him to paint; discouraged, Bernard writes melancholic poetry (JR, p. 502).

On 6 April, he leaves Paris for a journey on foot through Brittany; stays at Saint-Briac for two months (MS, p. 95).

Seems to have met van Gogh at Cormon's studio either before he left Paris for Brittany or later in the fall when he returned to Paris. In his article on van Gogh for *Les Hommes d'Aujourd'hui* (1891), Bernard states that he first met van Gogh at Cormon's studio (SS, p. 283).

August

Meets Gauguin in Pont-Aven in late summer (MS, p. 95).

September

Returns to Paris (MS, p. 95).

Attends the Indépendants with Anquetin and meets Camille Pissarro there (LA, p. 104).

October

Visits Toulouse-Lautrec and Anquetin at Cormon's where he notices van Gogh at work (SS, pp. 90–92).

Takes his new Breton work to Père Tanguy's shop where he encounters van Gogh (MS, p. 95). A friendship is soon established and the two exchange canvases (JR, p. 56). Introduces Anquetin to van Gogh (EB, p. 114). Frequents Toulouse-Lautrec's studio where he sits for his portrait (JR, p. 27). Begins to experiment with pointillism (JR, p. 30).

Winter

Exhibits pointillist works in small exhibition at Asnières. Signac, who sees Bernard's work there, tells Bernard that he is the inventor of the neo-impressionist technique. Signac invites Bernard to visit his studio (MS, p. 126).

PAUL GAUGUIN

January

Desperate for money, takes a job for five francs a day as a bill poster for the train stations (RB, p. 9; PG 94).

Atelier Cormon, 1885–86

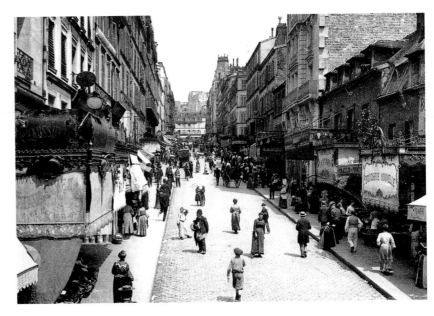

Rue Lepic in Paris

1886

May–June

Attends 6 May dinner in honor of the last impressionist exhibition to which he contributes nineteen paintings and one wood relief (RB, p. 9; PG 96).

On 15 June he attends the private opening of the fifth *Exposition internationale* at Galerie Georges Petit (PG XXVII).

Sells a painting for 250 francs to the engraver Félix Bracquemond who puts him in touch with the ceramicist Ernest Chaplet (PG 99). While in Paris, borrows Signac's studio so he can work before leaving for Pont-Aven (PG 103). Seurat encounters Gauguin there and an argument erupts between them (PG XXVIII).

July

Arrives in Brittany; lives on credit at the Pension Gloanec (PG 107). Declares himself the leader of all the artists in Pont-Aven (PG 110, 111).

August

Meets Bernard in Pont-Aven (MS, p. 95). Refuses to participate in the Indépendants exhibition partially because of the quarrel with Seurat in Signac's studio (RB, p. 44).

October

Returns to Paris; moves to 257, rue Lecourbe; begins making ceramics with Chaplet (RB, p. 44).

November

Meets van Gogh after his return to Paris (JR, p. 39).

At the café La Nouvelle-Athènes he encounters the neo-impressionists; refuses to shake hands with Signac and Camille Pissarro because of the misunderstanding that occurred in Signac's studio (CP 361).

VINCENT VAN GOGH

January

Enters Antwerp Art Academy (VG 446). Writes almost daily about moving to Paris to his brother Theo who is an art dealer there (VG 447).

March

Leaves the Antwerp Academy before completing the winter course. Arrives in Paris in early March (VG 459). Stays in Theo's apartment at 25, rue de Laval (VG 462a).

Late spring

May have entered Cormon's studio, 104, boulevard de Clichy (BWO 2, pp. 209–12). Whether he met Bernard before the latter left Paris for Brittany is uncertain (MS, p. 95).

June

Moves with Theo to a larger apartment at 54, rue Lepic, Montmartre (VG 462a).

Postcard of Pont-Aven woman in bridal costume

September

Works at Cormon's studio where he meets Toulouse-Lautrec (VG 1, p. 29).

October

Frequents Père Tanguy's shop at 14, rue Clauzel where he meets many young artists, including Bernard who has recently returned from Brittany (possibly their first acquaintance; EB, p. 114). The two go to van Gogh's apartment where they exchange canvases (JR, p. 56).

Meets Angrand at Père Tanguy's and greatly admires his work displayed there (BWO 1, pp. 37–39). In a letter postmarked 25 October 1886, he proposes an exchange of one of his paintings for Angrand's *Les Poules*, 1884 (BWO 1, p. 60).

Meets Anquetin through Bernard, possibly at Père Tanguy's (EB, p. 114).

Has works on display at Père Tanguy's shop (VG 459a, 561).

November

Meets Angrand at the Café du Théâtre to discuss an exchange of paintings, but Angrand is unwilling (SS, p. 89).

Meets Camille Pissarro through his brother Theo and subsequently becomes acquainted

Portrait of Theo van Gogh, 1878 (left)
Portrait of Vincent van Gogh, 1873 (right)

with Lucien Pissarro through Camille (JR, p. 34). Meets Gauguin who has just returned to Paris from Pont-Aven (JR, p. 39).

December

Is invited by Toulouse-Lautrec to accompany him to Le Mirliton where Toulouse-Lautrec has paintings on display (HTL 2, p. 525).

CAMILLE PISSARRO

May

Organizes a dinner in honor of the last impressionist exhibition on 6 May at the music hall Lac St. Fargeau, 296, rue de Belleville, Paris. Exhibits eight paintings, four gouaches, six pastels, and eight etchings in the show (CP/LP, p. 76). Visits Seurat's studio with his son Lucien (RH, p. 403).

June

Attends the private opening of the fifth *Exposition internationale*, Galerie Georges Petit, on 15 June (PG XXVII).
Stores his paintings from the impressionist exhibition at Signac's studio in Paris (PG XXVII).
Meets the writer Octave Mirbeau (CP 2, p. 157).

September

Encounters Anquetin and Bernard at the Indépendants (LA, p. 104).
Fénéon asks him to check his analysis of the neo-impressionist technique in the article he has prepared for the Belgian review *L'Art*

moderne (CP 352). Camille insists that Seurat receive credit in the article for being the first painter to practice Eugène Chevreul's color theories (CP 356).

November

Durand-Ruel asks him to write an account of his artistic theories; Camille refers him to Fénéon's pamphlet (RH, p. 405).
Meets Vincent van Gogh through Theo (JR, p. 34).
Frequents the café La Nouvelle-Athènes with Seurat and Signac (CP 360). Encounters Gauguin who refuses to shake hands with the neo-impressionists (CP 361).

LUCIEN PISSARRO

February

Drawings published in *Le Chat noir*, 27 February (LP/CP, p. 65).

May

Visits Seurat's studio with his father (RH, p. 403).

May–June

Participates in the final impressionist exhibition with fifteen works, which are favorably discussed in Ajalbert's review in *Revue moderne*, June 20 (LP/CP, p. 66).

June

Has three illustrations for a short story by Octave Mirbeau published in *La Revue illustrée*, 15 June (LP/CP, p. 66).

August

Spends the month at Les Andelys; Signac works there at same time (LP/CP, p. 70, n. 2).

August–September

Shows ten works at the Indépendants (INDE, 1886, p. 20).

GEORGES SEURAT

May

Visited by Camille and Lucien Pissarro at his studio, Rue de Chabrol (RH, p. 403).
Visited by Berthe Morisot who invites him to participate in the impressionist exhibition (RH, p. 403).

May–June

Exhibits nine works at the last impressionist exhibition, including the large painting *A Sunday Afternoon on the Island of La Grande Jatte—1884* (p. 77); meets the art critic Fénéon there. Is disappointed by the reaction of the older generation of painters (RH, p. 403).
Attends the private opening of the fifth *Exposition internationale*, Galerie Georges Petit on 15 June (RH, p. 403; PG XXVII).
Unexpectedly encounters Gauguin at Signac's studio around 18 June and is unpleasantly surprised. Relates the story to Camille Pissarro, who dismisses Gauguin's behavior as that of a "sailor" (PG XXVIII).
Is accompanied by Angrand to paint on the island of La Grande Jatte (unpublished letter to Angrand's parents, n.d.).

21 June–mid-August

Stays in Honfleur, but produces only six canvases due to bad weather (RH, p. 404).

August–September

Shows *La Grande Jatte* at the Indépendants, along with nine other works, some of Grandcamp and Honfleur (INDE, 1886, p. 22).
His work meets with both hostility (Octave Mirbeau, Emile Hennequin, Téodor de Wyzewa) and approval (Félix Fénéon, Octave Maus, Emile Verhaeren) (JR, p. 503).

Henri de Toulouse-Lautrec, *The Quadrille of the Louis XIII Chair at the Elysée-Montmartre*, published on the cover of *Le Mirliton*, 29 December 1886

1886

October

Attends gatherings at the café La Nouvelle-Athènes with Signac and Camille Pissarro (CP 361). Anquetin, Bernard, Angrand, van Gogh, Gauguin, and others are often there (JR, pp. 39, 503).

Visited on 23 October by Verhaeren, the Belgian poet, and possibly Octave Maus, secretary of Les XX, who invite him to exhibit with them in Brussels in 1887. Verhaeren purchases one of Seurat's paintings (RH, p. 405).

November

News of his invitation to Les XX causes great excitement at the café La Nouvelle-Athènes (CP 360, 361).

December 1886–January 1887

Galerie Martinet, 26, boulevard des Italiens; two paintings by Seurat are displayed in windows on the Rue du Helder (CP 374; RH, p. 413).

PAUL SIGNAC

May–June

Invited by Berthe Morisot to participate in the impressionist exhibition and is encouraged by Camille Pissarro (RH, p. 403). Exhibits *The Railway Junction*, 1886 (p. 162) (P-I, p. 136).

Le Chat Noir

June

Permits Camille Pissarro to store his paintings from the impressionist exhibition in his Paris studio (PG XXVII).

Leaves for Les Andelys where he spends the summer painting (CP 339). Lucien Pissarro is there in August (LP/CP, p. 70, n. 2).

August–September

Submits ten works, including *The Railway Junction*, to the Indépendants and serves as a member of the hanging committee (INDE, 1886, pp. 22–23).

Fall

Establishes friendships with Fénéon, Charles Henry, Paul Alexis, and Verhaeren (JR, p. 503).

November

Is snubbed at the café La Nouvelle-Athènes by Gauguin who refuses to shake hands with the neo-impressionists (CP 361).

Winter

Sees a small exhibition of pointillist works by Bernard in Asnières. Informs Bernard that he is the inventor of the neo-impressionist technique, and invites Bernard to his studio in Paris (MS, pp. 96, 373).

HENRI DE TOULOUSE-LAUTREC

May

Submits painting of Camembert cheese to the official Salon to mock the jury, which refuses the painting (HTL 2, p. 525).

July

Frequents the cabaret Le Chat Noir, 12, rue de Laval, with his friends (HTL 129).

September

Drawing published in *Le Courrier français*, September 26 (p. 87) (HTL 125, n. 1, 127). Meets van Gogh who enters Cormon's studio (VG 1, p. 29).

Fall

Rents large studio at 27, rue Caulaincourt, corner of rue Tourlaque (HTL 130, n. 2). Paints Bernard's portrait (p. 18) (JR, p. 27).

October–December

Exhibits at the *Exposition des Arts incohérents* under the pseudonym Tolau-Segroeg (HTL 132; GM, p. 265).

December

Shows work at Aristide Bruant's Le Mirliton, 84, boulevard de Clichy, and makes illustrations for Bruant's songs (GM, p. 265); invites van Gogh to accompany him to Le Mirliton where his paintings are on display (HTL 2, p. 525).

Aristide Bruant

1887

GENERAL

2 February–end of February
IVe Exposition annuelle des XX, Brussels, held
at former Musée Royale de Peinture, includes
works by Camille Pissarro and Seurat
(XX, p. 105). Fénéon writes about Seurat's
La Grande Jatte for *L'Art moderne*, 6 February.
Verhaeren writes an article on the neo-impres-
sionists for the Belgian avant-garde journal
La Vie moderne, 26 February, praising Camille
Pissarro's work (CP 399); also writes review
for *Revue indépendante*, March.

26 March–3 May
Exposition de la Société des Indépendants,
Pavillon de la Ville de Paris, Champs-Elysées,
includes Angrand, Lucien Pissarro, Seurat,
and Signac (INDE, 1887). Fénéon reviews the
exhibition for *La Vogue*, 26 March, and high-
lights neo-impressionism in *L'Art moderne*,
1 May. Other reviewers include: Paul Alexis
for *Le Cri du peuple*, 26 March; Joris-Karl
Huysmans for *Revue indépendante*, April; Jules
Christophe for *Le Journal des artistes*, 24 April;
and Paul Adam for *Revue rose*, May.

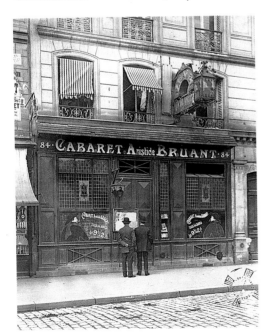

Cabaret Aristide Bruant

8 May–8 June
*Exposition internationale de Peinture et de
Sculpture, 6ème année*, Galerie Georges Petit,
8, rue de Sèze, includes Camille Pissarro,
Monet, Renoir, Sisley, and Morisot (JR, p. 60;
CP 1, p. 258). Seurat criticizes the "old impres-
sionists," sparing only Pissarro and Morisot,
both of whom encouraged the younger genera-
tion of painters. Huysmans reviews the exhi-
bition for *Revue indépendante*, June, preferring
Camille Pissarro's earlier work over his poin-
tillist landscapes (CP 423).

May–June
Millet (retrospective), Ecole des Beaux-Arts (RH,
p. 406; P-I, p. 282); Millet was admired by many
of the younger artists, especially van Gogh.

June
The Théâtre Libre, 96, rue Blanche, is
founded by André Antoine (P-I, p. 282).
The Théâtre des Ombres Chinoises is founded
by Rodolphe Salis at Le Chat Noir, 12, rue de
Laval (P-I, p. 282).

October
Japanese Art, Union Centrale des Arts
Décoratifs, Paris (P-I, p. 282).

November–December
Exhibition of the Petit Boulevard, Grand
Bouillon-Restaurant du Chalet, 43, avenue
de Clichy, includes Anquetin, Bernard, van
Gogh, Arnold H. Koning, and Toulouse-

Lautrec (LA, p. 108); organized by van Gogh.
Anquetin and Bernard each sell a work; van
Gogh exchanges work with Gauguin (VG 510).
Camille Pissarro, Seurat, Gauguin, and
others visit the show (MS, p. 97).

Late November 1887–January 1888
Théâtre Libre shows works by Seurat, Signac,
and van Gogh in the lobby (RH, p. 407).

December
Gauguin, Guillaumin, Camille Pissarro at
Boussod and Valadon, 19, boulevard Mont-
martre; organized by branch manager Theo
van Gogh (P-I, p. 282).
Revue indépendante, 11, rue de la Chaussée-
d'Antin, works by Anquetin, Camille
Pissarro, and Seurat are exhibited in the
offices (FF, pp. 91–94).

CHARLES ANGRAND

February
Meets Bernard and Lucien Pissarro at Père
Tanguy's shop (MS, pp. 96, 373).

March–May
Exhibits four paintings at the Indépendants
(INDE, 1887, p. 4).

LOUIS ANQUETIN

February
Asks Bernard to pose for his large painting
Chez Bruant (now lost). Does several portrait
studies of Bernard (p. 26) (MS, p. 96).

March
Accompanies Bernard to Signac's studio,
130, boulevard de Clichy, on 12 March. They
decide to abandon divisionism in favor of an
alternative style of painting in which "ideas
dominate the form" (MS, p. 96).

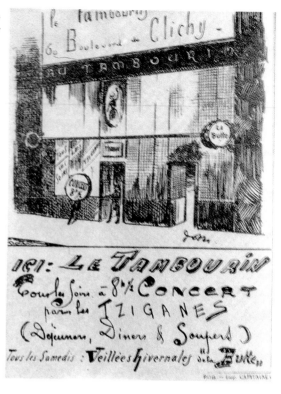

1887

Van Gogh takes Anquetin and Bernard to Samuel Bing's store, 19, rue Chauchat, to teach them about Japanese prints, which come to influence Anquetin's and Bernard's artistic development (MS, p. 97).

May

Encounters Camille Pissarro at the *Millet* retrospective (CP 424).

Summer

Works in Etrépagny where he paints *Mower at Noon: Summer*, his first cloisonnist painting (BWO 2, p. 229).

November–December

Works with Bernard to develop cloisonnism. Paints his second cloisonnist work, *Avenue Clichy, Five O'Clock in the Evening* (p. 59) (BWO 2, p. 229).

Shows paintings at van Gogh's *Exhibition of the Petit Boulevard*, including *Mower at Noon: Summer* and *Avenue Clichy* (BWO 2, p. 229); sells a work from the show (VG 510).

EMILE BERNARD

February

Works in the outskirts of Paris. Frequents Père Tanguy's shop where he meets Lucien Pissarro and Angrand; deposits his Breton works with Tanguy (MS, pp. 96, 373).

Poses for Anquetin's large painting *Chez Bruant* (now lost) (MS, p. 96).

March

Goes with Anquetin to visit Signac's studio on 12 March; he and Anquetin decide to abandon the divisionist technique in favor of painting in which "ideas dominate the form" (MS, p. 96).

He and Anquetin are invited to accompany

van Gogh to Samuel Bing's store to study Japanese prints (MS, p. 97).

April

Visits Le Ribay, Brittany, for two months; decorates his room at Madame Lemasson's inn with pastoral scenes (MS, p. 97).

July

Stays in Pont-Aven hoping to see Gauguin who, however, has already departed for Martinique (MS, p. 97).

Fall

Moves with his parents to a larger house, 5, avenue de Beaulieu, Asnières, where his maternal grandmother comes to live with the family; she has a studio built for Bernard in the garden (MS, p. 97).

Works with van Gogh in Asnières; van Gogh often visits Bernard's studio where the two painters begin their respective portraits of Père Tanguy (pp. 122, 123) (MS, p. 98). Van Gogh leaves abruptly after a quarrel with Bernard's father and does not return (SS, pp. 91–92).

November

Participates in *Exhibition of the Petit Boulevard* organized by van Gogh; sells his first painting (from the show) to the dealer George Thomas (MS, pp. 97, 373).

November–December

Works with Anquetin to develop cloisonnism; paints his first cloisonnist work, *Iron Bridge at Asnières* (p. 89) (BWO 2, p. 229; MS, p. 130).

PAUL GAUGUIN

Winter

Teaches at the Académie Vitti in Paris; makes ceramics with Ernest Chaplet (JR, p. 504).

Spring

Plans trip to Panama and Madagascar where he wants "to live as a savage" (PG 121, 122).

April–May

Leaves for Panama on 9 April with the painter Charles Laval; works for two weeks on the building of the Panama Canal to earn money (PG 124, 125; BWO 2, p. 169).

June

Arrives in Martinique; lives in native hut near the beach (PG 154).

November

Returns to Paris on 13 November (PG 135).

Stays with Emile Schuffenecker at 19, rue

Boulard; counts on working with Chaplet but learns that the latter has closed his ceramics business (PG 136).

Exhibits his Martinique paintings at Alphonse Portier's gallery, 54, rue Lepic, Paris, but has few sales (BD, p. 34).

December

Exhibits three paintings and five ceramics at Boussod and Valadon (BWO 2, p. 169).

Sees van Gogh's *Exhibition of the Petit Boulevard* and exchanges a painting with him (VG 510).

VINCENT VAN GOGH

January–Februry

Meets Signac at Père Tanguy's shop (BWO 2, p. 91).

February–March

Presents exhibition of Japanese prints at Café du Tambourin, 62, boulevard de Clichy (VG 510; P-I, p. 282).

March

Takes Anquetin and Bernard to Samuel Bing's store to teach them about Bing's collection of Japanese prints (MS, p. 97).

April–May

Paints in Asnières with Signac (BWO 2, p. 91).

Summer

Exhibits his paintings at Café du Tambourin, but removes them after a disagreement with the owner, Agostina Segatori (p. 84) (VG 461, 462).

Displays a painting in the shop window at Père Tanguy's (VG 462).

In contact with Toulouse-Lautrec who has sold a picture through the dealer Alphonse Portier (VG 461).

Fall

Works with Bernard in Asnières where he paints a portrait of Père Tanguy (p. 123) (MS, p. 98).

Exchanges a still-life painting with Lucien Pissarro for some of the latter's wood engravings (SS, p. 88).

November–December

Organizes the *Exhibition of the Petit Boulevard*, which includes Anquetin, Bernard, Toulouse-Lautrec, Koning, and himself. Exchanges a painting with Gauguin (VG 510). Meets Seurat, who visits the exhibition (SS, p. 90).

Late November 1887–January 1888

Shows works in the lobby of the Théâtre Libre with Signac and Seurat (JR, p. 64).

CAMILLE PISSARRO

January

Goes to Louis Martinet's gallery with Seurat to see the latter's paintings on display; is angry that Martinet has placed the neo-impressionist works in the window on the rue du Helder instead of in the main window on the boulevard des Italiens (CP 374).

Because the Pissarro family is struggling financially, Seurat's mother commissions Camille to do a small neo-impressionist painting for 100 francs (CP 374, 381–384, 391).

On 21 January, he goes to La Taverne Anglaise, frequented by the young contributors to *La Vogue*, to seek Fénéon's editorial advice for a fairy tale that Lucien has written and illustrated (CP 386).

February

Exhibits three works with Les XX (CP 394); the critic Emile Verhaeren praises his work in his review in *La Vie moderne*, 26 February (CP 399).

March

Exhibits works at Chez Paulin, Paris (P-I, p. 282).

May

Exhibits eight oils in the *Exposition internationale* at Galerie Georges Petit and assists with the hanging of the show (CP 421).

Huysmans reviews show and prefers Camille's

Vincent van Gogh and Emile Bernard in Asnières, 1886

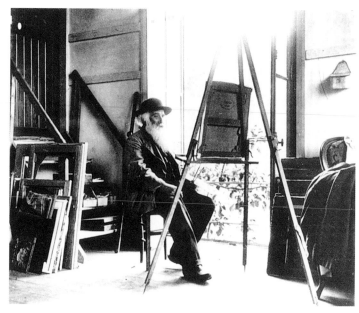

Camille Pissarro in his studio
at Eragny-sur-Epte, c.1890

1887

earlier works to his neo-impressionist ones
(*Revue indépendante*, June).

Visits the *Millet* retrospective on 20 May
and sees Anquetin there (CP 424; VG 1,
pp. 149–50, 153).

Resumes painting by the end of the month
in Eragny (CP 431).

June

Visits Seurat's studio on 15 June and is sur-
prised to see Seurat painting his frames;
writes to Signac about Seurat's latest innova-
tion and suggests they follow suit, but only
after Seurat receives recognition for this new
development (CP 441).

Theo van Gogh agrees to sell and exhibit
Camille's works at Boussod and Valadon
(CP 2, p. 157).

September

Attends a luncheon on 20 September at which
Renoir berates Seurat for his neo-impression-
ism; Pissarro defends it (CP 452).

Is relieved to learn that Theo van Gogh sells
a painting and a gouache of his for 800 francs
because he desperately needs the money to
support his family (CP 454).

November–December

Visits the *Exhibition of the Petit Boulevard*
organized by Vincent van Gogh (MS, p. 97).

December

Exhibits works at Boussod and Valadon along
with Gauguin and Armand Guillaumin
(P-I, p. 282).

LUCIEN PISSARRO

January–April

His woodcuts and drawings are published
in *La Vie moderne*: 25 January, 26 February,
12 March, and 9 April (LP/CP, pp. 76–78,
83–84).

February

Meets Bernard at Père Tanguy's shop (MS,
pp. 96, 373).

March–May

Exhibits nine works at the Indépendants, three
of which are neo-impressionist oils (INDE,
1887, pp. 19–20).

May

Expresses interest in working for Theo
van Gogh of Boussod and Valadon. Although
Alphonse Portier, Theo's neighbor, tries to
help Lucien, the job does not materialize
(LP/CP 25/5/87, p. 89).

Lucien Pissarro

June

Sheet of twelve illustrations published in
Le Chat noir, 11 June (LP/CP 11/6/87, p. 90).

Late June–early July

With Degas's help, he obtains a job with
Boussod and Valadon's François Marie Manzi,
who is in the business of publishing illustra-
tions; Lucien does chromolithography for
them but is paid very little (LP/CP 11/8/87,
p. 98).

Fall

Exchanges some of his wood engravings with
van Gogh from whom he receives a still-life
painting, *Basket with Apples* (F378), with
the dedication "à l'ami Lucien Pissarro"
(SS, p. 88).

October

Wood engraving published in *La Vie moderne*,
1 October (LP/CP, p. 102).

GEORGES SEURAT

January

Sends two canvases to Martinet for display
in his gallery window (CP 374).

February

Participates in Les XX with seven paintings
including *A Sunday Afternoon on the Island*

of *La Grande Jatte—1884* (p. 77) (XX, p. 116). Attends the opening of Les XX with Signac; sells two paintings from the show (RH, p. 405). Fénéon discusses *La Grande Jatte* in his review (*L'Art moderne*, 6 February) and Verhaeren writes about the neo-impressionists in *La Vie moderne*, 26 February (CP 399).

March
Submits eight paintings plus two drawings to the Indépendants (INDE, 1887, p. 23).

June
Is visited at his studio by Camille Pissarro who is surprised to see him painting on his frames (CP 441).

August
Drawing illustrated in *Revue indépendante*, August (RH, p. 407).

November
Visits the *Exhibition of the Petit Boulevard* organized by Vincent van Gogh (MS, p. 97). Meets van Gogh at a restaurant near La Fourche (most likely the Grand Bouillon-Restaurant du Chalet) where van Gogh has paintings on exhibit (SS, p. 90).

Late November–January 1888
In late November exhibits at the Théâtre Libre with Signac and van Gogh (RH, p. 407); Huysmans attacks his work, but Jules

Christophe, Paul Alexis, and Gustave Kahn praise it (JR, p. 505).

PAUL SIGNAC

January–February
Meets van Gogh at Père Tanguy's shop (BWO 2, p. 91).

February
Attends opening of Les XX in Brussels with Seurat; suggests to Octave Maus, secretary of Les XX, that a Les XX exhibition be held in Paris with avant-garde French art represented by Camille and Lucien Pissarro, Seurat, and himself; Seurat does not approve of this proposal (CP 398).

March–May
Is visited at his studio by Anquetin and Bernard on 12 March (MS, p. 96). Exhibits nine paintings and one drawing at the Indépendants, including *Snow, Boulevard de Clichy, Paris*, 1886 (p. 64) (INDE, 1887, p. 23).

April–May
Encounters van Gogh at Père Tanguy's shop. The two artists often work together at Asnières and Saint-Ouen where they paint along the riverbanks (SS, p. 89; VG 1, p. 31). Encourages Vincent to experiment with divisionism.

May
Departs on 23 May for Auvergne where he works in Comblat-le-Château; continues on to the Mediterranean where he stays at Collioure, his first contact with southern France and the Mediterranean (LP/CP 25/5/87).

November
Participates in exhibition at the Théâtre Libre with Seurat and van Gogh (JR, p. 64; RH, p. 407). Contributes drawings to *La Vie moderne* (JR, p. 505).

HENRI DE TOULOUSE-LAUTREC

Winter
Makes a colored crayon portrait of Vincent van Gogh (p. 20) (GM, p. 245).

Spring–summer
Invites his friends for evening soirées at his studio; van Gogh frequently attends (SS, p. 87). Sells a painting through the dealer Alphonse Portier (VG 461).

July
Receives invitation from the Belgian painter Théo van Rysselberghe to participate in the next exhibition of Les XX (HTL 146, 147).

November
Exhibits images of prostitutes at the *Exhibition of the Petit Boulevard* (GM, p. 265).

December
Theo van Gogh sells one of his paintings to the printer Manzi (HTL 156, 158).

The bridge at Asnières, c.1890

213

1888

January–February

Revue indépendante, 11, rue de la Chaussée-d'Antin; works by Angrand, Seurat, and Signac are exhibited (FF, pp. 91–94).

February

The paper *La Vie franco-russe* is founded by Paul Adam (LP/CP, pp. 107–8).

2 February–March

Ve Exposition des XX, Brussels; includes Anquetin, Signac, and Toulouse-Lautrec (XX, p. 127).

22 March–3 May

Exposition de la Société des Indépendants, Pavillon de la Ville de Paris, Champs-Elysées; includes Angrand, Anquetin, van Gogh, Lucien Pissarro, Seurat, and Signac; hanging committee includes Lucien Pissarro, Seurat, and Signac (INDE, 1888). Dujardin reviews the exhibition for *Revue indépendante*, 1 March, and hails Anquetin as the inventor of cloisonnism. Signac reviews the exhibition for *Le Cri du peuple*, 29 March, and mentions Lucien Pissarro's drawings favorably (LP/CP, p. 107). Gustave Geffroy writes about pointillism and cloisonnism for *La Justice*, 2 April. Other reviewers include: Gustave Kahn for *Revue indépendante*, April; Fénéon for *L'Art moderne*, 15 April; Paul Adam for *La Vie moderne*, 15 April; and Jules Christophe for *Le Journal des artistes*, 6 May.

April

Daumier (retrospective) at the Ecole des Beaux-Arts (VG 478).

25 May–25 June

Divers artistes at Galerie Durand-Ruel, 11, rue Le Peletier, Paris; important exhibition of impressionist works by Renoir, Camille Pissarro, and Sisley (JR, p. 504).

June

Charles Henry publishes *Cercle chromatique et rapporteur esthétique* for which Signac designs poster and publicity release (RH, p. 407). Arsène Alexandre's book *H. Daumier: L'Homme et l'oeuvre* is published.

June–July

Monet at Boussod and Valadon, 19, rue Montmartre; exhibition of paintings from Antibes; organized by Theo van Gogh (P-I, p. 282). Geffroy writes a review for *La Justice* (VG 501). *Exposition historique de l'art de la gravure au Japon* at Galerie Samuel Bing, 19, rue Chauchat (corner of 22, rue de Provence); exhibition of Japanese woodcuts (P-I, p. 282).

August

Arsène Alexandre writes "Le Mouvement artistique" for *Paris*, 13 August, in which he declares Seurat the inventor of neo-impressionism (RH, p. 408).

Title page for Arsène Alexandre's
H. Daumier: L'Homme et l'oeuvre

September

Manet, Camille Pissarro, Zandomeneghi at Boussod and Valadon, 19, rue Montmartre; organized by Theo van Gogh (P-I, p. 282).

September–October

L'Affiche de M. Paul Signac at Galerie Sequin, boulevard Saint-Michel, Paris (P-I, p. 282).

CHARLES ANGRAND

31 December 1887–January 1888

Exposition de Peinture et de Sculpture par 33 artistes français et étrangers at Galerie Georges Petit, 8, rue de Sèze; exhibits nine works (CA 12/87). Gustave Kahn reviews show for *Revue indépendante*, January (BWO 1, pp. 53, 56).

February

Revue indépendante, 11, rue de la Chaussée-d'Antin; shows two of his works in offices. Fénéon reviews for *Revue indépendante*, March (BWO 1, pp. 53, 56).

March–May

Exhibits three paintings at the Indépendants (INDE, 1888, p. 12).

July

Finishes two canvases depicting the Seine, including *The Seine at Courbevoie* (p. 163) (CA 7/88).

Summer

Invited to participate in the next *Exposition des 33* at Galerie Georges Petit (CA summer 1888).

LOUIS ANQUETIN

January

Exhibits three works at the offices of *Revue indépendante*, 11, rue de la Chaussée-d'Antin (BWO 2, p. 229).

February–March

Dujardin recommends Anquetin's work to the
Belgians Rysselberghe and Maus, who invite
him to participate with Les XX (BWO 2,
p. 229); exhibits eight works, including *Avenue
Clichy, Five O'Clock in the Evening*, (p. 59)
(XX, p. 133).

March–May

Exhibits the same eight works at the Indé-
pendants (INDE, 1888, p. 12). Is proclaimed
the inventor of "cloisonnism" by Dujardin
(*Revue indépendante*, 1 March).

Spring–summer

Suffering from rheumatism, he retires to
Etrépagny (BWO 2, p. 230).

October

Is back in Paris (VG B19).

Winter

Divides his time between Paris and Etrépagny.
(BWO 2, p. 230).

EMILE BERNARD

February

Helps Vincent van Gogh decorate his room
in Theo's apartment with Japanese prints on
18 Feburary, the day before van Gogh departs
for Arles (SS, p. 92).

March

Receives first letter from van Gogh in Arles,
which marks the beginning of an active corre-
spondence between the two painters (VG B1).

April–July

In late April he goes to Saint-Briac, Brittany,
accompanied by his sister Madeleine. His
work is noticed by the young critic Albert
Aurier who is also in Brittany (MS, p. 98;
JR, pp. 173–74).
Sends sketches to van Gogh in Arles in May
(VG 480).
In late July sends drawings of brothel scenes
to van Gogh (VG 514).

August

Encouraged by van Gogh, Bernard is accom-
panied by his mother and sister Madeleine
to visit Gauguin in Pont-Aven; they stay at the
Pension Gloanec (VG B7, B14, B15). Bernard
and Gauguin work closely together.
Makes an album of the drawings van Gogh
has sent him (VG 526).

September

Paints several portraits of his sister Madeleine
(p. 51) (BWO 2, p. 265).
Van Gogh asks Bernard to paint Gauguin's
portrait and vice versa (VG 535). Bernard
feels intimidated by the prospect of painting

Gauguin's portrait. Instead, he agrees to
paint a self-portrait for van Gogh in exchange
for a study (VG 539, B16).
Writes to van Gogh of his plans to come to
Arles in the winter (VG 539, B16).
Towards the end of the month, sends van
Gogh drawings of brothel subjects and
Asnières scenes (VG B17).

October

Informs van Gogh that three other artists at
Pont-Aven would like to exchange works with
him. Although van Gogh is excited about
the prospect, the exchanges do not take place
(VG 544).
Sends his self-portrait to van Gogh as well
as "At the Brothel," a series of pen and ink
drawings with a poem (VG B19).

November

Returns to Paris from Brittany on 10 Novem-
ber (MS, p. 98).

December

Is visited by Gauguin who has returned from
Arles; is saddened to hear about van Gogh's
illness (BWO 2, p. 266).

PAUL GAUGUIN

January

Is visited by Theo and Vincent van Gogh at
Schuffenecker's. Theo buys three of his
Martinique paintings for 900 francs (PG 138).
Degas, Gauguin at Boussod and Valadon,
19, boulevard Montmartre; organized by Theo
van Gogh (P-I, p. 282).
Is invited to exhibit with Les XX in Brussels,
but chooses not to participate because he does
not want to show with the neo-impressionists
(PG 138).

1888

Women harvesting seaweed on the Ile de Sein

February

Leaves for Pont-Aven on either 9 or 16 February; settles in at the Pension Gloanec (BWO 2, p. 169).

April

Gauguin, Schuffenecker, Zandomeneghi at Boussod and Valadon, 19, rue Montmartre; organized by Theo van Gogh (P-I, p. 282).

May

Is invited by Vincent van Gogh to join him in Arles (VG 493, 494a).

June

To help alleviate Gauguin's financial distress, Theo advances him fifty francs to be repaid with a drawing (VG 496). In response, Gauguin suggests that he become a dealer of impressionist paintings with Theo van Gogh leading the operation (VG 496).

July

Accepts an offer from Theo who will pay him a stipend of 150 francs per month in exchange for one painting per month if he will live with Vincent in Arles (VG 507; PG 156). However, remains in Pont-Aven and continues to paint with other artists (BWO 2, p. 169).

August

Is joined in Pont-Aven by Bernard, whose sister Madeleine sits for him (p. 52) (BWO 2, p. 169).

September

Receives Vincent van Gogh's request that he and Bernard paint each other's portraits for an exchange with van Gogh (VG 535). Gauguin responds that he will do one self-portrait. Works on his self-portrait and the painting *The Vision after the Sermon* (p. 114).

Describes and provides a sketch of the latter painting in a letter to van Gogh who realizes its importance (PG 165).

October

Writes to van Gogh explaining the symbolism of his self-portrait *Les Misérables* (W239). The painting is sent to van Gogh in Arles (PG 167, 168).

Theo van Gogh sells some of his ceramics for 300 francs (PG 168). Gauguin pays his debts in Pont-Aven with the money; Theo pays for his train fare to Arles (PG 172), where he arrives on 23 October (PG 174).

Receives 500 francs from Theo for the sale of one of his Breton paintings, which helps Gauguin financially and gives him hope for future sales (VG 557; PG 176).

He and van Gogh work intensely and discuss possibilities for an association of painters, perhaps even establishing a "Studio in the Tropics" (VG B19a; PG 177).

November

Gauguin at Boussod and Valadon, 19, rue Montmartre; exhibition of Breton paintings organized by Theo van Gogh (PG XCIII; VG T3a).

Invites Bernard to join van Gogh and him in Arles if Bernard does not do military service (PG 178).

Is invited again to exhibit with Les XX; plans to mount a serious attack on the neo-impressionists there (PG 184, 185).

December

Invited to exhibit at the offices of *Revue indépendante*, but refuses (PG 187).

Wants to return to Paris because of his and van Gogh's incompatible temperaments (PG 191).

On 17 December he and van Gogh take a day trip to Montpellier to visit the Alfred Bruyas collection in the Musée Fabre (PG 192; VG 564). Tension escalates between Gauguin and van Gogh. An argument on 23 December results in van Gogh's self-mutilation. Gauguin informs Theo of the incident and soon thereafter leaves for Paris where he stays with his friend Emile Schuffenecker (BWO 2, p. 169).

Visits Bernard and informs him of van Gogh's illness (BWO 2, p. 266).

VINCENT VAN GOGH

February

With Bernard's help, decorates his room in Theo's apartment with Japanese prints on 18 February (SS, p. 92).

Visits Seurat at his studio with Theo on 19 February; leaves later that day for Arles (VG 544a).

Arrives in Arles on 20 February to find it is cold and snowing. Stays at the Hôtel-Restaurant Carrel, 30, rue Cavalerie (VG 463). Purchases paints and canvases and begins to paint. Visits the Musée Réattu and the museum of antiquities (VG 464).

Encourages Theo to establish a good working relationship with H. G. Tersteeg, manager of The Hague branch of Boussod and Valadon, for the purpose of showing works by the French avant-garde in Holland (VG 465).

March

Outlines his idea for an artistic fraternity in which both the older impressionists and the younger members of the avant-garde will contribute a specified number of paintings that will become general property of the association. Proceeds from sales are to be divided equally among artists in order to provide income for each of them to live and work (VG 468).

Congratulates Theo on the purchase of Seurat's drawing *Eden Concert*, and asks Theo to arrange an exchange of one of his paintings with Seurat (VG 468).

Meets the Danish artist Christian W. Mourier-Petersen who paints in Arles for several months (VG 468).

Conceives of a studio in Arles where other painters can come on occasion to relax from the rigors of Paris (VG 469).

March–May

Exhibits two views of the Butte Montmartre and one still-life at the Indépendants (INDE, 1888, p. 42; VG 473); wants to have his name listed as "Vincent" in future exhibition catalogues because that is how he signs his canvases (VG 471).

April

Informs Theo that the studies he is doing can be used for exchanges with other artists such as Camille Pissarro and Seurat (VG 474). Receives sonnets that Bernard has written (VG 477).

Temporarily stops painting and resumes drawing—a precautionary measure to cut down on expenses because he is worried about Theo's future with Boussod and Valadon and his brother's ability to keep sending him money (VG 479).

Plans a visit to Marseille in order to paint seascapes and to find a venue for exhibiting paintings (VG 479).

May

Receives sketches from Bernard (VG 480). Anxious to establish a studio, he rents four rooms at 2, place Lamartine in Arles, the "Yellow House," on 1 May (VG 480); moves temporarily to a less expensive hotel, the Café de la Gare, 30, place Lamartine, until the Yellow House is ready (VG 485).

Reads about the impressionist show *Divers artistes* at Galerie Durand-Ruel in *L'Intransigeant* (VG 490).

Outlines a plan, which Theo will underwrite, to encourage the financially strapped Gauguin to come to Arles (VG 493).

June

Makes a one-day journey to Tarascon on 8 June (p. 37) (VG 496).

Goes to Saintes-Maries-de-la-Mer for five days; sees the Mediterranean for the first time (VG 499).

Takes issue with Dujardin's article (*Revue indépendante*, 1 March) that proclaims Anquetin the inventor of cloisonnism. Despite this new development, van Gogh still considers Seurat to be the leader of the *petit boulevard* painters (VG 500).

Reads Gustave Geffroy's article in *La Justice* on the exhibition of Monet's works organized by Theo at Boussod and Valadon; regrets not

being able to see the show (VG 501).

Has second thoughts about Gauguin coming to Arles, since Gauguin has proposed that he become a paintings dealer (VG 501).

Gives drawing lessons to Lieutenant Milliet of the Zouave regiment with whom he has established a friendship (VG 501, B7). Sends sketches to Bernard (VG B7).

July

Reads Pierre Loti's *Madame Chrysanthème*, which feeds his interest in Japanese art and culture (VG 505).

Admires Toulouse-Lautrec's illustrations published in *Paris illustré*, 7 July (VG 505). Meets Belgian painter Eugène Boch, who is living near Arles (VG 505).

Sends Theo five pen-and-ink drawings with hopes that the art dealer George Thomas will buy them at 100 francs each to help finance Gauguin's trip to Arles (VG 509).

Receives ten of Bernard's Pont-Aven drawings in exchange for the fifteen he has sent to Bernard (VG 514, B10, B11, B12).

Begins first portrait of Joseph Roulin, the postman at the railroad station, who agrees to model for him (p. 138) (VG 516).

Eugène Boch, c.1888

1888

September

Paints *Portrait of Eugène Boch* (p. 35) (VG 531). Proposes an exchange of paintings between Gauguin, Bernard, and himself. He wants Gauguin to paint Bernard's portrait and vice versa, for an exchange with him (VG 535). Moves into the Yellow House in mid-September (VG 538).
Lieutenant Milliet returns to Arles from Paris on 20 September, bringing the Japanese prints and lithographs by Delacroix, Géricault, and Daumier that Vincent had requested from Theo (VG 540).
Paints Milliet's portrait (p. 39) (VG 541a). Receives more drawings by Bernard, some of prostitutes (VG B17).
Receives a letter from Gauguin with a description and sketch of *The Vision after the Sermon* (PG 165).

October

Receives letter from Gauguin describing his self-portrait *Les Misérables* (PG 166). Impressed with Gauguin's description of the painting, he instructs Theo to save the letter (VG 544, 544a).
Receives letter from Bernard stating his desire to come to Arles along with several other painters working at Pont-Aven. Although van Gogh is interested in establishing an artist's community in Arles, he wants Gauguin to assume leadership of the studio in Arles (VG 544). Writes to Gauguin expressing his eagerness to receive his self-portrait. Describes his own self-portrait in which he represents himself as a bonze (VG 544a).
Decorates the Yellow House with paintings in anticipation of Gauguin's arrival (VG 544a).

Is impressed by the self-portraits he receives from Bernard and Gauguin on 4 October. He sends his self-portrait as a bonze (p. 112) in exchange for Gauguin's portrait and several other paintings to be exchanged with Bernard (VG 545).
Receives Bernard's poem "At the Brothel" with ten drawings (VG 545).
Welcomes Gauguin to Arles on 23 October (VG 557), after which the two begin almost immediately to work together and discuss ideas (VG 558).

November

Works with Gauguin all day, sometimes painting similar motifs (VG 559).
Works on portraits of the Roulin family (VG 560).
Is invited by Dujardin to exhibit at the offices of *Revue indépendante*, but refuses because of the condition that he must contribute a work in payment for the exhibition (VG 561).

Is encouraged to paint from his imagination by Gauguin (VG 562).

December

Visits Montpellier with Gauguin on 17 December; they go to the Musée Fabre to see the Alfred Bruyas collection (VG 564). Works on a portrait of Madame Roulin portrayed as a mother rocking an imaginary cradle (F504; VG 574).
Tensions mount and the two artists quarrel on 23 December. Van Gogh cuts off part of his ear and offers it to a prostitute in the brothel he and Gauguin frequent (SS, p. 131). The next day he is taken to the hospital in Arles, where he remains for three days. Gauguin returns shortly thereafter to Paris. Theo goes to Arles to be with his brother (BWO 2, p. 169).
Becomes ill on 27 December and is placed in isolation (RP 1, p. 239).

CAMILLE PISSARRO

March

Theo van Gogh sells Pissarro's painting *Maisons de paysans* (PV710) for 300 francs (CP 474, 475).

May–June

Exhibits eleven paintings and fifteen pastels and gouaches in *Divers artistes*, Galerie Durand-Ruel (CP 486, n. 1).

July

Refuses to deal solely with Durand-Ruel who is upset because Theo van Gogh has already lured Monet away from his gallery (CP 496).

August

Contracts an eye infection that afflicts him for the rest of his life (CP 501).

September

Visits Theo to see van Gogh's paintings from Arles (VG 533).

Exhibits works in the group show *Manet, Camille Pissarro, Zandomeneghi* organized by Theo van Gogh (P-I, p. 282).

LUCIEN PISSARRO

January

Drawings on exhibit at the offices of *Revue indépendante*; Fénéon describes them and Lucien's portrait of Camille Pissarro in *Revue indépendante*, January (LP/CP, p. 105).

Quits his job with the printer Manzi (LP/CP, p. 105).

March

Sees Signac who updates him on his trip to Belgium where he attended the opening of Les XX exhibition (LP/CP 2/3/88).

Late March–April

Contributes illustrations regularly for the weekly paper *La Vie franco-russe*; paper closes down at the end of April after two months (LP/CP 4/4/88).

March–May

Member of the hanging committee for the Indépendants; exhibits five works: two oil paintings done in the pointillist technique, plus drawings of cafés and café-concerts (INDE, 1888, p. 37). Signac makes special mention of Lucien's drawings in his review for *Le Cri du peuple*, 29 March. His work is also noted in Fénéon's review for *L'Art moderne*, 15 April (LP/CP, p. 106, n. 7).

May

Woodcuts published in the journal *La Vie moderne*, 6 and 20 May (LP/CP, pp. 108–9). Returns in mid-May to Eragny, where he spends the summer working; paints *The Cathedral of Gisors* (p. 156) using larger dots of paint because he is impatient with the time-consuming neo-impressionist technique (LP/CP, p. 109).

July

Two woodcuts published in *La Vie moderne*, 15 and 22 July (LP/CP, pp. 108, 111).

October

Returns to Paris to live at 12, rue de l'Abreuvoir (LP/CP, p. 113). Woodcut published in *Revue indépendante*, deluxe edition, October (LP/CP, p. 113).

October–November

Exposition internationale du blanc et noir includes some of his works, which are mentioned favorably in Fénéon's review for *Revue indépendante*, November (LP/CP, p. 113).

Paul Signac

November

Woodcut published in *La Vie moderne*, 18 November (LP/CP, pp. 108, 112).

GEORGES SEURAT

January

Revue indépendante, 11, rue de la Chaussée-d'Antin; exhibits two paintings in the offices (RH, p. 407).

February

Revue indépendante; exhibits two café-concert drawings and one painting in the offices (RH, p. 407).

Receives Vincent and Theo van Gogh at his studio on 19 February, just prior to van Gogh's departure for Arles (VG 544a).

March

Theo van Gogh purchases his drawing, *Eden Concert*, at the Hôtel Drouot auction (VG 468).

March–May

Exhibits ten works at the Indépendants and serves as a member of the hanging committee (INDE, 1888, p. 40); Fénéon criticizes his colored frames (*L'Art moderne*, 15 April).

June

Having heard of Dujardin's article proclaiming Anquetin the inventor of cloisonnism, van Gogh still considers Seurat the leader of the *petit boulevard* painters (VG 500).

July

Stays in Port-en-Bessin (RH, p. 102).

August

Is accused by Signac of being behind Arsène Alexandre's article in 13 August issue of *Paris*, in which Alexandre proclaims Seurat the true inventor of neo-impressionism, ignoring

1888

Signac's role in its development. Seurat denies his accusation (HD, p. LXV). Fears having too many followers working in the neo-impressionist technique. In order to protect his originality, refuses to receive artists at his studio (CP 503; JR, pp. 102–4). Contributes drawings to *La Vie moderne* along with Signac, Lucien Pissarro, and others (JR, p. 505).

PAUL SIGNAC

February–March

Exhibits twelve oils with Les XX in Brussels, including *Quai de Clichy*, (p. 28), and *View of Collioure*, (p. 170) (XX, p. 156). Establishes friendships with the Belgian painters Théo van Rysselberghe and Henry van de Velde (JR, p. 505).

March

Returns from attending Les XX in Brussels; meets Lucien Pissarro in Asnières and tells him about the opening (LP/CP 2/3/88). Is visited by Theo van Gogh at his studio (VG 469).

March–May

Serves as a member of the hanging committee for the Indépendants and exhibits ten works, including *Quai de Clichy* and *View of Collioure*. Writes a review of the show for *Le Cri du peuple*, 29 March (INDE, 1888, pp. 40–41). Becomes friends with the symbolists Jean Ajalbert and Stéphane Mallarmé (JR, p. 505). Designs color lithographs for Charles Henry's *Cercle chromatique et rapporteur esthétique* (JR, p. 125).

August

Suspects that Seurat has initiated Arsène Alexandre's article in *Paris* (13 August) that declares Seurat the true inventor of neo-impressionism and ignores Signac's role (HD, p. lxv).
Contributes drawings to *La Vie moderne* (JR, p. 505).

HENRI DE TOULOUSE-LAUTREC

January

Theo van Gogh purchases for his personal collection *Woman Seated at a Table*, later entitled *Rice Powder* (D348), from Toulouse-Lautrec for 150 francs (HTL 160).

February–March

Shows eleven works with Les XX, including *Portrait of Justine Dieuhl* (p. 57) and possibly a colored crayon portrait of Vincent van Gogh (p. 20) (XX, p. 143).

March and July

Produces illustrations for *Paris illustré* (HTL 164).

November

A group of his paintings are on permanent exhibit at Aristide Bruant's Le Mirliton (JR, p. 15).

Henri de Toulouse-Lautrec with friends at the Moulin de la Galette

1889

GENERAL

Joris-Karl Huysmans publishes *Certains*, a collection of art criticism that features works by Odilon Redon, Gustave Moreau, Pierre Puvis de Chavannes, Edouard Degas, and Paul Cézanne (JR, p. 163).

Jean Moréas publishes *Les Premières années du symbolisme* (P-I, p. 284).

23 January–14 February

Exposition des Peintres-Graveurs at Galerie Durand-Ruel, 16, rue Lafitte, includes works by Camille and Lucien Pissarro. Fénéon reviews the show for *La Cravache*, 2 February (LP/CP, p. 117, n. 1).

February–March

Monet at Boussod and Valadon, 19, boulevard Montmartre; exhibition organized by Theo van Gogh (P-I, p. 284).

VIme Exposition des XX includes Gauguin, Monet, Camille Pissarro, and Seurat (XX, p. 175). Octave Maus reviews the show for *La Cravache*, 16 February (RH, p. 430).

April

Aurier begins to publish *Le Moderniste illustré*, 6 April; publication ceases five months later (MS, p. 381).

5 May–31 October

Exposition Universelle, Paris; all nations are invited to participate. The Eiffel Tower, begun in 1887, is finished on 15 May (LP/CP, p. 120). Among the *petit boulevard* painters, only Seurat seems to have taken an interest in depicting the technological marvel, painting the tower before completion (JR, p. 256).

Gauguin and Toulouse-Lautrec find the Colonial Palace of great interest (right); both are intrigued by the cultures of other nations (JR, p. 265; HTL 2, p. 527).

6 May–6 November

Exposition centennale de l'art français 1789–1889 at Pavillon des Beaux-Arts, Champ de Mars; held in conjunction with the Exposition Universelle. Includes works by Camille Pissarro; excludes the younger generation of artists, leading them to stage an independent exhibition. According to Angrand, Mirbeau would have liked to have seen Seurat's works hanging alongside those of Monet and Camille Pissarro in order to reveal the developments in French art (CA 8/89).

Late May–November

Exposition de Peintures du Groupe impressionniste et synthétiste at Café des Arts, Champ de Mars, 33, boulevard de Clichy; includes Anquetin, Bernard, and Gauguin (P-IGE, n.p.). Also known as the Café Volpini exhibition, it was organized by Gauguin and Schuffenecker because their works were rejected by the jury for the *Exposition centennale*. Opens opposite the Pavillon des Beaux-Arts with nearly 100 works on view. Reviewers of the show include: Aurier for *Le Moderniste illustré*, 27 June; Fénéon for *La Cravache*, 6 July; Kahn for *La Vogue*, no. 2, August; and Jules Antoine for *Art et critique*, 9 November. No paintings are sold from the show, but Gauguin emerges as the leader of a new art movement (JR, pp. 256–61).

June–July

Monet — Rodin (retrospective) at Galerie Georges Petit, 8, rue de Sèze, includes 145 works by Monet and Rodin (JR, p. 506).

3 September–4 October

Exposition de la Société des Indépendants at Salle de la Société d'Horticulture, 84, rue de Grenelle, Saint-Germain. Includes Anquetin, van Gogh, Lucien Pissarro, Seurat, Signac, and Toulouse-Lautrec; Seurat and Signac serve on the hanging committee (INDE, 1889). Participants are limited to only a few canvases each, due to the small size of the exhibition space (CA 5/89).

The Colonial Palace at
the Exposition Universelle, 1889

1889

GROUPE IMPRESSIONNISTE ET SYNTHÉTISTE

CAFÉ DES ARTS

VOLPINI, DIRECTEUR

EXPOSITION UNIVERSELLE

Champ-de-Mars, en face le Pavillon de la Presse

EXPOSITION DE PEINTURES

DE

Paul Gauguin	Émile Schuffenecker	Émile Bernard
Charles Laval	Louis Anquetin	Louis Roy
Léon Fauché	Daniel	Nemo

Paris, Imp. E. WATELET, 55, Boulevard Edgar Quinet.

Affiche pour l'intérieur

Reviewers for the show include: A. Germain for *Art et critique*, 15 September; and Fénéon for *La Vogue*, September (reprinted in *L'Art moderne*, 27 October).

October

Joseph Oller opens the cabaret Le Moulin Rouge in Montmartre on the boulevard de Clichy, 5 October (P-I, p. 284).

CHARLES ANGRAND

January

Exposition de la Société des 33 at Galerie Georges Petit, 8, rue de Sèze; includes Angrand who exhibits nine paintings (BWO 1, pp. 53–54). Fénéon reviews the show for *La Cravache*, 19 January.

12 May–15 October

Exposition des Arts incohérents; includes Angrand who exhibits a landscape (CA 6/89; INCO, p. 5).

LOUIS ANQUETIN

January–March

Leaves Paris to care for his ailing mother in Etrépagny (BWO 2, p. 230).

April

Returns to Paris after his mother's death (BWO 2, p. 230).

May

Exhibits seven works in the Café Volpini exhibition (P-IGE, n.p.) only because Bernard insists that he be allowed to participate (BWO 2, p. 230).

September–October

Exhibits three works with the Indépendants (INDE, 1889, p. 4).

Fall–winter

Leaves his studio at 86, avenue de Clichy in Montmartre for a larger studio at 62, rue de Rome. Remains in contact with some of his old Montmartre friends, especially Toulouse-Lautrec, with whom he frequents the Moulin Rouge (BWO 2, p. 230).

EMILE BERNARD

February

Collaborates with Gauguin on a series of lithographs representing Breton subjects (JR, p. 249).

Cover and title page of the catalogue for the Volpini exhibition, 1889

Spring

Works at Asnières and collaborates with Schuffenecker and Gauguin to prepare the Café Volpini exhibition (MS, p. 98). His recent Breton paintings are on view at Père Tanguy's shop (MS, p. 98).

May

Has the largest group of works (over twenty paintings) in the *Exposition de Peintures du Groupe impressionniste et synthétiste* at Café Volpini (P-IGE, n.p.). Also has an album of lithographs entitled "Les Bretonneries" available upon request (MS, p. 268).

July

Writes article "Aux Palais des Beaux-Arts, notes sur la peinture" for Aurier's *Le Moderniste illustré*, 27 July (MS, p. 98).

August

Drawings from the Café Volpini show are reproduced in *Le Moderniste illustré* (BWO 2, p. 266).

Is forbidden to join Gauguin in Pont-Aven by his father who does not approve of Gauguin; Bernard goes instead to Saint-Briac (MS, p. 98).

Prepares notes on van Gogh in hopes that his friend Aurier will publish an article in *Le Moderniste illustré* (MS, p. 381).

Is invited by Maus to participate with Les XX, but he does not exhibit due to his dislike for Signac and the other neo-impressionists (MS, p. 98).

September
Returns to Paris despite Gauguin's invitation to visit him at Le Pouldu, where he is now staying (MS, p. 98).

October
Visits Theo in Paris to see Vincent's paintings from Arles and Saint-Rémy (VG T18). Contacts Aurier regarding a potential article on van Gogh (BWO 2, p. 266). Aurier does not publish Bernard's notes in *Le Moderniste illustré*; instead decides to write a series on artists, the first of which is on van Gogh, for the symbolist journal *Mercure de France* in January 1890 (JR, pp. 341–42).

November
Is visited in mid-November by Theo van Gogh who is interested in viewing his recent work (VG T20).
Suggests exchange of paintings with van Gogh prompted by his interest in *La Berceuse (Augustine Roulin)*, a portrait of van Gogh's friend Madame Roulin whom the artist depicts as a consoling and comforting mother figure (VG 614).
Sends photographs of his religious compositions to van Gogh who criticizes them as too artificial and not based on reality (VG B21).

December
As his parents do not support his efforts to be a painter, Bernard moves to Lille and lives with his maternal grandmother; works for six months designing textiles to earn money (MS, p. 99).

PAUL GAUGUIN

January
Lives with Schuffenecker in Paris at 29, rue Boulard (BWO 2, p. 170).

February
With Bernard, works on a series of lithographs representing Breton subjects (JR, p. 249).

February–March
Exhibits twelve works with Les XX, including *Blue Tree Trunks, Arles*, (p. 109) (XX, p. 184). Although Gauguin's paintings are poorly received by the public and none sell, Octave Maus praises their primitive character and color in his review for *La Cravache*, 2 March (JR, p. 249).

March
Travels to Pont-Aven (BWO 2, p. 170). Receives news from Schuffenecker that the owner of the Café des Arts, Mr. Volpini, will allow painters to hang works there during the Exposition Universelle (JR, p. 256).

May
Returns to Paris some time in May to assist with the Café Volpini show (VG T9; BWO 2, p. 170). Exhibits seventeen works and an album of lithographs known as the "Volpini Suite" (JR, p. 258, n. 14; P-IGE, n.p.).

June
Bernard introduces him to the critic Aurier; Gauguin subsequently writes articles for Aurier's journal, including "Notes sur l'art à l'Exposition Universelle," *Le Moderniste illustré*, 4 and 13 June (JR, p. 265). Returns to Pont-Aven and stays at Pension Gloanec for two months (BWO 2, p. 170). Many official artists also reside there and criticize Gauguin's work (JR, p. 266).

August–September
Seeking isolation from other artists, Gauguin moves to Le Pouldu, about fifteen miles from Pont-Aven, where he shares a studio with Jacob Meyer de Haan (JR, pp. 266–67). His article, "Qui trompe-t-on-ici?" published in *Le Moderniste illustré*, 21 September, attacks art criticism and government policies for the purchase of works of art (JR, p. 290).

October
Resides at Marie Henry's inn from 2 October to 7 November 1890; he and other resident artists decorate its dining room with ceiling and wall paintings (p. 144) (BWO 2, p. 170). Paints *Still Life "Ripipoint à Marie, souvenir Pouldu 89,"* in derision of Seurat's and Signac's pointillism (JR, pp. 273–74).

Postcard of Le Pouldu showing the mouth of the Laita River and the beach

1889

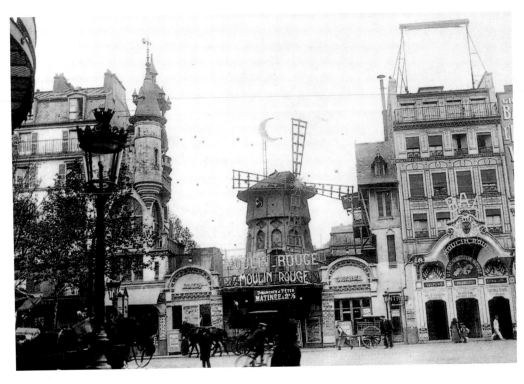

VINCENT VAN GOGH

January – February
Makes three more versions of *La Berceuse*
(F505, 506, 508; VG 574, 575).

February
Is ill and hospitalized for ten days (VG 577).
On 25 February he is taken back to the
hospital due to a petition signed by thirty
people in Arles who fear his condition is
dangerous (VG 579; RP 1, p. 240).

March
Signac visits him in Arles on 23 March; they
go to the Yellow House to look at van Gogh's
works; he gives Signac a still-life painting of
herrings (F510; VG 581–590a).
Starts a fifth version of *La Berceuse* (F507;
VG 582).

May
After presenting his situation to Theo, van
Gogh decides that it would be better if he lives
under supervised care (VG 585–587, 589, 590).
He leaves for the asylum of Saint-Paul-de-
Mausole at Saint-Rémy on 8 May (VG 591).
Is invited to participate in the Café Volpini
show, but Theo declines the offer on his
brother's behalf because he does not approve
of Gauguin's and Schuffenecker's pompous
attitudes (VG T10).

May – July
Camille and Lucien Pissarro, Père Tanguy, and
Octave Maus visit Theo van Gogh and see
Vincent's recent paintings from Arles. As a
result, van Gogh is invited to participate in
the next Les XX exhibition (VG T12).

June
Reads about the Exposition Universelle and
the Café Volpini exhibition (VG 594). Agrees
with Theo's decision to refuse his invitation to
participate in the Volpini show (VG 595).

July
Makes a short visit to Arles on 7 July to collect
his paintings that were left in the Yellow
House (VG 600).
Becomes ill in late July while painting in the
fields around Saint-Rémy and is sick for five
weeks (VG 601).

August
Receives a catalogue of the Café Volpini
exhibition from Gauguin, which he finds
interesting (VG 601).
Receives a catalogue of the *Monet — Rodin*
exhibition held at Galerie Georges Petit from
Theo (VG 601).
Resumes painting at the end of the month;
writes about returning to Paris or possibly
going to Brittany (VG 602).

September – October
Exhibits two paintings in the fifth Indépen-
dants (INDE, 1889, p. 20).
Proposes to Theo the possibility of staying
with Camille Pissarro and his family at
Eragny-sur-Epte or perhaps with some other
artist friend in Paris (VG 605).

November
Responds to photographs of Bernard's biblical
scenes with harsh criticism and expresses
distaste for this new trend in Bernard's and
Gauguin's paintings. Criticizes Gauguin's
Christ in the Garden of Olives (W326) as being
too abstract and artificial (VG B21).

December
Exhibits paintings in Père Tanguy's shop
window. The critic Aurier is interested in van
Gogh's work and writes an article on Tanguy's
shop that mentions his paintings (VG T21).
Ill during the last week of December (VG T23,
T24).

CAMILLE PISSARRO

January – February
Participates in the first exhibition of the
Société des Peintres-Graveurs (CP 1, p. 258).

February – March
Shows eight paintings and two watercolors
with Les XX (XX, p. 189).

Still seeks alternative to the pointillist technique that will allow for rapid execution (CP 519).

March

Receives 300 francs from Theo van Gogh, who sells one of his watercolors to Meyer de Haan's brother (CP 520, n. 1).

May–July

Visits Theo van Gogh with Lucien to see Vincent's recent paintings from Arles (VG T8, T11, T12).

Summer

Undergoes an operation on his eyes (VG T16).

September

Theo van Gogh asks Camille to help find a place for his brother to stay near Paris. Camille is sorry that he is unable to accommodate van Gogh in his own home (CP 544; VG 609).

November

Suggests to Theo that van Gogh consider staying with Dr. Gachet in Auvers (VG T20, 609).

LUCIEN PISSARRO

January–February

Participates in the exhibition of the Société des Peintres-Graveurs with seven works (LP/CP, p. 117, n. 1).

May

Drawing published in *Le Figaro revue de l'exposition*, May (LP/CP, p. 121).

May–July

Visits Theo van Gogh with his father to see Vincent's recent work from Arles (VG T8, T11, T12).

May–August

Has numerous drawings printed in *Le Courrier*

français: 12 May, 28 May, 30 June, 28 July, 4 August, and 11 August (LP/CP, p. 121).

June

Drawings published in *Le Chat noir*, 1 June (LP/CP, p. 121).

September–October

Participates in the Indépendants with two oils, one of which is *Portrait of Jeanne* (p. 54) (INDE, 1889, p. 16).

GEORGES SEURAT

January

Paints the Eiffel Tower under construction (RH, p. 408).

February–March

Exhibits *Port-en-Bessin: The Outer Harbor, Low Tide* (p. 169) and *Seascape at Port-en-Bessin, Normandy* (p. 15) plus seven other paintings and three drawings with Les XX (XX, p. 191); sells a painting (CP 520, n. 1).

Summer

Spends summer in Le Crotoy, but paints only two landscapes there (RH, p. 409). Simplifies his frames by painting borders

directly on the edges of his canvases (JR, p. 93).

September–October

Exhibits three landscapes at the Indépendants and serves as a member of the hanging committee (INDE, 1889, p. 18). Begins work on *Le Chahut* (H199), for which he does several preparatory studies (p. 99) (JR, p. 507).

Is criticized by Fénéon for the overt linear structure of his recent work (JR, p. 507).

Moves to 39, passage de l'Elysée des Beaux-Arts near the place Pigalle (JR, p. 507).

PAUL SIGNAC

March

Stops in Arles on 23 March to visit van Gogh on his way to Cassis on the French coast; they visit the Yellow House and van Gogh gives Signac a still-life painting of herrings (F510; VG 581).

April–June

Lives and works at Cassis (VG 583a). Collaborates with Charles Henry on the book *Education du sens des formes* (VG 584a).

The Trocadéro with a view of the Eiffel Tower

Henri de Toulouse-Lautrec
in his studio

1890

September–October

Serves as a member of the hanging committee for the Indépendants and exhibits three paintings (INDE, 1889, p. 18).

Fall

Goes to Herblay where he paints for several months, producing many landscape paintings of the Seine and its environs (JS, p. 49).

HENRI DE TOULOUSE-LAUTREC

April–June

Drawings published in *Le Courrier français*: 21 April, 12 May, 19 May, and 2 June (HTL 2, p. 527).

May

Wants to participate in Café Volpini show but is excluded by Gauguin, who does not approve of a group of artists with whom Toulouse-Lautrec has previously exhibited (VG T10).

12 May–15 October

In the *Exposition des Arts incohérents*, he exhibits the painting *Portraits of an Unfortunate Family Stricken by Chicken Pox*, an apparent parody of neo-impressionism (GM, pp. 122, 266).

June

Cercle Artistique et Littéraire Volney shows his portraits, which receive special mention in *L'Art français*, 22 June (HTL 2, p. 527).

September–October

Exhibits three works at the Indépendants (INDE, 1889, p. 19).

October

His *Equestrienne (At the Circus Fernando)* (p. 102) is on display in the foyer of the Moulin Rouge for the grand opening on 5 October (HTL 2, p. 527).

GENERAL

January

Mercure de France is founded by Alfred Vallette (JR, pp. 342, 506).

18 January–February

VIIme Exposition annuelle des XX includes van Gogh, Lucien Pissarro, Signac, and Toulouse-Lautrec (XX, p. 199). Signac reviews the show for *Art et critique*, 1 February, highlighting his own work (SS, p. 198).

6–26 March

Deuxième Exposition de Peintres-Graveurs at Galerie Durand-Ruel, 16, rue Lafitte, includes works by Lucien Pissarro (LP/CP, p. 136).

March–April

Monet breaks his contract with Boussod and Valadon (JR, p. 506).

20 March–27 April

Exposition de la Société des Indépendants at Pavillon de la Ville de Paris, Champs-Elysées, includes Angrand, Anquetin, van Gogh, Lucien Pissarro, Seurat, Signac, and Toulouse-Lautrec. Seurat and Signac are members of the hanging committee (INDE, 1890). French president Sadi Carnot visits the exhibition and is accompanied by Seurat and Signac who explain the methods of neo-impressionism (RH, p. 410; *La petite Presse* 21 March 1890).

Among reviewers are: Georges Lecomte for *Art et critique*, 29 March, and for *L'Art moderne*, 30 March; Firmin Javel for *L'Art moderne*, 12 April; Gustave Geffroy for *Revue d'aujourd'hui*, 15 April; Julien Leclercq for *Mercure de France*, May; Mario Varvara for *Ecrits pour l'art*, 15 June.

Title page of the catalogue for the
VIIme Exposition annuelle des XX, 1890

22 April–13 May

La Gravure japonaise at Ecole des Beaux-Arts,
14, rue Bonaparte; exhibition of Japanese
drawings and prints organized with the help
of Samuel Bing (LP/CP, p. 138).

May

Salon du Champ de Mars at Champ de
Mars. First exhibition of the Société
Nationale des Beaux-Arts, founded as an
alternative to the Salon des Artistes Français,
the official salon, includes works by Anquetin
(P-I, p. 284).

June

Raffaëlli at Boussod and Valadon, 19, boule-
vard Montmartre; exhibition organized by
Theo van Gogh (HTL 2, p. 528).

December 1890–January 1891

*Peintres impressionnistes et symbolistes 1e
exposition* at Galerie Le Barc de Boutteville,
47, rue Le Peletier, Paris, includes works
by Anquetin, Bernard, Gauguin, van Gogh,
Signac, and Toulouse-Lautrec (P-IGE,
n.p.); organized by the Nabi painters (JR,
p. 462).

CHARLES ANGRAND

February

Attends the exhibition of Camille Pissarro's
recent paintings at Boussod and Valadon
(CA 2/90).

March–April

Exhibits seven works at the Indépendants,
some of which he had previously shown at
Galerie Georges Petit and at the Indépendants
in 1888 (INDE, 1890, p. 3; CA 2/90).

November

Is invited to participate for the first time with
Les XX; accepts Octave Maus's invitation
(CA 11/90).

LOUIS ANQUETIN

March–April

Exhibits one work in the Indépendants
(INDE, 1890, p. 4).

May–June

Exhibits one painting and two pastels at the
Salon du Champ de Mars (BWO 2, p. 230).

December 1890–January 1891

Exhibits four works at the *Peintres impression-
nistes et symbolistes 1e exposition* (P-IGE, p. 15).

EMILE BERNARD

Winter–spring

Makes industrial signs at Lille to earn money
(MS, p. 99).

January–March

Provides information on van Gogh for Aurier's
article "Les Isolés—Vincent van Gogh,"
Mercure de France, January; shows Aurier
letters and sketches he received from van Gogh
in Arles. They also plan to visit Theo to see
van Gogh's latest work (BWO 2, p. 266).

March

Accompanied by Aurier, he visits Theo,
around 23 March, to see Vincent's recent
paintings from the South of France
(VG T29).

Late May–June

Is interested in Gauguin's invitation to go
to the tropics (MS, p. 56).

July

Learns of van Gogh's death and attends his
funeral in Auvers on 30 July (MS, p. 99).

August

Loses financial support from his parents
and prepares a lottery to sell his paintings
(MS, p. 99).

September

Assists Theo van Gogh in hanging a small
memorial exhibition of Vincent's works in
Theo's apartment in Paris (SS, pp. 236–38).

September–December

Has paintings on view at Père Tanguy's shop
(MS, pp. 99, 373).

December 1890–January 1891

Shows three works at the *Peintres impres-
sionnistes et symbolistes 1e exposition* (P-IGE,
1890, p. 15).

PAUL GAUGUIN

February

Returns to Paris from Le Pouldu. His sculp-
ture and ceramics are on view at Boussod and
Valadon along with some of Camille Pissarro's
recent paintings (VG T28).

Is interested in van Gogh's paintings of sun-
flowers and *La Berceuse* (VG 626).

Jo van Gogh-Bonger with her son
Vincent-Willem van Gogh, 1890

1890

March
Is greatly impressed with van Gogh's paintings at the Indépendants; proposes an exchange for van Gogh's *The Alpilles with Dark Hut* (p. 179) (VG T29).

June
Hopes to sell thirty-eight paintings and five ceramic pots for 5,000 francs to the inventor Dr. Charlopin. Gauguin needs the money to finance his trip to Madagascar (VG T37; BWO 2, p. 171).

Leaves in mid-June for Le Pouldu, where he stays with Jacob Meyer de Haan until November (BWO 2, p. 171).

Summer
Paints the walls of Marie Henry's inn in Le Pouldu (p. 144; BWO 2, p. 170).

In August sends Theo van Gogh a letter expressing his sorrow over Vincent's death (SS, p. 231).

November
Returns to Paris and stays with Schuffenecker. Becomes a regular at the Gangloff Brasserie, 6, rue de la Gaîte, and at the symbolist gatherings at the Café Voltaire where he becomes friends with the symbolists Aurier, Charles Morice, Redon, Mallarmé, and Eugène Carrière, and the Nabi painters (JR, pp. 419–22; RB, p. 49).

The deal with Dr. Charlopin goes awry, forcing Gauguin to arrange an auction of his works to raise money for his trip to the tropics (JR, p. 438).

December 1890–January 1891
One of his landscapes is included in the *Peintres impressionnistes et symbolistes 1e exposition* (P-IGE, 1890, p. 21).

VINCENT VAN GOGH

January
Aurier publishes the article "Les Isolés— Vincent van Gogh" in the first issue of *Mercure de France* (BWO 2, p. 95).

Exhibits with Les XX for the first time, showing six works (XX, p. 216); Anna Boch, sister of Eugène Boch and a member of Les XX, purchases one of his paintings for 400 francs (VG 627, T29). Excerpts from Aurier's article on van Gogh (*Mercure de France*, January) are reprinted in *L'Art moderne*, 19 January (SS, p. 193).

Receives a review of the Les XX exhibition and a copy of Aurier's article from Theo (VG 625). Goes to Arles on 19 January and visits old friends (VG T25); two days later becomes ill (VG T27; RP 2, p. 61).

February
Tells Theo that if Gauguin insists, he can have the copies of *Sunflowers* and *La Berceuse* (F506) in exchange for one of Gauguin's paintings that Theo likes (VG 626).

March
Exhibits ten paintings at the Indépendants (INDE, 1890, p. 41). Julien Leclercq highlights van Gogh's paintings in his review (*Mercure de France*, May). Gauguin hails them as the chief attraction of the exhibition and wants to exchange a canvas for van Gogh's *The Alpilles with Dark Hut* (VG T29). Camille Pissarro tells Theo that van Gogh has achieved real success with the artists (VG T31).

April
Asks Theo to send *Cypresses* (p. 52) as a thank-you to Aurier for his article in *Mercure de France* (VG 629).

May
Agrees to exchange his Alpilles landscape for a work by Gauguin, which Theo will choose (VG 630).

Leaves the asylum at Saint-Rémy on 16 May for Paris. He and Theo visit Tanguy's shop to

Notification of the death of
Vincent van Gogh

look at van Gogh's paintings there. They also visit the *Salon du Champ de Mars* (VG W21). Leaves Paris on 20 May for Auvers-sur-Oise with Theo's letter of introduction to Dr. Gachet; rents an attic room in a hotel on the place de la Mairie run by Arthur-Gustave Ravoux (VG 635).

Establishes a friendship with Dr. Gachet, who is knowledgeable about art; paints and dines at the doctor's home frequently (VG 637).

June

Begins a portrait of Dr. Gachet on 4 June (VG 638).

Is visited in Auvers on 8 June by Theo, Johanna, and their baby (VG 641a).

July

Travels to Paris on 6 July. Many friends visit him at Theo's apartment, including Aurier and Toulouse-Lautrec. Returns to Auvers in the evening (BWO 2, p. 95).

Lucien Pissarro's drawing of his father for
Les Hommes d'Aujourd'hui 8, no. 366, 1890

Invitation to the Camille Pissarro exhibition organized by Theo van Gogh at Boussod and Valadon, 1890

Shoots himself on 27 July and dies on 29 July with Theo at his side (BWO 2, p. 95). Friends, including Père Tanguy, Lucien Pissarro, and Bernard, begin to arrive in Auvers on the morning of 30 July for Vincent's funeral (RP 2, p. 217).

September

Posthumous exhibition of his works held in Theo's Paris apartment; paintings are arranged by Theo and Bernard (SS, pp. 236–38).

December 1890–January 1891

Three of his paintings are exhibited at the *Peintres impressionnistes et symbolistes 1e exposition* (P-IGE, 1890, p. 20).

CAMILLE PISSARRO

25 February–15 March

Exposition d'oeuvres récentes de Camille Pissarro at Boussod and Valadon, 19, rue Montmartre; exhibition organized by Theo van Gogh (CP 2, p. 157); five of the paintings sell (VG T29).

March

Issue of *Les Hommes d'Aujourd'hui*, no. 366, is devoted to him. Georges Lecomte writes Camille's biography and Lucien prepares a drawing of his father for the cover (LP/CP, p. 135).

May–June

Visits Lucien in London (CP 2, p. 157).

Fall

Abandons the neo-impressionist technique because he finds it too rigid and systematic (JR, pp. 387–88).

LUCIEN PISSARRO

January–February

Exhibits for the first time with Les XX; sends three oils done in 1889, including *Portrait of Jeanne* (p. 54) (XX, p. 207).

February

Designs a woodcut for the cover of the catalogue for Camille Pissarro's one-man show at Boussod and Valadon (LP/CP, pp. 134–35).

March

Completes drawing of his father for the cover of the issue of *Les Hommes d'Aujourd'hui* devoted to Camille Pissarro (LP/CP, pp. 135, 137).

Shows five drawings, five etchings, and three woodcuts at the second exhibition of the Société des Peintres-Graveurs (LP/CP, p. 136).

March–April

Exhibits three oil paintings at the Indépendants (INDE, 1890, p. 31). Receives glowing accolades from Mario Varvara in *Ecrits pour l'art*, 15 June (LP/CP, p. 136).

May–June

Stays in London where he is visited by Camille (CP 2, p. 157).

July

Attends van Gogh's funeral in Auvers on 30 July (LP/CP, p. 140).

1890

July–November

Contributes drawings regularly to the anarchist weekly *Le Père peinard* (LP/CP, p. 139).

10 October–30 November

Exposition internationale du blanc et noir at Pavillon de la Ville de Paris, Champs Elysées, Paris, includes woodcuts by Lucien (LP/CP, p. 140). Georges Lecomte reviews the show for *Revue indépendante*, November.

November

Moves permanently to London, where he plans to give painting and drawing lessons while making a career for himself in wood engravings, illustrations, and typography (LP/CP 14/11/90).

GEORGES SEURAT

February

His mistress, Madeleine Knobloch, gives birth to a son, Pierre Georges, on 16 February (RH, p. 410).

March–April

Serves as member of the hanging committee for the Indépendants where he exhibits *Le Chahut* and *Port-en-Bessin: The Outer Harbor,*

Low Tide (p. 169) plus seven other paintings and two drawings, one of which is *Portrait of Paul Signac* (p. 24) (INDE, 1890, p. 36). Firmin Javel criticizes the rigidness of Seurat's *Le Chahut* in his review of the show (*L'Art moderne*, 12 April).

April

Issue of *Les Hommes d'Aujourd'hui*, no. 368 is devoted to him. Jules Christophe writes his biography and Maximilien Luce's portrait drawing of him is reproduced on the cover (RH, p. 410).

June

Is critical of Fénéon's biography of Signac in *Les Hommes d'Aujourd'hui*, no. 373, because it fails to mention Seurat as the founder of neo-impressionism. Careful to protect his paternity of the style, Seurat writes Fénéon a letter correcting the Signac chronology (RH, p. 383).

In late June leaves for Gravelines in the north of France where he spends most of the summer (RH, pp. 410–11).

July

Learns of van Gogh's death on 29 July (RH, p. 410).

PAUL SIGNAC

January

Exhibits twelve works with Les XX in Brussels (XX, p. 212). Attends the opening and supports Toulouse-Lautrec in his defense of van Gogh against the critical remarks of the Belgian Henry de Groux. Is elected a member of Les XX, the first non-Belgian so honored. Ironically, he replaces de Groux who is expelled from the group after his harsh remarks against van Gogh (JR, p. 347). Writes a review of the show for *Art et critique*, 1 February, focusing on the neo-impressionist works.

Goes to Saint-Briac and Herblay to work (JS, p. 49).

March

Serves as member of the hanging committee for the Indépendants and participates with nine works (INDE, 1890, pp. 36–37).

Has an entire issue of *Les Hommes d'Aujourd'hui*, no. 373, devoted to him. Fénéon writes his biography and reproduces Seurat's

F. Lunel's illustration *The Salon des Indépendants: Full Stops, Commas, and Semi-Colons*, published in *Le Courrier français*, March 1890

Portrait of Paul Signac on the cover (RH, p. 383).

Fall

Offers his help to Octave Maus in organizing a retrospective of van Gogh's works at the upcoming exhibition of Les XX (JR, p. 384). Is disheartened by Camille Pissarro's abandonment of the neo-impressionist technique (CP/LP, pp. 230–31).

December 1890–January 1891

Exhibits three paintings at the *Peintres impressionnistes et symbolistes 1e exposition* (P-IGE, p. 20).

HENRI DE TOULOUSE-LAUTREC

January

Contributes five works to Les XX and attends its opening in Brussels (HTL 174; XX, p. 214). At the inaugural dinner on 16 January, he defends van Gogh's work against vicious remarks made by the Belgian Henry de Groux, whom he challenges to a duel. De Groux

apologizes, so duel does not take place (JR, p. 347).

March–April

Exhibits two paintings at the Indépendants (INDE, 1890, p. 39; HTL 175).

July

Sees van Gogh in Paris on a visit from Auvers (HTL 2, p. 528).
Receives news of van Gogh's death too late to attend the funeral; sends his condolences to Theo, noting the friendship he had with his brother (HTL 176).

October

His friend Maurice Joyant succeeds Theo van Gogh at Boussod and Valadon (HTL 2, p. 528).

December 1890–January 1891

Shows seven works in the first group show of *Peintres impressionnistes et symbolistes 1e exposition* including *Woman Smoking a Cigarette* (p. 72) (P-IGE, p. 20).

1891

GENERAL

7 February–8 March

8e Exposition annuelle des XX at Musée d'Art Moderne, Brussels, includes Angrand, Gauguin, van Gogh, Camille Pissarro, Seurat, and Signac (XX, p. 223). Homage is paid to van Gogh with a retrospective of fifteen works that Signac helps organize (JR, p. 385). Among reviewers are: José Hennebicq for *Les Jeunes*, March; Gustave Lagye for *L'Eventail*, 1 March; Ernest Closson for *Impartial bruxellois*, 22 March (SS, pp. 266–67).

20 March–27 April

Exposition de la Société des Indépendants at Pavillon de la Ville de Paris, Champs-Elysées, includes Angrand, Anquetin, Bernard, van Gogh, Lucien Pissarro, Seurat, Signac, and Toulouse-Lautrec. Hanging committee members include Seurat, Signac, and Toulouse-Lautrec. A retrospective of ten works by van Gogh is held (INDE, 1891, p. 63). Among reviewers are: Fénéon (under pseudonym "Willy") for *Le Chat noir*, 21 March; Lecomte for *L'Art dans les deux mondes*, 28 March; Verhaeren for *L'Art dans les deux mondes*, 28 March, and for *L'Art moderne*, 15 April; Mirbeau for *L'Echo de Paris*, 31 March; Eugène Tardieu for *Le Magazine français illustré*, 25 April; and Jules Antoine for *La Plume*, 1 May.

May

Salon du Champ de Mars at Champ de Mars, Paris. Second exhibition of the Société Nationale des Beaux-Arts includes one work by Anquetin (CP 660; BWO 2, p. 231).
Salon des refusés at Palais des Arts Libéraux, Paris, includes Anquetin and Toulouse-Lautrec (P-I, p. 284).

CHARLES ANGRAND

February–March

Exhibits with Les XX for the first time and shows seven canvases (XX, p. 226).

March–April

Participates in the Indépendants with four works (INDE, 1891, p. 5).

April

Is in Rouen when Signac informs him of Seurat's death; is deeply saddened by his friend's unexpected and early death (CA 4/91). Abandons color and turns to charcoal for *pierre noire* drawings (FL, p. 105).

LOUIS ANQUETIN

March–April

Exhibits ten works at the Indépendants, including *A Gust of Wind on the Bridge of Saintes-Pères* (p. 69) (INDE, 1891, p. 6).

May

Exhibits one work at the *Salon du Champ de Mars* (CP 660; BWO 2, p. 231). Participates in the *Salon des Refusés* (P-I, p. 284).

EMILE BERNARD

January

Stays with Eugène Boch at Couilly, Brittany (MS, p. 99).

February

Attends a banquet in Paris in honor of Jean Moréas, where Gauguin is hailed as the leader of the symbolist school of painting and is extremely upset because his role is not even acknowledged. Abandons his plans to accompany Gauguin to Tahiti, completely breaking off contact with Gauguin at the auction of the latter's works on 22 February (MS, p. 99).

March

Is offended when Aurier does not mention his role in the development of symbolism in his article on Gauguin for the *Mercure de France* (MS, pp. 100, 377).

March–April

Shows six works at his first showing with the Indépendants (INDE, 1891, p. 9).

June

Is the subject of an article prepared by Schuffenecker for *Les Hommes d'Aujourd'hui*, but the text is not published (MS, p. 377).

July

Publishes article on van Gogh in *Les Hommes d'Aujourd'hui*, no. 390, and designs the cover, a portrait of van Gogh after the latter's *Self-Portrait with Straw Hat* (F526; MS, p. 376).

August–September

Impressionnistes et symbolistes at Château de Saint-Germain-en-Laye; this first Nabi exhibition may have included Bernard (MS, pp. 100, 373).

August–October

Resides at Saint-Briac with his sister Madeleine; meets Sâr Péladan and is invited to exhibit at the *Salon de la Rose + Croix* (MS, p. 100).

September

Writes an article on van Gogh for *La Plume*, 1 September (SS, p. 282).

December

Tries to launch a new periodical devoted to prints entitled *Le Bois* (MS, p. 100). Contributes drawings to the symbolist publication *La Vie moderne* from 1891 to 1892 (JR, p. 508).

PAUL GAUGUIN

January

Opposes Bernard's plans to organize a memorial exhibition of van Gogh's works

Paul Gauguin wearing a Breton waistcoat, 1891

because he fears it might affect his and other avant-garde artists' reputations (SS, p. 240).

February

Attends the symbolist banquet honoring Jean Moréas on 2 February (RB, p. 49).

Mirbeau publishes an article on him in *L'Echo de Paris*, 16 February, which helps advertise Gauguin's auction sale to finance his trip to Tahiti (JR, p. 439).

Holds an exhibition and auction of thirty paintings from Martinique, Arles, and Brittany at Hôtel Drouot, 22–23 February. His painting *The Vision after the Sermon* (p. 114) brings the highest bid at 900 francs (JR, pp. 442–44).

February–March

Participates in Les XX, exhibiting two wood reliefs, three ceramics, and an enameled statue (XX, p. 234); his work is highly criticized by Belgian critics in *L'Art moderne*, 15 February and 29 March.

March

Aurier publishes "Le Symbolisme en peinture: Paul Gauguin" in *Mercure de France*, March, which acknowledges Gauguin as the leader of the symbolist movement (JR, p. 447).

Goes to Copenhagen on 7 March to see his wife and children, which is the last time he sees his family (BD, p. 58).

Is honored at a banquet at the Café Voltaire on 23 March just prior to his departure for Tahiti; Mallarmé presides (JR, p. 452).

April

Leaves from Marseille for Tahiti on 4 April (JR, p. 454).

Emile Bernard's drawing of Vincent van Gogh for *Les Hommes d'Aujourd'hui* 8, no. 390, 1891

June

Arrives in Tahiti on 8 June and settles in Mataiea (JR, p. 457).

VINCENT VAN GOGH

February–March

Is posthumously honored with a retrospective of eight paintings and seven drawings at Les XX that Signac helps organize (XX, p. 244).

March–April

Signac organizes a retrospective of ten of van Gogh's works at the Indépendants (INDE, 1891, p. 63); Mirbeau writes an article in his memory for *L'Echo de Paris*, 31 March (SS, pp. 267–79).

July

An issue of *Les Hommes d'Aujourd'hui*, no. 390, is devoted to van Gogh. Bernard writes an article on van Gogh and does the portrait drawing for the cover illustration (MS, p. 376).

September

Is the subject of an article written by Bernard for *La Plume*, 1 September (SS, p. 282).

CAMILLE PISSARRO

February

Concentrates more on etchings and lithographs; has a printing press set up in his studio at Eragny; makes drawings to be cut in wood by his son Lucien (JR, p. 508).

February–March

Exhibits two paintings at Les XX (XX, p. 238).

April

Exposition de pastels, aquarelles et eaux-fortes par Camille Pissarro at Galerie Durand-Ruel, 16, rue Lafitte; shows pastels, watercolors, and prints (CP 1, p. 258).

May

Sells *Haymakers Resting* (p. 157) through Portier to the Japanese collector Hayashi (CP 660).

LUCIEN PISSARRO

Participates in artistic activities and pursues friendships among British artists. His first portfolio of twelve woodcuts is published at The Vale in England (LP, p. 9).

March–April

Participates in the annual Indépendants with nine works, mostly woodcuts (INDE, 1891, pp. 49–50).

August–October

Returns to France and spends the fall painting with his father at Eragny (LP, p. 9).

Camille Pissarro

1891

GEORGES SEURAT

February

Attends the literary banquet in honor of Jean Moréas on 2 February; the dinner is chaired by Stéphane Mallarmé (RH, p. 411).

February–March

Shows *Le Chahut* and six landscapes at Les XX (XX, p. 239).

March–April

Exhibits five works at the Indépendants; serves as member of the hanging committee along with Signac and Toulouse-Lautrec (INDE, 1891, pp. 57–58).

Dies on 29 March of infectious angina (possibly malignant diphtheria) at age thirty-one. His funeral service is held at Saint-Vincent-de-Paul on 30 March (JR, p. 394). Fénéon writes his obituary for *Entretiens politiques et littéraires*, April.

Seurat's son Pierre dies of the same illness on 13 April (RH, p. 411).

On Signac's advice, Seurat's brother Emile asks Fénéon to help settle the affairs of Seurat's studio and to represent the Seurat family as his mistress, Madeleine Knobloch, will probably ask Maximilien Luce to represent her interests (RH, p. 411).

Wyzewa writes an important article on Seurat for *L'Art dans les deux mondes*, 18 April (RH, p. 432).

May

An inventory of Seurat's studio is taken by Fénéon, Signac, and Luce on 5 May (RH, p. 411).

July

Exposition de dessins at Boussod and Valadon, 19, rue Montmartre, includes drawings by Seurat (RH, p. 414).

September

Christophe writes an article about Seurat for *La Plume*, 1 September (RH, p. 426).

PAUL SIGNAC

February–March

Shows eight paintings with Les XX and helps Maus organize memorial exhibition of van Gogh's works (XX, p. 240).

March–April

Serves as member of the hanging committee for the Indépendants and participates with nine works (INDE, 1891, p. 58); helps organize a retrospective of van Gogh's works (JR, p. 385).

Charles Angrand in his studio

Henri de Toulouse-Lautrec's models, one of whom is Maurice Guibert, posing for *At the Café la Mie*, 1891

Deeply affected by Seurat's death, he helps to organize Seurat's studio (JR, pp. 394–96).

May

Assists Fénéon and Luce with an inventory of Seurat's studio on 5 May (RH, p. 411). Works at Mont Saint-Michel and Concarneau, spending a day at Pont-Aven (JR, p. 509).

June

Returns to Paris and assumes leadership of neo-impressionism (JR, pp. 400–1).

HENRI DE TOULOUSE-LAUTREC

26 January–February

Cercle Artistique et Littéraire Volney includes three of his works (HTL 182, 187; GM, p. 267).

February

In his article on Aristide Bruant for *La Plume*, 1 February, Oscar Méténier notes that Toulouse-Lautrec has two superb canvases and a charcoal drawing hanging at Le Mirliton (HTL 2, p. 529).

March–April

Serves as member of the hanging committee for the seventh Indépendants; exhibits nine works, including *At the Café la Mie* (p. 67) (INDE, 1891, p. 23).

April

Moves to 21, rue Fontaine (HTL 2, p. 529).

May

Participates in the *Salon des refusés* with two works (GM, p. 267).

Fall

Becomes interested in lithography and does his first poster for Le Moulin Rouge to announce the fall season (HTL 209, 211, 212, 215).

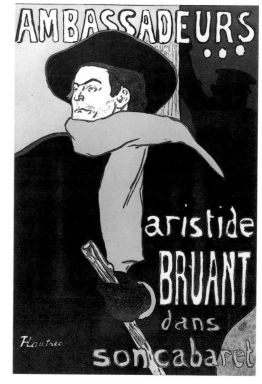

Henri de Toulouse-Lautrec, *Ambassadeurs,
Aristide Bruant dans son cabaret*, 1892

1892

GENERAL

6 February–March

Neuvième Exposition annuelle des XX at Musée
d'Art Moderne, Brussels, includes Lucien
Pissarro, Seurat, Signac, and Toulouse-Lautrec.
A memorial exhibition of forty of Seurat's
works is included (XX, pp. 255, 268–69).
Verhaeren reviews the show for *Art et critique*,
13 February.

March–April

1er Salon de la Rose + Croix at Galerie Durand-
Ruel, 16, rue Lafitte, includes Bernard (MS,
p. 100).

19 March–27 April

Exposition de la Société des Indépendants at
Pavillon de la Ville de Paris, Cours La Reine,
Champs-Elysées, includes works by Angrand,
Anquetin, Bernard, Lucien Pissarro, Seurat,
Signac, and Toulouse-Lautrec. Its hanging
committee includes Signac and Toulouse-
Lautrec. Reviewers include: Christophe for
La Plume, 1 April; Fénéon for *Le Chat noir*,
2 April; and Maurice Denis for *La Revue
blanche*, April. A special homage to Seurat,
Exposition commémorative Seurat, is included
(INDE, 1892).

April

Aurier publishes "Les peintres symbolistes"
in *Revue encyclopédique* 2, no. 32, April.

May–August

*Deuxième Exposition des Peintres impres-
sionnistes et symbolistes* at Galerie le Barc
de Boutteville, 47, rue Le Peletier; exhibition
includes Angrand, Anquetin, Bernard, Lucien
Pissarro, Signac, and Toulouse-Lautrec
(P-IGE, 1892).

November

*Troisième Exposition des Peintres impressionnistes
et symbolistes* at Galerie le Barc de Boutteville,
includes Angrand, Anquetin, Gauguin, Lucien
Pissarro, and Toulouse-Lautrec
(P-IGE, 1892).

2 December 1892–8 January 1893

Exposition des Peintres néo-impressionnistes
at Hôtel Brébant, 32, boulevard Poissonnière,
Paris, includes Lucien Pissarro, Seurat, and
Signac (P-I, p. 286).

CHARLES ANGRAND

March–April

Submits four oils and three conté crayon
drawings to the eighth Indépendants (INDE,
1892, p. 6).

April

Fénéon discusses his landscapes in *Le Chat
noir*, 2 April (CA, p. 49, n. 2).

May–August

Shows six works at the *Deuxième Exposition
des Peintres impressionnistes et symbolistes* (CA,
p. 15).

November

Exhibits six works at the *Troisième Exposition
des Peintres impressionnistes et symbolistes*
(P-IGE 1892, p. 7).

LOUIS ANQUETIN

March–April

Exhibits six oils and four pastels in the Indé-
pendants (INDE, 1892, pp. 6–7).
Begins to study the art of Peter Paul Rubens,
and gradually turns away from painting sub-
jects of modern life to explore more traditional
themes such as mythology (BWO 2, p. 231).
Continues to focus on Montmartre nightlife
with Toulouse-Lautrec (BWO 2, p. 231).

May–August

Exhibits two paintings at the *Deuxième Exposi-
tion des Peintres impressionnistes et symbolistes*
(P-IGE 1892, p. 7).

November

Exhibits three works at the *Troisième Exposi-
tion des Peintres impressionnistes et symbolistes*
(P-IGE 1892, p. 7).

EMILE BERNARD

March–April

Participates in the first *Salon de la Rose + Croix*
(MS, p. 100).

Paul and Georges Durand-Ruel, c.1910

1892

Exhibits nine synthetist works at the Indépendants (INDE, 1892, pp. 10–11).

April

Organizes a retrospective exhibition of sixteen of van Gogh's works at the Galerie Le Barc de Boutteville; the show receives little attention from the press (SS, p. 239; JR, p. 480).

May–August

Exhibits one painting in the *Deuxième Exposition des Peintres impressionnistes et symbolistes* (P-IGE 1892, p. 8).
Returns to Brittany in the summer and remains there through January 1893 (MS, p. 100).

PAUL GAUGUIN

February–March

Has to be hospitalized for illness in Papeete, Tahiti (JR, p. 469).

June

Applies for repatriation to France on 12 June, but remains in Tahiti until June 1893 (JR, pp. 484, 494).

September

His first Tahitian painting is shown at Boussod and Valadon in Paris (JR, p. 472).

November

A study of his is shown in the *Troisième Exposition des Peintres impressionnistes et symbolistes* by Le Barc de Boutteville without his knowledge or consent (P-IGE 1892, p. 9; JR, p. 480).

VINCENT VAN GOGH

April

Vincent van Gogh at Galerie Le Barc de Boutteville, 47, rue Le Peletier; memorial

exhibition of sixteen works organized by Bernard (JR, pp. 479–80). Reviewers of the show include: Francis for *La Vie moderne*, 24 April, and Camille Mauclair for *Revue indépendante*, April.

CAMILLE PISSARRO

January

Exposition Camille Pissarro at Galerie Durand-Ruel, 16, rue Lafitte; large retrospective of seventy-two paintings and gouaches dating from 1870 to 1892. Octave Mirbeau favorably reviews the show. At the end of show, Durand-Ruel purchases all unsold canvases (JR, p. 474).

May–August

Spends most of the summer in London with his son Lucien who marries on 11 August (CP 2, p. 157).

LUCIEN PISSARRO

February–March

Exhibits two oil paintings and nine woodcuts with Les XX (XX, p. 265).

Catalogue for the Vincent van Gogh exhibition at Le Barc de Boutteville's, April 1892

March–April

Exhibits four works at the Indépendants (INDE, 1892, p. 58).

May–August

Exhibits a landscape at the *Deuxième Exposition des Peintres impressionnistes et symbolistes* (P-IGE 1892, p. 13)

August

Marries Esther Bensusan on 11 August. Accompanied by his wife, spends the next eight months in Eragny working with his father (LP, p. 9).

December

Participates in the exhibition *Peintres néo-impressionnistes* at the Hôtel Brébant (P-I, p. 286).

GEORGES SEURAT

February–March

A memorial exhibition of Seurat's works is held at Les XX; consists of eighteen paintings, twelve sketches, and ten drawings, including *Port-en-Bessin: The Outer Harbor, Low Tide* (p. 169) and *Portrait of Paul Signac* (p. 24) (XX, pp. 268–69).

March–April

The Indépendants pay tribute to him with a retrospective exhibition of forty-six works, including the paintings *Port-en-Bessin: The Outer Harbor, Low Tide*; *Seascape at Port-en-Bessin, Normandy* (p. 15); and *Study for "Le Chahut"* (p. 99), as well as the drawing *Portrait of Paul Signac* (INDE, 1892, pp. 66–68).

May

Seurat Retrospective at *Revue blanche* offices; posthumous exhibition of his works (RH, p. 415).

December 1892–January 1893

Six of his works are included in the first exhibition of *Peintres néo-impressionnistes* at the Hôtel Brébant (RH, p. 415).

PAUL SIGNAC

February–March

Exhibits six works with Les XX and helps organize the Seurat memorial exhibition (XX, p. 270).

March–April

Exhibits seven works at the Indépendants; serves as member of the hanging committee (INDE, 1892, pp. 68–69). Helps organize the Seurat retrospective (JR, p. 511).

May

Meets Aurier in Marseille; discovers Saint-Tropez where he establishes a permanent residence in 1893 (JR, pp. 492, 511).

May–August

Exhibits one painting at the *Deuxième Exposition des Peintres impressionnistes et symbolistes* (P-IGE 1892, p. 14).

December 1892–January 1893

Participates in the first exhibition of *Peintres néo-impressionnistes* at the Hôtel Brébant (JR, p. 481).

HENRI DE TOULOUSE-LAUTREC

January

Exhibits two works and attends the opening for Cercle Artistique et Littéraire Volney on 25 January (HTL 215; GM, p. 268).

February–March

Attends the opening of the Les XX exhibition; contributes nine works, including *Woman Smoking a Cigarette* (p. 72) (XX, p. 272; HTL 215).

March–April

Exhibits seven works at the Indépendants, including *Woman Smoking a Cigarette*; serves as member of the hanging committee (INDE, 1892, p. 71).

May–August

A study and poster are on exhibit at the *Deuxième Exposition des Peintres impression-nistes et symbolistes* (P-IGE 1892, p. 14).

November

Exhibits five works in the *Troisième Exposition des Peintres impressionnistes et symbolistes* (P-IGE 1892, p. 15).

Chronology References

AD Anne Distel. *Seurat.* [Paris]: Chêne, 1991.

AH A. M. Hammacher. "Van Gogh's Relationship with Signac." In *Van Gogh's Life in His Drawings; Van Gogh's Relationship with Signac.* London: Marlborough Fine Art Ltd., 1962.

BD Bernard Denvir. *Paul Gauguin: The Search for Paradise: Letters from Brittany and the South Seas.* London: Collins & Brown, 1992.

BWO 1 Bogomila Welsh-Ovcharov. *The Early Work of Charles Angrand and His Contact with Vincent van Gogh.* Utrecht and The Hague: Editions Victorine, 1971.

BWO 2 Bogomila Welsh-Ovcharov. *Vincent van Gogh and the Birth of Cloisonism* (exh. cat.). Toronto: Art Gallery of Ontario, 1981.

CA Charles Angrand. *Charles Angrand: Correspondances, 1883–1926.* Edited by François Lespinasse. N.p., 1988.

CP Camille Pissarro. *Correspondance de Camille Pissarro, 1866–1890.* Vol. 2. Paris: Editions du Valhermeil, 1986.
Camille Pissarro. *Correspondance de Camille Pissarro, 1891–1894.* Vol. 3. Paris: Editions du Valhermeil, 1988.

CP 1 Hayward Gallery. *Pissarro: Camille Pissarro, 1830–1903* (exh. cat.). London: Arts Council of Great Britain, 1980.

CP 2 Isetan Museum of Art, Tokyo. *Retrospective: Camille Pissarro* (exh. cat.). [Tokyo]: Art Life Ltd., 1984.

CP/LP Camille Pissarro. *Camille Pissarro: Letters to His Son Lucien.* Edited with the assistance of Lucien Pissarro by John Rewald. Translated by Lionel Abel. New York: Pantheon Books, [1943].

EB Emile Bernard. "Louis Anquetin." *Gazette des Beaux-Arts,* 6th ser., 11 (February 1934): 108–21.

EL Ellen Wardwell Lee. *The Aura of Neo-Impressionism: The W. J. Holliday Collection* (exh. cat.). Indianapolis: Indianapolis Museum of Art and Indiana University Press, 1983.

F J.-B. de la Faille. *The Works of Vincent van Gogh: His Paintings and Drawings.* Amsterdam: Meulenhoff International, [1970]. First published as *L'Oeuvre de Vincent van Gogh: Catalogue raisonné.* Paris and Brussels: Les Editions G. van Oest, 1928.

FF Félix Fénéon. *Oeuvres plus que complètes.* Edited by Joan U. Halperin. Geneva: Droz, 1970.

FL François Lespinasse. *Charles Angrand, 1854–1926.* Rouen: LECERF, 1982.

GA Götz Adriani. *Toulouse-Lautrec: The Complete Graphic Works: A Catalogue Raisonné: The Gerstenberg Collection.* Translated by Eileen Martin. London: Thames and Hudson, 1988.

GM Gale B. Murray. *Toulouse-Lautrec: The Formative Years, 1878–1891.* Oxford: Clarendon Press, 1991.

HD Henri Dorra and John Rewald. *Seurat: L'Oeuvre peint, biographie et catalogue critique.* Paris: Les Beaux-Arts, 1959.

HTL Henri de Toulouse-Lautrec. *The Letters of Henri de Toulouse-Lautrec.* Edited by Herbert D. Schimmel. Introduction by Gale B. Murray. Oxford: Oxford University Press, 1991.

HTL 1 Fondation Pierre Gianadda. *T-Lautrec* (exh. cat.). Martigny, Switzerland: Fondation Pierre Gianadda, 1987.

HTL 2 Hayward Gallery. *Toulouse-Lautrec* (exh. cat.). London: South Bank Centre; Paris: Réunion des Musées Nationaux, 1992.

INCO *Catalogue illustré de l'Exposition Universelle des Arts incohérents, 1889.*

INDE *Salons of the "Indépendants," 1884–1895.* Vols. 1 and 2. New York and London: Garland Publishing, Inc., 1981.

JL Jean-Jacques Luthi. *Emile Bernard: Catalogue raisonné de l'oeuvre peint.* Paris: Editions SIDE, 1982.

JR John Rewald. *Post-Impressionism: From van Gogh to Gauguin.* 3rd ed., rev. New York: The Museum of Modern Art, 1978.

JS Jean Sutter, ed. *The Neo-Impressionists.* Translated by Chantel Deliss. Greenwich: New York Graphic Society, 1970.

LA Galerie Brame et Lorenceau. *Anquetin: La Passion d'être peintre* (exh. cat.). Paris: Brame et Lorenceau, 1991.

LP Arts Council of Great Britain. *Lucien Pissarro, 1863–1944: A Centenary Exhibition of Paintings, Watercolors, Drawings, and Graphic Work* (exh. cat.). [London]: Arts Council of Great Britain, 1963.

LP/CP Lucien Pissarro. *The Letters of Lucien to Camille Pissarro, 1883–1903.* Edited by Anne Thorold. Cambridge: Cambridge University Press, 1993.

MS Mary Anne Stevens et al. *Emile Bernard, 1868–1941: A Pioneer of Modern Art* (exh. cat.). Translated by J. C. Garcias et al. Mannheim: Städtische Kunsthalle; Amsterdam: Van Gogh Museum; Zwolle, Netherlands: Waanders Publishers, 1990.

NB Norma Broude, ed. *Seurat in Perspective.* Englewood Cliffs, N.J.: Prentice-Hall, 1978.

PG Paul Gauguin. *Correspondance de Paul Gauguin: Documents, Témoignages.* Edited by Victor Merlhès. Paris: Fondation Singer-Polignac, 1984.

PH Philippe Huisman and M. G. Dortu. *Lautrec by Lautrec.* Edited and translated by Corinne Bellow. New York: The Viking Press, 1964.

P-I Royal Academy of Arts. *Post-Impressionism: Cross-Currents in European Painting* (exh. cat.). London: Royal Academy of Arts in association with Weidenfeld and Nicolson, 1979.

P-IGE *Post-Impressionist Group Exhibitions.* New York and London: Garland Publishing, Inc., 1982.

RB Richard Brettell et al. *The Art of Paul Gauguin* (exh. cat.). Washington, D.C.: National Gallery of Art, 1988.

RH Robert L. Herbert et al. *Georges Seurat, 1859–1891* (exh. cat.). New York: The Metropolitan Museum of Art, 1991.

RP 1 Ronald Pickvance. *Van Gogh in Arles* (exh. cat.). New York: The Metropolitan Museum of Art and Harry N. Abrams, 1984.

RP 2 Ronald Pickvance. *Van Gogh in Saint-Rémy and Auvers* (exh. cat.). New York: The Metropolitan Museum of Art and Harry N. Abrams, 1986.

SS Susan Alyson Stein, ed. *Van Gogh: A Retrospective.* New York: Hugh Lauter Levin Associates, 1986.

VG Vincent van Gogh. *The Complete Letters of Vincent van Gogh.* Vols. 2 and 3. Greenwich: New York Graphic Society, [1958].

VG 1 Musée d'Orsay. *Van Gogh à Paris* (exh. cat.). Paris: Réunion des Musées Nationaux, 1988.

XX *Catalogue des dix expositions annuelles Bruxelles.* Brussels: Centre International pour l'Etude du XIXe Siècle, 1981.

Checklist and Illustrations

CHARLES ANGRAND

Self-Portrait, 1882
charcoal on paper, 59 x 42 cm
Private Collection
(not in the exhibition)
p. 31

The Seine at Courbevoie, 1888
oil on canvas, 50 x 65 cm
Private Collection,
Courtesy Galerie Larock-Granoff
p. 163

The Seine at Dawn, 1889
oil on canvas, 65 x 81 cm
Petit Palais, Musée d'Art Moderne, Geneva
p. 10

LOUIS ANQUETIN

*Boulevard des Batignolles, The Kiosk:
Boulevard de Clichy*, 1886
oil on canvas, 44.2 x 36.5 cm
Collection of
Mr. and Mrs. Arthur G. Altschul
p. 16

Portrait of Henri de Toulouse-Lautrec, c.1886
oil on canvas, 40.3 x 32.5 cm
Private Collection, Paris
p. 17

At the Circus, 1887
pastel on buff card, 46.5 x 61.7 cm
Private Collection, Courtesy Hazlitt,
Gooden & Fox
(not in the exhibition)
p. 101

Avenue Clichy, Five O'Clock in the Evening, 1887
oil on canvas, 69.2 x 53.5 cm
Wadsworth Atheneum, Ella Gallup Sumner
and Mary Catlin Sumner Collection
p. 59

Portrait of Emile Bernard (study), 1887
pastel and ink on paper, 29 x 24 cm
Private Collection,
Courtesy Brame et Lorenceau
p. 26

A Gust of Wind on the Bridge of Saintes-Pères,
1889
black ink and watercolor over black chalk
on paper, 49 x 39 cm
Private Collection
(not in the exhibition)
p. 69

Girl Reading a Newspaper, 1890
pastel on paper, 54 x 43.2 cm
The Tate Gallery,
Presented by Francis Howard 1922
p. 74

Woman with a Veil, 1891
oil on canvas, 81 x 55 cm
Private Collection,
Courtesy Brame et Lorenceau
p. 94

EMILE BERNARD

The Café, 1885
pen and ink on paper, 23 x 19 cm
Jane Voorhees Zimmerli Art Museum,
Rutgers, The State University of New Jersey,
Edward and Lois Grayson Purchase Fund
p. 60

Le Bougre (The John), c.1885–86
pen and ink and watercolor on paper,
20.3 x 10.9 cm
Jane Voorhees Zimmerli Art Museum,
Rutgers, The State University of New Jersey,
Edward and Lois Grayson Purchase Fund
p. 91

The Brasserie, c.1885–86
pen and ink and watercolor on paper,
13.3 x 16.2 cm
Jane Voorhees Zimmerli Art Museum,
Rutgers, The State University of New Jersey,
Edward and Lois Grayson Purchase Fund
p. 61

*Café Scene (study related to The Hour of
the Flesh)*, 1885–86
ink on paper, 17 x 33 cm
Private Collection, Paris
p. 90

The Hour of the Flesh, 1885–86
pastel and gouache on wrapping paper,
mounted on linen, 125 x 170 cm
Private Collection, Paris
p. 93

Iron Bridge at Asnières, 1887
oil on canvas, 45.9 x 54.2 cm
The Museum of Modern Art, New York,
Grace Rainey Rogers Fund
L43
p. 89

Portrait of Père Tanguy, 1887
oil on canvas, 36 x 31 cm
Öffentliche Kunstsammlung Basel,
Kunstmuseum
L72
p. 122

View from the Bridge of Asnières, 1887
oil on canvas, 38 x 46 cm
Musée de Brest
p. 70

Portrait of Madeleine Bernard, 1887–88
oil on canvas, 41 x 32 cm
Private Collection
L33
(not in the exhibition)
p. 51

Portrait of a Man (said to be Theo van Gogh), 1888
oil on canvas, 41.5 x 32.5 cm
Private Collection, Paris
L134
p. 40

Breton Women at the Seaweed Harvest,
1888–89
gouache and charcoal on cardboard,
27.5 x 41.1 cm
Musée Départemental Maurice Denis
"Le Prieuré"
p. 145

The Café Concert (Au Cabaret), 1889
oil on canvas, 27 x 61 cm
Private Collection
L145
p. 62

Apple Picking, 1890
oil on canvas, 105 x 45 cm
Musée des Beaux-Arts de Nantes
L246
p. 154

The Cliffs of Yport, 1892
oil on canvas, 91.7 x 65.8 cm
Collection of Daniel Malingue, Paris
L342
p. 110

The Yellow Tree, c.1892
oil on canvas, 65.8 x 36.2 cm
Musée des Beaux-Arts, Rennes
L129
p. 8

PAUL GAUGUIN

Self-Portrait, 1885
oil on canvas, 65.2 x 54.3 cm
Kimbell Art Museum, Fort Worth, Texas
W138
p. 19

Tropical Landscape, 1887
oil on canvas, 115 x 88.5 cm
National Gallery of Scotland
W232
(not in the exhibition)
p. 142

Arlésiennes (Mistral), 1888
oil on canvas, 72 x 93 cm
The Art Institute of Chicago,
Mr. and Mrs. Lewis Larned Coburn
Memorial Collection
W300
p. 177

Blue Tree Trunks, Arles, 1888
oil on canvas, 92 x 73 cm
Ordrupgaard, Copenhagen
W311
p. 109

Farm at Arles, 1888
oil on canvas, 90.2 x 70.5 cm
Indianapolis Museum of Art,
Gift in memory of William Ray Adams
W308
p. 131

The Grape Harvest at Arles. Misères humaines,
1888
oil on canvas, 73.5 x 92.5 cm
Ordrupgaard, Copenhagen
W304
(not in the exhibition)
p. 192

Portrait of Madame Roulin, 1888
oil on canvas, 48.2 x 62.2 cm
Saint Louis Art Museum,
Funds given by Mrs. Mark C. Steinberg
W298
p. 49

Portrait of Madeleine Bernard, 1888
oil on canvas, 72 x 58 cm
Musée de Grenoble
W240
p. 50

Portrait of Van Gogh Painting Sunflowers, 1888
oil on canvas, 73 x 91 cm
Van Gogh Museum, Amsterdam (Vincent
van Gogh Foundation)
W296
(not in the exhibition)
p. 194

Seascape with Cow on the Edge of a Cliff, 1888
oil on canvas, 73 x 60 cm
Musée des Arts Décoratifs, Paris
W282
p. 188

The Vision after the Sermon, 1888
oil on canvas, 73 x 92 cm
National Gallery of Scotland
W245
(not in the exhibition)
p. 114

Breton Calvary — Green Christ, 1889
oil on canvas, 92 x 73 cm
Musées Royaux des Beaux-Arts de Belgique,
Brussels
W328
(not in the exhibition)
p. 184

Harvest in Brittany, 1889
oil on canvas, 92 x 73.3 cm
Courtauld Gallery,
Courtauld Institute of Art
W352
p. 183

The Seaweed Gatherers, 1889
oil on canvas, 87 x 122.5 cm
Museum Folkwang Essen
W349
(not in the exhibition)
p. 185

Self-Portrait with Halo, 1889
oil on wood, 79.6 x 51.7 cm
National Gallery of Art, Washington,
Chester Dale Collection
W323
(not in the exhibition)
p. 111

Young Brittany Girl, 1889
oil on canvas, 46 x 38 cm
Private Collection
W316
p. 117

Gauguin and others
Decoration of the dining room at the Maison
Marie-Henry, Le Pouldu, Brittany, 1889–90
(not in the exhibition)
p. 144

Faaturuma, 1891
oil on canvas, 92 x 73 cm
The Nelson-Atkins Museum of Art
W424
p. 147

Young Christian Girl, 1894
oil on canvas, 65 x 46 cm
Sterling and Francine Clark Art Institute,
Purchased in honor of Harding F. Bancroft,
Institute Trustee 1970–87; President 1977–87
W518
p. 141

Sunflowers, 1901
oil on canvas, 73 x 92 cm
The State Hermitage Museum, St. Petersburg
(not in the exhibition)
W603
p. 148

VINCENT VAN GOGH

*Factories at Asnières, Seen from the
Quai de Clichy*, 1887
oil on canvas, 54 x 72 cm
Saint Louis Art Museum,
Funds given by Mrs. Mark C. Steinberg,
by exchange
F317
p. 29

*Industrial Landscape/Environs of Paris
near Montmartre*, 1887
pastel and gouache on green paper,
39.5 x 53.5 cm
Stedelijk Museum, Amsterdam
F1410
p. 58

Interior of a Restaurant, 1887
oil on canvas, 54 x 64.5 cm
Private Collection,
Courtesy James Roundell
F549
(not in the exhibition)
p. 105

*Japonaiserie: The Flowering Plum Tree
(after Hiroshige)*, 1887
oil on canvas, 55 x 46 cm
Van Gogh Museum, Amsterdam (Vincent
van Gogh Foundation)
F371
(not in the exhibition)
p. 120

Voyer — d'Argenson Park at Asnières, 1887
oil on canvas, 75 x 112.5 cm
Van Gogh Museum, Amsterdam (Vincent
van Gogh Foundation)
F314
(not in the exhibition)
p. 78

Woman at a Table in the Café du Tambourin,
1887
oil on canvas, 55.5 x 46.5 cm
Van Gogh Museum, Amsterdam (Vincent
van Gogh Foundation)
F370
(not in the exhibition)
p. 84

Portrait of Père Tanguy, 1887–88
oil on canvas, 92 x 75 cm
Musée Rodin
F363
(not in the exhibition)
p. 123

Self-Portrait with Gray Felt Hat, 1887–88
oil on canvas, 44 x 37.5 cm
Van Gogh Museum, Amsterdam (Vincent
van Gogh Foundation)
F344
p. 6

Fishing Boats at Saintes-Maries-de-la-Mer, 1888
pen and ink and graphite on wove paper,
24.3 x 31.9 cm

Saint Louis Art Museum,
Gift of Mr. and Mrs. Joseph Pulitzer, Jr.
F1433
p. 190

The Garden of the Poets, 1888
oil on canvas, 73 x 92.1 cm
The Art Institute of Chicago,
Mr. and Mrs. Lewis Larned Coburn
Memorial Collection
F468
(not in the exhibition)
p. 175

Garden with Weeping Tree, Arles, 1888
ink with traces of charcoal on paper,
24 x 31.5 cm
The Menil Collection, Houston
F1451
p. 36

La Mousmé, 1888
oil on canvas, 73.3 x 60.3 cm
National Gallery of Art, Washington,
Chester Dale Collection
F431
(not in the exhibition)
p. 127

Pear Tree in Blossom, 1888
oil on canvas, 73 x 46 cm
Van Gogh Museum, Amsterdam (Vincent
van Gogh Foundation)
F405
(not in the exhibition)
p. 121

Portrait of Eugène Boch, 1888
oil on canvas, 60 x 45 cm
Musée d'Orsay, Paris
F462
(not in the exhibition)
p. 35

Portrait of Milliet, 1888
oil on canvas, 60 x 49 cm
Kröller-Müller Museum, Otterlo,
Netherlands
F473
p. 39

CAMILLE PISSARRO

Apple Picking at Eragny-sur-Epte, 1888
oil on canvas, 60 x 73 cm
Dallas Museum of Art
PV726
p. 155

Self-Portrait, c.1890
etching and drypoint on zinc, printed on laid
paper, state 2 of 2, 18.6 x 17.7 cm
Boston Public Library, Print Department,
Albert H. Wiggin Collection
p. 30

Haymakers Resting, 1891
oil on canvas, 65.4 x 81.3 cm
Collection of the McNay Art Museum,
Bequest of Marion Koogler McNay
p. 157

LUCIEN PISSARRO

The Church of Eragny, 1886
oil on canvas, 51 x 70 cm
The Visitors of the Ashmolean Museum,
Oxford
p. 33

Vincent in Conversation, 1887
black crayon on paper, 19.6 x 29.2 cm
The Visitors of the Ashmolean Museum,
Oxford
p. 23

A L'Exposition de la caricature, 1888
Published in *La Vie moderne*, 6 May 1888
Bibliothèque nationale de France
(not in the exhibition)
p. 100

The Cathedral of Gisors, 1888
oil on canvas, 60 x 73 cm
Musée d'Orsay, Paris,
Gift of Mrs. Esther Pissarro,
wife of the artist, 1948
p. 156

At the Café-Concert, 1889
gouache on silk, 18.4 x 22.5 cm
The British Museum, London
p. 63

Portrait of Jeanne, 1889
oil on canvas, 73 x 59 cm
Private Collection
p. 54

GEORGES SEURAT

Bathers at Asnières, 1883–84
oil on canvas, 201 x 300 cm
The National Gallery, London
H92
(not in the exhibition)
p. 167

*A Sunday Afternoon on the Island of
La Grande Jatte—1884*, 1884–86
oil on canvas, 207.6 x 308 cm
The Art Institute of Chicago,
Helen Birch Bartlett Memorial Collection
H162
(not in the exhibition)
p. 77

Port-en-Bessin: The Outer Harbor, Low Tide,
1888
oil on canvas, 53.7 x 65.7 cm
Saint Louis Art Museum
H189
p. 169

Seascape at Port-en-Bessin, Normandy, 1888
oil on canvas, 65.1 x 80.9 cm
National Gallery of Art, Washington,
Gift of the W. Averell Harriman Foundation
in memory of Marie N. Harriman
H190
p. 15

Study for "Le Chahut," 1889
oil on canvas, 55.5 x 46.5 cm
Albright-Knox Art Gallery, Buffalo,
New York, General Purchase Funds, 1943
H198
p. 99

Portrait of Paul Signac, 1889–90
conté crayon on paper, 36.5 x 31.6 cm
Private Collection, Paris
H694
p. 24

PAUL SIGNAC

The Railway Junction, 1886
oil on canvas, 33 x 47 cm
Leeds Museums and Galleries
(City Art Gallery), Great Britain
p. 162

Snow, Boulevard de Clichy, Paris, 1886
oil on canvas, 45.7 x 65.4 cm
Lent by The Minneapolis Institute of Arts,
Bequest of Putnam Dana McMillan
p. 64

The Bench, 1887
illustration for Jean Ajalbert,
Sur le Talus, 1887
conté crayon on paper
Private Collection, Paris
(not in the exhibition)
p. 86

Quai de Clichy, 1887
oil on canvas, 46 x 65 cm
The Baltimore Museum of Art:
Gift of Frederick H. Gottlieb
p. 28

View of Collioure, 1887
oil on canvas, 33 x 46 cm
Kröller-Müller Museum, Otterlo,
Netherlands
p. 170

*M. Paul Alexis, aux répétitions de
"Lucie Pellegrin,"* 1888
Published in *La Vie moderne*,
17 June 1888, p. 373
Bibliothèque nationale de France
(not in the exhibition)
p. 80

Concarneau: Fishing Boats, 1891
oil on canvas, 64.8 x 81.3 cm
The Metropolitan Museum of Art,
Robert Lehman Collection, 1975
(not in the exhibition)
p. 187

Bibliography

Adriani, Götz. *Toulouse-Lautrec: The Complete Graphic Works: A Catalogue Raisonné: The Gerstenberg Collection.* Translated by Eileen Martin. London: Thames and Hudson, 1988.

Alexandre, Arsène. *H. Daumier: L'Homme et l'oeuvre.* Paris: H. Laurens, 1888.

Angrand, Charles. *Charles Angrand: Correspondances, 1883–1926.* Edited by François Lespinasse. N.p., 1988.

Antoine, André. *"Mes souvenirs" sur le Théâtre-Libre.* Paris: A. Fayard, 1921.

Arts Council of Great Britain. *Lucien Pissarro, 1863–1944: A Centenary Exhibition of Paintings, Watercolors, Drawings, and Graphic Work* (exh. cat.). [London]: Arts Council of Great Britain, 1963.

Aurier, Gabriel-Albert. "Les Isolés–Vincent van Gogh." *Mercure de France* 1, no. 1 (January 1890): 24–29.

———. "Le Symbolisme en peinture: Paul Gauguin." *Mercure de France* (March 1891): 155–65.

———. *Le Symbolisme en peinture: Van Gogh, Gauguin et quelques autres.* [Caen]: L'Echoppe, 1991.

Bailly-Herzberg, Janine. *Pissarro et Paris.* Paris: Flammarion, 1992.

Bernard, Emile. "Louis Anquetin." *Gazette des Beaux-Arts,* 6th ser., 11 (February 1934): 108–21.

———. "Notes sur l'école dite de 'Pont Aven.'" In *Propos sur l'art.* Edited by Anne Rivière. Paris: Séguier, 1994. First published in *Mercure de France* (December 1903).

Blanc, Charles. *Les Artistes de mon temps.* Paris: Firmin-Didot, 1876.

———. *Grammaire des arts du dessin, architecture, sculpture, peinture.* Paris: Ve J. Renouard, 1867.

Brettell, Richard, et al. *The Art of Paul Gauguin* (exh. cat.). Washington, D.C.: National Gallery of Art, 1988.

Broude, Norma. *Georges Seurat.* New York: Rizzoli, 1992.

———, ed. *Seurat in Perspective.* Englewood Cliffs, N.J.: Prentice-Hall, 1978.

Bullington, Judy. "Emile Bernard's 1889 *Portrait de Madeleine, soeur de l'artiste.*" *Gazette des Beaux-Arts,* 6th ser., 117, no. 1464 (January 1991): 53–58.

Cachin, Françoise. *Paul Signac.* Greenwich: New York Graphic Society, 1971.

———. *Seurat: Le Rêve de l'art-science.* [Paris]: Gallimard and Réunion des Musées Nationaux, 1991.

Catalogue des dix expositions annuelles Bruxelles. Brussels: Centre International pour l'Etude du XIXe Siècle, 1981.

Cate, Phillip Dennis, and Mary Shaw, eds. *The Spirit of Montmartre: Cabarets, Humor, and the Avant-Garde, 1875–1905* (exh. cat.). New Brunswick, N.J.: Jane Voorhees Zimmerli Art Museum, 1996.

Cate, Phillip Dennis, and Patricia Eckert Boyer. *The Circle of Toulouse-Lautrec: An Exhibition of the Work of the Artist and of his Close Associates* (exh. cat.). New Brunswick, N.J.: Jane Voorhees Zimmerli Art Museum, 1985.

Cooper, Douglas, ed. *Paul Gauguin: 45 lettres à Vincent, Théo et Jo van Gogh.* The Hague: Staatsuitgeverij; Lausanne: Bibliothèque des Arts, 1983.

Coquiot, Gustave. *Seurat.* Paris: Albin Michel, [1924].

De Hauke, C. M. *Seurat et son oeuvre* (cat. raisonné). 2 vols. Paris: Gründ, 1961.

Denis, Maurice. *Théories, 1890–1910: Du symbolisme et de Gauguin vers un nouvel ordre classique.* 4th ed. Paris: L. Rouart et J. Watelin, 1920.

Denvir, Bernard. *Paul Gauguin: The Search for Paradise: Letters from Brittany and the South Seas.* London: Collins & Brown, 1992.

Distel, Anne. *Seurat.* [Paris]: Chêne, 1991.

Distel, Anne, and Susan Alyson Stein. *Cézanne to Van Gogh: The Collection of Doctor Gachet* (exh. cat.). New York: The Metropolitan Museum of Art, 1999.

Dorn, Roland. *Décoration: Vincent van Goghs Werkreihe für das gelbe Haus in Arles.* Hildesheim, Germany, and New York: G. Olms, 1990.

Dorn, Roland, et al. *Van Gogh Face to Face: The Portraits* (exh. cat.). Detroit: Detroit Institute of Arts; New York: Thames and Hudson, 2000.

Dorra, Henri, and John Rewald. *Seurat: L'Oeuvre peint, biographie et catalogue critique.* Paris: Les Beaux-Arts, 1959.

Dortu, M.-G. *Toulouse-Lautrec et son oeuvre.* New York: Collectors Editions, 1971.

Exposition Universelle de 1889. *Catalogue illustré des beaux-arts, 1789–1889.* Edited by F. G. Dumas. Lille and Paris: L. Daniel, 1889.

Faille, J.-B. de la. *The Works of Vincent van Gogh: His Paintings and Drawings.* Amsterdam: Meulenhoff International, [1970]. First published as *L'Oeuvre de Vincent van Gogh: Catalogue raisonné.* Paris and Brussels: Les Editions G. van Oest, 1928.

Fénéon, Félix. *Oeuvres.* Paris: Gallimard, 1991.

———. *Oeuvres plus que complètes.* Edited by Joan U. Halperin. Geneva: Droz, 1970.

Fine Arts Museums of San Francisco. *The New Painting: Impressionism, 1874–1886* (exh. cat.). Geneva: Richard Burton SA, Publishers, 1986.

Fondation Pierre Gianadda. *T-Lautrec* (exh. cat.). Martigny, Switzerland: Fondation Pierre Gianadda, 1987.

Galerie Brame et Lorenceau. *Anquetin: La Passion d'être peintre* (exh. cat.). Paris: Brame et Lorenceau, 1991.

Gauguin, Paul. *Correspondance de Paul Gauguin: Documents, Témoignages.* Edited by Victor Merlhès. Paris: Fondation Singer-Polignac, 1984.

———. *The Writings of a Savage.* Edited by Daniel Guérin; translated by Eleanor Levieux; with an introduction by Wayne Anderson. New York: Da Capo Press, 1996

Gogh, Vincent van. *The Complete Letters of Vincent van Gogh.* Vols. 1–3. Greenwich: New York Graphic Society, [1958].

———. *Correspondance complète de Vincent van Gogh: enrichie de tous les dessins originaux.* Translated by M. Beerblock and L. Roelandt. Paris: Gallimard/Grasset, 1960.

———. *Letters of Vincent van Gogh, 1886–1890: A Facsimile Edition.* London: Scolar Press, 1977.

Gray, Christopher. *Sculpture and Ceramics of Paul Gauguin.* Rev. ed. New York: Hacker Art Books, 1980.

Hartrick, A. S. *A Painter's Pilgrimage through Fifty Years.* Cambridge: Cambridge University Press, 1939.

Hayward Gallery. *Pissarro: Camille Pissarro, 1830–1903* (exh. cat.). London: Arts Council of Great Britain, 1980.

———. *Toulouse-Lautrec* (exh. cat.). London: South Bank Centre; Paris: Réunion des Musées Nationaux, 1992.

Herbert, Robert L. *Neo-Impressionism.* New York: Solomon R. Guggenheim Museum, 1968.

Herbert, Robert L., et al. *Georges Seurat, 1859–1891* (exh. cat.). New York: The Metropolitan Museum of Art, 1991.

Homburg, Cornelia. *The Copy Turns Original: Vincent van Gogh and a New Approach to Traditional Art Practice.* Amsterdam and Philadelphia: John Benjamins, 1996.

Homer, William Innes. *Seurat and the Science of Painting.* Cambridge: M.I.T. Press, 1964.

House, John. *Monet: Nature into Art.* New Haven and London: Yale University Press, 1986.

Huisman, Philippe, and M. G. Dortu. *Lautrec by Lautrec.* Edited and translated by Corinne Bellow. New York: The Viking Press, 1964.

Hulsker, Jan. *The New Complete Van Gogh: Paintings, Drawings, Sketches: Revised and Enlarged Edition of the Catalogue Raisonné of the Works of Vincent van Gogh.* Amsterdam: J. M. Meulenhoff; Philadelphia: John Benjamins, 1996.

———. *Vincent and Theo van Gogh: A Dual Biography.* Ann Arbor: Fuller Publications, 1990.

Isetan Museum of Art, Tokyo. *Retrospective: Camille Pissarro* (exh. cat.). [Tokyo]: Art Life Ltd., 1984.

Jampoller, Lili. "Theo van Gogh and Camille Pissarro: Correspondence and an Exhibition." *Simiolus* 16, no. 1 (1986): 50–61.

Jensen, Robert. *Marketing Modernism in Fin-de-Siècle Europe.* Princeton: Princeton University Press, 1994.

Jirat-Wasiutyński, Vojtěch. "Vincent van Gogh's Paintings of Olive Trees and Cypresses from St.-Rémy." *Art Bulletin* 75, no. 4 (December 1993): 647–70.

Jirat-Wasiutyński, Vojtěch, et al. *Vincent van Gogh's Self-Portrait Dedicated to Paul Gauguin: An Historical and Technical Study.* Cambridge: Harvard University Art Museums, Center for Conservation and Technical Studies, 1984.

Joyant, Maurice. *Henri de Toulouse-Lautrec, 1864–1901: Dessins, estampes, affiches.* Paris: H. Floury, 1927.

———. *Henri de Toulouse-Lautrec, 1864–1901: Peintre.* Paris: H. Floury, 1926.

Kōdera, Tsukasa. *Vincent van Gogh: Christianity versus Nature.* Amsterdam and Philadelphia: John Benjamins, 1990.

———, ed. *The Mythology of Vincent van Gogh.* Tokyo: TV Asahi; Amsterdam and Philadelphia: John Benjamins, 1993.

Lee, Ellen Wardwell. *The Aura of Neo-Impressionism: The W. J. Holliday Collection* (exh. cat.). Indianapolis: Indianapolis Museum of Art and Indiana University Press, 1983.

Leighton, John, and Richard Thomson. *Seurat and the Bathers.* London: National Gallery Publications, 1997.

Lespinasse, François. *Charles Angrand, 1854–1926.* Rouen: LECERF, 1982.

Lindert, Juleke van, and Evert van Uitert. *Een eigentijdse expressie: Vincent van Gogh en zijn portretten.* [Amsterdam]: Meulenhoff/Landshoff, 1990.

Lloyd, Christopher. *Pissarro.* London: Phaidon, 1992.

Lövgren, Sven. *The Genesis of Modernism: Seurat, Gauguin, van Gogh, and French Symbolism in the 1880's.* Rev. ed. Bloomington: Indiana University Press, [1971].

Luthi, Jean-Jacques. *Emile Bernard: Catalogue raisonné de l'oeuvre peint.* Paris: Editions SIDE, 1982.

Malingue, Maurice, ed. *Lettres de Gauguin à sa femme et à ses amis.* Paris: B. Grasset, 1946.

Margerie, Anne de, et al. *Le Temps Toulouse-Lautrec.* Paris: Textuel and Reunion des Musées Nationaux, 1991.

Marlborough Fine Art, Ltd. *Van Gogh's Life in His Drawings; Van Gogh's Relationship with Signac.* London: Marlborough Fine Art, Ltd., 1962.

Mathews, Patricia T. *Aurier's Symbolist Art Criticism and Theory.* Ann Arbor: UMI Research Press, 1986.

Maurer, Naomi. "The Pursuit of Spiritual Knowledge: The Phylosophical Meaning and Origins of Symbolist Theory and Its Expression in the Thought and Art of Odilon Redon, Vincent van Gogh, and Paul Gauguin." Ph.D. diss., University of Chicago, 1985.

———. *The Pursuit of Spiritual Wisdom: The Thought and Art of Vincent van Gogh and Paul Gauguin.* Madison, N.J.: Fairleigh Dickinson University Press; London: Associated University Presses in association with The Minneapolis Institute of Arts, 1998.

Merlhès, Victor. *Paul Gauguin et Vincent van Gogh, 1887–1888: Lettres retrouvées, sources ignorées.* Papeete, Tahiti: Avant et Après, 1989.

Milner, John. *The Studios of Paris: The Capital of Art in the Late Nineteenth Century.* New Haven: Yale University Press, 1988.

Mirbeau, Octave. *Correspondance avec Camille Pissarro.* Tusson, Charente: Du Lérot, 1990.

Murray, Gale B. *Toulouse-Lautrec: The Formative Years, 1878–1891.* Oxford: Clarendon Press, 1991.

Musée d'Orsay. *Millet/Van Gogh* (exh. cat.). Paris: Réunion des Musées Nationaux, 1998.

———. *Van Gogh à Paris* (exh. cat.). Paris: Réunion des Musées Nationaux, 1988.

Museum Folkwang Essen. *Das Verlorene Paradies: Paul Gauguin* (exh. cat.). Essen, Germany: Museum Folkwang Essen; Berlin: Staatliche Museen zu Berlin Neue Nationalgalerie; Cologne: DuMont, 1998.

Oberthür, Mariel. *Le chat noir, 1881–1897* (exh. cat.). Paris: Réunion des Musées Nationaux, 1992.

Peres, Cornelia, et al., eds. *A Closer Look: Technical and Art-Historical Studies on Works by van Gogh and Gauguin.* Zwolle, Netherlands: Waanders Publishers, 1991.

Pickvance, Ronald. *Van Gogh in Arles* (exh. cat.). New York: The Metropolitan Museum of Art and Harry N. Abrams, 1984.

———. *Van Gogh in Saint-Rémy and Auvers* (exh. cat.). New York: The Metropolitan Museum of Art and Harry N. Abrams, 1986.

Pissarro, Camille. *Camille Pissarro: Letters to His Son Lucien.* Edited with the assistance of Lucien Pissarro by John Rewald. Translated by Lionel Abel. New York: Pantheon Books, [1943].

———. *Correspondance de Camille Pissarro, 1866–1903.* Vols. 2–5. Edited by Janine Bailly-Herzberg. Paris: Editions du Valhermeil, 1986–1991.

Pissarro, 1830–1903. London: Pavilion, 1995.

Pissarro, Joachim. *Camille Pissarro.* New York: Harry N. Abrams, 1993.

Pissarro, Lucien. *The Letters of Lucien to Camille Pissarro, 1883–1903.* Edited by Anne Thorold. Cambridge: Cambridge University Press, 1993.

Pissarro, Ludovico Rodo, and Lionello Venturi. *Camille Pissarro: Son art—son oeuvre.* 2 vols. Paris: Paul Rosenberg, 1939.

Prather, Marla, and Charles F. Stuckey, eds. *Gauguin: A Retrospective.* New York: Hugh Lauter Levin Associates, 1987.

Rappard-Boon, Charlotte van, Willem van Gulik, and Keiko van Bremen-Ito. *Catalogue of the Van Gogh Museum's Collection of Japanese Prints.* Amsterdam: Van Gogh Museum; Zwolle, Netherlands: Waanders Publishers, 1991.

Ratliff, Floyd. *Paul Signac and Color in Neo-Impressionism.* New York: Rockefeller University Press, 1992.

Rewald, John. *Post-Impressionism: From van Gogh to Gauguin.* 3rd ed., rev. New York: The Museum of Modern Art, 1978.

Rijksmuseum Vincent van Gogh. *Emile Bernard: Retrospective du 24 août au 4 novembre 1990* (exh. cat.). Amsterdam: Rijksmuseum Vincent van Gogh, 1990.

Roskill, Mark W. *Van Gogh, Gauguin and French Painting of the 1880s: A Catalogue Raisonné of Key Works.* Ann Arbor: University Microfilms, 1970.

———. *Van Gogh, Gauguin, and the Impressionist Circle.* Greenwich: New York Graphic Society, 1970.

Royal Academy of Arts. *Post-Impressionism: Cross-Currents in European Painting* (exh. cat.). London: Royal Academy of Arts in association with Weidenfeld and Nicolson, 1979.

Salons of the "Indépendants," 1884–1900. 3 vols. New York and London: Garland Publishing, Inc., 1981.

Seyres, Helene, ed. *Seurat: Correspondances, témoignages, notes inédites, critiques.* Foreword by Eric Darragon. Paris: Acropole, 1991.

Shiff, Richard. *Cézanne and the End of Impressionism: A Study of the Theory, Technique, and Critical Evaluation of Modern Art.* Chicago: University of Chicago Press, 1984.

Signac, Paul. *D'Eugène Delacroix au néo-impressionnisme.* 1899. New ed., Paris: Hermann, 1964.

Silvestre, Théophile. *Eugène Delacroix: Documents nouveaux.* Paris: M. Lévy Frères, 1864.

Smith, Paul. *Seurat and the Avant-Garde.* New Haven and London: Yale University Press, 1997.

Solomon-Godeau, Abigail. "Going Native: Paul Gauguin and the Invention of Primitivist Modernism." *Art in America* 77 (July 1989): 118–29.

Stein, Susan Alyson, ed. *Van Gogh: A Retrospective.* New York: Hugh Lauter Levin Associates, 1986.

Stevens, Mary Anne, et al. *Emile Bernard, 1868–1941: A Pioneer of Modern Art* (exh. cat.). Translated by J. C. Garcias et al. Mannheim: Städtische Kunsthalle; Amsterdam: Van Gogh Museum; Zwolle, Netherlands: Waanders Publishers, 1990.

Stolwijk, Chris, and Richard Thomson. *Theo van Gogh, 1857–1891: Art Dealer, Collector, and Brother of Vincent* (exh. cat.). Amsterdam: Van Gogh Museum; Zwolle, Netherlands: Waanders Publishers, 1999.

Sund, Judy. *True to Temperament: Van Gogh and French Naturalist Literature.* Cambridge and New York: Cambridge University Press, 1992.

Sutter, Jean, ed. *The Neo-Impressionists.* Translated by Chantel Deliss. Greenwich: New York Graphic Society, 1970.

Thomson, Belinda. *Gauguin.* Translated by Olivier Meyer. Paris: Thames and Hudson, 1995.

Thomson, Richard. *Camille Pissarro: Impressionism, Landscape, and Rural Labour.* London: South Bank Centre, 1990.

Tilborgh, Louis van, ed. *Van Gogh & Millet* (exh. cat.). Translated by Martin Cleaver. Zwolle, Netherlands:

Waanders Publishers; Amsterdam: Rijksmuseum Vincent van Gogh, 1989.

Toulouse-Lautrec, Henri de. *The Letters of Henri de Toulouse-Lautrec*. Edited by Herbert D. Schimmel. Introduction by Gale B. Murray. Oxford: Oxford University Press, 1991.

Uitert, Evert van. "Van Gogh and Gauguin in Competition: Vincent's Original Contribution." *Simiolus* 11, no. 2 (1980): 81–106.

———. "Van Gogh's Concept of His *Oeuvre*." *Simiolus* 12, no. 4 (1981–82): 223–44.

———. "Vincent van Gogh in Anticipation of Paul Gauguin." *Simiolus* 10, no. 3/4 (1978–79): 182–99.

Uitert, Evert van, and Michael Hoyle, eds. *The Rijksmuseum Vincent Van Gogh*. Amsterdam: Meulenhoff, 1987.

Urbanelli, Lora S. *The Wood Engravings of Lucien Pissarro and a Bibliographical List of Eragny Books*. Cambridge, England: Silent Books; Oxford: Ashmolean Museum, 1994.

Ward, Martha. *Pissarro, Neo-Impressionism, and the Spaces of the Avant-garde*. Chicago: University of Chicago Press, 1996.

Welsh-Ovcharov, Bogomila. *The Early Work of Charles Angrand and His Contact with Vincent Van Gogh*. Utrecht and The Hague: Editions Victorine, 1971.

———. *Emile Bernard (1868–1941): The Theme of Bordellos and Prostitutes in Turn-of-the-Century French Art* (exh. cat.). New Brunswick, N.J.: Jane Voorhees Zimmerli Art Museum, 1988.

———. *Vincent van Gogh and the Birth of Cloisonism* (exh. cat.). Toronto: Art Gallery of Ontario; Amsterdam: Rijksmuseum Vincent Van Gogh, 1981.

Westfälisches Landesmuseum für Kunst und Kulturge-schichte, Münster. *Signac et la libération de la couleur: De Matisse à Mondrian* (exh. cat.). Paris: Réunion des Musées Nationaux, 1997.

Wildenstein, Georges. *Gauguin*. Vol. 1. Paris: Beaux-Arts, 1964.

Wolk, Johannes van der, Evert van Uitert, et al. *Vincent van Gogh* (exh. cat.). New York: Rizzoli, 1990.

Zemel, Carol M. *The Formation of a Legend: Van Gogh Criticism, 1890–1920*. Ann Arbor: UMI Research Press, 1980.

———. *Van Gogh's Progress: Utopia, Modernity, and Late-Nineteenth-Century Art*. Berkeley and Los Angeles: University of California Press, 1997.

Zimmermann, Michael F. *Seurat and the Art Theory of His Time*. Antwerp: Fonds Mercator, 1991.

Photography Credits

p. 6 Van Gogh Museum (Vincent van Gogh Foundation), Amsterdam; p. 8 Musée des Beaux-Arts, Rennes. Photo by Adélaïde Beaudoin. © 2000 Artists Rights Society (ARS), New York/ADAGP, Paris; p. 10 Petit Palais, Musée d'Art Moderne, Geneva; p. 12 Saint Louis Art Museum. Photo by David Ulmer; p. 15 © 2000 Board of Trustees, National Gallery of Art, Washington; p. 16 Mr. and Mrs. Arthur G. Altschul. © 2000 Artists Rights Society (ARS), New York/ADAGP, Paris; p. 17 © 2000 Artists Rights Society (ARS), New York/ADAGP, Paris; p. 18 © Tate, London 2000. Photo by John Webb; p. 19 Kimbell Art Museum, Fort Worth, Texas. Photo by Michael Bodycomb; p. 20 Van Gogh Museum (Vincent van Gogh Foundation), Amsterdam; p. 23 © Ashmolean Museum, Oxford; p. 24 Photo by P. Trawinski; p. 26 Brame et Lorenceau. © 2000 Artists Rights Society (ARS), New York/ADAGP, Paris; p. 28 The Baltimore Museum of Art. © 2000 Artists Rights Society (ARS), New York/ADAGP, Paris; p. 29 Saint Louis Art Museum. Photo by David Ulmer; p. 30 Boston Public Library; p. 31 François Lespinasse; p. 33 © Ashmolean Museum, Oxford; p. 35 Musée d'Orsay, Paris. © Photo RMN–Hervé Lewandowski; p. 36 The Menil Collection, Houston. Photo by Hickey-Robertson, Houston; p. 37 © Solomon R. Guggenheim Foundation, New York. Photo by David Heald; p. 39 © Stichting Kröller-Müller Museum. © indien van toepassing, kontakt opnemen met Stichting Beeldrecht, Amsterdam; p. 40 © 2000 Artists Rights Society (ARS), New York/ADAGP, Paris; p. 41 Kunstmuseum Solothurn, Switzerland, Dübi-Müller-Stiftung; p. 42 Van Gogh Museum (Vincent van Gogh Foundation), Amsterdam; p. 44 © 1997 The Nelson Gallery Foundation —All Reproduction Rights Reserved. Photo by Robert Newcombe; p. 47 Museum of Fine Arts, Boston. Reproduced with permission. © 1999 Museum of Fine Arts, Boston. All Rights Reserved; p. 48 Van Gogh Museum (Vincent van Gogh Foundation), Amsterdam; p. 49 Courtesy Saint Louis Art Museum. Photo by David Ulmer; p. 50 © Musée de Grenoble; p. 51 © 2000 Artists Rights Society (ARS), New York/ADAGP, Paris; p. 52 © Stichting Kröller-Müller Museum. © indien van toepassing, kontakt opnemen met Stichting Beeldrecht, Amsterdam; p. 57 Musée d'Orsay, Paris. © Photo RMN–Hervé Lewandowski; p. 58 Stedelijk Museum, Amsterdam; p. 59 © Wadsworth Antheneum. © 2000 Artists Rights Society (ARS), New York/ADAGP, Paris; p. 60, 61 Jane Voorhees Zimmerli Art Museum. © 2000 Artists Rights Society (ARS), New York/ADAGP, Paris. Photo by Jack Abraham/Photo by Victor Pustai; p. 62 © 2000 Artists Rights Society (ARS), New York/ADAGP, Paris; p. 63 © The British Museum; p. 64 © The Minneapolis Institute of Arts. © 2000 Artists Rights Society (ARS), New York/ADAGP, Paris; p. 67 Museum of Fine Arts, Boston. Reproduced with permission. © 1999 Museum of Fine Arts, Boston. All Rights Reserved; p. 69 © Hazlitt, Gooden & Fox. © 2000 Artists Rights Society (ARS), New York/ADAGP, Paris; p. 70 Musée de Brest. © 2000 Artists Rights Society (ARS), New York/ADAGP, Paris; p. 72 Brooklyn Museum of Art; p. 74 © Tate, London 2000. © 2000 Artists Rights Society (ARS), New York/ADAGP, Paris. Photo by John Webb; p. 77 Photograph © 2000, The Art Institute of Chicago, All Rights Reserved; p. 78 Van Gogh Museum (Vincent van Gogh Foundation), Amsterdam; p. 80 Bibliothèque nationale de France. © 2000 Artists Rights Society (ARS), New York/ADAGP, Paris; p. 84 Van Gogh Museum (Vincent van Gogh Foundation), Amsterdam; p. 85 © 2000 Board of Trustees, National Gallery of Art, Washington; p. 86 Photo by Jacqueline Hyde. © 2000 Artists Rights Society (ARS), New York/ADAGP, Paris; p. 87 Hiroshima Museum of Art; p. 89 Photograph © 2001 The Museum of Modern Art, New York. © 2000 Artists Rights Society (ARS), New York/ADAGP, Paris; p. 90 © 2000 Artists Rights Society (ARS), New York/ADAGP, Paris; p. 91 Jane Voorhees Zimmerli Art Museum. © 2000 Artists Rights Society (ARS), New York/ADAGP, Paris. Photo by Jack Abraham; p. 93 © 2000 Artists Rights Society (ARS), New York/ADAGP, Paris; p. 94 Courtesy Brame et Lorenceau. © 2000 Artists Rights Society (ARS), New York/ADAGP, Paris; p. 96 The Henry and Rose Pearlman Foundation, Inc. © 2000 Trustees of Princeton University. Photo by Clem Fiori; p. 97 Photograph © 1979 The Metropolitan Museum of Art; p. 98 Hazlitt, Gooden & Fox; p. 99 Courtesy Albright-Knox Art Gallery, Buffalo, New York; p. 100 Bibliothèque nationale de France; p. 101 Hazlitt, Gooden & Fox. © 2000 Artists Rights Society (ARS), New York/ADAGP, Paris; p. 102 Photograph © 2000, The Art Institute of Chicago, All Rights Reserved; p. 105 James Roundell; p. 109 Ordrupgaard, Copenhagen. Photo © Ole Woldbye; p. 110 Daniel Malingue, Paris. © 2000 Artists Rights Society (ARS), New York/ADAGP, Paris; p. 111 Photograph © 2000 Board of Trustees, National Gallery of Art, Washington. Photo by Jose A. Naranjo; p. 112 © President and Fellows of Harvard College. Photo by Katya Kallsen; p. 114 National Gallery of Scotland; p. 118 The State Hermitage Museum, St. Petersburg; p. 120 Van Gogh Museum (Vincent van Gogh Foundation), Amsterdam; p. 121 Van Gogh Museum (Vincent van Gogh Foundation), Amsterdam; p. 122 Photo: Öffentliche Kunstsammlung Basel, Martin Bühler. © 2000 Artists Rights Society (ARS), New York/ADAGP, Paris; p. 123 Musée Rodin; p. 125 Van Gogh Museum (Vincent van Gogh Foundation), Amsterdam; p. 127 Photograph © 2000 Board of Trustees, National Gallery of Art, Washington. Photo by Bob Grove; p. 131 Indianapolis Museum of Art; p. 135 The Courtauld Gallery, London; p. 138 Museum of Fine Arts, Boston. Reproduced with permission. © 1999 Museum of Fine Arts, Boston. All Rights Reserved; p. 141 © Sterling and Francine Clark Art Institute, Williamstown, Massachusetts; p. 142 National Gallery of Scotland; p. 144 Association des Amis de la Maison Marie-Henry; p. 145 © Le Musée Départemental du Prieuré, Saint Germain-en-Laye, France. © 2000 Artists Rights Society (ARS), New York/ADAGP, Paris; p. 147 © 1989 The Nelson Gallery Foundation —All Reproduction Rights Reserved. Photo by Mel McLean, 1989; p. 148 The State Hermitage Museum, St. Petersburg; p. 153 Photograph © 2001 The Museum of Modern Art, New York; p. 154 Musée des Beaux-Arts de Nantes. Photo by H. Josse. © 2000 Artists Rights Society (ARS), New York/ADAGP, Paris; p. 155 Courtesy Dallas Museum of Art; p. 156 Musée d'Orsay, Paris. © Photo RMN–Hervé Lewandowski; p. 157 Marion Koogler McNay Art Museum; p. 158 © The National Gallery, London; p. 160 Musée d'Orsay, Paris. © Photo RMN–Hervé Lewandowski; p. 162 Leeds Museums and Galleries (City Art Gallery), Great Britain. © 2000 Artists Rights Society (ARS), New York/ADAGP, Paris; p. 163 Galerie Larock-Granoff Paris; p. 165 Helly Nahmad Gallery, London; p. 167 © The National Gallery, London; p. 169 Saint Louis Art Museum. Photo by David Ulmer; p. 170 © Stichting Kröller-Müller Museum. © indien van toepassing, kontakt opnemen met Stichting Beeldrecht, Amsterdam. © 2000 Artists Rights Society (ARS), New York/ADAGP, Paris; p. 171 The Courtauld Gallery, London; p. 172 Private Collection; p. 175 Photograph © 2000, The Art Institute of Chicago, All Rights Reserved; p. 177 Photograph © 2000, The Art Institute of Chicago, All Rights Reserved; p. 178 Museum Folkwang Essen; p. 179 © The Solomon R. Guggenheim Foundation, New York. Photo by David Heald;p. 180 © Stichting Kröller-Müller Museum. © indien van toepassing, kontakt opnemen met Stichting Beeldrecht, Amsterdam; p. 182 Museu Calouste Gulbenkian; p. 183 The Courtauld Gallery, London; p. 184 Musées Royaux des Beaux-Arts de Belgique, Brussels; p. 185 Museum Folkwang Essen; p. 187 Photograph © 1998 The Metropolitan Museum of Art. © 2000 Artists Rights Society (ARS), New York/ADAGP, Paris; p. 188 Musée des Arts Décoratifs, Paris. Photo by Laurent-Sully Jaulmes; p. 190 Saint Louis Art Museum; p. 191 © Stichting Kröller-Müller Museum. © indien van toepassing, kontakt opnemen met Stichting Beeldrecht, Amsterdam; p. 192 Ordrupgaard, Copenhagen. Photo © Ole Woldbye; p. 194 Van Gogh Museum (Vincent van Gogh Foundation), Amsterdam; p. 204 (top) Bibliothèque nationale de France; p. 204 (bottom) Paulhan Archives, Paris; p. 205 Musée Toulouse-Lautrec, Albi, Tarn, France. All rights reserved; p. 206 (top) © Roger-Viollet; p. 207 Van Gogh Museum (Vincent van Gogh Foundation), Amsterdam. Photo (left) by Ernest Ladrey. Photo (right) by J. M. W. de Louw; p. 208 (top) Bibliothèque nationale de France; p. 208 (bottom) Musée Toulouse-Lautrec, Albi, Tarn, France. All Rights Reserved; p. 209 (top) Bibliothèque nationale de France. Photo by Nadar; p. 209 (bottom) Musée de Montmartre; p. 210 (bottom) Musée Toulouse-Lautrec, Albi, Tarn, France. All Rights Reserved; p. 211 Van Gogh Museum (Vincent van Gogh Foundation), Amsterdam; p. 212 (top) Musée Pissarro, Pontoise; p. 212 (bottom) © Ashmolean Museum, Oxford; p. 213 © Roger-Viollet; p. 215 Private Collection; p. 216 © Le Musée Départemental du Prieuré, Saint Germain-en-Laye, France; p. 217 Library Archives, National Gallery of Art, Washington, D.C. © Sabine Rewald; p. 218 The Museum of Modern Art, New York. Purchase. Platinum print, 22.4 x 14.9 cm. Copy Print © 2000 The Museum of Modern Art, New York; p. 219 Paul Signac, Signac Archives; p. 220 (top) Van Gogh Museum (Vincent van Gogh Foundation), Amsterdam; p. 220 (bottom) Bibliothèque nationale de France; p. 222 Private Collection; p. 223 Private Collection; p. 224 Musée de Montmartre; p. 225 Musée d'Orsay, Paris; p. 226 Musée Toulouse-Lautrec, Albi, Tarn, France. All rights reserved; p. 227, 228, 229 Van Gogh Museum (Vincent van Gogh Foundation), Amsterdam; p. 232 (top) Bibliothèque d'Art et d'Archéologie Jacques Doucet, Paris; p. 232 (bottom) © Musée de Pont-Aven. Photo by Boutet de Monvel; p. 233 (bottom) Musée Pissarro, Pontoise; p. 234 (bottom) François Lespinasse; p. 235 (top) Bibliothèque nationale de France. Color lithograph, 141.2 x 98.4 cm; p. 235 (bottom) Document Archives Durand-Ruel. Rights Reserved. Photo by Dornac; p. 236 Van Gogh Museum (Vincent van Gogh Foundation), Amsterdam

Index